Andrea Zittel Critical Space

Paola Morsiani / Trevor Smith

with contributions by

Cornelia Butler

Beatriz Colomina / Mark Wigley

Robert Cook

CONTEMPORARY ARTS MUSEUM HOUSTON

NEW MUSEUM OF CONTEMPORARY ART · NEW YORK

PRESTEL · MUNICH · BERLIN · LONDON · NEW YORK

Andrea Zittel

Critical Space

This catalogue has been published to accompany the exhibition
Andrea Zittel: Critical Space organized by Paola Morsiani,
Curator, Contemporary Arts Museum Houston, and Trevor Smith,
Curator, New Museum of Contemporary Art, New York, for
both institutions and a North American tour.

Contemporary Arts Museum Houston
October 1, 2005–January 1, 2006

New Museum of Contemporary Art, New York
January 26–April 29, 2006

Albright-Knox Art Gallery, Buffalo, New York
October 6, 2006–January 7, 2007

The Museum of Contemporary Art, Los Angeles
March 4–May 21, 2007

Vancouver Art Gallery, British Columbia
June 9–September 16, 2007

Published by

Prestel Verlag
Königinstrasse 9
80539 Munich
Tel: +49 (89) 38 17 09-0
Fax: +49 (89) 38 17 09-35
www.prestel.de

Prestel Publishing Ltd.
4 Bloomsbury Place
London WC1A 2QA
Tel: +44 (20) 7323-5004
Fax: +44 (20) 7636-8004

Prestel Publishing
900 Broadway, Suite 603
New York, NY 10003
Tel: +1 (212) 995-2720
Fax: +1 (212) 995-2733
www.prestel.com

Contemporary Arts Museum Houston
5216 Montrose Boulevard
Houston, TX 77006-6598
Tel: +1 (713) 284-8250
Fax: +1 (713) 284-8275
www.camh.org

New Museum of Contemporary Art
210 Eleventh Avenue, 2nd floor
New York, NY 10001
Tel: +1 (212) 219-1222
Fax: +1 (212) 431-5328
www.newmuseum.org

Library of Congress Control Number 2005904401

Die Deutsche Bibliothek holds a record of this publication in the Deutsche
Nationalbibliografie; detailed bibliographical data can be found under:
http://dnb.dde.de

Prestel books are available worldwide. Please contact your nearest
bookseller or one of the above addresses for information concerning
your local distributor.

Printed on acid-free paper.

ISBN 3-7913-3397-6 (trade edition)
ISBN 3-7913-6040-X (museum edition)

Front cover:
Installation view, four *A–Z Wagon Stations* (2003) in *On-Site:
Andrea Zittel*, Milwaukee Art Museum, 2003–2004 [see p. 215]

Back cover:
A–Z Fiber Form Uniform (White Felted Dress #7), 2002
Merino wool
Courtesy of the artist and Regen Projects, Los Angeles

Contents

Andrea Zittel: Critical Space is a co-production
of the Contemporary Arts Museum Houston and the
New Museum of Contemporary Art, New York.

The exhibition has been made possible by a grant from the
National Endowment for the Arts, a Federal agency;

NATIONAL
ENDOWMENT
FOR THE ARTS

the Peter Norton Family Foundation; and by the patrons,
benefactors, and donors to the Contemporary Arts Museum
Houston's Major Exhibition Fund.

The catalogue accompanying the exhibition *Andrea Zittel:
Critical Space* has been made possible by a grant from The
Brown Foundation, Inc. of Houston. Additional support for
the publication has been provided by the Elizabeth Firestone
Graham Foundation.

The **Contemporary Arts Museum Houston**'s operations and
programs are made possible through the generosity of the
Museum's trustees, patrons, members and donors to its
programs. The Contemporary Arts Museum Houston receives
partial operating support from the Houston Endowment, Inc.,
the City of Houston through the Cultural Arts Council of
Houston/Harris County, and the Texas Commission on the Arts.

Official airline of the Contemporary Arts Museum Houston.

The **New Museum of Contemporary Art** receives general
operating support from the Carnegie Corporation, the New York
State Council on the Arts, the New York City Department of
Cultural Affairs, JPMorgan Chase, and members of the
New Museum.

Major Exhibition Fund

Major Patrons
Eddie and Chinhui Allen
Fayez Sarofim & Co.

Patrons
Mr. and Mrs. A. L. Ballard
Mr. and Mrs. I. H. Kempner III
Ms. Louisa Stude Sarofim
Stephen and Ellen Susman
Mr. and Mrs. Michael Zilkha

Benefactors
Baker Botts L.L.P.
Robert J. Card, M.D./
 Karol Kreymer
George and Mary Josephine
 Hamman Foundation
Jackson Hicks/
 Jackson and Company
Elizabeth Howard
Rob and Louise Jamail
King & Spalding L.L.P.
Leigh and Reggie Smith
Susan Vaughan Foundation
VITOL

Donors
Mr. and Mrs. Thomas Au
The Citigroup Private Bank
Barbara and Michael Gamson
KPMG LLP
Judy and Scott Nyquist
Karen and Eric Pulaski
Jeff Shankman
Karen and Harry Susman
Mr. and Mrs. Wallace S. Wilson

Lenders to the Exhibition

Cincinnati Art Museum

Sadie Coles HQ, London

Galleria Massimo De Carlo, Milan

Rebecca and Martin Eisenberg

Editions Fawbush, New York

Goetz Collection, Munich

Eileen Harris Norton, Santa Monica, California

Emanuel Hoffmann Foundation, on permanent loan to the
Öffentliche Kunstsammlung, Basel, Switzerland

Hort Family Collection, New York

Steven Johnson and Walter Sudol, New York

Milwaukee Art Museum

Barbara and Howard Morse, New York

The Museum of Contemporary Art, Los Angeles

The Museum of Modern Art, New York

Peter Norton, Santa Monica, California

Olbricht Collection

Private Collections

Regen Projects, Los Angeles

Andrea Rosen, New York

Andrea Rosen Gallery, New York

Robert J. Shiffler Foundation

Dean Valentine and Amy Adelson, Los Angeles

David and Diane Waldman, Rancho Mirage, California

White Cube, London

Andrea Zittel

Foreword

Museums that focus on the work of today's artists have the special pleasure of pursuing some of the most intriguing current ideas and points of view about contemporary life. The work of Andrea Zittel challenges even the most forward-thinking philosophies and assumptions about the way we live and work in today's world. It questions the relationship between our social and personal lives, our simultaneous need for security and adventure, the impact of human existence on the environment, commonly perceived differences between urban and non-urban living, and the creation and consumption of everyday products —including art itself. Related, at first glance, to Conceptualist art of the 1960s and 1970s in Europe and America, Zittel's work, which refuses to differentiate between art and life, stands alone in its conscious use of everyday strategies to advance newer ideas regarding the place of art in political, social, and cultural contexts worldwide. Zittel's sincerely accessible work, coupled with her use of the contradictions inherent in irony and parody, quietly questions the status quo and the beliefs that inform the everyday actions and habits of even the most enlightened among us. Her search for new ways of living and working in this world illuminates our own journey and contributes new paradigms to the continuing conversation about the intersection of life and art.

We are most grateful to Paola Morsiani, curator, Contemporary Arts Museum Houston, and Trevor Smith, curator, New Museum of Contemporary Art, New York, for their organization of this exhibition. Both curators had a profound mutual interest in the work of the artist that, once discovered, led to this special collaboration between our institutions. Their combined insight and expertise provides a richer and more rewarding experience for the audiences of the project, broader scholarship and knowledge about contemporary art, and entry into the special relationship between artists and art professionals. Our colleagues Louis Grachos and Doug Dreishpoon of the Albright-Knox Art Gallery, Buffalo, New York; Jeremy Strick, Paul Schimmel, and Cornelia Butler of The Museum of Contemporary Art, Los Angeles; and Kathleen Bartels and Daina Augaitis of the Vancouver Art Gallery in British Columbia are owed deep appreciation for their early and continuing support of the exhibition's tour.

This is the most recent in a long line of collaborations between our museums over the past twenty-five years. We are closely related in size, mission, and institutional culture, and through our mutual respect and shared interests here, we have combined resources to produce a more ambitious project than either of us could have accomplished alone.

Andrea Zittel: Critical Space is supported by a grant from the National Endowment for the Arts, a Federal agency, Washington, D.C. Awarded early in the project's life, initially to the Contemporary Arts Museum Houston, the grant was amended to support the shared project. The Peter Norton Family Foundation has provided important support for the exhibition. We are also grateful to The Brown Foundation, Inc. for generous and continuing support of publications at the Contemporary Arts Museum Houston. The Foundation has assured the documentation of exhibitions of today's art at the Museum for many years, allowing the dissemination of scholarship about contemporary art far beyond the walls of any institution; its support has assured the quality of this joint publication. We are, as well, indebted to the Elizabeth Firestone Graham Foundation for additional support of the major publication that accompanies the project. We also thank the contributors to the Major Exhibition Fund at the Contemporary Arts Museum Houston, listed on page 8. Acknowledgment of and thanks are due the trustees, donors, and members of the Contemporary Arts Museum Houston and the New Museum of Contemporary Art, New York, for their continuing support of programming that brings today's art and artists to broad audiences in the U.S. and beyond.

Finally, all associated with this remarkable project thank the artist for her continuing cooperation, for her collaboration, and—most of all—for her work. Her explorations lead ours and reach beyond this project, our institutions, and the contemporary world, allowing us a glimpse into fresh ways of living and working on our planet.

Marti Mayo
Director
Contemporary Arts Museum
Houston

Lisa Phillips
Henry Luce III Director
New Museum
of Contemporary Art, New York

Acknowledgments

For the past fifteen years, with a keen and critical eye, Andrea Zittel has closely observed the contemporary urban ecosystem. Her work as an artist has engaged vigorously with design, architecture, and urbanism, forming an experimental investigation into, and conceptual assessment of, our aspirations to live fully and in harmony within that often contradictory landscape. By relating first and foremost to her personal experience as an American and a Californian, Zittel has heightened awareness of those cultural constructs in the West that mark the divide between the reality of our everyday metropolitan/suburban lives and the idealistic projections created by the larger social and economic power structures. With her acute sensitivity to European and American social history of the past two centuries, especially the utopian ideals that brought together art and industry at the beginning of the twentieth century, Zittel has explored those constructs with a unique spirit and an independent vision.

While Zittel's work has had a great influence on younger generations of artists throughout the past decade, it has until now lacked a significant synopsis on this side of the Atlantic. We both felt it was time to propose an exhibition that would extend the debate around the issues that Zittel has brought to our attention, while illuminating the artist's vision by taking a closer look at the varied production that comprises her output to date. The exhibition *Andrea Zittel: Critical Space* brings together a large selection of habitats, installations, drawings, and documentation, with representative work from most of Zittel's projects. This book is a first attempt to document her work comprehensively. Given Zittel's intense focus and prolific output, we realize that this is only a beginning, but we hope it will help clarify (and provoke further investigation around) Zittel's contribution to contemporary art.

This exhibition and catalogue were developed in close collaboration with Zittel. In fact, it was at her suggestion that our mutual curatorial interests in her work converged in this project. Our thanks go to the trustees of the Contemporary Arts Museum Houston and the New Museum of Contemporary Art, New York, for supporting this exhibition, and to directors Marti Mayo and Lisa Phillips, respectively, for their enthusiastic input. And we are most grateful to Andrea Zittel for her trust and commitment. She has been a wonderfully generous interlocutor, and the exhibition is greatly enriched by her dedicated presence.

We are proud that the exhibition will reach other audiences in North America, and for their participation we thank our colleagues Daina Augaitis, chief curator and associate director, Vancouver Art Gallery, British Columbia; Cornelia Butler, curator, The Museum of Contemporary Art, Los Angeles; and Douglas Dreishpoon, senior curator, Albright-Knox Art Gallery, Buffalo, New York. This exhibition could not have been realized without the support, enthusiasm, and intelligent work of Andrea Rosen and her staff at Andrea Rosen Gallery, New York. Rosen has championed Zittel since the very beginning of the artist's career and continues to do so today. Her meticulous documentation of the artist's work has greatly enhanced this publication and exhibition, as well as smoothed the way to a constructive dialogue with the exhibition's lenders. We are also deeply indebted to Susanna Greeves, director, Andrea Rosen Gallery, for her hard work, thorough research, and graceful patience with our unrelenting queries. At Andrea Rosen Gallery, we would further like to thank Jeremy Lawson and Renee Reyes for their efficient assistance. We are grateful as well to Shaun Caley Regen at Regen Projects, Los Angeles, for her continuous help throughout the organization of the exhibition, and for her wonderful hospitality and dialogue during our research trips to Los Angeles. At Regen Projects we would also like to thank director Lisa Overduin, Amra Brooks, Julie Hough, and Martha Otero for their valuable support.

We extend our most heartfelt gratitude to all the lenders of this exhibition, listed on page 9, for their extreme generosity in lending their works to a long touring exhibition. We feel privileged to share in their intelligent and farsighted appreciation of Zittel's work and are pleased that we can extend that appreciation to new audiences.

The catalogue has benefited from the scholarly contributions of some exceptional colleagues and writers, including Cornelia Butler; Robert Cook, associate curator at the Art Gallery of Western Australia, Perth; and the interview team of Beatriz Colomina, professor of architecture and founding director of the Program in Media and Modernity at Princeton University, and Mark Wigley, dean of the Graduate School of Architecture, Planning, and Preservation, Columbia University, New York. We are grateful for their astute insight into Zittel's work, which has made this publication that much more valuable. This catalogue is the brainchild of designer Don Quaintance, principal of Public Address Design, Houston. Not only has he

devised a lucid design that allows the reader to approach Zittel's production from a variety of intersecting perspectives, but he has also contributed significantly to the research and interpretation of Zittel's work, providing us with a rigorous intellectual partnership. It was a great pleasure to work with him, and we are profoundly indebted to his vision and dedication. At Public Address Design, we also thank Elizabeth Frizzell for her scrupulous help. This publication has benefited from the always insightful and patient editing of Polly Koch, to whom we are very grateful. At Prestel, our publishers, we want to express our deepest thanks to Thomas Zuhr, head of corporate publishing; to Angeli Sachs, editor-in-chief, architecture and design, for her enthusiasm and appreciation; to Stephen Hulbert, sales and marketing director in New York; and to Andrea Mogwitz for her thoughtful production work.

We are grateful as well to Jim Kanter, Zittel's technical assistant, for his dedication to this project and its touring schedule. At the Contemporary Arts Museum Houston and the New Museum of Contemporary Art, New York, we thank all the staff, listed on pages 242 and 243, for their dedicated collaboration in this complex exhibition. In particular, at the New Museum we thank Emily Rothschild, curatorial coordinator, for her diligent work in captioning correctly and coherently the hundreds of works documented in this catalogue; Kellie Feltman, registrar, for her skillful management of the difficult shipping involved in this exhibition; John Hatfield, associate director, for his expert financial supervision; and Lisa Roumell, deputy director, for her intelligent feedback on this cross-institutional collaboration. At the Contemporary Arts Museum Houston, we thank Tim Barkley, registrar, and Jeff Shore, head preparator, for mastering the details of a complex installation; Pete Hannon, IT manager/webmaster, for his punctual assistance with documenting the exhibition; and Paula Newton, director of education and public programs, for devising the exhibition's educational program. We thank Ellen Efsic and Anne Shisler-Hughes, directors of development at our respective institutions, for securing the financial support for this ambitious project.

At both museums we were very fortunate to have the committed engagement of our curatorial interns, Jennifer H. Cheng in Houston and Meg Shiffler in New York, who completed with exactitude the meticulous research on the biography and bibliography found on pages 227–41; in Houston Mia Lopez also compiled the introductions to Zittel's groups of work documented in this catalogue, bringing her inquisitive and thorough research to the effort.

Finally, we have consulted a large number of colleagues, friends, and professionals throughout this project, and we wish to thank them for their crucial advice and feedback, and their wonderful assistance and patience: Gabriela Rangel, director of visual arts, The Americas Society, New York; Amber Noland, Art Collection Management, Inc., Altadena, California; Floor Boogaart, Atelier van Lieshout; Ian Pedigo, archivist, Tanya Bonakdar Gallery, New York; Daniel Buren and Sophie Streefkerk, Daniel Buren Studio, Paris; Luca Buvoli; Timothy Rub, director, Rebecca Posage, registrar, and Scott Hisey, photographic services, Cincinnati Art Museum; Sadie Coles, and Jackie Daish, Sadie Coles HQ, London; Matt Distel, associate curator, Contemporary Arts Center, Cincinnati; Massimo De Carlo and Lidia Pellecchia, Galleria Massimo De Carlo, Milan; Catherine Retter, licensing executive, Design and Artists Copyright Society, London; Adrienne Parks, Dia Center for the Arts, New York; David Dodge; Emmett Dodge; Llisa Demetrios and David Hertsgaard, Eames Office, Los Angeles; Russell Calabrese, Editions Fawbush, New York; Elizabeth Finch, New York; Ulrikka Gernes, the Estate of Poul Gernes, Copenhagen; Rainald Schumacher, director, Goetz Collection, Munich; Catherine Belloy, archivist/ librarian, Marian Goodman Gallery, New York; Susan Davidson, curator, Solomon R. Guggenheim Museum, New York; Margaret Culbertson, library director, Jon Evans, reference librarian, and Scott Calhoun, library assistant, acquisitions, Hirsch Library, Museum of Fine Arts, Houston; Olga Viso, deputy director, Hirshhorn Museum and Sculpture Garden, Smithsonian Institution, Washington, D.C.; Nigel Prince, curator, Ikon Gallery, Birmingham, England; Ingrid Schaffner, senior curator, Institute of Contemporary Art, University of Pennsylvania, Philadelphia; Oliver Karlin; Maria-Theresa Brunner, rights and reproduction, Kunstmuseum Basel, Switzerland; Rachel and Jean-Pierre Lehmann; Nathalie Afnan, archives and copyrights, Luhring Augustine, New York; Matthew Lyons; Monika Sprüth Philomene Magers, Munich; Thomas Matyk, imaging services and permissions, MAK– Austrian Museum of Applied Arts/Contemporary Art, Vienna; Matthew Drutt, chief curator, The Menil Collection, Houston; Linda Muller; Margaret Andera, curator, and Melissa Hartley, coordinator of photographic rights and reproduction, Milwaukee Art Museum; Vance Muse; Sandra Grant Marchand, curator, Musée d'art

contemporain de Montreal; Susan L. Jenkins, manager of exhibition programs, Cory Peipon, curatorial assistant to Cornelia Butler, and Melissa Altman, rights and reproductions, The Museum of Contemporary Art, Los Angeles; Cindi Strauss, curator of modern & contemporary decorative arts and design, Museum of Fine Arts, Houston; John Elderfield, chief curator at large, Anne Umland, curator, Ann Temkin, curator, and Cora Rosevear, associate curator, department of painting and sculpture, and Gary Garrels, chief curator, and Francesca Pietropaolo, curatorial assistant, department of drawings, The Museum of Modern Art, New York; Ion Sørvin, N55, Copenhagen; Kris Kuramitsu, curator, and Gwen Hill, registrar, Norton Family Office, Santa Monica, California; Wolfgang Schoppmann and Benita Röver, Olbricht Collection, Essen, Germany; Dennis Szakacs, director, Elizabeth Armstrong, deputy director for programs & chief curator, and Irene Hofmann, curator of contemporary art, Orange County Museum of Art, Newport Beach, California; Tom Eccles, director, and Jane Koh, press and archive coordinator, Public Art Fund, New York; Jody Udelsman, Rockdale Capital, Union, New Jersey; Alexander Lavrentiev, Rodchenko and Stepanova Archive, Moscow; Sarah L. Ross, Los Angeles; Neal Benezra, director, Madeleine Grynsztejn, senior curator, Maria Naula, deputy director's office, and Jennifer Belt, permissions department, San Francisco Museum of Modern Art; Theodora Vischer, director, and Charlotte Gutzwiller, registrar, Schaulager, Basel, Switzerland; Patricia Seator and Nina Holland, artistic director, The Glen Seator Foundation, Los Angeles; Staci Boris, senior curator, Spertus Museum, Chicago; Zelfira Tregulova, Moscow; Jacqueline Gijssen, head of museum services, Vancouver Art Gallery; Jay Jopling and Paula Feldman, White Cube, London; Meegan Williams; and Peter Zweig, architect, Houston.

These things I know for sure:

1. It is a human trait to want to organize things into categories. Inventing categories creates an illusion that there is an overriding rationale in the way that the world works.

2. Surfaces that are "easy to clean" also show dirt more. In reality a surface that camouflages dirt is much more practical than one that is easy to clean.

3. Maintenance takes time and energy that can sometimes impede other forms of progress such as learning about new things.

4. All materials ultimately deteriorate and show signs of wear. It is therefore important to create designs that will look better after years of distress.

5. A perfected filing system can sometimes decrease efficiency. For instance, when letters and bills are filed away too quickly, it is easy to forget to respond to them.

6. Many "progressive" designs actually hark back towards a lost idea of nature or a more "original form."

7. Ambiguity in visual design ultimately leads to a greater variety of functions than designs that are functionally fixed.

8. No matter how many options there are, it is human nature to always narrow things down to two polar, yet inextricably linked choices.

9. The creation of rules is more creative than the destruction of them. Creation demands a higher level of reasoning and draws connections between cause and effect. The best rules are never stable or permanent, but evolve naturally according to context or need.

10. What makes us feel liberated is not total freedom, but rather living in a set of limitations that we have created and prescribed for ourselves.

11. Things that we think are liberating can ultimately become restrictive, and things that we initially think are controlling can sometimes give us a sense of comfort and security.

12. Ideas seem to gestate best in a void—when that void is filled, it is more difficult to access them. In our consumption-driven society, almost all voids are filled, blocking moments of greater clarity and creativity. Things that block voids are called "avoids."

13. Sometimes if you can't change a situation, you just have to change the way that you think about the situation.

14. People are most happy when they are moving forwards towards something not quite yet attained. (I also wonder if this extends as well to the sensation of physical motion in space. I believe that I am happier when I am in a plane or car because I am moving towards an identifiable and attainable goal.)

—Andrea Zittel *(as of Spring 2005)*

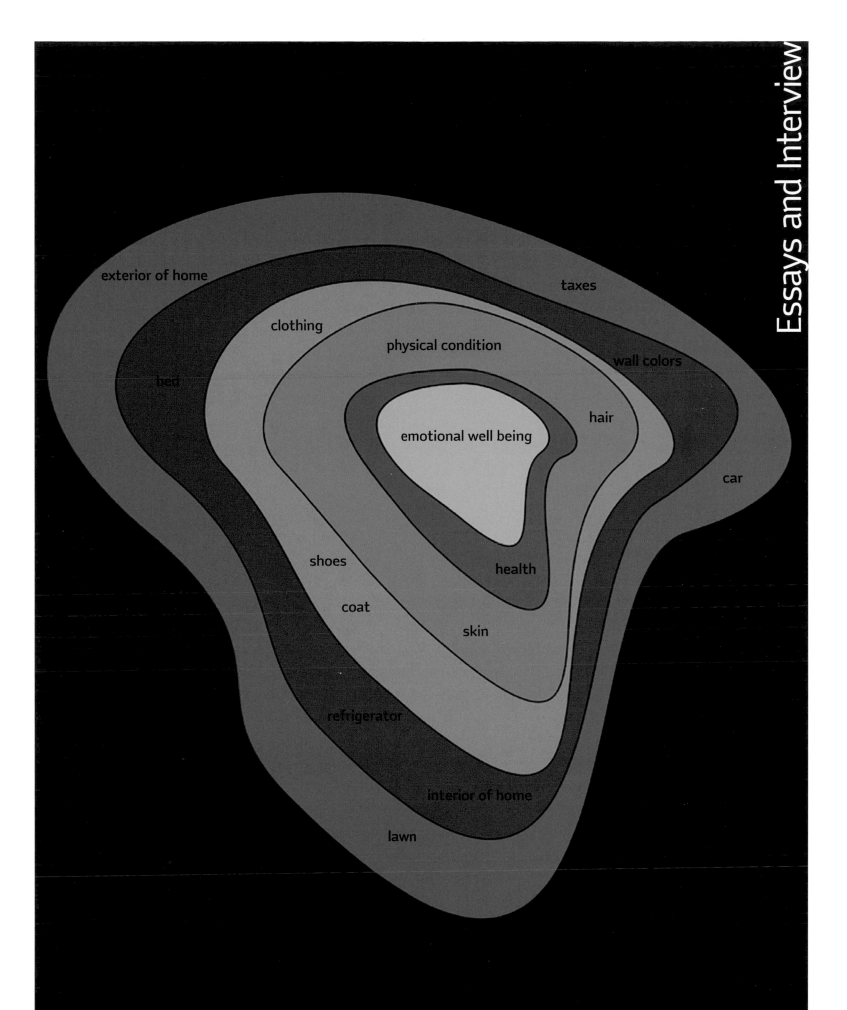

Emancipated Usage: The Work of Andrea Zittel

Paola Morsiani

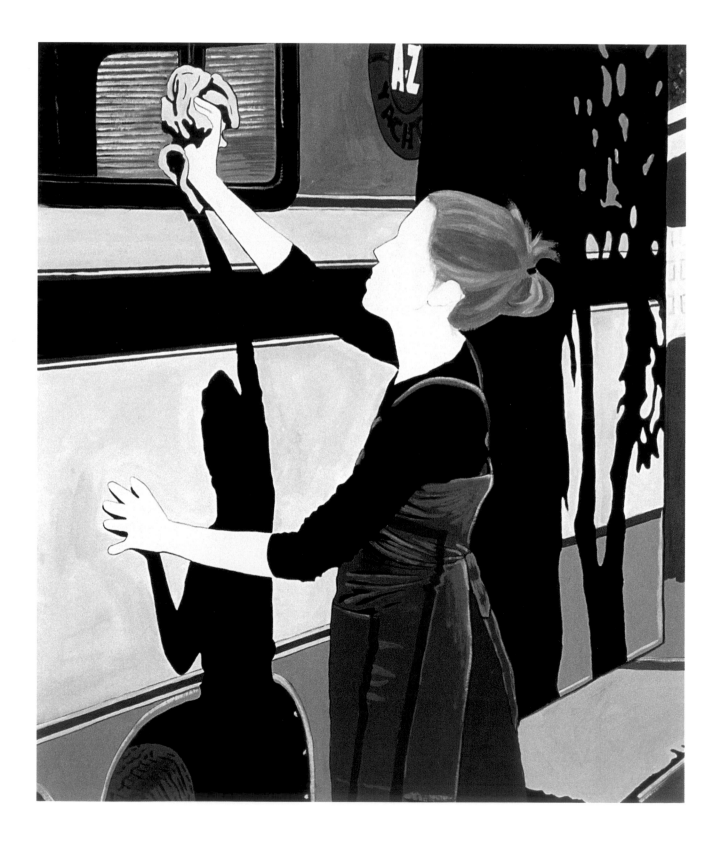

Andrea Zittel's A–Z: an institute of investigative living
The A–Z enterprise encompasses all aspects of day-to-day living. Home furniture, clothing, food, all become the sites of investigation in an ongoing endeavor to better understand human nature and the social construction of needs.
—A–Z website

A defining aspect of the work of Andrea Zittel is what we could call her methodological process, her interest in founding the production of her artwork on the act of questioning reality and formulating answers. This anthropocentric effort, as was the case among many thinkers at the origin of Western modernity, is a combination of heretical doubt about the status quo, methodical research, ingenious experimentation, and exhortatory engagement. Since she began her career as an artist in 1990, Zittel's investigation has been sustained and systematic.

Zittel holds a distinct place in recent contemporary American art. Her signature sculptural objects and environments have made the spreads of home design magazines even as her personalized method of creating and disseminating her art has animated a debate about the role of the functional objects with which we surround ourselves in contemporary habitats. This debate shares similar concerns with discussions currently at the center of disciplines such as design, architecture, engineering, and biology, to name a few, all involved in addressing the quality and cultural significance of our lives in the urban sprawls that have shaped public and private spheres in the Western world.

Zittel looks at how we perceive ourselves in our home, office, and personal lives, and at the belief systems we have created in order to balance personal aspirations with the covertly authoritarian logic that comprises the consumerist economic and capitalist political power structures. Our daily regimens reflect our contradictory impulses to achieve a sense of control and security without sacrificing individual freedom. In her work Zittel points to these impulses as reflexive and obsessive, but at the same time she inverts them and demonstrates how they can become the basis of countercultural and emancipatory action. For all their experimental look, specific forms, and essential functions, Zittel's livable structures are at once the practice and the enunciation of her guiding principles, including both aphorisms about human nature and truisms about Western societies.

This essay highlights selected instances in the larger art historical context of the artist's work. Zittel is adamant about

her uninterest in a reading of her work that is limited to the "insular issues of art history." Nevertheless, given the specific framework of a survey publication and exhibition, it is important to begin sketching in some of these contextual relationships as a way to understand why the issues that "stem from broader arenas of social and cultural content,"[1] which Zittel's work has brought to the fore, are timely and critical. Because her will to engage her audience and her strategies to do so are intrinsically embedded in her method, the following pages examine her work from this standpoint: ranging from the communicative and expansive archive of written and visual components that accompany her sculptural environments to the personalized renditions of her conceptual sculpture, and from the perspective of the owner and user of Zittel's services to the experience of the museum viewer in front of Zittel's work.

Central to Zittel's methodology, and an important extension of her livable sculpture, is a variety of written, printed, and pictorial works and documents. These include flyers, brochures, and posters that Zittel often publishes in conjunction with her exhibitions, as well as statements that the artist has written for each body of work, which can be found on her website at www.zittel.org or in the press releases for her exhibitions. The personal (unpublished) correspondence Zittel maintains with the individuals who acquire her "living units" in order to discuss the process and details of personalizing them documents the fundamental relationship the artist has developed with her collectors. In addition, The A–Z, Zittel's studio in Brooklyn (called A–Z East since 2000 and temporarily suspended since 2003) published thirteen issues of *A–Z Personal Profiles Newsletter* (p. 95) between September 1996 and August 1997. The newsletters reported on the personalized use of Zittel's work by her collectors and documented the proceedings of the *Thursday Evening Personal Presentations at The A–Z*, gatherings designed to facilitate socialization among a community of artists and neighbors in Brooklyn, and to make up for the absence of interpersonal exchange in the otherwise hostile dynamics of metropolitan life.

Among her prolific production on paper, Zittel's pencil drawings are mostly studies for her three-dimensional work or her experiments; the few autonomous pieces include the 1991–92 drawings that are part of her *Breeding Works* (p. 143) and the 1999 drawings she made in conjunction with a temporary public sculpture for Central Park titled *Point of Interest: An A–Z*

fig. 1
Andrea Zittel
Me in Personal Panel
Cleaning A–Z Yard Yacht,
1998
Gouache on paper
20 x 15 inches (51 x 38 cm)
G. Papadimitriou
Collection, Athens

fig. 2
Artist's brochure, **Andrea Zittel**, *Introducing the A–Z Administrative Services Comfort Unit by Zittel*, 1994 (detail), published in conjunction with the exhibition *Comfort*, Anthony d'Offay Gallery, London.

Land Brand (1999, pp. 174–75). Zittel began her gouaches on paper in 1992 as studies for the color patterns in the *A–Z Carpet Furniture* (1992–93, pp. 110–13), resumed them in 1996 to study the *A–Z Escape Vehicle* (p. 200) of that year, and started exhibiting them consistently with her installations around 1998. In addition, pamphlets conceived and written by Lisa Anne Auerbach accompany the *High Desert Test Sites* (*HDTS*), events in California's Mojave Desert, initiated in 2002 by Zittel's newest studio, A–Z West, which has been located in Joshua Tree, California, since 2000. The *HDTS* are artist installations and interventions placed indefinitely at locations provided by the various townships in the desert, including Pioneertown, Yucca Valley, Joshua Tree, and Twentynine Palms. New works are added yearly with an inauguration held during a weekend gathering of artists and visitors. Zittel is one of the founders and organizers of the *HDTS* project.[2]

Zittel's parallel creation of both visual and linguistic output, richly articulated in her work, conveys a distinct expression of the artist's thinking and the exhortatory nature of her work. It is a direction that obviously has developed from the strategies devised by earlier American Conceptual artists, who also used the medium of publishing to disseminate their ideas, including purchasing advertising space in the press. But Zittel's own practice derives as well from the exercises of conscience by a more recent generation of artists. Among them, Jenny Holzer can be singled out as particularly relevant in Zittel's case

for "her ambition to create an evocative, socially useful art" by employing the authoritarian voice of advertising in a way related to how, earlier on, Joseph Beuys adopted shamanistic techniques in his edifying lectures.[3]

At the end of 1991, two years after moving to New York and after completing her first works—*Repair Work* (1991, fig. 36 and p. 109) and the experiments in her *Breeding Works* (1991–93, pp. 142–51) —Zittel began working under the designation "A–Z Administrative Apparel" (quickly renamed "A–Z Administrative Services"), the impersonal identity and collective persona with which she continues to sign her work today. In conjunction with her exhibitions in the 1990s, Zittel published a number of monochromatic foldouts, designed to look like advertising brochures for commercial products, which she addressed to general consumers and potential customers in order to introduce them to the advantages of owning one of the following: the *A–Z 1993 Living Unit* (p. 130–31), *A–Z 1994 Living Unit* (fig. 11 and pp. 131–33), *A–Z Comfort Unit* (1994–95, fig. 2 and pp. 134–35), *A–Z Ottoman Furniture* (1994, pp. 90–91), *A–Z Sleeping Arrangements* (1994, pp. 136–39), or *A–Z Travel Trailer Unit* (1995, pp. 195–99).[4] Using text inset over pictures, multiple silhouetted views of the products, and images of happy customers perusing them (including Zittel herself), the brochures bear the round A–Z company logo visibly on their covers, simultaneously engaging and spoofing the corporate mentality. The largely conceptual content of the first brochures eventually transitioned to the friendlier, more conversational tenor of the *A–Z Travel Trailer Unit* brochure, and hence to the concise and suggestive slogans in the *A–Z Bed Book* that accompanies the *A–Z Small Bed* (1994, p. 117), the *A–Z Fled* (1994, p. 137), and the *A–Z Blanket Bed* (1993), in which keywords of Zittel's belief system—i.e., comfort, dream, protection, alternative, support, easy, isolation, socialization—are repeated throughout, producing an insistent message. While two drafts on vellum for an unpublished brochure to accompany *A–Z Escape Vehicle* (1996) extend an idealistic yet convincing invitation— "The Making of a Perfect Escape" and "You'll Love This Place"— the *A–Z Bed Book* describes *A–Z Carpet Furniture* as "elegance, economy, and just the right energy," where the term "the right energy" (here associated with the idea of sleeping on the floor) clearly asks the reader to think about what "energy" really means, especially in light of personal goals.

While the bold statements of Holzer's *Truisms* series of the 1980s emphasized the moral content and institutionalized voice

- The Comfort Unit is large enough to shelter two people at once within its intimate nest-like structure

- Additional service units may be fabricated for additional needs

- Each Comfort Unit is unique and will become more so with modifications and alterations made by the user

Talk to us! A-Z will be happy to create an individual formula specific to your needs

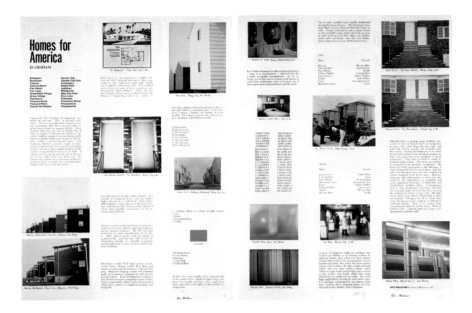

fig. 3
Dan Graham
Homes for America, 1966–1967
Photo offset reproduction of layout for magazine article
23¾ x 19½ inches (60 x 50 cm)
Courtesy Marian Goodman Gallery, New York

of her earlier public service messages, Zittel, in adopting her own social image, has opted instead for the suavely persuasive tone of advertising language. But like Holzer, Zittel aims directly and persistently at her interlocutors, inviting them to visualize their "anxious inner core"[5] and their most personal needs. "That kind of language," Zittel said, "allowed me to say things that I couldn't say in an artist's statement.... Ads allow me to say what I believe or hope that products will do, and since everybody understands the language of advertising as one of fantasy, I don't feel that I am leading people on or lying to them." Zittel had earlier in the interview distinguished between "knowing" and "believing," noting:

> how people can believe in something even though some deeper more rational part of them is telling them that it may not exactly be true. One of the reasons that I am fascinated by Modernism is that it was the last era of great faith, people still really *believed*. Faith seems to be a natural human trait, and although I don't want to embarrass myself or be overly naïve, I still like to indulge the act of belief now and then.[6]

Zittel's *A–Z Raugh Posters* (1998, p. 169) and her gouaches continued in the direction of her advertising pamphlets. The posters accompanied her *A–Z Raugh Furniture* (1998, fig. 22 and pp. 168–71), a faux-rock landscape for indoor lounging. Against the gray charcoal foam of the sculpture, the Cibachrome posters are loud in color and dramatic in composition. They incorporate thunderous slogans—such as "We think that every house should make their lives a little more RAUGH!"—which advertise the advantages of "raugh." This particular furniture design of Zittel's adapts to personal disorder and the domestic accumulation of dirt, and so reflects a more harmonious way of life. With the posters Zittel could illustrate this idea with familiar images of private relaxation and slogans that reduce our sense of embarrassment about disorder in our own personal spaces. The posters also let Zittel brand the phonetic ambiguity of the neologism "raugh" (raw/rough) with an eye-catching

logo designed in bombastic, fiery, and raggedy block letters that recall advertisements in sports car magazines. This neologism is but the latest exploit in Zittel's adaptation of Madison Avenue-like nomenclature for her conceptual sculpture —i.e., *A–Z Living Unit*, *A–Z Yard Yacht* (1998, pp. 210–13), *A–Z Wagon Station* (2002–present, pp. 214–17)—all devised to short-circuit given beliefs about people's aspirations in their everyday lives and to pinpoint the profound and multilayered needs the sculptures are set up to satisfy and explore.

Drawn in a naturalistic but illustrative and concise style, using flat colors, soft outlines, and warm tones, Zittel's production in the gouache medium incorporates the artist's apparel and environment works. Usually based on actual photographs, such as *Me in Personal Panel Cleaning A–Z Yard Yacht* (1998, fig. 1), they at times transform into advertising posters, such as the series of drawings dedicated to the *A–Z Food Group* series (2001, p. 121) or the imaginary scenarios in the *sfnwvlei (Something for Nothing with Very Little Effort Involved)* series (2002, fig. 17 and p. 104). In these gouaches the artist often portrays herself at work, making them reflect the core of her process: each new body of work matures on the basis of modifications Zittel first introduces in her own life and then brings to fruition in tests and sculptural prototypes. Direct and subjective experience is the basis of Zittel's thinking. The gouaches have a meditative tone, and while their images are direct and matter of fact, they also emanate a sense of the accomplishment and dignity found in nineteenth-century painting celebrating the moral stamina of the rural and urban working class.

Her adoption of a style grounded in illustration and advertising reflects Zittel's adamant interest in appealing to, if only partially reaching, a much larger audience, one that goes beyond the institutional and semiotic confines of an art gallery. With the creation of A–Z Administrative Services, she opted to speak in a more impersonal voice—a contemporary version of the literary tradition of aphorisms and maxims, which communicates knowledge attributed to collective wisdom. But Zittel's persona is not as anonymous as practitioners in that mode, including the undefined agent felt behind Holzer's *Truisms*. While sincere in their message, Zittel's advertising stratagems are also a parody of mass communication—of its occult pervasiveness and of our dependence on it—in the same way that the influential 1966–67 reportage by Dan Graham entitled *Homes for America* (fig. 3) was not actual reporting but a Conceptualist

work of art in the form of an architecture magazine article denouncing the anonymity of tract housing in America.[7] With respect to this precedent, Zittel decided to go further and both assume a persona and become a transparent commercial entity with a precise identity and program. Her strategy overcomes the sense of inaccessibility and the lack of a larger contextual community that had characterized Conceptual Art.[8] It also renounces the tension between truth and persuasion that pervades Holzer's work. One of Zittel's defining motivations is to overcome what the artist perceives as the limits of the artistic avant-garde—its elitism, isolationism, and ultimate failure—and to explore (with faith, as she says) a set of alternative strategies that aim at unearthing the nature of art, both the relative autonomy of a work of art and its existence as an independent style within contemporary culture.

The connection that Zittel establishes between art and the more commercially viable practices of design and architecture does not "blur" the boundaries among these disciplines, whose aims and methods remain, in fact, discrete and specialized. But by referring to these sources effectively, Zittel exploits to the utmost those functions typical of the language of art, which is symbolic, reflective, and experiential. For this reason Zittel situates her drawings in the direct vicinity of her three-dimensional environments. Their verbal and illustrational support is a way

to counteract the object-based aspect of her art: her "promotional material" allows Zittel to undercut the apparent formalism of her sculptures and to engage another kind of vision on the part of the viewer. While the noted tripartite works developed by Joseph Kosuth in the mid-sixties—such as *One and Three Chairs (Etymological)* (1965, fig. 4), comprising a photograph of a chair, the chair, and the dictionary definition of chair—considered the ways that we register external reality, Zittel's coupling of her functional-looking objects with her illustration of them elaborates on the notions of "function" and "usage": how we actually do "use art" to our advantage and what kind of emancipated "use" of objects an artist can devise within contemporary Western societies.

The communicative speed brought about by the dematerialization of art (through the use of publishing, mail art, and billboards, among other strategies) provided American Conceptual artists in the 1960s, as Lucy Lippard described, with "a way of getting the power structure out of New York and spreading it around to wherever an artist feels like being at the time. Much art now is transported by the artist, or *in* the artist himself [sic], rather than by watered-down, belated circulating exhibitions or by existing information networks."[9] The essence of one of Zittel's most recent works, *Sufficient Self* (2004), her first video projection, echoes Lippard's words, but contextualizes them in a much transformed world where "the discourse of utopia has given way to one of globalization,"[10] a globalization revealed as problematic, one-sided, and dominated by a few power centers. *Sufficient Self* is a diaristic documentation of Zittel's A–Z West studio, twenty-five acres of land that Zittel conceives as a compound "to integrate the production, use, and viewing of my work in a single site."[11] In an intensely sincere account developed around Zittel's notion of an "intimate universe" (as expressed in the diagram on p. 15), the artist presents in this DVD projection her vision of the desert region and takes us through her current personal trajectory as an artist.

Vaster and more remote than the Brooklyn-based A–Z East, this new location has allowed Zittel to make pieces, live with them, and slow down the process of disseminating the work in the world. After observing the object-laden art production of American artists in the 1980s and 1990s, Zittel treasures the notion that "the work is *in* the artist," where it is therefore more powerful, but she transfers the understanding of this principle from the work's self-referentiality to the very

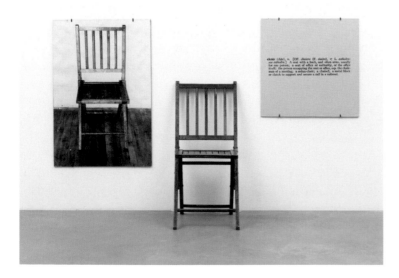

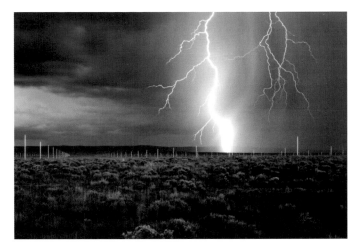

fig. 5
Walter de Maria
The Lightning Field, 1971–77
400 polished stainless steel poles installed in a
grid array located in southwestern New Mexico
400 poles: 246 inches (625 cm) height each; array:
1 mile x 1 km
Dia Art Foundation, New York

process of its creation, distribution, and use. This is the difference between A–Z West and the precedents of noted interventions in desert regions by American artists such as, among others, *Double Negative* (1969) by Michael Heizer, located in the Mormon Mesa of Nevada; *Spiral Jetty* (1970) by Robert Smithson, in the Great Salt Lake of Utah; *Sun Tunnels* (1973–76) by Nancy Holt, in the Great Basin Desert of Utah; *The Lightning Field* (1971–77, fig. 5) by Walter de Maria, built in southwestern New Mexico; James Turrell's *Roden Crater* (in progress), in Flagstaff Arizona, and also Donald Judd's Chinati Foundation in Marfa, Texas.

In the same way that she uses her drawings, Zittel first showed *Sufficient Self* together with *Prototype for A–Z Raugh Desk #2* (2001, p. 173), her design concept for the office workstation at A–Z West. *Sufficient Self* is a seventeen-and-a-half-minute silent DVD projection of digital slides that interleaves Zittel's written account with photographs taken in the region. She begins the account by focusing our attention on the rarefied grid of dirt roads that derives from the homestead land division system that marked the American desert. She proceeds to a description of the development of her projects at her compound, but takes care to integrate A–Z West within a survey of endeavors by other longtime, often eccentric, residents in the region. Zittel expresses a personal affinity with the renegade and quixotic endeavors of many of the homesteaders who have been drawn to the desert region. While today the American Earthworks from the 1970s are becoming tourist destinations, Zittel is less interested in altering a place than in understanding and interpreting it. Those earlier artists, whom Zittel of course admires, had looked at the desert as an alternative to the institutionalized cultural confinement of the museum, a somewhat less over-determined space in which to place their finally incommensurable sculptures. Without dismissing its importance, Zittel forgoes such contemplation. *Sufficient Self* describes A–Z West as a site for experimentation and references the surrounding landscape—its colors, temperature, and lack of sharp horizon—for the specific pace it gives experimentation itself. Zittel's attraction to the desert does not lie in the dichotomy of nature/culture that produces the experience of the sublime. To Zittel the desert offers the example of another kind of social space available to us, which, by virtue of its expansion, "seems to generate such unique personal visions and 'life missions.'"[12]

Sufficient Self was shown first at the 2004 Whitney Biennial, and in the exhibition catalogue Zittel published a list of what she calls her principles, which forms her latest manifesto entitled *These things I know for sure* (p. 14).[13] Topping fourteen entries today and still accumulating more, the list reads as a spontaneous and unsystematic sequence of affirmations, an approach that is distinctive of artist manifestos. Its content at first sounds rather slight and marginal, touching upon everyday tasks, practical directions, and human behavior. As if by carefully removing the layers of a fossilized formation in order to locate the core of a genuine individual buried deep, Zittel arrives at these main beliefs more "by way of taking away" from the figure we know at present than "by way of adding" to it, and her findings appear as yet disjointed. This embryonic inventory of certainties questions what defines an individual—whether a set of universal parameters or the conventions that each one of us finds for ourselves. It aims to identify genuine human traits—such as freedom, organization, and genius—against what is merely a behavioral reaction to impulses that society and cultural tradition have artificially impressed on us. Finally, these principles represent Zittel's assessment of her own move to Joshua Tree and its effect on her—exploring whether such isolation can truthfully give her personal vision more effectiveness. As Zittel has remarked, even interiority is a sociocultural denomination[14] and not an autonomous human trait, which means we can see these precepts as guidelines for our free-will efforts to both preserve and change ourselves. Such a state of mind also informs one of her most recent drawing series, *A–Z Advanced Technologies* (2002, p. 79). These gouaches (again self-portraits) showcase Zittel's latest *A–Z Personal Uniform*, which she makes by hand-felting wool. While in earlier gouaches the artist represented herself directly at work, here Zittel poses, in a close medium shot, wearing her artifact. What most viewers may interpret as a mere fashion shoot—a semiotic strategy that Zittel does acknowledge and exploit—is in fact a substitution of the artwork with the maker, and the containment of the infinite landscape within its inhabitant, namely her presence. In a gesture perhaps closer to Smithson's sprint along *Spiral Jetty*, recorded when he documented on film the completion of his work, Zittel wedges herself within the locale, and her quasi-heroic posture represents her embrace of the place.

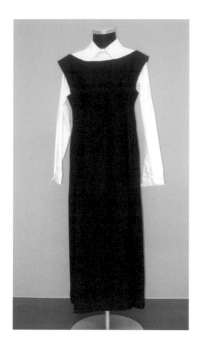

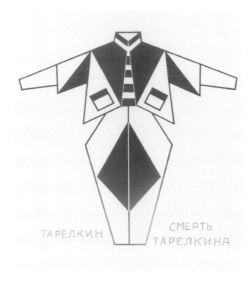

fig. 6
Andrea Zittel
A–Z Six-Month Personal Uniform (Fall/Winter 1991/1992), 1991
Wool dress and cotton shirt
Emanuel Hoffmann Foundation, permanent loan to the Öffentliche
Kunstsammlung, Basel, Switzerland

fig. 7
Varvara Stepanova
*Costume design for Tarelkin, for the Meierkhold production of
Sukhovo-Kobylin's play* **The Death of Tarelkin**, 1922
Ink on paper
Approx. 10 x 8 inches (25 x 20 cm)
Rodchenko–Stepanova Archive, Moscow

fig. 8
Lewis W. Hine
*Fourteen-Year-Old Spooler Tender, Berkshire Cotton Mills, Adams,
Mass.*, July 10, 1916
Digital color scan from black-and-white vintage photographic print
8 x 10 inches (20 x 25 cm)
Courtesy Library of Congress Prints and Photographs Division, Washington, D.C.

Then there is the *A–Z Personal Uniform* itself (fig. 6, pp. 70–81), which she began in 1991, producing more than forty-five examples to date. These are dresses that Zittel tailors and sews for herself to serve both her working and her social needs. Producing them annually in a spare number, she wears each for extended periods of time. Over the years Zittel has explored a great variety of purposes, styles, and manufacturing processes with these garments even as she has maintained a core relationship to women's wear. Zittel often emphasizes the origin of the *A–Z Personal Uniform*—her need to manage her anxiety about facing the New York art world's socialites with dignity—and their economical and expedient means. But more than their connection to being fashionably correct, we recognize the *A–Z Uniform*'s link to working garments. Zittel's first designs especially remind us of working class clothing at the beginning of the twentieth century, when women joined the assembly line wearing long skirts, aprons, and headscarves (fig. 8)—a practice that in the West held until World War I when designer Coco Chanel introduced menswear-inspired clothing style for women; it was after World War II that the ready-to-wear industry promoted the uniform look of the mass-produced dress.[15] Another source of Zittel's inspiration are Constructivist design principles that required clothing to possess the qualities of "appropriateness, hygiene, psychology, and harmony of proportion with the human body" (fig. 7).[16] The notion of the "uniform" in Zittel's work thus assumes an ethical dimension having to do with preserving one's identity and role clearly before it is appropriated by social impositions and banality. As a consequence it became increasingly important to Zittel to analyze and make even the elemental fabric itself of her dresses more and more her own. While the *A–Z Personal Panel Uniform* (1995–98, pp. 72–73) comprises manageable layers of geometrically cut fabric, later dresses— *A–Z Single-Strand Uniform* (1998–2001, pp. 75–77), *A–Z Handmade Single-Strand Uniform* (2001– 2002, p. 77), and *A–Z Fiber Form Uniform* (begun in 2002, pp. 78–79, 164–65)—are worked around the organic form of the body using Zittel's own variations on hand-knitting and wool-felting techniques.

Finally, but most importantly, Zittel considers the *A–Z Personal Uniform* as public sculpture, releasing them from her own private everyday use to a larger existence as works of art with collective significance. They are public sculptures whose use value remains visible—as artist Daniel Buren has demonstrated in his *Photo-souvenir: "Hommes/Sandwichs"* (Paris, April 1968) (fig. 9) and *Photo-souvenir: Essai Hétéroclite, Les Gilets* (Stedelijk Van Abbemuseum, Eindhoven, Netherlands, February 1981)[17]— but whose content remains symbolic, extending the viewer's perception beyond the dress itself to the contexts that generate and receive it: the artist, the museum, the collection, and especially the world in which we exist. In a move both intimate and powerful, Zittel asserts that we can use art to our advantage in order to illuminate the context in which we live. This assertion extends to the large and more visible catalogue of Zittel's *Living Unit*, which most evidently illustrates her involvement of the user with the functionality of her artworks.

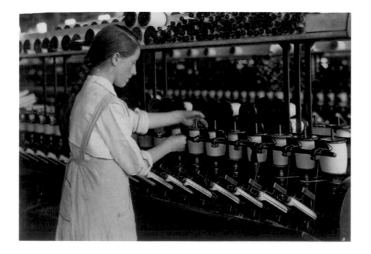

When Zittel arrived in New York in 1990 from California, after earning a master's degree from Rhode Island School of Design in Providence, her work shared an interest in science—biology and genetics in particular—with that of many of her peers. Janine Antoni, Matthew Barney, Mel Chin, Mark Dion, Michael Joaquín Grey, and General Idea, among other artists, approached in their work different aspects of the contemporary disciplines in science, including their methodologies and politics, with a focus on the cultural notion of the body—especially prominent in times marked by the AIDS crisis and the ensuing intensification of the debate around sexual identity. While many of these artists pursued an expressive language that engages the personal sphere and employs a metaphorical idiom, Zittel elected to operate in the realm of what she calls "literalness," creating meaning via functional objects. Her work developed around a reevaluation of our notions of experience, action, and participation, and she formulated a conceptual approach to the issues involving our attitudes toward ideas of space and individual freedom, as well as the cultural and social constructions that define them in Western societies. The original working center in Brooklyn, The A–Z (later called A–Z East), remains the context in which her livable sculptural structures must be understood: her studio became the fulcrum of her systematic investigation and the testing laboratory of her designs, but it was also a destination open to visitors and friends.

Zittel's early investigations revolved around the human activity of breeding animals. Between 1991 and 1993, she conducted a variety of reproductive tests in her studio. She used functional laboratories of her own design and applied her tests first to common flies, and then to Cortunix quails and Bantam chickens.[18] Among the drawings Zittel made in connection to this body of work, the pencil drawings from the *Clone Series* (1992) concentrate on asexual reproduction. In *Men* from the *Clone Series* (fig. 10), two identical men in suits, walking like fashion models, are captioned as "a set of homozygote twins produced by transfer of bisected embryos." *Rabbits* from the

Clone Series illustrates the genetic principle noted on the drawing, that "sexual reproduction engenders diversity but there is sameness among individuals reproduced asexually." In the Magritte-like third drawing, *Teacups* from the *Clone Series*, Zittel used the same taxonomy with an image of stacked teacups, which she repeated three times on the page as if in a decorative pattern. In this last drawing in particular, which enucleates Zittel's focus in the years to follow, the artist equated the mass production of consumer products to the control that biological engineering and science in general have attained over life, and she questioned the false aura of equality and accessibility that both economics and science endeavor to exert over developed Western market systems. With these and other works in her investigation of breeding, Zittel addressed a complex web of issues regarding the act of "producing something" and the dynamic of reception, dependence, and ownership that develops from the triangular relationship among producer, object, and consumer. Most of all, by adopting an animal as a ready-made work, Zittel directed this interrogation at herself as an artist and object producer, seeing it as a means to understand her interlocutor—the viewer and collector—as well. She questioned the nature of human desire, as reflected in the impulse to create artificial breeds as pets and personal systems of support. Posed at the very beginning of her artistic activity, this

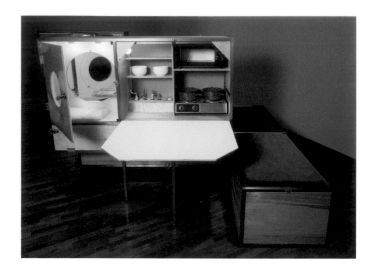

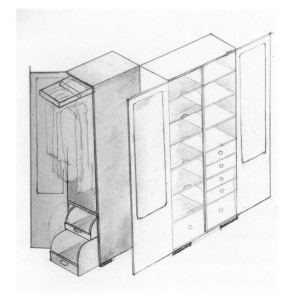

question and the dynamics of the exchange would remain a core motivation of her work.[19]

The *Clone Series* are pencil drawings on vellum that the artist mounted on a one-and-a-half-inch layer of polyester cotton balls and boxed within a frame. Presented in this way, the drawing becomes an object. For Zittel it was a way to underline the seriality implied in cloning, using these works' translucent surfaces to convey the sense of fading and loss of vigor that results from identical repetition. The hard-edged construction of its presentation in fact softens the definition of the drawn figure, but it also produces a slight impression of depth and chiaroscuro, a phenomenological approach to painting that artist Piero Manzoni favored with his own cotton paintings at the beginning of the 1960s.

At the time she made these drawings, Zittel had just begun working on her *Living Unit* series, inhabitable sculptures that organize space and life functions within a contained area. These mark the beginning of a prolific exploration into people's relationship to personal space and how the durability of deeply rooted, simultaneously conflicting impulses, such as the need to belong and the aspiration to be independent, are dealt with in developed Western societies. Having already looked into the alterations of our concepts of life and nature brought on by the acceleration of technology, Zittel felt an urgency to look at a more comprehensive picture of Western culture and its idealistic drive. What she found was a contradiction that combined the inheritance from the nineteenth century of a romanticized relationship to landscape; the persistence from the twentieth century of a modernist and utopian idea of progress; and the settlement in the twenty-first century into an inertia of postmodern capitalism. Thinking that this picture needed further exploration, Zittel found it useful to look into the effects of the strengthened connection between the design of objects or space for living and the capitalist system.

By using her *Living Unit* to analyze American urbanism— the enduring clash among idealist design strategies, the capitalist market system, standardized societal behavior, and concrete economic reality—Zittel asked us to reconstruct our

psychophysical link to the actual places in which we live and to reconsider the true content of our aspirations regarding our own well-being, whether comfort, freedom, happiness, or a sense of empowerment. The artist also retooled the relationship of artist/collector and collector/artwork by asking new owners to integrate the artwork into their lives as an actual piece of usable furniture, modifying it to fit their domestic and individual needs. She envisioned her livable units as mass-produced objects and so established a minimum design to which each buyer would then add personal touches.

Beginning with the *A–Z Management and Maintenance Unit, Model 003* (1992, p. 129), *A–Z Carpet Furniture, A–Z 1993 Living Unit, A–Z 1994 Living Unit,* and *A–Z Comfort Unit,* Zittel went on to articulate this production in a variety of directions, including *A–Z Raugh Furniture* and, most recently, *A–Z Cellular Compartment Units* (2001, pp. 184–89) and *A–Z Homestead Unit* (2001–2005, pp. 180–83). After a yearlong residency in Berlin, Zittel in 1995 began taking note of the distinctly American phenomenon of trailer homes and the car culture. *A–Z Travel Trailer Unit, A–Z Escape Vehicle, A–Z Yard Yacht,* and *A–Z Wagon Station* all explore the role of fantasy in the notion of a home disconnected from the fabric of the city and yet fully participant in it—a form of permanent tourism. With *A–Z Deserted Islands* (1997, pp. 207–209), *Point of Interest: An A–Z Land Brand,* and *A–Z Pocket Property* (2000, pp. 177–79), Zittel expanded this investigation to landed property, a defining good in capitalist economies that hovers in people's minds somewhere between a pure consumer concept and an idealistic image of landscape.

Zittel's catalogue of inhabitable works represents a vision that attempts the integration of systems and realities in constant danger of disconnection from one another—society and individual, city and home, body and space, art and economic production. The shell left in evidence of the units' structure supports a straightforward interlocking of perpendicular planes. Their volumetric expansion is modular, and so is the production of the units as multiples. They provide economy of space and maximum usability with the aim of streamlining their users' lives

fig. 11
Andrea Zittel
A–Z 1994 Living Unit, 1994
Steel, birch plywood, metal, mattress, glass, mirror, lighting fixture,
stovetop, toaster oven, green velvet, and household objects
59 x 84 x 82 inches (150 x 213 x 208 cm) open
Collection of Craig Robins

fig. 12
Alexander Rodchenko
Cupboard/wardrobe for Inga, 1929
Pencil on paper
14 3/4 x 10 1/8 inches (37 x 25 cm)
Rodchenko–Stepanova Archive, Moscow

and, as a consequence, of modifying their behavior, releasing them from a fetishistic dependence on things. While Zittel in her designs follows notions of rationalism and functionalism defined during and after World War I by Eastern European Constructivist and Western European Bauhaus artists and theorists (fig. 12), her understanding of standardization derives more from the American middleclass housing that has filled suburban developments since World War II.[20] The standardization applied to Zittel's own work is limited to the artist's impersonal intervention—the manufacture of the module—which the user then interprets: the various particular functions contained in her units are customized based on the user's personal wishes. While her 1992–94 living systems unfold in space and address different intellectual and leisure activities, her later ones, most evidently *A–Z Escape Vehicle*, *A–Z Platform Bed* (1995, p. 138), *A–Z Pit Bed* (1996, pp. 138–39), and also the recent *A–Z Cellular Compartment Units*, are shaped like capsules that compress "function" into one intense experience, focusing on the fulcrum that is the user's inner self. Hence, standardization in Zittel's methodology is an educational path to self-awareness.

Zittel emphasizes that the components of the duality freedom/constriction are not two different societal ideologies but complementary aspects inherent to human nature. True to this principle, Zittel forgoes the usual distance that visual artists enjoy from collectors of their work (via the brokerage of their art dealer) and instead maintains an intense dialogue with the individuals who buy her work, seeing that as an essential component of the activities at A–Z Administrative Services. She closely follows the customization of a piece and may help with any design interventions needed to accommodate special features. Each relationship evolves from the different personalities and experiences of her buyers. We can read about these relationships in the short-lived *A–Z Personal Profiles Newsletter* with which Zittel kept in touch with her clients as well as with a larger host of peers and fans. Written in an overtly cheery style, the newsletters relate enthusiastic comments from A–Z brand users and describe the many home improvements implemented at A–Z East in Brooklyn. While *A–Z Personal Profiles Newsletter* never settled into steady publication, and each one of the thirteen published issues experiments with content, they remain an important witness to the vitality of A–Z East.

Zittel's restructuring of the artist/collector and collector/artwork relationship shows the influence of Constructivist and Marxist interpretations of capitalist economy, which view the commodity in the user's hands as problematically disconnected from social labor. Writer Umberto Eco illustrated this disconnect by noting the difference between the "beautiful" objects and the "ugly" objects one can see at a trade fair: the former are accessible consumer goods—i.e., easy chairs, lamps, sausages, liquors, motorboats, and swimming pools—while the latter are the inaccessible means of production that make an industry—i.e., cranes, cement mixers, lathes, excavators, and hydraulic presses. A person who desires beautiful objects and rejects those that are ugly "in reality has not chosen; he has only accepted his role as consumer of goods since he cannot be a proprietor of means of production. But he is content. Tomorrow he will work harder in order to be able to buy, one day, an easy chair and a refrigerator. He will work at the lathe, which is not his because (the fair has told him) he doesn't want it."[21]

Zittel strives to liberate our relationship to objects from this authoritarian system and conceives of her artistic production as requiring a deeper involvement both on the side of the maker and on that of the user. Her modular production requires a further process of adding meaning or signification, represented by the user's involvement in the completion of the unit in lieu of mere contemplation. While maintaining the same skeleton, her modules change in their destination and details. This becomes evident when groupings of customized units are put on display. We see, for example, the *Escape Vehicle* transformed into individual fantasy worlds—a sensory deprivation tank (by Bob Shiffler), a Joseph Cornell box (by Dean Valentine), a modern carriage or limousine (by Andrea Rosen), King Ludwig's grotto (by Zittel), and a place to spend time with precious personal objects (by Rachel and Jean-Pierre Lehmann), among others—peering into their identical involucres and accessing diverse personal universes and expressions (pp. 202–205).

Zittel's form does not follow an immediately evident function. A Zittel *Living Unit* does not communicate any information in the way Western modern and contemporary design has accustomed us to expect. Only once her units are truly lived in do they manifest themselves clearly to the viewer—always as very individual, somewhat eccentric, vernacular artistic forms. While on the one hand each piece simply becomes "a photograph" of the owner, on the other hand their coexistence within Zittel's production in all their diversity represents a short-circuiting of the artist's semiotic process, that is, a loss of stylistic unity, but most

of all a loss of stability and plain coherence. This is a welcome result for Zittel, who has often commented that she accepts failure as an inevitable outgrowth of her process. Every new project evolves by redirecting her previous efforts towards different, at times opposite, goals. For example, the passage from the mobile *A–Z Travel Trailer Unit* to the fixed indoor *A–Z Escape Vehicle* originated in Zittel's realization that most people who live in trailer homes find a congenial place to set it up, and then stay there. Notwithstanding their finished look, Zittel's works carry a precarious, ever evolving identity within themselves, which has become a dynamic aspect of the artist's own method. In *The Regenerating Field* (2002, pp. 104–105, 162–63)—an outdoor grid of steel trays at A–Z West used for drying wall paneling made of recycled pulped paper materials—Zittel pushed this concept even further. By representing the making of her art as a sort of agricultural activity—also literally rendered in the drawings from the *sfnwvlei* series—she emphasized components such as time and process. The image of "natural growth" here plays down the more intellectual factors in her art-making in order to highlight what is transformative and necessary and centered around life itself.

In this context the recurring reference to the role of "fun" —and luxury, independence, and fantasy—in Zittel's statements takes on new meaning, pointing to the pursuit and manifestation of pure energy, which begins and ends with the subject's own world. This private and apparently futile tourism opposes the pervasive economic capitalization of free time in advanced Western economies. In Zittel's principles listed in *These things I know for sure,* she defines this as the difference between "voids"—time that one spends being completely idle and therefore thinking freely—and "avoids"—the compulsion to fill in the voids with a consumerist activity, such as watching television. This vein of thought, concurrent with the thinking of functionalist art and Conceptual Art, finds prolific expression in her work, linking it to Surrealism and the interpretation of urban geography theorized by the Situationist International in the 1950s, which emphasized the importance of the citizen's own psychological free associations in the understanding of how urban space is actually perceived and lived through. This lineage extends to the so-called "radical architecture" and "anti-design" movements of the second half of the 1960s, such as Archigram in England, Archizoom and Superstudio in Italy, and some aspects of the group Ant Farm in the United States—

each in its own terms and context attempted to move design away from consumerism, high style, and corporations, and to infuse it with political direction and social responsibility. As put by Superstudio architect Adolfo Natalini:

> If design is merely an inducement to consume, then we must reject design; if architecture is merely the codifying of the bourgeois models of ownership and society, then we must reject architecture; if architecture and town planning is merely the formalization of present unjust social division, then we must reject town planning and its cities until all design activities are aimed towards meeting primary needs. Until then, design must disappear. We can live without architecture.[22]

At the onset of the twenty-first century, with global capitalism much advanced, the Western world has changed and so has the meaning of the work of artists like Zittel, who conceive of their activity as interventions in society. As critic Hal Foster has pointed out in his analysis of the influence of historical Constructivism:

> (Productivist) Constructivism was repressed and/or recoded in the West, for its collectivist transformation of industrial culture could not be countenanced by Western institutions—individual artist, artisanal medium, capitalist exhibition, idealist museum and so on. Certainly Western movements such as the Bauhaus also attempted to challenge these institutions, to integrate art and industry, but the Bauhaus did so only partially... [T]he Bauhaus could only subsume art in capitalist design rather than supersede it in collectivist culture. The scandal of Constructivism was that it forged connections rather than posed analogies between artistic and industrial production, cultural and political revolution.[23]

While Constructivism's status as "the primary modernism active in social and political transformation" remains influential, Foster highlights how contemporary "theory and practice have shifted from class as a given subject of history to the cultural constitution of (class) subjectivity, from economic identity to social difference."[24] In the case of Zittel, then, we should ask which kind of personal fantasy the users of her services cultivate. If we look at her entire trajectory, East to West, Zittel's commissioners/collectors have ranged from artist Jon Tower, who in 1991 asked Zittel to turn around his disorderly lifestyle (p. 69); to travel magazine writers and motor-home club founders Kristin and Todd Kimmell, who journeyed in an *A–Z Travel Trailer Unit;* to the Public Art Fund in New York, which

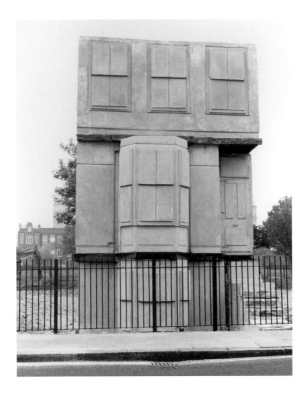

fig. 13
Rachel Whiteread
House, 1993
Video still, from *House* (1995, 26 minutes), showing cast of Victorian
terraced house in London's East End commissioned by Artangel and Beck's,
London, and demolished in January 1994
Courtesy of the artist and Luhring Augustine, New York

commissioned *Point of Interest* for use by visitors in Central Park; to art museums such as the Österreichische Galerie Belvedere in Vienna, which in 1998 commissioned an *A–Z Pit Bed* for their audiences; to art dealer Jennifer Flay, who turned an *A–Z 1993 Living Unit* into her office; to collaborators, designers, and friends at A–Z West, who have customized *A–Z Wagon Stations* as resting posts at the compound; and to the art collectors, representing a large variety of backgrounds and aspirations, some of whom have kept her work as a pristine artwork and others of whom have been able to functionally integrate it into their homes, professions, and lives.[25]

Overall, however, all these individuals share a certain idea of "home," or personal space, that we can trace to the familiar nucleus of the middleclass house—comfortable, manageable, parceled into private and social moments, separate and yet integrated into the neighborhood. In effect, Zittel works with the educated fantasy of domestic life typical of capitalist economies. To her, home is not a place of paralyzing conflicts and entrapment—as it was, for example, in *House* (1993, fig. 13), a life-size solid cast of a terraced family home from a working-class neighborhood in the East End of London made by Rachel Whiteread. *House*, a transitory memorial that remained on display in the neighborhood for two and a half months, also stood for the public sociopolitical battle against gentrification going on in tandem with an attempt to keep new, lowerclass immigrants out of the neighborhood. Unlike Whiteread with her focus on the house's public role, Zittel dives into the psycho-physical space of middleclass housing in America and explodes it like an architectonic drawing that not only projects representations of space and function, but also makes visible related notions of time, property, necessity, and desire. By analyzing these notions and devising alternative habitats, Zittel attempts to evidence precisely those habits in a dweller's life that are a genuine reaction to manipulative and constructed consumerist

impositions. Zittel's house is a nucleus of energy and work, the place that makes us active in relation to the rest of the world.

In addition to designing her *Living Unit* as a habitation for others, Zittel has conducted personal tests to help her define this nucleus, beginning with the work from the 1993 *A–Z Purity* series, such as *Prototype for A–Z Warm Chamber* and *Prototype for A–Z Cool Chamber* (both pp. 124–25), *A–Z Food Group* (p. 120), and *A–Z Cover* (pp. 116–17), among others. These works break down traditional domestic demarcations, in place since the establishment of modern hygiene in the European and American urbanism of the eighteenth century, and focus on those biological functions that allow us to store up energy. In *Free Running Rhythms and Patterns* [Berlin] (1999, p. 154)—an experiment documented in the group of drawings *Free Running Rhythms and Patterns, Version I* and *II* (2000, pp. 156–57 and 159) and the *A–Z Timeless Chamber* and *A–Z Time Tunnel* maquettes (2000, pp. 156 and 158)—during a week of total insulation from any kind of time reference, Zittel assessed the variability of her own circadian rhythms against the norm of conventional sequences such as night and day. For *A–Z Pocket Property*, she lived for a month in a handcrafted, approximately 1,500 square-foot, island-cum-home in order to test out Western fantasies about property and independence.

Museum viewers very rarely are able to step into a Zittel unit, but must be content to witness her practice and observe the owners' habits, needs, and wishes. Zittel, however, does not leave this constituency unaddressed. To include a sense of the museum audience's specific position in relation to her work, Zittel uses the gallery literally as a presentation room: painting walls, carpeting the floor, and adding illustrative drawings. So the viewers' first encounter, already both contemplative and voyeuristic, is further transformed into a somewhat participatory experience, induced by Zittel's creation of an emphatic tableau that hovers between commercial showroom and museum installation.

This approach in Zittel's work has roots in the sculptural installations predating her *Living Unit*, which include a group of works entitled *Repair Work*. The artist repaired objects found on the streets of New York and displayed a number of them in a composition, placing some on a patched-up table and others on the floor adjacent to the table, as if to point to a transition in progress, from "thing" to "object," from "ugly"—a hubcap and a tile floor—to "beautiful"—a statue of one of the wise men and another of an elephant, teacups, a dish—and from "object" to

"artwork." This strategy had been employed before by American sculptor Scott Burton, whose work, which emerged in the 1970s and matured in the following decade, is unique in its experiential character among the object-based production of the 1980s. In the 1970s Burton, who was also a furniture collector and connoisseur, arranged various tableaux in "which common found furnishings (chairs and tables) sometimes restored or altered by the artist were placed in static arrangements either in a stage space or in an exterior landscape setting."[26] This series played out the distinctions between useful and useless, the found and the fabricated object, and the relationship of furniture to the body.

This and Burton's subsequent production constitute an important immediate precedent to Zittel's own work, for Burton pointed to the vernacular of everyday furniture and integrated a psychological and operative standpoint into the language of sculpture. Zittel pushed further by considering the art object and its presence in contemporary culture. Like Burton, Zittel declined to launch a Duchampian attack, ironic or anarchic, on the museum and culture industry as other artists did in the 1980s.[27] But along with artists belonging to later generations, such as Felix Gonzalez-Torres and Rirkrit Tiravanija, Zittel attempted to transform the art institution by looking into ways to dismantle the regular distribution of art—as we have seen—and by embracing and addressing the viewer with an experience and message that regards life directly. Some of Zittel's installations play with social relations and a sense of familiarity—as in the public lounging provoked by A–Z Raugh Furniture—and others induce the sense of abstract space that capitalist economies have produced—as in the inviting yet anonymous showroom installation of the A–Z Escape Vehicle.[28]

By virtue of their heterogeneous and artificial nature, Zittel's installations also shift the visitor's attention to another place altogether. With A–Z East and even more radically with A–Z West, Zittel has redirected the presence of the artist from the art gallery or museum to another focal point: her own center of existence. Here the artist operates very clearly through a local reality, projecting out to the rest of the world. Having sensitized our awareness to the continuous connections of our personal landscape with the much larger horizon that contains it, Zittel is not speaking simply of the artist and the museum. She is also alluding to our homes and lives, encouraging us all to examine more closely our existence, to make it again our very own.

NOTES

1. Andrea Zittel, "Talking with Allan McCollum," in Diary: Andrea Zittel, Diary, ed. Simona Vendrame, no. #01 (Milan: Tema Celeste Editions, 2002), p. 128.

2. The High Desert Test Sites are organized by Lisa Anne Auerbach, John Connelly, Shaun Regen, Andy Stillpass, and Andrea Zittel.

3. Michael Auping, Jenny Holzer (New York: Universe Publishing, 1992), pp. 11–12. Auping also highlights the connection of Holzer's strategy to the notion of social sculpture found in the work of Joseph Beuys.

4. These brochures are listed in the artist's bibliography on p. 236.

5. Auping, Jenny Holzer, p. 14.

6. Zittel, "Talking with Allan McCollum," pp. 125 and 119.

7. Jeff Wall, "'Marks of Indifference': Aspects of Photography in, Or As, Conceptual Art," in 1965–1975: Reconsidering the Object of Art, exh. cat. (Los Angeles: The Museum of Contemporary Art, and Cambridge, Mass., and London: The MIT Press, 1996), p. 257.

8. "Communication (but not community) and distribution (but not accessibility) were inherent in Conceptual Art. Although the forms pointed toward democratic outreach, the content did not. However rebellious the escape attempts, most of the work remained anti-referential, and neither economic nor esthetic ties to the art world were fully severed." Lucy Lippard, "Escape Attempts," in 1965–1975: Reconsidering the Object of Art, p. 31.

9. Lippard, "Escape Attempts," p. 32. (Emphasis in original.)

10. Hamza Walker, "Disguise the Limit: Thomas Hirschhorn's World Airport," in Thomas Hirschhorn, exh. cat. (Chicago: The Art Institute of Chicago and The Renaissance Society, 2000), p. 21.

11. Text from Sufficient Self.

12. Text from Sufficient Self.

13. First published in the magazine Catwalk, no. 6; reproduced in Diary: Andrea Zittel (2002), p. 114, and in the artists' project box accompanying Whitney Biennial 2004, exh. cat. (New York: Whitney Museum of American Art and Harry N. Abrams, Inc., and Göttingen: Steidl, 2004), folio 107.

14. Andrea Zittel, "Talking with Allan McCollum," p. 132.

15. See Rebecca Voight, "Emancipation and Uniform," in Francesco Bonami, Maria Luisa Frisa, and Stefano Tonchi, eds., Uniform: Order and Disorder, exh. cat. (Milan: Charta, 2000), pp. 217–20; and Sarah Levitt and Jane Tozer, "Working Class Clothing," in Fabric of Society: A Century of People and Their Clothes, 1770–1870 (Carno, Powys, Wales: L. Ashley, 1983), pp. 121–39.

16. Aleksandra Ekster, "V konstruktivnoi odezhde," Atel'e, no. 1, 1923, pp. 4–5, quoted in Christina Lodder, Russian Constructivism (New Haven and London: Yale University Press, 1983), p. 153. As another Constructivist designer, Varvara Stepanova, put it, "Fashion, which used to be the psychological reflection of everyday life, of costumes and aesthetic taste, is now being replaced by a form of dress designed for use in various kinds of labor, for a particular activity in society. This form of dress can be shown only during the process of work. Outside of practical life it does not represent a self-sufficient value or a particular kind of 'work of art'" (emphasis in original). Varvara Stepanova, quoted in Left (Moscow), no. 2, April–May 1923, p. 65; reproduced in John E. Bowlt, "Introduction," in I[rina Mikhailovna] Yasinskaya, Revolutionary Textile Design: Russia in the 1920s and 1930s (New York: The Viking Press, 1983), p. 4.

17. See Daniel Buren, "Essai hétéroclite," in *Daniel Buren: Les Ecrits (1965–1990),* vol. 2 (Bordeaux, France: capc Musée d'art contemporain de Bordeaux, 1991), pp. 293–312. The term "heteroclite," Buren explains, indicates "what goes against the rules. In the visual arts and literature, heteroclite is a work of art that embodies a variety of disparate styles and genres" (304). Author's translation.

18. Some "breeding units" were designed on a domestic scale with a furniture look, such as *A–Z Quail Breeding Unit* (1991, p. 147), and some were created in larger scale as an installation for a museum environment, such as *A–Z Breeding Unit for Reassigning Flight* (1993, p. 150). Zittel also gave some of them a purely conceptual format, such as *A–Z Breeding Unit for Averaging Eight Breeds* (1993, p. 151) and the fantastical *Ponds for Developing Amphibian Appendages* and *Family Tree Apartment Complex* (both 1991, p. 143).

19. Zittel has spoken of this body of work on various occasions, and she has emphasized at different times different motivations and findings, which have shifted as this output became recontextualized in relation to her later production. A very early statement by Zittel, written for her work *Twins* (1990) and describing her focus on "order as our way of mastering or controlling our environment," appeared in *On Target '90: Zephyr Gallery Third Annual Invitational,* exh. cat. (Louisville, Ky.: Zephyr Gallery, 1990), n.p. See also Andrea Zittel, "Animal Breeding and Class Structure," 1991–92, unpublished typed text, artist's personal archives.

20. "I remembered being completely amazed when I began to notice many of the ways in which the things that I learned about the ambitions of the modernist European avant-garde seemed to resemble the optimism and the hunger for progress of my own home culture. Things like Le Corbusier's ideas for living seemed to be answered by the huge communities of planned housing around my own home. There was also a sort of an interesting (if temporary) leveling effect, since everything was so homogenous in its 'newness.'" Theodora Vischer, "Questions Addressed to Andrea Zittel," in *Andrea Zittel: Living Units*, exh. cat. (Basel,Switzerland: Museum für Gegenwartskunst, and Graz, Austria: Neue Galerie am Landesmuseum Joanneum, 1996), p. 16. See also Madeleine Grynsztejn, *About Place: Recent Art of the Americas*, exh. cat. (Chicago: The Art Institute of Chicago, 1994), pp. 18–20. Here Grynsztejn relates Zittel's works to Graham's *Homes for America*.

21. Umberto Eco, "Two Families of Objects," in *Travels in Hyperreality* (1973; reprint, San Diego: Harcourt Brace & Company, 1986), p. 185.

22. Adolfo Natalini, quoted in Peter Lang and William Menking, *Superstudio: Life without Objects* (Milan: Skira, 2003), pp. 20–21. Superstudio member and architect Natalini was presenting a lecture about Superstudio at the AA School of Architecture, London, on March 3, 1971.

23. Hal Foster, "Some Uses and Abuses of Russian Constructivism," in *Art into Life: Russian Constructivism, 1914–1932,* exh. cat. (Seattle: The Henry Art Gallery, University of Washington, and New York: Rizzoli, 1990), p. 244.

24. Foster, "Some Uses and Abuses of Russian Constructivism," pp. 252–53.

25. See interviews with Leonora and Jimmy Belilty, Jennifer Flay, Jay Jopling, Frank Kolodny, Pier Luigi Mazzari, Eileen Harris Norton and Peter Norton, Craig Robins, Andrea Rosen, and Patrizia Sandretto Re Rebaudengo, in *Andrea Zittel: Living Units*, pp. 12–44. For Wendy and Cliff Moran, who acquired *Rendition of an A–Z Pit Bed* (1995) for their family room, see *Living with Contemporary Art*, exh. cat. (Ridgefield, Conn.: The Aldrich Contemporary Art Museum, 1995), pp. 56–58. Lisa Ivorian Gray also transformed an *A–Z Homestead Unit* into her office and added a doghouse for her pet (*A–Z Homestead Office Customized for Lisa Ivorian Gray*, 2003).

26. Brenda Richardson, *Scott Burton,* exh. cat. (Baltimore: The Baltimore Museum of Art, 1986), p. 20. Burton developed these into tableaux staged for an audience, such as *Behavioral Tableaux* (1972–80), with performers moving among the chairs in a rhythmic movement (35).

27. See Foster, "Some Uses and Abuses of Russian Constructivism," pp. 249–50.

28. Here I am referencing the work of Martha Rosler, *In the Place of the Public* (Frankfurt: Editions Cantz, 1997), which is commented on by John S. Weber in *Public Information: Desire, Disaster, Document*, exh. cat. (San Francisco: San Francisco Museum of Modern Art, 1995), p. 116.

New Deeds: A Frontier Practice

Robert Cook

"I am average because, …" I wrote, "I stand on the seashore here in Santa Monica and I let the Pacific Ocean touch my toes and I know I am at the most western edge of our nation, and that I am a descendant of the settlers who came to California as pioneers. And is not every American a pioneer? Does this spirit not reside in each one of us, in every city, in every heart on every rural road, in every traveller in every Winnebago, in every American living in every mansion or slum? I am average," I wrote, "because the cry of individuality flows confidently through my blood, with little attention drawn to itself, like the still power of an apple pie sitting in an open window to cool."[1]

—Steve Martin

No way of thinking or doing, however ancient, can be trusted without proof. What everybody echoes or in silence passes by as true to-day may turn out to be a falsehood to-morrow, mere smoke of opinion. What old people say you cannot do you try and find that you can. Old deeds for old people, and new deeds for new.[2]

—Henry David Thoreau

The American frontier had been declared over before, but in 1930 John Dewey rediagnosed its death. He then proceeded to get worked up about the simpering cultural re-creations that had popped up in its place. As he did, he asked (and answered) the following:

> Where is the wilderness which now beckons creative energy and affords untold opportunity to initiative and vigour? Where is the pioneer who goes forth rejoicing, even in the midst of privation, to its conquest? The wilderness exists in the movie and the novel; and the children of the pioneers, who live in the midst of surroundings artificially made over by the marching, enjoy pioneer life idly in the vicarious film.[3]

Dewey's response was heated because he sensed a lack of desire in his fellows to vigorously engage with the world in order to make it all it might be. So while he was aware of the frontier's easy perversion into glib nostalgia *and* amoral selfishness, Dewey argued for a dynamic extension of the frontier ethos that would remobilize its initial dream of personal and social transformation in order to courageously address the world as it changed around him. Basically, he sought a new type of pioneering individualism, one that would be capable of creating "a secure and morally rewarding place in a troubled and tangled economic scene."[4]

More than sixty years later, Andrea Zittel's practice models just that kind of individualism. Ruminating across an expanded and interiorized frontier, she is engaged in the redesign of so much that we take for granted. Moving beyond mere "frontier style," she uses the frontier's potentially radical kernel of philosophy— of self-sufficiency, engaged inquiry, a trust in our "state of nature"—to examine the structures that shape our humanity. But while others—such as Jack Kerouac, Allen Ginsberg, and even Jackson Pollock in his way—utilized aspects of this sensibility to activate their practices, Zittel is almost unique in her ability to do so with a neat balance of ironic suspicion *and* optimism about the whole enterprise.

In this spirit, Zittel's work is grounded by her determination not to follow the findings of others as she explores the cracks in Old World-style received wisdom. With its stress on making room for a particular mode of living, her *A–Z Raugh* project (1998, pp. 168–73) is especially important here. It features posters such as *Raugh and Relaxed* (replete with a reclining German shepherd), an instructional video about the *Raugh* lifestyle

fig. 14
A–Z Homestead Unit under construction at A–Z West, August 2001.

aimed at allowing you to embrace your "primal self," a giant, gray foam rock outcrop for lounging and roaming on (exhibited at Andrea Rosen Gallery, New York, in 1998), and a range of prototype objects and structures for the home and/or office made from recycled and found materials. This series of domestic, public, and graphic works has a casual, free-dress-Friday kind of feel that makes room for the needs and desires of a specific body and its lifestyle. Unlike mass-produced "design in general," *A–Z Raugh Furniture* (pp. 169–71) does not deign to know in advance the needs of "most people," but is responsive in a relaxed way to a precise user and situation in their complex entirety. As such, *A–Z Raugh* systems work out the kinks in our lives caused by design generalizations, hopefully producing an arrangement of seamless functionality that carries the possibility of its continual reworking. Of course, *A–Z Raugh*'s roughness, its outdoorsy feel, also encourages a feral state, a counterculture of shoelessness and constructed naïveté. *A–Z Raugh* promotes an attentive drifting away from the superficially civilized crowd. It's an invitation to go it alone, to traverse the border of existing design solutions in order to see what type of people we might be like outside their reach.

Here, *A–Z Raugh* mobilizes America's New World frontier cult of individuality set free from the moorings of Europe's Old World expectations. One way of reading this project is to say that Zittel implicitly colors the preexisting social landscape that we reside in (and its products) as a "contemporary relic" of a lingering, metaphorical Old World—one that we have become so used to, we don't even realize we're fettered by it. As she offers us the structures to remap our physical environments according to our gait, our reach, our temper, we're reminded that the individual carries the possibility of the New World within. Accordingly, our "lived experience" will be the place of continuing social re-creation and rejuvenation. In a subtle ghosting of that original transatlantic journey, Zittel casts our bodies as players in a restatement of faith in the regenerative potential of our own nature. *A–Z Raugh* is, therefore, an occasion for us to enjoy the freedom that comes from escaping the repressiveness of our fussy, overcultured habits and lives.

Zittel continues this process of creative resocialization in the *A–Z Time Trials* works (1999–2000, pp. 152–59). In *Free Running Rhythms and Patterns* [Berlin] (p. 154), the experiment that she ran in Germany from October 31 to November 6, 1999, Zittel tried to figure out how she might function outside the ordering mechanisms of societal time restraints and conditioning. It was an effort to discover whether the world we live in has been making us suffer from a form of jet lag. To do so, first principles needed to be reestablished. The strategy here was on par with Ralph Waldo Emerson's sentiments in the famous essay "Self-Reliance": "Society is a wave. The wave moves onward, but the water of which it is composed does not. The same particle does not rise from the valley to the ridge. Its unity is only phenomenal. The persons who make up a nation to-day, next year die, and their experience dies with them."[5] As was true for Henry David Thoreau, too, nothing should be taken for granted—not even our attitudes to time. In a similar way to both men, Zittel used the measure of the human body, *her* body, as a standard—a Greenwich Mean Time of subjectivity. Of course, this *A–Z Time Trials* inquiry also ran against the historical background of protests about the length of the working day. Zittel's vision of a natural body that obeys its own rhythms therefore teased out a tacit politics of industrialization and consequent alienation that, in many ways, her other work seeks to remedy. The hope appears to be that the body will retain enough of its pre-socialized "natural memory" to offer a platform of resistance to the capitalist status quo or at least a yardstick to measure how far things have gone wrong. There is a little bit of Jean-Jacques Rousseau hanging around here, as Zittel's project goes against decades of poststructuralist and postmodern rhetoric, taking us back to an embodied, pre-Saussurean idyll.[6]

This Arcadian regression is theatricalized in *A–Z Deserted Islands* (1997, pp. 207–209), which leaves us adrift in a situation where we have lost even an imaginary settler society to give our lives meaning. Afloat on a body of water, we have the opportunity (and feel the necessity) to make a little society of our own, which throws us back to our more blissful (and perversely onanistic) childhood fantasies, when we mulled over how, if no one else existed, we would spend our days. It's the same in *A–Z Pocket Property* (2000, pp. 177–79)—the floating island-cum-living unit. Obviously, there is an anti- or counter-capitalist bent to the prospect of being able to indulge in self-sufficiency, to be truly independent, and to live outside the market economy. As such, these works are models of countercultural "capital A" Adulthood, a type of personal development that arrives only when one wrests responsibility back from the existing social world and lives one's life for oneself. Of course, there is also something here that harks back to the types of fictional characters that followed

fig. 15
Zittel's neighbor Charles relaxing on his *A–Z Carpet Furniture*
(Sofa, Chairs, and End Tables), 72 South 8th Street, Brooklyn, c. 1992.

in the wake of the frontier's vanquishing—Philip Marlowe, Sam Spade, and more recently any number of male protagonists in the books of Richard Ford or Haruki Murakami. Life is a matter of defining a zone of adult self-determination and moral accountability that one finds not directly within the banal and corrupt social world, but in a contained, self-critical response to it.

Despite Zittel's repeated motifs of movement away from the existing social layout, she doesn't always seek to leave it entirely. For instance, the *A–Z Escape Vehicle* (1996, pp. 200–205) offers a trapdoor *within* our product culture: getting away is more simply about quickly creating some distance between us and "the problem." Even so, the care involved in these works' construction implies a strategy of escape planned out well in advance. The hours spent figuring out what requirements are necessary, ensuring the clean production values, and devising the particular customizations cannot help but speak to the long-held, long-stifled dreams we all have of rerouting ourselves away from the world that is grinding us down. In Zittel's hands, these interior narratives that we tend to keep to ourselves are given shape and circulated like a slightly dirty secret.

The artist's sleek, retro-modern designs also imply that once one has escaped, one will fit into some kind of equally modernist receptacle that will provide more fulfilment than our present lives. One doesn't hop into one of these babies and end up in Kansas or Karratha. This is the flipside to the *A–Z Raugh*

Furniture: modernity becomes a blissful savior. We thus see Zittel running complex dialectical nuances through her oeuvre as she lays new tracks over her work to avoid any clear sense of practical or ideational passage. Possibly, it's a quite pragmatic refusal to put all her eggs in the same basket. If so, it's hard to shake the thought that the process of restless remaking and the *idea* of escape or refuge are, at base, most important—not the form the work or strategy takes. As a direct consequence of this activity, we can imagine utopia in any guise. We might live equally happily in streamlined modernized lives or rustic nature-based ones. Notably, however, Zittel's work encompasses a critique *and* an exploratory extension of each of all these possible futures.

Amplifying this democracy of utopia is *A–Z Carpet Furniture* (1992–93, fig. 15, pp. 110–13), which riffs off the *A–Z Raugh* gambit while also offering a model of apparent calm and playing against the latter's "student digs" feel. As the spartan items comprising *A–Z Carpet Furniture* spread out on the floor, the work suggests mature purposefulness and repose. The ease with which people lounge on the elements and move from station to station conveys a clear feeling of satiety. The restlessness of frontier desire is gone. One lives simply for the moment with the material at hand. This is another model of self-reliance, an Eastern one, which gives a cute spin to Emerson's claim that "discontent is the want of self-reliance: it is infirmity of will."[7]

Will is important, but in *A–Z Carpet Furniture*, it's the abdication of will that seems most significant in the quest for self-reliance.

Again, we see a remodeling of frontier types and being, and an explication of their possibilities and range. The subtlety and varied dimension of this enterprise makes Zittel's practice so much more than a nostalgic escapade. The frontier of the now, Zittel shows us, has room for many types, many ways of being, and many stylistics. Yes, as the cliché goes, it's a matter of "attitude." Accordingly, Zittel's composite picture of the frontier is continually shifting. In some work, a new take on modernity (say, *A–Z Cellular Compartment Units* [2001, pp. 184–89] and *A–Z Living Unit* [1993–94, pp. 130-33]) keeps the picture open, both ironizing and seeking solace in "Euromodtopias," while other material pushes a premodern stance to keep personal liberty alive. Obviously, these "solutions" are only half serious, and this playful attitude prevents the work from ossifying into a set of programmatically banal ideological fixtures. Indeed, as much as utopia itself seems to be the goal—an ironing out of the problems in our lives and lifestyles—we never quite believe in its eventual success either. In fact, Zittel's practice is in a continual state of construction and deconstruction as she redesigns, re-solves, and reproblematizes. The degree that this is so marks her clear distance from the historical avant-garde with its generally key belief in large-scale social transformation. Thankfully, though, Zittel doesn't adopt a condescending "pomo" tone, and the searching optimism her practice conveys feels very real. So somewhere, amid all the implicit caveats and slippery reflexivity, is indeed a committed tracing of the complexities of the ongoing frontier dynamic. Its distance, its impossibility, its closeness, its occasional successes, its comedy lend it a tragic dimension that is fitting considering the gruesome history of the real frontier that Zittel's work acts upon and harks back to.

Of course, of special significance within this is the figure of Andrea Zittel herself—as a participant and maker, but also as a type of subjectivity. In many ways, Zittel comes off as an "artist of the self." It's not that her production has shifted "beyond" art (in its apparent usefulness) or "beyond" design (in its performative metaphorical capacity)—"Those boundaries were broken so long ago that it's almost embarrassing that people still worry about them"[8]—but that her performance of the experimental self is indivisible from the work itself. Curiously, though, as she articulates this combination of physical production and selfhood, she also reveals an obsessive strand of perfectionism

that neurotically twists the pragmatic maxim where "good enough" is traditionally "good enough." Once life becomes a test site, "good enough" starts to look like a challenge. Hyperfunctionality and reflexivity might then become a form of dysfunction.

The artistic athleticism and asceticism that stems from this challenge, which haunts all the work, should be seen in the same light as the disparate artistic endurance machines of On Kawara and Chris Burden. But a more important reference point might be *Seinfeld*'s Kramer—the wide-eyed frontier optimist writ goof and large. Continually engaged in thinking about the structure of his life, Kramer and his "work" are perfectly Zittelesque in flavor. One time he walks into Jerry's apartment with the *Raugh*-ish idea to transform his living space: "Levels, Jerry, levels. No furniture. It's all gonna be levels." Another time he engages in his own *Time Trials* as he explores the delights of "da Vinci sleep"—twenty minutes sleep per hour. It gives him time enough to piss Jerry off by appearing at four a.m., bouncing on his bed like an oversized puppy wanting to play. Time enough also to fall asleep on his Italian girlfriend and wake up in a sack in the Hudson River, thanks to her "family" connections: "I woke up in a *SACK,* Jerry! In a sack!!!"

There are countless other examples, but what's important to note is that Kramer's activities and their consistent failure obey the law of the sitcom: everything must stay the same. Situations and characters cannot develop, learn from their mistakes, and move on or change; they are caught in the hell of an endless repetition of their most obvious traits. Kramer's labor is therefore a form doubly devised for him to stay in place and avoid becoming a functional member of society. The tinkering, the plans, and the capers are all a way of making his own desert island within the sea of New York City. Productivity, then, is not an issue for Kramer; of sole interest is the continuation of a *lifestyle* of inquiry and enthusiasm. In fact, actual productivity would get in the way of that. It's as if Kramer has taken Zittel's focus on redemptive individualism and run it into the ground, using it not to rejuvenate a social and personal connection with the world, but to isolate himself entirely from all forms of communal responsibility.[9] Ultimately, Kramer's almost autistic self-absorption marks the potential dangers of reading Zittel's project in a purely formal or stylistic way outside of the broader world she is intent on continually challenging and butting up against. Indeed, what this comparison shows is that the significance of Zittel's objects and subjective social play

lies in the maintenance of a spirit of openness to the world. This comparison might also shed light on the possible dangers of the otherwise rampantly creative DIY and "kustomization" movements that her work has something in common with, too—their endless fussing and tinkering can be simply a way of refusing to take a stand in the political world outside the kar klub or the shed.

As we see Zittel's work and "character" successfully move between the personal and the social, it rejuvenates the often dour pragmatic situation as well; needs/ends thinking expands into a mode of embodied inquiry and desiring. Equally, in the world and in the objects and subjectivities that Zittel creates for us there, we find no nihilism, no dry "use-only" value, no (*contra* Marc Auge) non-places. We find instead opportunities to be more mindfully involved—in a pragmatic tweak of the late Allan Kaprow perhaps—in the expansive rearticulation of our lives. As such, Zittel's example very clearly encourages us to avoid complacency in our lives and, in a neat twist, to avoid relying on *her* solutions to our problems and needs. (Perhaps we should avoid turning into Kramer, too.) Given this, Zittel's challenge to us is to channel the form of selfish, disengaged individualism that most Westerners are living in some variation and degree into another mode of being that is more richly interested, socially engaged, and transformative. Over half a century after Dewey's remarks, we still need to work out what this might be. That remains the frontier. Zittel has fixed some signposts on it.

NOTES

1. Steve Martin, *The Pleasure of My Company* (London: Phoenix, 2004), p. 10.

2. Henry David Thoreau, *Walden, or Life in the Woods* (1854; New York: Dover, 1995), p. 5.

3. John Dewey, "Toward a New Individualism" (1930), in John J. McDermott, ed., *The Philosophy of John Dewey: The Structure of Experience and the Lived Experience* (Chicago: University of Chicago Press, 1981), p. 611.

4. Dewey, p. 609.

5. Ralph Waldo Emerson, "Self-Reliance," in *The Complete Essays and Other Writings of Ralph Waldo Emerson* (New York: Modern Library, 1940), p. 168.

6. At other moments, however, her determined commitment to understand what she sees as a socially constructed mode of being resembles, say, the approach of Clifford Gertz in its anthropological attitude and scope.

7. Emerson, p. 163.

8. Andrea Zittel, "Talking with Allan McCollum," in *Diary: Andrea Zittel*, Diary, ed. Simona Vendrame, no. #01 (Milan: Tema Celeste Editions, 2002), p. 129.

9. "Individuals who are not bound together in associations, whether domestic, economic, religious, political, artistic or educational, are monstrosities." Dewey, p. 612. Ergo, Jerry explains to Kramer, "You're not like us; you're not human—you're Pod."

I don't think that you are freer artistically in the desert than you are inside a room.[1]

—Robert Smithson, 1970

I have never been forced to accept compromises but I have willingly accepted constraints.[2]

—Charles Eames, 1969

Over the last fifteen years, Andrea Zittel has offered a timely and playful critique of the conflation of leisure and freedom in contemporary consumer culture. Her establishment of A–Z Administrative Services in 1991, followed by The A–Z in 1994 (now called A–Z East) and A–Z West in 2000 as a combination of home, studio, and presentation space, has been crucial to this endeavor. Zittel's creative engagement with the physical constraints and social situations at play in each of these sites has consistently evolved new developments in her work. While A–Z West is located on twenty-five acres adjacent to the Joshua Tree National Park in California, the East Coast manifestations, established in the inner-city environment of Williamsburg, Brooklyn, echoed the tradition of the home business or corner shop, a "pre 7-Eleven" quick stop where the owner's family would live above or behind the storefront. Such a model refuses the segregation of work and play so central to consumer marketing of leisure lifestyle as recompense for thankless and unrewarding work.

In 1989 Zittel moved from southern California to the East Coast to earn her master's degree at the Rhode Island School of Design in Providence and eventually to set up her first studio in New York City, renting space in the Fink building at the corner of Berry Street and Broadway on the south side of Williamsburg, Brooklyn, a neighborhood that would be her base of operations for the next decade. While Williamsburg today is a bustling inner-city neighborhood already at the other side of an arts-led recovery, in the early 1990s the local economy was in a recession, and New York's infrastructure was still only just shaking off the effects of the city's late 1970s near-bankruptcy. Although it is just one subway stop out of Manhattan, Williamsburg was a post-industrial frontier, pockmarked with empty buildings and boarded-up shops. Filled with underutilized industrial buildings, the neighborhood seemed to be a victim of urban decay, shifting demographics, corporatism, and the franchising of American productivity.

Zittel recalls being "overwhelmed by the decay. In California everything had been all about progress and newness, but here in New York buildings were being abandoned and rents were going down and nothing was being repaired."[3] One response to her shock at this state of affairs was to collect and repair badly damaged objects found lying discarded in the street. Most of the *Repair Work* (1991, fig. 36 and p. 109) began with objects damaged beyond any obvious likelihood of restoration: a side table with two missing legs and no cross bracing, a statuette with its facial features completely worn away, or an ordinary drinking glass broken in several pieces. By lavishing attention on these most abject of discards, Zittel formulated a reproach to the ease with which society often casually discards objects with changes in style and fashion. Her repairs were minimal and pragmatic: for example, she replaced the missing table legs with unfinished pieces of wood, sawn to length and nailed in place without consideration for style or codes of craftsmanship. The comic visibility of the repair made palpable the difference between the table's use value and its display value: while it had lost its stylistic gestalt, it was once again a supportive surface.

Like the *Repair Work,* which in effect inaugurated Zittel's engagement with the New York environment, one of her earliest projects at A–Z West was inspired by the problem of waste. A diary entry for Thursday, June 21, 2001, reads:

> Trash bags were piling up behind the house, so today I loaded them into the truck and drove to the landfill, which is in the middle of some of the most beautiful rock formations in the area. Whoever decided to turn that area into a dump had a sick sense of humor. Hauling everything away myself makes me realize how much I "consume" and also how much I seem to value visual stimulation over efficiency. I really love great packaging, but I wish that I could find a way to reconcile this with the need to be economical. For instance, if there were a way to turn that packaging and other waste into something beautiful and practical like furniture.[4]

The project that resulted after several experiments was *A–Z Paper Pulp Panel* (2002, pp. 162–63) in which Zittel used a papier-mâché technique to "farm" her household waste in *The Regenerating Field* (2002, p. 163), a gridlike array of molding trays set out in the desert in front of her home. The molds are made in various low-relief rectangular patterns, and varied materials can be added to the pulp paper to play with different looks for the decorative or architectural panels. Zittel's move to the desert was not unprecedented, art historically speaking.

Donald Judd famously decamped from his five-story loft building in New York to Marfa, Texas, in early 1972. Judd's move represented, at least in part, an ideological refusal of the slipshod and ephemeral installation options for the presentation of contemporary art. As he put it in 1983, "If somewhere there were serious and permanent installations, the ephemeral exhibitions of the gallery and the awful environments of the work in public could be criticized and endured."[5] Zittel, on the other hand, described her move as more "logistical than ideological," a search for a place where she could remain in an urban dialogue but "where existence isn't quite so difficult and where more experimental artworks could actually happen."[6] If Judd chose Marfa because its isolation provided the stable environment necessary to produce his large-scale permanent installations, Zittel chose Joshua Tree because it was only relatively isolated. The population density is low, but on a good day it is only a three-hour drive from Los Angeles. It thus held the potential to develop a supportive community where she didn't have to "disappear from the face of the earth."[7]

Looking at Zittel's *sfnwvlei (Something for Nothing with Very Little Effort Involved)* gouaches (fig. 17 and p. 104), which document the production of the *A–Z Paper Pulp Panel,* it is possible to see her playing knowingly with the mythic tropes of homesteading and the heroic individualism that led an earlier generation of artists to the desert. Her self-representation echoes, even if obliquely, photographs of Robert Smithson walking on *Spiral Jetty* or Michael Heizer on his motorcycle. Posing in a desert landscape, she depicts her body or hands up

close to the picture plane, at once monumentalizing her body and placing it within a vast landscape, with a far distant horizon line both echoed and flattened by parallel bands of color. While these drawings might appear to be a sly feminist retort to visual tropes of masculinity, it is instructive to look at these hallucinatory images of Zittel's back-to-the-earth, do-it-yourself activity in relation to her recent observation that Minimalism and Conceptualism emerged as a reaction against not only:

> the subjectivity of the Abstract Expressionists or the illusionism of spatial representation but also hallucinogenic-drug culture, grassroots political movements, and the era's newfound interest in Eastern religion, which opened new modes of experience and of reading the "self" in relationship to the greater whole.[8]

The exploration of forms of sociability—"the 'self' in relationship to the greater whole"—is central to Zittel's practice. From 1991, art and life, studio practice and public engagement, all commingled to facilitate a working process more closely modeled on workshop critique, design iteration, and prototyping than the traditional professional artistic cycle of long studio isolation and brief public exhibition. Each of the sites presented a very different set of constraints. From 1991 to 1993, A–Z Administrative Services occupied a small 200-square-foot shopfront on South 8th Street. In 1993 she moved to a large raw space on Union Street, and beginning in 1994, she occupied a three-story former boardinghouse at 150 Wythe Avenue. Since 2000 A–Z West has been located in the Mojave Desert just beyond Los Angeles' exurban sprawl.

Even as Zittel extended the visual vocabularies and design strategies of modernism to work with the unique constraints of each of these sites, the environments she created for herself operated in critical contrast to the separation of work and leisure privileged in modern consumer culture. Even if, for a brief moment at the height of the dot-com boom in the 1990s, such blending became the representative cliché of a new media company workspace, it remained the exception rather than the corporate rule. (As such, it was later held up as a sign of the folly and decadence that led to that market bubble's collapse.) Unlike dot-com offices, or even most home offices for that matter, Zittel's studios did not develop from a simple interest in engendering a pleasant and creative work environment. Describing her *A–Z Yard Yacht* (1998, pp. 210–13), later *A–Z Yard Yacht: Work*

Station—a large recreational vehicle that she customized as a home office when she relocated to Los Angeles in 1997—she suggested that one of its most interesting qualities was that it inverted "the function of a recreational vehicle from leisure-time freedoms to labor-based freedoms. Rather than escaping labor, it became more interesting to think about ways to give it more meaning and use it as a means of pleasure."[9]

The *A–Z Six-Month Personal Uniform* (fig. 6 and pp. 70–71) that Zittel produced between 1991 and 1993 similarly used the language of labor—uniforms—to describe dresses that she produced to take care of all her clothing needs for a six-month period. For example, she described the *Spring/Summer 1991 Uniform* as "a simple sleeveless linen design that made an easy transition from an un-air-conditioned Brooklyn studio to a day job in a Soho gallery."[10] The skirt/pant combination for *Spring/ Summer 1993* was inspired by the need to take visitors up a ladder to the chicken coop she was keeping on the roof. By contrast *Fall/Winter 1992–93* was:

> something of a fantasy dress mixing heavy leather suspenders and a tailored men's dress shirt with a full black taffeta skirt and a hidden petticoat. The dense petticoat was sewn from layers of wool jersey (for warmth) and black tulle. It was then edged with two shades of pale green satin ribbon and decorated all over with tiny green silk flowers.[11]

The idea of wearing a uniform every day for six months relieved Zittel of the time spent making clothing decisions or shopping for fashions. And the monotony of wearing the same dress each day was relieved by "dreaming up the next season's design."[12]

At *A–Z East*, Zittel took this drive to customize and produce to the point that it was extremely rare to find a corporate logo anywhere on the premises. Not only did she customize the early Apple Mac computer with black spray paint, but she covered the spines of all the books with green buckram tape, and then shelved them by subject (p. 89 top). With neither author names nor publisher logos visible, one could only locate books by familiarity with their subject, shape, and heft.

It is hard not to escape the echo of William Morris, one of the founders of the Arts and Crafts Movement in England in the nineteenth century, in Zittel's individual customizations and her celebration of work-based freedoms (fig. 18). Where Morris posited a celebration of craftsmanship and the handmade as a challenge to the banalities of industrial production, Zittel's do-it-yourself approach to production, and her creation and experimentation with her own rules, offers a challenge to the passivity of consumer culture. Yet where Morris dreamed of a socialist utopia where creativity would be unleashed through the abolition of alienated labor and through democratic control of the means of production, Zittel is more ambivalent about collectivity, proposing instead a socially responsive self-awareness where each person examines "his own talents and options, and then based on these begins to invent new models or roles to fulfill his or her needs."[13] Strategically positioning herself in opposition to the tired cliché of the artist as bohemian rule-breaker, Zittel proposed instead that:

> the formation of rules is more "creative" than the destruction of them. Their creation demands a higher level of reasoning and the drawing of connections between cause and effect. The best rules are never stable or permanent, and they evolve naturally according to context or need. I like to make rules—but I don't really like to impose rules on other people. I guess that is why I am always making rules for myself.[14]

In this regard it is useful to briefly consider Zittel's work in relation to her contemporary Joep van Lieshout, who operates Atelier Van Lieshout—a Rotterdam-based art, architecture, and design collective that develops architectural and design forms examining the dynamics of individual desire in social situations. *Sportopia* (2002, fig. 19) is a sculpture that functions as a primitive exercise studio, bed, and bar, while his most recent installation, *The Technocrat* (2004), feeds, waters, and sleeps 1,000 people for the primary purpose of producing biogas. Many of his sculptures and drawings depict individuals engaged in orgiastic or anarchistic acts that are clear provocations of social conventions. Van Lieshout purposefully flaunts rules of social control—going so far as to declare his studio compound a free state at one point—to reveal the collective id repressed beneath the European social superego. As such his work has much in common with J. G. Ballard's hallucinatory fictions of the near future. While Ballard's writings were an early influence on Zittel, her work evolved in another direction. Unlike Van Lieshout, she

fig. 20
A–Z logotype signage, storefront window
of A–Z East, 150 Wythe Avenue, Brooklyn, 1995.

designs rules for herself, rather than flaunting society's man-
dates, in an effort to subvert the conformity produced by the
passive consumption of a branded lifestyle in American culture.

While Zittel's use of her initials to name A–Z East (fig. 20)
and A–Z West could be prosaically understood as a shorthand
version of the artist's signature, it is more interesting to con-
sider it as a branding strategy. Beginning as A–Z Administrative
Apparel briefly, which became A–Z Administrative Services in 1991,
Zittel's corporate guise was initially a humorous jest. While she
was working on her *Breeding Works* (1991–93, pp. 142–51), how-
ever, Zittel's adopted corporate identity lent her correspondence
with animal breeders and trainers a form of legitimation that an
emerging artist with a "southern California mall-girl accent"[15]
simply couldn't muster. Curiously, "A–Z Administrative Services"
is not at all suggestive of contemporary corporations, services,
and franchises with their wishful evocations of lifestyle and
well-being in their names—Starbucks, Target, Blockbuster. In-
stead the A–Z brand evokes the kinds of small companies from
the 1950s and 1960s that engendered customer confidence
through the projection of encyclopedic competence—Acme,
Paragon, Universal, and so on. As a brand, A–Z Administrative
Services evokes the world of the great Chuck Jones Roadrunner
and Coyote cartoons in which the Coyote, perched by the side
of the road on some distant desert mesa, would take delivery
of some implausible scheme from a company whose name always
began with ACME.

By today's standards such companies were small opera-
tions, sometimes even home businesses; the universalist con-
fidence writ large in their brand names belied their small scale
and local nature. Squeezed out by shrinking profit margins and
competition from franchise operations as well as the global-
ization of markets, they were the types of companies that had
closed up shop in Williamsburg and elsewhere by the early
1990s, just as Zittel's was taking shape. In an important group
of drawings on vellum from the early 1990s, Zittel reproduced
animal breeding advertisements drawn from small community
newspapers and specialist magazines. As direct appropriations
from advertisements, these drawings are singular in her oeuvre,
suggestive not only of the parallels she was making at the time
between the selection of aesthetic traits through breeding and
the art world's promotion of particular movements and aesthetic
values, but also of the fact that many such small-scale busi-
nesses were themselves becoming endangered species.

The early *Breeding Works* evolved out of Zittel's interest
in how the development of domestic breeds corresponded to
"the breakdown of traditional class structure in humans. In the
late 1800s breeds in animals like dogs were 'designed' possibly
as a way to try and create a stable and hierarchical social sys-
tem which the owners of the animals could identify with."[16]
While Zittel worked early on with houseflies and quails, chick-
ens quickly became her species of choice, particularly Bantams.
She spoke of how chickens made "perfect sense as a choice of
art material": they "hatch from eggs so there is complete au-
thorship of the 'creation,'" and they "have an amazing array of
genetic possibilities; they possess many types of physical vari-
ations with which to work with." She added, "Bantams are
'miniature' chickens used for 'decoration and for exhibition.'"[17]
Moving from aesthetic to social considerations, it is likely that
the fact that chickens are subject to industrial production was
also significant. Her *Single-Egg Incubator* (1991, p. 146), for ex-
ample, establishes an empathetic, quasi-parental relationship to
a single egg, something in sharp and deliberate contrast to the
factory incubators designed to anonymously hatch thousands
of eggs at a time.

Working specifically with breeder chickens in *A–Z Breeding
Unit for Reassigning Flight* (1993, p. 150), Zittel set up a series
of four compartments in the window of the New Museum of
Contemporary Art in New York. Designed to evolve the capacity
of flight back into these birds, each compartment featured
nests of different heights, arranged such that only eggs from
the highest nest would be channeled into the incubator in the
next compartment, where the chicks would:

> hatch, grow up, and then once again be presented with nests of
> different heights. The chickens could only reach each succes-
> sive breeding compartment by higher and higher passages. The
> idea was to bring this recessive gene forward through subse-
> quent generations and so return this bird to flight.[18]

With the *A–Z Breeding Unit for Averaging Eight Breeds*
(1993, p. 151), Zittel turned her attention not to bringing recessive
genes forward but to reversing evolution to reinstate a perfectly
average bird. This unit takes the ironic form of an upside-down
pyramid, inverting the usual progression of breeding refine-
ment. At the top are eight hutches for eight separate breeds
that have been bred to draw out highly unusual recessive
traits—long silky black feathers or a mottled black-and-white

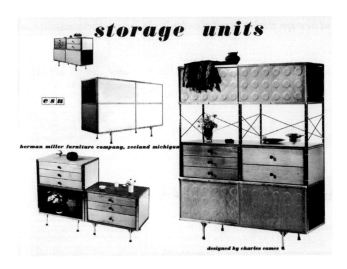

fig. 21
Advertisement for **Charles and Ray Eames Storage Units (ESU)**, Herman Miller Furniture Company catalog, 1950.
© 2005 Eames Office LLC (www.eamesoffice.com)

coloring or an enormous comb, and so on. At each successive layer down, the hutches halve in number as the chickens cross-breed. Finally at the bottom, the new breed of chicken emerges whose carefully cultivated recessive genes have once again been submerged.

Zittel carried out her early breeding experiments at the South 8th Street shopfront (p. 128), where she also began to produce works that dealt productively with the physical constraints of her space: two 100-square-foot rooms with an office in front and private space in back. Although they came slightly later and depict an apartment as opposed to a shopfront space, her *Domestic Models A–E* (1993, p. 115) test out alternative propositions to subdividing a small space or arranging furniture heights, based on activity, privacy, hygiene, and so on. While such schema address basic human needs, the rationales and functional combinations are often surprising. Model D reads, "Bed and bath are secluded in back as private areas. Kitchen and office are in front as public area," while Model E makes an alternative proposition, reading, "Bed and office are in front as areas associated with the mind. Kitchen and bath in back for processing the body."

Thinking through these kinds of basic needs led Zittel to produce one of her first signature works: the *A–Z Management and Maintenance Unit, Model 003* (1992, p. 129). Its square channel metal frame and birch plywood construction evokes the look of mid-century modernism, but unlike one of Charles and Ray Eames's 1950 Storage Units (ESU), which primarily store and display objects and books (fig. 21), Zittel's unit had to facilitate all the aspects of living. Within an extremely constrained footprint of sixty square feet, she attempted:

> to satisfy the often conflicting needs of security, stability, freedom and autonomy. Owning a *Living Unit* created the security and permanence of a home which could then be set up inside of homes that other people owned. It provided freedom because whenever the owner wanted to move they could collapse it and move the unit to a new location.[19]

When Zittel moved from the small shopfront to a large industrial space in 1993, the constraints that she was productively channeling in the *A–Z Management and Maintenance Unit* shifted dramatically. Where previously the small volume of

space was the limitation, here it became the challenges of a very large space that was impossible to heat, cool, and keep clean. This new environment gave birth to a series of works that were exhibited in the *Purity* exhibition in 1993. These include cabinets that Zittel called *Prototype for A–Z Warm Chamber* and *Prototype for A–Z Cool Chamber* (both 1993, pp. 124–25). These cabinets are big enough for one person to sit in comfortably and either cool off with an air conditioner or warm up under the heat of a light bulb. *Prototype for A–Z Cleansing Chamber* (1993, p. 126) combines all cleaning functions, from bathing to washing dishes, in a single unit.

While Zittel developed these works in relation to very real needs, her engagement with functionalism is clearly leavened with a sense of humor. *A–Z Body Processing Unit* (1993, p. 118), another *Purity* work, functions as both kitchen and toilet, and it packs down into a compact and elegant carrying case. Her dry wit comes through in the description:

> although the kitchen and the bathroom are similar to each other, traditional architecture always segregates them in the home. It always seemed that it would be more convenient to create an integrated but well organized hygienic system: the *A–Z Body Processing Unit*. The intake functions are on the top, and the out take functions are on the bottom.[20]

Another slyly subversive group of works is her *A–Z Carpet Furniture* (1992–93, pp. 110–13). Inspired by a neighbor who was also living in a very small space, but one without furniture, Zittel produced carpets that were in fact 1:1 scale representations of standard furniture arrangements—initially a living room and later a bedroom and dining room. With their rectangular forms and their rectilinear and angular arrangements, the furniture patterns evoke the visual vocabulary of Russian Constructivism and, more generally speaking, early twentieth-century modernism. Zittel has wittily proposed that you could use these flat carpets as furniture, but that they would also look elegant hanging on a wall if you needed to move the "furniture" out of the way.[21] Laid on the floor, the carpets provide a measure of comfort while parodying the idea of decor. Hanging on the wall in a more or less empty room, they also suggest a domestic travesty of the corporate practice of hanging soft, textured modernist tapestries in the lobbies of 1950s and 1960s skyscrapers.

If *A–Z Carpet Furniture* parodies domestic comforts, five years later *A–Z Raugh Furniture* (1998, fig. 22 and pp. 168–71) would refuse domestic space entirely. A series of rock formations

fig. 22
Andrea Zittel
A–Z Raugh Furniture (Jack), 1998
Foam rubber
101 1/2 x 296 x 214 1/2 inches (258 x 752 x 545 cm)
Courtesy of the artist and Andrea Rosen Gallery, New York

Installation view, *RAUGH,* Andrea Rosen Gallery, New York, 1998

carved from high density foam, *Raugh Furniture* appears more Neolithic than neo-modern. In spite of first appearances, this work continues Zittel's questioning of modernist assumptions —in this instance the conflation of modern design with democracy and ergonomic comfort. Zittel recalled anthropological studies that indicate chairs evolved as a means of elevating certain individuals in a social hierarchy and not as the most comfortable seating position for the body.[22] Both *A–Z Carpet Furniture* and *A–Z Raugh Furniture* refuse such hierarchies by positioning users on the ground where they are, at least metaphorically, equal.

If *A–Z Carpet Furniture* and *A–Z Raugh Furniture* propose a form of democratic primitivism, Zittel's egalitarian tendencies are based on valuing ways in which individuals make up their own rules and fantasies as to how they might interact with broader society. One way in which she explores this practice has been to invite purchasers to individually customize her works. Following the *A–Z Management and Maintenance Unit, Model 003,* which expressed her desire to turn her "limitations into luxuries," she produced a smaller portable exemplar, the first *A–Z 1993 Living Unit* (pp. 130–31). Closed, it is about the size of a large shipping trunk, but when it is opened, it provides a wardrobe, desk and filing space, and cooking facilities. A folding campstool for sitting and a cot for sleeping can also be stored in the unit. In 1994, the same year that she moved to A–Z East, she devised a slightly larger, more commodious version, the *A–Z 1994 Living Unit,* and invited purchasers of the work to customize it according to their tastes and needs.

This social aspect of her work was amplified by the incarnation of A–Z East in a converted, three-story former boarding-house at 150 Wythe Avenue. Of all the locations in Williamsburg where Zittel worked, this was the longest lasting and the site of her most playful social experiments and events. As if to underline these experiments' engagement with consumerism and lifestyle questions, Zittel used the building's storefront as the *A–Z Personal Presentation Room* (pp. 94–95), where she would present her latest projects and ideas. This room also was the site of loosely themed cocktail parties that she hosted with different artists and friends. During this period she also produced thirteen issues of the *A–Z Personal Profiles Newsletter* (p. 95), approximately one every month.

While the renovation of the building required a great deal of work, in this more commodious environment, Zittel focused on the ideals and constraints of comfort. In the upstairs *A–Z Comfort Room* (pp. 90–93), many different furniture sculptures such as the *A–Z Ottoman Furniture* (1994, pp. 90–91), *A–Z Fled* (1994, p. 137), *A–Z Pit Bed* (1995, p. 139), *A–Z Platform Bed* (1995, p. 138), and *A–Z Bofa* (1996, pp. 92–93) were prototyped and tested. Like the *A–Z 1994 Living Unit*, the A–Z *Comfort Unit* (1994, pp. 134–35) was developed to playfully explore individual fantasies of domestic comforts.

This creative negotiation with the purchasers of her work had already been going on for some time, involving other works such as the *A–Z Jon Tower Life Improvement Project* (1991–92, p. 69) or the 1993 *A–Z Apparel Commissions,* including *A–Z Uniform for Andy Stillpass* (p. 83) and *A–Z Collector's Coat for Frank Kolodny* (pp. 84–85). While these earlier projects were about developing a functional product based on the client's needs and desires, the *Living Unit* and *Comfort Unit* were vehicles to test and even contradict her hypotheses and rules for living. Yet because these works were purchased as an "Andrea Zittel" and because she proposed the units as functional objects, Zittel's rules were not subverted or questioned as often as she may have wished.

It was this desire for greater latitude of interpretation that led to the development of the *A–Z Escape Vehicle* (1996, pp. 200–205) in which Zittel shifted ground from the fantasy of function to the function of fantasy. The *Escape Vehicle* is a small, metal-clad trailer structure whose interior can be customized at the whim of the purchaser. Like the earlier *Living Unit*, the *Escape Vehicle* operates within an extremely constrained space. At this time Zittel was theorizing her idea that freedom is often exercised through constraint. In the "Limited Universe" issue of her *A–Z Personal Profiles Newsletter* in November 1996 she wrote:

Why is it that you find it so much easier to create a totally fantastic environment for yourself in the tiny capsule-like confines of the *EV* [*Escape Vehicle*]? We feel it is because in some ways limitations actually *liberate* you. Ultimately, it is within defined boundaries that make it easier for us to let go and be creative. We bet that if we gave you an entire room in which to construct your fantasy you would feel pretty overwhelmed. On the other hand, the little capsule-like space of the EV presents one with an intimate and malleable little universe. It is within the security and intimacy created by this structure that many of us feel most comfortable in extending our fantasies to their most exquisite realizations.[23]

Even in the expansive acreage of A–Z West, the recent *A–Z Wagon Station* (2002–present, pp. 214–17) continues Zittel's hypothesis of the freedom of the intimate universe. The prospect of customizing these units, this time undertaken by friends of the artist, seems to present a greater variety of challenges to Zittel's philosophy of invented constraints. Eighteen simple rectangular structures—approximately six feet long, four feet high, and four feet wide—with a curved hatch at the front, sit in the landscape around A–Z West, each customized by a different person. Hal McFeely's is rustic (p. 216), while Russell Whitten's draws on the culture of car customization (p. 217). Jonas Hauptman applied monster truck and camper expansion principles to build out from the original A–Z *Wagon Station* chassis to create a structure that has ended up looking more like the Apollo Lunar Landing Module (p. 214).

If Zittel's early *A–Z Management and Maintenance Unit, Model 003* stands as an extension of modernism's ironic inversion of industrial materials and luxury, later works such as the *A–Z Cellular Compartment Units* (2001, pp. 184–189) operate as a parody of functional regimentation in suburban home design: an accumulation of ten cabins, four by four by eight feet, fits into an overall area about the size of a large studio apartment, each unit customized around a single unique function—eating, sleeping, reading, and so on. While the tone and subject of Zittel's art shifts in these two signal works between the poles of constrained urban apartment and exurban sprawl (see fig. 16), her critique of consumerism and its effect on our culture and environment has remained consistent. That she leavens her critique with humor and playfulness does not diminish her seriousness. Writing a history of seventeenth-century Dutch painting, an art form ascendant at the birthplace of the stock market, Max J. Friedlander noted:

> To play is nothing but the imitative substitution of a pleasurable, superfluous and voluntary action for a serious, necessary, imperative and difficult one. At the cradle of play as well as of artistic activity there stood leisure, tedium entailed by increased spiritual mobility, a horror vacui, the need of letting forms no longer imprisoned move freely, of filling empty time with sequences of notes, empty space with sequences of form.[24]

Zittel's work suggests that consumer culture's promise of leisure-time freedom is inadequate and comes at too heavy a price. Part-time emancipation is no emancipation at all. Instead we each might need to look to our very real social and physical constraints to create new rules for our game: at work and at play.

NOTES

1. Robert Smithson, interview with Robert Smithson, Michael Heizer, and Dennis Oppenheim, *Avalanche* (1970), found in Andrea Zittel notebooks.

2. Charles Eames, "What Is Design?" in John Neuhart, Marilyn Neuhart, and Ray Eames, *Eames Design: The Work of the Office of Charles and Ray Eames* (New York: Harry N. Abrams, 1989), p. 15.

3. Andrea Zittel, quoted in Stefano Basilico, "Andrea Zittel," *Bomb,* Spring 2001, p. 72.

4. Andrea Zittel, *Diary: Andrea Zittel,* Diary, ed. Simona Vendrame, no. #01 (Milan: Tema Celeste Editions, 2002), p. 14.

5. Donald Judd, "On Installation," in *Donald Judd: Complete Writings 1975–1986* (Eindhoven, Netherlands: Van Abbemuseum, 1987), p. 20.

6. Zittel, quoted in Basilico, p. 76.

7. Zittel, quoted in Basilico, p. 76.

8. Andrea Zittel, "Shabby Clique," *Artforum*, Summer 2004, p. 211.

9. Andrea Zittel, quoted in Zdenek Felix, ed., *Andrea Zittel—Personal Programs* (Ostfildern-Ruit, Germany: Hatje Cantz Verlag, 2000), p. 58.

10. Andrea Zittel, www.zittel.org.

11. Zittel, www.zittel.org.

12. Zittel, *Diary: Andrea Zittel*, p. 76.

13. Zittel, quoted in Basilico, p. 76.

14. Zittel, *Diary: Andrea Zittel,* p. 33.

15. Zittel, quoted in Basilico, p. 72.

16. Zittel, www.zittel.org.

17. Zittel, www.zittel.org, and p. 149 in this book.

18. Zittel, www.zittel.org.

19. Zittel, quoted in Felix, p. 19.

20. Zittel, www.zittel.org.

21. Zittel, quoted in Felix, p. 32.

22. Zittel, www.zittel.org.

23. *A–Z Personal Profiles Newsletter #3*, November 1996, "Limited Universe" issue.

24. Max J. Friedlander, *On Art and Connoisseurship* (Oxford: Bruno Cassirer, 1942), p. 42.

This conversation among Beatriz Colomina, Mark Wigley, and Andrea Zittel took place while they were driving through Joshua Tree National Park in Andrea's pickup truck, January 29, 2005.

Beatriz Colomina: It feels like we are at the end of the world. Even the seven-hour drive from L.A. in heavy Friday afternoon traffic contributes to this feeling of being very far away.

Andrea Zittel: The park is the easiest drive to do while we talk. We can see a few man-made things later.

Mark Wigley: I think we should remain within the space of the park until we are done. I like the idea that the interview lasts as long as a scenic drive.

B: What do you consider your first work?

A: When I lived in San Diego, I did a totally different kind of work. I did sculptures and pastel drawings that were influenced by technology in the desert, but they were very regional and much more about a visual language. I never even talk about them; it's like they don't really exist now.

B: Yet it is interesting that they were already about the desert.

A: Well, I've always been really influenced by this area, by driving through here, which is why I wanted to come back ultimately.

B: Where did this interest in the desert come from?

A: My grandparents had a ranch in the desert just south of here, and I spent a lot of time there when I was growing up. My great-grandparents had been farmers who settled in this area. My grandfather would fly to his fields in an airplane when he had to irrigate them. They also introduced a sprinkler system to the area and did some speculative farming, which didn't quite work out. I think this whole idea of creating a universe, and then living in the middle of it always attracted me.

B: What is the difference between what your grandparents did and what you are doing?

A: Well, I think I always wanted to have a similar kind of lifestyle. And I also felt it was a limitation of my work that I would make it in one place and then it was displayed in a totally different context. So I wanted to create a world where the process was complete. I used to joke that I felt like I was always traveling for my career, but I wanted everyone else to have to travel instead of me. So instead of being the tourist, I'd be the tourist attraction.

B: I am still curious about your grandparents. What is the difference in your mind between this form of art practice as farming and the inventions of ordinary people?

A: Well, I would like to say that I don't think that there is such a difference, but I guess that the thing that bothers me about southern California suburban culture is that we seem to be caught in such a cycle of endless consumption. I was listening to Jerry Brown on the radio once, and he was describing the difference between a citizen and a consumer. And he said a consumer is only able to pick from a few selections that are offered to them, and a citizen is somebody who can come up with creative solutions outside of those few options.

B: In your work art is imitating a certain form of life that seems to have disappeared, the kind of life exemplified in the inventions of your grandparents.

M: Isn't everything you're doing here a kind of a farm? Farming art?

A: Sometimes. Though it's become much more social than I originally thought it would be.

M: Have you become a tourist attraction?

A: Definitely.

B: And is that part of your artwork?

A: Well, there's always this idea of what you think you want, and then what you really want. I thought I wanted to be in one place and have everyone come and view my work in that situation. I thought that would be the ultimate freedom, but it's actually become another form of oppression because sometimes I have no personal life. I think that I wanted the most literal kind of representation, or nonrepresentation: to use things exactly the way they were and to not illustrate in any way. But the more direct I become, the less distinction I feel between what is real and what is not real. In the last few months, I've started to think about how representation in art or in life might be necessary to have anything feel natural again.

fig. 23
Desert near Joshua Tree,
California, 2004.

M: So now the difference between your personal and your public works seems like a pretty hard line to draw.

A: Yes.

M: Your house has become a gallery?

A: Yes. Everyone knows how to find my house [fig. 24]— I'm in my pajamas in the morning and people are looking in my windows. But, you know, I suppose I asked for it.

B: What is the earliest work that is going to be in the exhibition in Houston?

A: Probably the *Repair Work* [1991, fig. 36 and p. 109]. When I moved to New York from southern California, I did work as a way of thinking to generate ideas. Since the whole city felt like it was decaying, I just started fixing things. Every time I'd see something broken in the street, I would take it home and repair it.

B: What kind of things?

A: Little statues, bumpers, cups, dishes. I found a floor once, tiles somebody had ripped from a bathroom, so I tried to put it back together. And while I was doing that, I actually started to think a lot about the difference between a creative gesture and a noncreative gesture. I decided that all gestures were creative, because you always have to make a decision at some point.

B: Did you repair them so you could use them? Did they become part of your life?

A: It was more about the act of repairing them. I just had a big stack of them in my studio, which was this tiny office, about a hundred square feet, which functioned as a thinking cubicle.

M: How did you know it was a hundred square feet?

A: I didn't know, but it was about a ten-foot by ten-foot room. My second studio was two hundred square feet.

M: Then you made the calculation?

A: There were twelve-inch tiles on the floor and you could count them.

M: So you did!

A: That's what I do, even in other people's houses.

M: But even that calculation of how much territory you are occupying is a decision: it's a creative act to declare to yourself that you occupy a hundred square feet.

B: Were you always so sensitive to space?

A: Yes. But the limited space also defined the kind of work that I thought I would be making. It wasn't a studio that you could cut a piece of wood in. So I decided, "This is where I'm going to go to think."

M: An architect would do the same: look at the space and say, oh, a hundred square feet. It's the first act of design.

B: I agree, the space is part of your work.

A: But the space defined the activities.

M: Yes, but you also redefined the space by declaring its size.

A: I guess. But as a sculptor, you think, "I can't move a piece of plywood around there, so I'm probably never going to build anything in that space."

B: You say "sculptor" and Mark says "architect." Do you think of yourself as an architect?

A: No, I'm more of a fan of architecture. I've consciously never designed a building.

fig. 24
House, A–Z West, 2004.

fig. 25
Highway sign for Joshua Tree National Park, Joshua Tree, California, 2004.

B: Regardless of this beautiful space you have made for yourself here?

A: I've always moved into spaces that exist. I respond to Archizoom saying they were designers, as opposed to architects, because they felt that architecture was inherently controlling, and they wanted their work to react against that. As a non-architect, and as a consumer, I'm always having to react against the spaces that architects have built.

M: Would you now resist the word *designer* for other reasons?

A: Because of what it's turned into?

M: Yeah.

A: Actually I've always loved the word *designer* because it is such a creation of modernity. It didn't exist at first— it appeared out of nowhere. I also love the ambiguity of the word. I mean, it's sort of a catchall term. I don't really consider myself a designer, but I think my work is about design, because its concerns interest me almost more than art issues. They're so symptomatic of the time that we live in. I'm not a designer because I don't design for the masses. I don't make products. I design experiments for myself.

B: An inventor perhaps?

A: Maybe that's one thing that an artist has become in our culture?

B: An inventor invents the need as well, and does the design for the need she has invented. Most of your objects are not for an identifiable need. You start by inventing the need.

A: Right. With the *A–Z Chamber Pot* [1993, p. 107], for example, I decided that bathrooms were tyrannical, so I was going to invent things that would liberate your body from the necessity of that.

M: You invent a constraint, and then you invent the release from the constraint.

A: Well, I always think it is more like I'm becoming aware of the constraint, not inventing it. But perhaps it's somewhat invented.

B: You also have some attraction to rules. I agree that you react against a constraint, as you said, but only to invent (or so it seems to me) other constraints. I am curious about how you invent those constraints. What are the rules?

A: Oh! This is getting into my favorite topic. (Laughter) I love rules, but not because they're controlling. There are so many rules in our culture. Anything from how you build a space to what you can inject into your body is dictated by rules. And the only way that I think you can be free from external rules is to create your own personal set of rules that are even more rigid, but because they are your own, you feel like you're completely free. So rules are actually a way of liberating oneself. I've also been thinking too about the creation of rules. The progression of art until the seventies was all about breaking boundaries or rules, but creating rules is almost more difficult and more creative, because it is a more complex level of reasoning, instead of blindly trying to break them down.

B: But it's an unending process because you identify a constraint, resist it by creating another rule, but then you end up feeling constrained by your own rules. As you were saying about your house, your rules are making you feel constrained.

A: But I break my rules a lot. Because it's my rule, I can break it, whereas if the rule was the law or a building code, I couldn't. I'm very conscientious. But it's a good rule as long as it works.

M: So, freedom through increased rules?

A: As long as they're my rules. In the early nineties, I got a lot of reviews saying that my work was fascist or controlling, but my point was never to impose those rules on other people, unless they willingly availed themselves. I always use myself as a guinea pig. I'm not interested in oppressing anyone.

B: You are your own test case?

A: Yes.

M: If the rules are your rules, and if the work is somehow driven by the rules, the work is also personal in that way— not because people look at the work and see you, but because they feel the rule-making, the decisions being taken.

A: It's personal but not that unique. It's pretty standard. I think I'm a pretty typical representative of what somebody in my age, gender, and economic background would do. And I think that's an important part of it, too. Even though some of my designs may seem very strange, when I lecture for a general audience, I'll have people coming up afterwards saying that they have the same ideas, too, and I really like that.

M: So, there is a community of people who would make rules in the same way. If the rules have to be your rules, counter-rules to the official rules, yet they are shared with a large group of people who can imagine that these are also their rules, then there is an implied mass production aspect to the work, or at least mass reception.

A: True. But it's also how people can identify with ideas. You can only really comprehend something through identification with an individual. Each issue needs to be pared down to that.

B: It seems that the narrative aspect is a crucial aspect of your work.

A: I've thought about it on the level of creating a story that people can identify with.

B: Each one of your pieces has a story. Even the way you started describing your work to us had a clear narrative to it: "I came to New York, New York was in such a state of decay, this is what happened, I started collecting and repairing things."

A: And I love stories.

B: And the story seems to be part of the work.

A: I agree. But the stories happen naturally. I love lecturing to art students because I have a message, which is basically that you can do everything wrong and still end up totally fine. I'll tell them all the stories of everything I did that was wrong, and how in some way it ended up being right again.

B: That's my favorite topic: failure. Success is so boring, in a way, because if everything turns out right, what do you learn? Failure and the frustration that comes from it is a lot more productive.

A: All my favorite pieces, even the ceiling of my house in Joshua Tree, happened partly because of a failure. Every really interesting twist in my work has happened because I fucked up on something, and then we had to compensate somewhere else. I think that you make much larger advancements through failures.

B: Inventions come after repeated failure.

A: The missteps are crucial.

M: A scientist would say something similar, and the word *experimental* is used a lot in the context of your work. What's your feeling about that word?

A: Well, it's the default word. It's not really radical. *Exploratory* might be better. I want to come up with a word that talks about looking at something and trying to explore it and understand it. Learn from it and then grow. An experiment is like a process. It's messier for me. Because I think that one thing will happen, but actually something else happens.

M: The desert is a famous place for experiments. If you have to make mistakes to progress, you should make a mistake in the desert where it's not going to hurt anyone. So we've got to keep our artists in the desert. (Laughter)

A: The desert seems to be the breeding ground of big, fabulous, beautiful mistakes. All of these people come out here with these crazy dreams.

B: So in that sense you fit perfectly.

A: I love the tradition of artists who have been working here for decade after decade. I am in awe of them.

B: When I think about the desert, I also think about the military installations.

A: Did you hear the bombing this morning?

B: No.

A: Really, really heavy bombing this morning. If you were at my house, you would have felt it. The whole house was shaking.

B: What do you think they are doing there?

A: They're getting ready to go back to Iraq. They're getting the next troops ready.

B: What does it mean to be doing your work in the backyard of the military?

A: The whole desert is the backyard of the military [fig. 26]. If you look at a map of the Southwest, a huge proportion of it is owned by the government.

M: You were talking about your grandparents making everything out of nothing, yet now we're talking about the desert as full of . . .

A: Layers.

M: But you have zoomed in on the architectural layer of the desert.

A: It's not even architectural; it's just marks that people make. Way out here, it's just the traces that people leave. Maybe in a denser urban center, they would just get erased by the next person.

B: Getting back to the question of mass production, your pieces seem to be unique prototypes, but you always do multiples. How many do you do of each?

A: Usually as many as I'm physically able to make. With the *A–Z Escape Vehicle* [1996, pp. 200–205], I had to stop at ten. With the *A–Z Wagon Station* [2002–present, pp. 214–17], I think there are eighteen. That is the most I have ever made of a single piece.

B: So this at least resembles mass production.

A: Right. But because they are customized, ultimately every one ends up being different. Allan McCollum once said that two things being identical is much rarer than everything being unique. So he suggested it was odd that people would value a unique object over a multiple.

M: Our culture is one of mass customization. The computer means it's no cheaper to produce many objects that are identical than many objects that are different, so there's a generic desire for the unique.

A: We're using the word *customization*, but what I'm really interested in is when another person takes control of the piece away from me. That doesn't happen to artists very often. Sometimes people do things that I hate, which is even better. It creates this tension, which makes it a better artwork.

M: What about the intermediate zone between the work and the exhibition of the work? What are your feelings about the curator of an exhibition—how much control do you allow them?

A: It depends. Again, with the *A–Z Pit Bed* [1996, p. 139], a lot of the curators redesigned them. The curator is just another person. In the pieces that were my prototypes, though, I'm pretty controlling about how I want them exhibited, because they represent my decisions, not theirs.

M: It makes sense, because you refuse any distinction

between living your life and your studio, and in the exhibition the studio somehow gets brought into the gallery. So the studio and the gallery get confused.

A: Or the life in the gallery. Like my living room gets brought into the gallery.

M: But your living room is also…

B: the gallery itself.

M: It's the place where you produce or at least test your products, so when you exhibit, you exhibit not your life (in the sense of feelings, dreams, history, and all that), but the architectural condition of your studio and your domestic situation. So it makes total sense that you'd be absolutely controlling about that because you want to have turned the gallery into a domestic space with domestic rules. People literally walk into your space, your rules.

A: Another symptom of the twentieth century was that it was the first time in history that people became acutely aware of their interior spaces and began to think those spaces in some way represented the interior of their souls. For the first time ever, I think we had that kind of self-consciousness about our homes and domestic interiors.

B: In Robert Musil's *The Man Without Qualities*, there's already at the beginning of the century this idea that the way your house looks is a symptom of your character. And he's mocking that.

A: People thought this was a liberation, to be able to express yourself. But in reality it's also very oppressive: you can't ever just have people over.

B: And not have everything judged.

A: Exactly.

M: But if there's this back-and-forth between domesticity, studio, exhibition, and reproduction, the labeling devices in a museum now find their way into the domestic. There's a blurring between labels given to works of art and labels given to products, like this is my "Epson" printer.

A: With branding.

M: I think you as an artist are just as controlling, if not more

so, with your branding labels. It goes all the way back to that brilliant decision, the "A–Z Administrative Services." That's a sort of narrative, but a design decision, too. It's all about design.

A: It's also playing with the division between being an individual and being something more authoritative. Like that fine line between the oppressor and the oppressed.

B: Funny that an agency that someone invents is more authoritative than its author, right?

A: Well, as an artist I certainly felt like that.

B: But in our culture the artist has become a kind of authority.

A: I was interested in that interplay between corporate and personal identity. For example, Liz Claiborne is obviously a corporation, not a person. A lot of corporations have used the guise of an individual, so it's flipping it where an individual assumes the guise of a corporation.

B: In the sequence of events, when did the A–Z Administrative Services originate?

A: I was doing the *Uniforms* [1991–present, pp. 70–81], I think. My friends would always comment on how I was really good at organizing my life, and one of them wanted me to organize his life and to help him dress. I wrote him these very official letters with the letterhead of "A–Z Administrative Apparel" [*A–Z Jon Tower Life Improvement Project*, 1991–92, p. 69].

B: Apparel?

A: Originally. It expanded into "Services" later on. I said, well, I'm going to help you change your look, and we started this correspondence. Then I went into his house and started really bossing him around, like making him throw everything out and reorganize his storage area.

B: There are people that are doing that professionally now. They come and do your life.

A: I know. For him the ultimate luxury of freedom was being organized by somebody else. He had no responsibility.

M: You gave him the rules?

A: I did and it was fun.

M: Every rule was obeyed?

A: No. But I made charts that he had to fill out every day. And of course he would revolt sometimes.

M: Bad boy.

A: Yeah.

M: You were designing the life of an artist, the everyday life of an artist.

A: His goal was to get a boyfriend and to be more attractive. He wanted to find love, and he did.

M: This is the "Straight Artist for the Queer Guy." (Laughter)

A: When I first adopted the title "A–Z Administrative Services," I was just joking around. Then I started to use it more consciously. Later I would have to contract with the fabricators or larger companies, and they wouldn't work with me because I was an unknown artist with no money. When I called them, they would ask, "What company are you calling from?" So I'd say "A–Z Administrative Services."

B: You created a need. That's design.

M: You design the problem and the way out.

A: Right.

B: And the name, "A–Z"? We both thought it meant A to Z, like A, B, C, and then of course we realized that it is also in your name. So what were you thinking?

A: Oh, both. Because it's my initials, but it is also a very standard business name. And it's all-encompassing. It was just kind of perfect in every way.

M: A generic name for the generic.

A: It worked on every level because you see it and you know immediately that it is a business, that it could be any business.

M: Is there anything you would not work on? In the domestic situation, for example, do you do everything or are there limits?

A: The only thing I've struggled with on an ideological level is whether or not to do architecture. I often think it's almost taking a position not to do it.

B: What is the difference in your mind between the design of your minimum *Living Unit* and the design of minimum dwellings

that in the twenties and thirties was so much part of architectural thinking?

A: I think a lot about the early modernists in California and how revolutionary their buildings must have seemed back then. Especially if you look at some of the houses that [Rudolf] Schindler and [Richard] Neutra were designing for the first fifteen years of their careers. So I often wonder, what could possibly seem that challenging or that radical now? When I think about designing a house, it always comes down to something that's pretty standard: it's all kind of rehashing modernism. In the last ten years especially, I have the feeling that modernism has become the new country kitchen. It's become the standard for good taste—but it just doesn't challenge notions of beauty or functionalism anymore. Not to name names, but I really don't like the phenomenon of Design Within Reach [mail-order designer furniture].

B: IKEA?

A: IKEA interests me a little bit more because it's truly for the masses. Design Within Reach is a really sanitized kind of elitism. But the problem is, I like the style. I like modernist architecture. I just hate what it's turned into, what it represents. That's why I liked Frank Gehry's own house [1978, Santa Monica, California]. I really felt like his house pushed out in an interesting direction.

B: Using all these materials that were rejected: the chain link, the plywood, and …

A: the way he exposed the framing. I've only seen it in images, but it always seemed like a really provocative space. It seems like a space that you would see and think it's really ugly. And I love that.

M: If you took your *A–Z Body Processing Unit* [1993, p. 118], the one that has the kitchen and the toilet together, and put it into a Design Within Reach catalogue, it would fit in there, with its Charles and Ray Eames Storage Unit quality, wouldn't it?

A: Yeah, it would.

M: So what makes your work different?

A: Besides the scatological reference? You know, that's my own question about my own work right now, too. I took time

fig. 27
Highway near the Salton Sea,
California, 2003.

off about a year and a half ago, and I feel like I'm still in this holding pattern, just kind of circling and thinking, processing ideas.

M: With the Design Within Reach catalogue, everything has to do with visual comfort.

A: Don't you think it's status, though?

M: Yet associated with words like *freedom, lightness, mobility*. All the stuff is light, mobile, airy, Californian. Whereas there's a neurotic thing going on in your work. I don't mean personally. I mean that if you collapse together the toilet and the kitchen in one unit, you're really forcing people to confront their stuff.

A: I always thought of it as a kind of dark humor.

M: I love that piece where the food is at the top and the toilet is at the bottom. You could say, as any good modernist would, it's "efficiency and standardization," because the intake and outlet occupy exactly the same modular unit. And yet forcing the two things together defies a century of social convention that has kept them apart architecturally. Simply removing architecture, removing the usual division between the kitchen and the bathroom, would produce anxiety for a lot of people. You force people to live without the limits.

A: Right.

M: So there would be a language of freedom and liberation, but also a language of fear.

A: I guess because the user doesn't have the guidelines of the separation.

M: Maybe a lot of your work involves removing divisions, rather than constructing them. So what you are left with is not so much a brilliant innovation as a condensation. You

provide a really dense combination of things that are normally separated.

A: Right, switching them around. One of my favorite pieces that works like that is the *A–Z Comfort Unit* [1994, pp. 134–35], which is based on the idea that you can do everything you have to do without ever leaving the comfort and security of your own bed. But I love that because, on the one hand, it sounds truly liberating, and on the other hand, it's like the most horrifying feeling I could imagine. Like being an invalid. I think, especially in my first decade of making work, I was interested in that fine line between freedom and control, and how people often felt liberated by parameters.

B: How about the *Breeding* project? Is that the next thing you did after the *Repair Work*?

A: That was the first official public work that people saw.

B: How does it feel now in relationship to breeding yourself? (Laughter)

A: Oh, I know, it's so funny, because when I was really interested in breeding and genetics and clones and stuff, I used to always think that it would be the ultimate art project to reproduce myself, making a baby. But back then I saw breeding animals as actually a masculine thing, because it's the male way of building something, of creating a biological entity. I'd always thought if I had children, they would come more into my work, but now that I have a baby, it's such an alien experience to me. I can't even process it. And I think I have to process it before I can make work out of it. It's so strange to "make" another being.

M: And the rules are now coming from the baby.

A: When I was pregnant, I kept thinking about *Alien II* and Sigourney Weaver. You have this alien who has commandeered

your body and you can't get it out of you. And you know that when you give birth, it's going to be horrible—it's going to break you—and yet there is nothing you can do to stop it from coming out. It's really a bit like a horror flick.

M: The clock is ticking. (Laughter)

A: But the baby's so great.

M: A baby changes the sense of time, and one of your projects was all about losing official time in favor of the time generated by activities. How would you describe it?

A: Well, it was about not having access to any method of knowing what time it is. Like losing an overriding structure and then trying to figure out what rhythm your body naturally falls into and simultaneously what it feels like not to have that temporal structure.

M: Which a child would also do to you. It's the same project in a way.

A: A bit, but as a parent, I'm still more conscious of time than Emmett is. Having him also makes me remember a lot of my own earlier reactions to structures. I think I first thought of the *Time Trials* project [1999–2000, pp. 152–59] when I was probably eight or nine. My parents had these encyclopedias, and I was reading in them about time tests where people lived in caves. And I always wanted to do that. The encyclopedias wrote about circadian rhythms and what their findings were, but they never wrote anything about the subjective experience of people who were the subjects of the test. I always wanted to see what it was like.

M: In a way that was your first project then?

A: Yes.

M: It just took a while to …

A: realize. That's probably one of my favorite projects.

M: It has something of the character of a diary.

A: But the hardest thing with that—and the thing that raises more questions about the nature of art—is that I thought it was successful as an experiment, attached to an unpredictable and extreme experience. But then it was unsuccessful as an artwork, because there was no way to present that experience

to an audience. So I became caught up in this web. Where does the art actually exist? Is the art in my own subjective experience of this thing or in what the audience perceives? So the diaristic aspect to it evolved into the panels describing the timeline of living through in this week [*Free Running Rhythms and Patterns*, 2000, pp. 157 and 159].

B: I did some work on bomb shelters in the Cold War, and a developer promoting bomb shelters in Florida chooses this couple and invites them to spend their honeymoon in a bomb shelter for fifteen days. The story was illustrated in *Life* magazine. They kept a diary and I always wondered about that diary.

A: What did *Life* show? Did it show different experiences?

B: There were photographs of the couple inside the shelter spending their day. They talk about how they are feeling and everything, but it cannot be that everything that they will have thought about ends up in the magazine. The photographs are astonishing. You first have the couple on the lawn with all their wedding gifts around them, mostly food supplies like Campbell's soup, and underneath them is this shelter. It seems to me that much of your work features very extreme environments, too, whether it be in the desert or deprived of time, or very hot or very cold.

A: But there's always a fear of insanity because what you are talking about reminds me, too, that I used to be very curious about what it was like to live on a submarine or oil derrick, or to be an astronomer. These situations where you're completely taken outside of ordinary life. And yet it's ordinary because it's the way that you live.

B: Extreme situations. That's why I think the word *capsule* is good for all your works.

A: Yeah. I don't know if there's any structure that epitomizes our culture better than the capsule. This truck, for example —I mean, we're riding in one right now.

M: In a hostile environment.

A: Everything about being in a car—you just feel so protected and safe. And you can go anywhere in this car. It's like a prosthesis. And then in southern California it extends to the home and your property. I think that it's always about

having that sort of capsule around you. In New York when I get home and I have a hard time leaving.

B: Right, we all do. The apartment is your armor. Like clothing is your armor.

A: And sometimes I think, in one form or another, there's a shape to describe every sort of emotional state or quality.

B: How did you come to making clothing?

A: I've always made clothing.

B: Since you were a kid?

A: When I was six, I would cut up my clothing. For example, I figured out (and I still like this idea) that I could cut the crotch out of my stockings and wear them like a shirt. I put the bottoms and the tops on so that they were perfectly symmetrical.

M: Another input-output project.

A: Exactly.

B: So you were experimenting with clothing since you were little.

A: I used to sew a lot.

B: Whom did you learn to sew from?

A: My grandmother. Actually I should add that I always think about clothing as being a form of public art. Because when you wear your clothing, it's one of the most practical ways to display something.

B: That's related to what you were saying before about the interior.

A: Well, the domestic interior is like your soul, but that's *inside*, and the clothing you can express outwardly. And clothing is so expressive. You can say so much with clothing, although that's not why I started making it as sculpture.

B: Why did you?

A: Well, this is another one of those stories. When I moved to New York, I worked at the Pat Hearn Gallery, and I had to look good, but I didn't have that much money. I started thinking of how complicated it was to have different outfits every day,

so I came up with the *Uniform*. You know, having a uniform would be much more liberating than having constant variety.

M: Yet it's not an entirely believable story.

A: It is super believable.

B: It is.

M: Well, the thought that you had resources for only one good garment is entirely believable, but when it grows into the *Uniform* and the rule of wearing it every day… If it were really driven by resources, you would get more clothes as you get more resources.

A: But I liked the *Uniform* dress and it freed me up psychologically.

M: What I like so much is that you find a way of taking a problem or a need, and turning it into a rule, and then going all the way with the rule. So after a while, the story only explains the creation of the need and the beginning of the rule, but the rule seems to extend way beyond the problem.

A: Okay, that's true. But I've also felt that we deal with a lot of social codes, especially in New York. And when I first entered the art world, I really felt like a fish out of water, both culturally and socially. It was a world that I was never prepared for. Just getting dressed became so complicated— what you wear and what that means. I could not possibly compete. But eventually I realized it doesn't matter what you wear, or what fashion rules you know to follow, as long as you have something, some structure, that you use. Since I could never figure out what it meant to wear any particular label or designer, I made up my own designer, which is me, which provided a built-in equal status.

B: Again it is a question of constraint. Men wear the same thing and nobody notices, but for you as a woman, the continuity stood out. It fits all the characteristics of your work, which is finding a constraint and undermining it by creating another set of constraints. The constraint becomes itself a work of art.

M: It's also a perfect image for this quality of your work: this transcendence of the personal/public boundary. Because you make the clothing in your house and you wear it to work, but

since you work in an art gallery, you are bringing your private show there. With the *Uniform* you had a one-woman show for six months, right?

A: Right. You're absolutely right

M: So, that's your first exhibited work, but it had no label at that time.

A: No, actually it did.

M: What did you say if somebody said: "What's that you're wearing?"

A: This is my uniform, my *A–Z Personal Uniform.*

B: "A–Z" already.

M: The name is absolutely crucial. Even the label is a capsule to contain a series of works. You are the capsule queen. You are a classifier-constrainer-encapsulator-organizer.

A: I just laugh, because to some extent I try not to do that. Because I used to waste a lot of time classifying and organizing.

M: What if it's not really a personal issue, since one of the crucial effects of the work is to create confusion about the personal/public distinction. Just because your own life is somehow built into the project doesn't mean that we necessarily really see or know anything about your personal life, right? It's just that somehow the question is raised, but not answered. Another synonym for *architect* is *organizer.* So instead of saying I need to do this, you could just say you are an architect and that's what we do. We make space for things and organize them. I'm circling back again to this word *architecture* not because you make inhabitable spaces like buildings but because each of your projects provides a organizational system, which also means a set of constraints.

A: But how do you define an architect?

M: For me, an architect is not somebody who makes buildings but someone who makes you think about them, makes you hesitate and see things differently, interrupting everyday rhythms to produce a sort of hesitation, which acts as the opportunity of thinking or seeing or living differently. It's a kind of process that creates doubt. So a chair is just a chair, but there's something about the angle of it, which is not like

other chairs, so you might see a chair, or feel it for the first time.

A: I always thought of an architect as a specialist, and I felt like I wasn't a specialist. But based on your description, then I suppose my work would qualify as an architectural gesture.

M: I think the architect is an intellectual, and the intellectual aspect of your work is very important and needs to be thought through. That aspect is easily overlooked because so much of the work has to do with craft, the actual production of these objects, the materials and even the particular attachment on your electric drill, or whether you're only going to use your hands for a certain garment, or the effect of the sun . . . there is a great attention to the construction of the thing.

B: I think fabrication is more important for you than construction because construction implies a lot of other people involved in the process, and in your case, even if you sometimes have to bring people into it, it has more of the quality of fabrication, even in the making of the fabric itself.

A: I think there's a trilogy: the way that something is made, the way it functions, and the way it looks. In a complete object or entity or building or anything, all three of these elements come into play, though I think that in the art world this triad has somehow been broken apart. I prefer to use the word *technology* in relationship to construction because sometimes the term *craft* implies that something is handmade. If you inspect the history of architecture, all significant breakthroughs were connected to technology.

M: That's a theory, right? So again you're really operating as an intellectual. I mean, you think, you label, you write, you lecture, you teach at Columbia, Yale, USC. You're describing thinking as much as making. Because there is so much in the work about making, the kind of intellectual position being taken is less obvious yet always there.

A: I guess the thing that I struggle with in my work is that it's more a way of understanding something. For instance, Dan Graham's work is so brilliant because he already knows what he's trying to say, and then he expresses it so succinctly within the sculptures.

B: Isn't that the way things always appear to others? I can imagine people saying that about you and your work.

A: I'd say maybe a quarter of my pieces really express something worthwhile, and a quarter of them are purely floundering in the dark. And about fifty percent are in the middle. I love making my work because I'm always working towards something, always trying to figure something out, but I often also feel thwarted at various phases of this process.

M: Yet that just sounds like the necessarily self-critical attitude that increases your concentration. When you write about Minimalism in that short essay, even if it's presented in the form of an informal reflection on how a group of artists represented themselves in a particular moment in time, it is actually a full-fledged theoretical analysis of the relationship between work today and the work of that period. And I think the same is true of each of your projects, including the clothes. From the moment you used that word "uniform," the work was fully theorized.

A: Or hypothesized…

M: That's the experimental attitude: "I only have a hypothesis. I'm still working on it. I'm still in the lab. I'll get back to you."

A: Right now I have been compiling a list, *These things I know for sure* [p. 14]. There's fourteen of them. They're stupid things.

B: Like what?

A: Like design principles. This is one of them: "Good design, rather than being easy to clean, should just camouflage dirt." That makes something a better design, I'm absolutely sure of that. And the idea of forward motion, that we are always happy when we are moving towards something. These kinds of things. They are really abstract and kind of ridiculous.

B: You have finished the list?

A: It changes every year. Because I'm almost forty and I've been working on this project since I was twenty. What do I actually know *for sure*? Even if it's a stupid thing, this is something that I've discovered that I'm pretty sure about.

M: What if you are simply a theorist, and these are the results after years of experimentation.

A: I don't have any big ideas.

M: So you keep saying. But any idea is big.

A: I think you start with the little things. As you keep putting them together, eventually it gets to be a big idea.

M: Is it possible that the only reason for all of this work, from the first *Repair Work*—the childhood dreams even—through all of the various projects, was simply to generate these fourteen things?

A: (Laughter) Oh, no, don't say that.

M: Yet it is very striking that all of your works are unified under the one "A–Z Administrative Services" label. In other words, it is actually a single work. So, if you end up with a list of fourteen conclusions, the first thing to say is that it is part of the work, not simply a result. It's the thing that gets updated from all the moves. Everything suggests that you are working from first principles, like a philosopher, starting with nothing (whether it be a hundred square feet of space in Brooklyn or the emptiness of the desert) in order to determine the secret laws of the universe—the rules—working twenty years on it.

A: Well, if I retitle it "The Secret Laws of the Universe A–Z." (Laughter)

B: Because we were both confused and intrigued by the A–Z label, I had the idea to try to do an A–Z dictionary. This will be the rule of this game: We go from A to Z, and you name what goes for each letter.

A: Oh, my God. I'm not a spontaneous thinker.

M: But I don't think it will be spontaneous. With you everything has been figured out.

B: So what would "A" be?

A: Artist, I guess.

M: And you're an artist?

A: Yes. (Laughter)

M: Just wanted to make sure.

fig. 28
Highway sign for Zzyzx Road, Mojave Desert,
California, 2004.

A— ARBITRARY

B— BREEDING

C— CAPSULE

D— DOGMA

E— EXPLORATORY

F— FAILURE

G— GARBAGE

H— HIERARCHY

I— INCREMENTAL

J— JOSHUA TREE

K— KEY

L— LIFESTYLE

M— MACHINE

N— NOISE

O— ON-DEMAND

P— PANEL

Q— QUARANTINE

R— REPAIR

S— STRAND

T— TRAJECTORY

U— UGLY

V— VOLATILE

W— WAGON

X— X-RAY

Y— YARN

Z— ZZYZX

A: What was F?

M: "Failure."

B: You also said "Forward."

M: "Forward" and "Failure." Maybe they are the same thing?

B: Yes, because a failure makes you move forward.

A: Failure fuels you forward.

M: D was?

A: "Dogma?"

M: Ooh, that's good.

A: Yes. I also like the reference to Dogma Films.[1]

M: Doesn't surprise me because they are into constraining rules.

A: Brilliant.

NOTE

1. Dogma Films are produced by Dogme 95, a Danish film collective devoted to a rigid type of cinema verité governed by a strict set of ten guidelines that eschew Hollywoodlike cinematic artifice.

Live/Work Space

Cornelia Butler

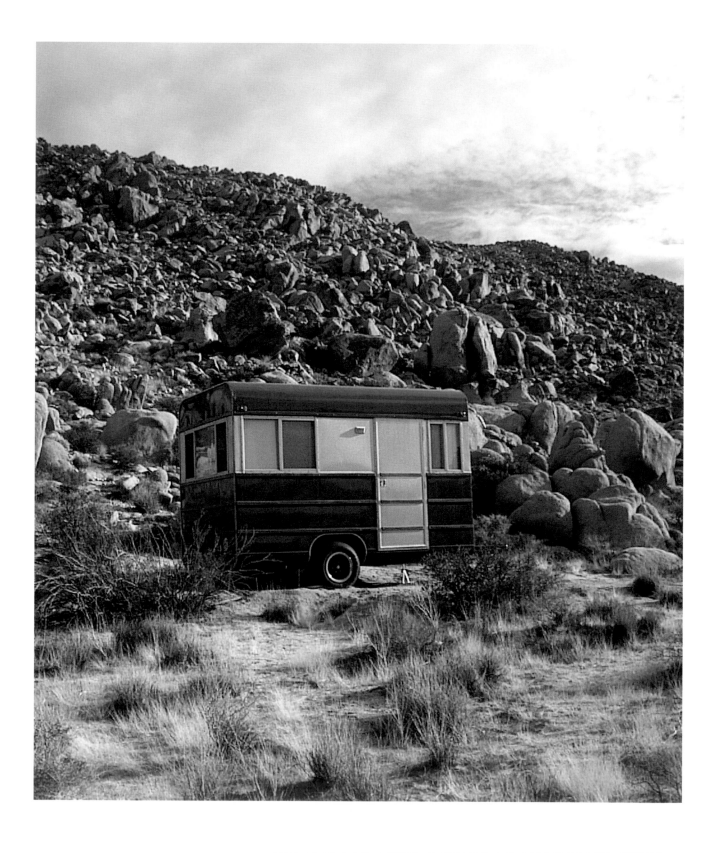

In the 1985 film *Lost in America*, Albert Brooks's neurotic, disaffected Los Angeles adman finds freedom and a kind of infantile satisfaction behind the wheel of a thirty-foot Winnebago. Crossing the country encased in the cushy domestic bliss of the RV and invoking *Easy Rider* as often as possible, Brooks traverses the West, signified most magnificently by the grandeur of Hoover Dam and the folly of Las Vegas. Both locations make critical plot appearances. The former is the backdrop against which Brooks learns that his newly liberated wife, high on the release from her nine-to-five life, has gambled away their nest egg in the latter. Each of these exotic imaginaries constructs the West as a site of release and libidinous fulfillment.

Many of us born on the West Coast have a particular relationship to the mythology of the "camper" (see fig. 29), as my family quaintly called the large vehicle that enabled our roaming, which always culminated in the staging of a pseudo-camping scenario in various spectacular and far-flung western locations. Nature performed, and we followed from shore to geyser, happily couched in a pared down domestic cocoon that, for the duration of the vacation, represented everything important and essential for convenient self-sufficiency. I remembered this fondly when confronted with Andrea Zittel's *A–Z Escape Vehicle* (1996, pp. 200–205)—hard-boiled, sculptural mini-pods for transporting all that strikes the fancy of their owners. Like their Winnebago-scaled counterparts, the compact *Escape Vehicle* can contain the imaginative clutter of a Joseph Cornell box or the sensuosity of a boudoir, all camouflaged by the pre-fab cladding that masks the sculptures and readies them for their potential road trip.

Zittel's singular body of work has its biological and spiritual roots in her upbringing on the West Coast. Indeed the importance of location, the coincidence of memory and place—what Lucy Lippard has called the lure of the local—and the promise of a particular landscape are somewhat overlooked thematics in Zittel's work. Drawing her back to the locale of her upbringing in suburban southern California, her own escape fantasy has now culminated in A–Z West, the life/style project through which she lives, makes artwork, and performs an ongoing negotiation with issues of site, nomadism, and productivity. In seeking out a nomadic lifestyle, Zittel claims that she was drawn to the desert as a landscape in which she could finally be completely alone and invisible.[1] This fantasy of hiding in plain sight is complicated by her gathering of artists around her, creating a kind of collective compound from which she can produce art, but also orchestrate the activities of her company, A–Z Administrative Services, and her life.

I read this investigation-cum-life project in feminist terms and propose that Zittel's work occupies a curious conceptual space somewhere between Robert Smithson's invention of the non-site and what I'll call the "collective domestic," an impulse forged by Zittel's feminist predecessors in the 1970s. While Zittel is not the only artist to emerge from the 1990s situated at this intersection, she is perhaps the one to push the project the furthest and the most playfully. The *High Desert Test Sites (HDTS, 2002–present)*, for example, comprise an unwieldy and insistently generous amalgam of explicitly site-specific artists projects (fig. 30), culled democratically (as far as one can tell) and loosely gathered under the umbrella of a website and Zittel's desire to make a community around her. While the significance of the Mojave Desert as Zittel's self-proclaimed non-site is worth further discussion in a moment, her version of community as a fully transparent, fluid entity—at once standing in for the artist and yet fully independent—also merits scrutiny. As stated on the HDTS website, its geographic location is significant precisely because it lies at the edge of Los Angeles' urban sprawl as a kind of neutral territory, a margin for experimental error:

> HDTS exist in a series of communities that edge one of the largest suburban sprawls in the nation. Most of the artists who settle in this area are from larger cities, but want to live in a place where they can control and shape the development of their own community. For the time being there is still a feeling in the air that if we join together we can still hold back the salmon stucco housing tracts and big box retail centers. Well maybe.[2]

fig. 29
Andrea Zittel
A–Z Travel Trailer Unit Customized by Gordon and Miriam Zittel, 1995
Steel, wood, glass, carpet, aluminum, and objects
93 x 93 x 192 inches
(236 x 236 x 488 cm)
Courtesy of the artist

Installed at A–Z West, 2003

fig. 30
Lisi Raskin
The Research Station, 2003
Metal, mixed media, and paint
Dimensions variable
Courtesy the artist

Installed at *High Desert Test Sites 3*, 2003

fig. 31
Glen Seator
Untitled (*End*), 1999
Cibachrome
20 x 24 inches (51 x 61 cm)
Courtesy of the Estate of Glen Seator

fig. 32
Michael Elmgreen and **Ingar Dragset**
Dug Down Gallery / Powerless Structures, Fig. 45, 1998
86⅝ x 126 x 197 inches (220 x 320 x 500 cm)
Wood, paint, office furniture, and halogen spots
Courtesy of Tanya Bonakdar Gallery, New York;
Galerie Klosterfelde Berlin; and Galleri Nicolai Wallner, Copenhagen

Installation view, Galleri 18, Reykjavik Art Museum, Reykjavik

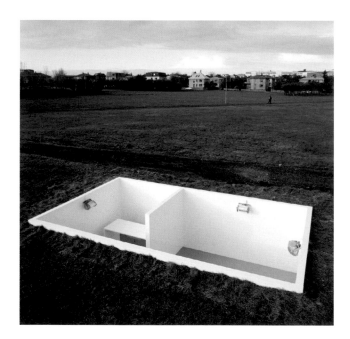

Reminiscent of communal live/work situations both constructed and adapted by feminist artists in the '70s, Zittel's version of a kind of political and aesthetic safe haven nestled in the off-world and very conservative population of Joshua Tree, comprises a central and radical part of her practice. She has indeed initiated an alternative living system that is both conceptual project and new century commune for the world-weary cultural producer.

There is a cheerful narcissism to the critical bracketing that Zittel self-consciously constructs to accommodate her life-as-work equation. In *Diary: Andrea Zittel,* which documents her homesteading in 2001 in the desert of Joshua Tree, she talks about her use of the self as subject, saying, "Work comes to represent a personal symptom, a societal symptom and a possible solution to a problem, all at the same time."[3] This notion of the personal effect or residual as something that can be scrutinized as a societal indicator is fundamentally a feminist one. Whether in the dance works of Yvonne Rainer, who abstracted quotidian movement in choreography that disrupted the familiar modernist hierarchies of the body and the narratives it could convey, or in the communal performance works of Barbara T. Smith, who invited the audience to observe, feed, and festoon her naked body, the impulse to form a community around the shared experience of daily ritual is the feminist antecedent to Zittel's effort to make her desert experiment the ground zero for all manner of collective experimentation. From the construction of her home/office/studio compound, with its very basic, essential problems like water, food preparation, and plumbing, to the making of site-specific projects on her property (see pp. 214–17) Zittel invites the participation of basically anyone who can contribute constructively. Everyone from the indigenous workers and desert types to the artists who set up camp and installations on her property is integrated into an expanded notion of site, collectivity, and home.

Tracing feminism's legacy through the work of the last decade, it is apparent that one of the most profoundly influential impulses of 1970s feminist practice is that of the social collective. In part born out of a fundamental questioning of the "use value" of art, this art–life discourse was carried on by women artists who were interested in a re-inscription of their lives as the subject of art and a reassertion of the devalued into their production of objects and activities that embodied nothing so much as the social landscape. Certainly the collaborative

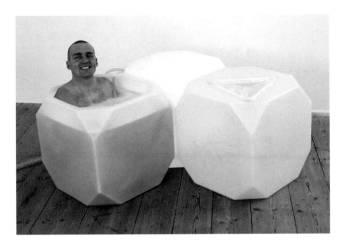

hybridized objects for living created by the N55 collective (fig. 33)
—beautiful in their sculptural economy and fully useable as
systems for living—Christensen's mobile, communal living struc-
tures are informed by the Calvinist roots of Denmark's socialist
political history. An interest in collective social practice, fused
with the design history of that country, has yielded an inter-
esting group of artists whose practices are decidedly feminist
in their interrogation of the domestic realm and its collective
possibilities. Poul Gernes, a contemporary of the Danish femi-
nist artists, also created fabulous, Pop-inspired environments
that account for all the senses (fig. 34).

Zittel's '90s version of the *Gesamtkunstwerk* occupies an
equally and intentionally ambiguous social space. Hers offers
a kind of salvo for a life lived in the face of technology and an
overabundance of style. As Mimi Zeiger has observed:

> In Zittel's artwork, *Gesamtkunstwerk* defies totality in that it is
> neither totally an aesthetic endeavor nor a functional one. Both
> craft and efficiency combine in her work to reveal highly indi-
> vidualized needs and desires … ultimately they mirror individ-
> ual needs of a society dealing with the impact of technology and
> information.[4]

Not unlike her colleagues Jorge Pardo, Liam Gillick, Lincoln
Tobier, Rirkrit Tiravanija, or Ann Veronica Jansens, Zittel is com-
fortable with and even cultivates the confusion generated by
a practice in which objects slip from one context to another.[5]
The *A–Z Personal Uniform* clothing line (1991–present, pp. 70–81),
for example, is at some level both utilitarian and luxuriously
hewn even as it borrows liberally from fashion's deconstructive
tropes and sits comfortably alongside the deadpan fabric flour-
ishes of a Martin Margiela. Photographs of the artist sporting
one of her own designs as she comfortably works on her desert
homestead, holds a hose, or strides around the desert scrub tes-
tify to the way she teases these boundaries. Her creation of the
alternative *A–Z Raugh* (1998, pp. 168–71) line of furniture or
posters—invented, in her words, to "accept and accommodate
human imperfection"—is a humorous attempt at countering
the trap of idealism and grandiosity in high design.[6] Far from
addressing the masses, Zittel configures her social equation
around herself and her universe of artists, friends, collectors,
gallerists, and intellectuals, which comprise her own community.[7]
And why not? Jan Avgikos has described this privileging of the
personal as:

activities of Group Material, Gran Fury, and more recently the
Danish collectives N55 and Superflex, the more hermetic sculp-
tural practices of the late Glen Seator (fig. 31) or the duo
Elmgreen and Dragset (fig. 32), and even collective curatorial
efforts such as *Utopia Station* at the 2003 Venice Biennale are
unthinkable without the pioneering work of such practitioners as
Danish artist Ursula Reuter Christensen or Marta Minujín in
Brazil. These artists constructed social spaces that were both
functional and used as staging sites for a kind of selective
group participation ranging from communal living to the rela-
tively aestheticized spontaneity of a happening. Like the

Margarete Schütte-Lihotzky, **Frankfurter Küche [Frankfurt Kitchen]**, 1926–27. Cabinetry, fixtures, plumbing, and appliances as viewed from entrance doorway, 70 square feet (6.5 sq m) overall. Courtesy of MAK—Austrian Museum of Applied Arts/Contemporary Art, Vienna.

a corrective to conglomerate, institutional "massification." The personal as "habitat," representing a place in the world where one can always go and feel secure. To view her work in terms of the everyday environment it presupposes as its field of reference is to acknowledge Zittel's defense against the machinery of mass culture and, at the same time, her identification with it.[8]

There is another lineage, arguably a proto-feminist one, into which Zittel fits in interesting ways, that of the 1920s German school of architecture and applied arts, the Bauhaus. Indeed the objects that are produced by A–Z Administrative Services occupy a space between design, architecture, and sculpture; though produced by hand, they collectively defy the traditional categories of art and manifest a belief in the optimism and transformation of modernist design solutions. Not only have designers, architects, and women of the Bauhaus quietly shaped the way we understand and experience domestic space, but their movements in history as teachers and anonymous practitioners have fundamentally changed how we understand community.

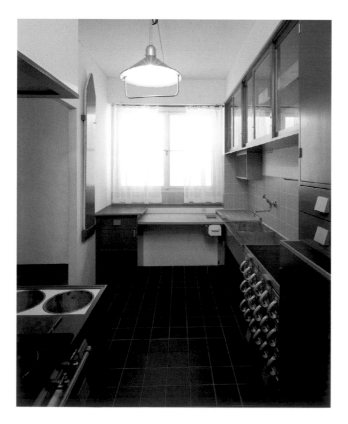

I am thinking here of women such as the Bauhaus-trained weaver and printmaker Anni Albers or her contemporary the Austrian architect Margarete Schütte-Lihotzky, who worked with Adolf Loos and Josef Hoffmann. As the foremost female designer of social spaces working in Europe before World War II, Schütte-Lihotzky created the Frankfurt Kitchen, a prefab unit reflecting the influence of the Taylorist doctrine of efficiency, which was built into 10,000 workingclass apartments in 1927 (fig. 35). She was concerned with transforming the environment of the working woman so that she could more easily perform for her family and herself: all design features of the Kitchen were carefully worked out to enhance the woman's experience of her housework.

The notion of achieving liberation by measuring individual tasks and organizing the workday at best humanized the workplace in the United States and at worst led to a kind of enslavement (finding its most unappealing expression in the orchestration of social space through the bland aural Pablum of Muzak). This idea of marking time and tasks is extended beautifully in Zittel's investigations such as *Free Running Rhythms and Patterns* [Berlin] (1999, p. 154) or *A–Z Clock* (1994, p. 152) and *A–Z Time Trial* (*BSM Turbo Edition*) (1999, pp. 141 and 153). Even the *A–Z Personal Uniform* and *A–Z Personal Panel Uniform* (1993–98, pp. 72–73) elevate the unfolding of daily existence within a kind of maintenance typology: each category of activity, no matter how banal, is indicated and in a way celebrated by a change of panel or a change of dress, signifying a conscious assignation to the everyday. Attempting to resist the accepted norms of spatial and temporal organization, Zittel experiments on herself, scrutinizing her own activities as an artist in an exercise akin to many of the time-tracking performances and Conceptual projects of the late 1960s, which the feminists in the 1970s then extracted as they returned subjectivity to the center of their project.

What is noteworthy here is that Zittel's project is, of course, not emancipatory in any way. In fact she harnesses and subverts the slavish desire to live well surrounded by good design—what she's doing in the desert may look cool, but it is possible only through hard, manual labor, perseverance, and force of will. While she does not want a wider audience or a mass embrace of her work, and while the work refutes a gendered reading of its social agenda, it undeniably cultivates the marginal as a productive territory from which to work and live. It is noteworthy

Live/Work Space | Cornelia Butler

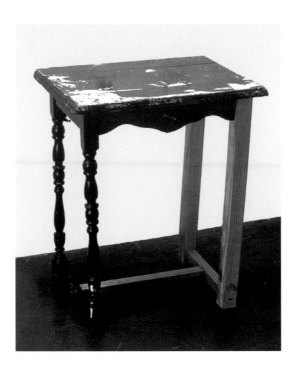

fig. 36
Andrea Zittel
Repair Work **[Table]**, 1991
Wood and glue
22 x 18 x 13 inches (56 x 46 x 33 cm)
Collection of Barbara and Howard Morse, New York

of everyday objects she had found on the street. It now occurs to me that these concurrent activities observed in that visit in some way foreshadowed the duality that has come to characterize Zittel's practice: one an almost primitive, agrarian impulse, thoroughly at odds with the Brooklyn neighborhood in which she worked, and the other a typical New York urban activity, the culling and resuscitation of objects from one's anonymous neighbors, such as the *Repair Work* (1991, fig. 36 and p. 109). A kind of happy coexistence of East and West Coast impulses, both projects constituted the beginning of her investigation into living systems. Essentially she was making work from nothing—which, though now a familiar mode of operation, was then very arresting to confront in the studio situation. Zittel's "collective domestic" functions as a site of production that extends this trajectory by exploiting the marginal territory of personal space as if it were a ready-made.

that *HDTS* reappropriate the language of site-specific work, retooling its original definition as work that literally cannot exist in any other place. The desert site is a kind of non-place dotted with tiny, abandoned homesteads once belonging to people back from the war to begin a new life who were given a shack and five acres. Joshua Tree is home to some of the oldest trees on the planet, and yet the picturesque desert also serves as the backdrop for music videos. Pro-life billboards share the highway with New Age organic restaurants. This hybrid place is Zittel's non-site, the margin that she revalues as a site of production.

In the early 1990s, when Zittel's work first appeared in New York and well before I knew she had roots on the West Coast (no doubt we were both hiding our southern California provenance), cultural theorist bell hooks and others were arguing convincingly for the margins as a site of production. This idea of a generative liminal space gave permission to a then emerging generation of artists whose work indeed circumscribed the dominant discourse and the institutional spaces that supported it. When I first visited Zittel's Williamsburg studio in 1991—which was even then more of an office inhabited by projects than a conventional studio—she was researching the breeding of chickens and simultaneously was occupied with the repair

NOTES

1. Stefano Basilico, "Andrea Zittel," *Bomb,* Spring 2001, pp. 70–76.

2. From "Mission Statement, The Experiment," HDTS website, available at http://www.highdeserttestsites.com.

3. Andrea Zittel, *Diary: Andrea Zittel,* ed. Simona Vendrame, no. #01 (Milan: Tema Celeste Editions, 2002), p. 118.

4. Mimi Zeiger, "Complete: Laboratories for Living," in *Andrea Zittel,* exh. cat. (Munich: Sammlung Goetz, 2003) p. 114.

5. Ibid., p. 75.

6. Zittel, *Diary: Andrea Zittel*, p. 85.

7. I have written elsewhere on the role of Zittel's dealers as supporters of *HDTS.* Recalling the dealer/collaborator role of such luminaries as Virginia Dwan and her relationship with artists such as Robert Smithson and Michael Heizer in the 1960s, this enlightened partnership serves to invert the usual artist/dealer relationship, creating a nonhierarchical social structure within the project. Zittel's interest in the remaking of social hierarchies is reflected in the idea of the uniform for artists, collectors, etc.

8. Jan Avgikos, "One or Two Things I Know About Her," in *Andrea Zittel— Personal Programs,* exh. cat. (Hamburg: Deichtorhallen, 1999), p. 16.

NOTE TO PLATES

Works are divided into five thematic sections and within each section works are organized chronologically. Each section is introduced by a timeline of selected works.

Texts typeset in *italics* are quotations from the artist and bibliographical references for these quotations appear on page 218. All other quotations are taken from the artist's website, www.zittel.org. Bibliographical references for artist's brochures and books illustrated in the plates are listed on page 236.

Dimensions are listed in inches, followed by centimeters in parentheses. Height precedes width precedes depth.

Subjects are identified in the photographs left to right, top to bottom, unless otherwise noted.

For works produced as an edition, collections are omitted, unless the works are included in the exhibition.

Plates

Administer

Inhabit

Investigate

Locate

Escape

Administer

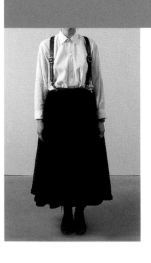

1991 — A–Z Administrative Services

A–Z Personal Uniform

1992 — A–Z Apparel Commissions

1994 — The A–Z (A–Z East in 2000)

A–Z Ottoman Furniture

1996 — A–Z Personal Presentation Room

A–Z Personal Profiles Newsletter

2000 — A–Z West

2003

present

I initially saw A–Z as a service. Later, I realized that ultimately I was only able to design to serve my own needs. Because I could not truly design for anyone else, I had to come to terms with the idea that once a product departed from my own possession, it would need to be claimed by its new owner… What we forget is that there are at least two authors of every object: one is the designer, the other is the owner (or user). This in the end may be the solution to the dilemma presented by mass production. Where on the one hand, mass production may create greater equality by making the same goods available to everyone; on the other hand it diminishes individuality and identity. What we as consumers must do is to redefine our objects within the context of our own needs.[1]

Zittel working on *A–Z Single-Strand Uniform,* 2001.

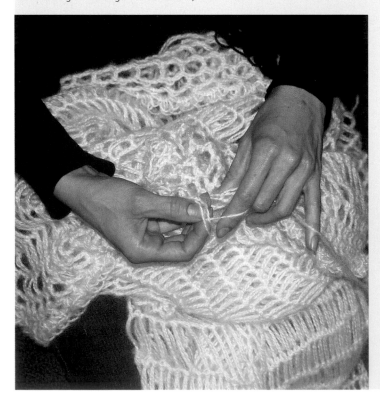

1991–1992 **A–Z Jon Tower Life Improvement Project**

Jon Tower in his apartment during the *A–Z Jon Tower Life Improvement Project,* 1992.

1991–1992 **A–Z Jon Tower Life Improvement Project Portfolio**

Ink on paper in plastic sleeves in aluminum notebook
11 x 8½ inches (28 x 22 cm) each page
Courtesy of the artist and Andrea Rosen Gallery, New York

Dear Mr. Tower,
We would like to offer you a systematized apparel program to eliminate disorder and confusion in your daily attire dilemma.

Our company has chosen a prototype based on your social position, reputation, and occupation which we feel will be suitable for your needs. . . . However, first we ask that you review the A to Z commitment plan.

In exchange for a new life of order and efficiency we only ask that you be prepared to adhere to our guidelines. No slacker will be tolerated.
—Letter to Jon Tower, December 12, 1991

Zittel began creating garments as a response to the social dictates of changing clothes every day. By wearing a single uniform for six months, she eliminated the stress associated with choosing a daily outfit. More than forty-five variations of the *A–Z Personal Uniform* exist, with distinctions between warm and cold weather apparel, as well as specific needs.

The first *A–Z Personal Uniforms* were cut and sewn. They ranged from basic wool dresses to silk-adorned tulle and wool petticoats. For her job in an art gallery and the work in her studio, the artist needed an attractive yet flexible uniform (1992); for her work maintaining a chicken coop and other more strenuous daily activities, the uniform design added pants (1993). In a few years, the artist had shifted her design focus to concepts such as the preservation of a fabric's flat origins, resulting in the *A–Z Personal Panel Uniform* (1995–98)—rectangular garments pinned and tied to fit. This concept later evolved into the *A–Z Raugh Uniform* (1998), made of fabric literally torn from a bolt with only a few modifications such as a single seam or safety pin fasteners. In the *A–Z Single-Strand Uniform* (1998–2001) that followed, Zittel abandoned pre-woven fibers and created clothing directly, from a single strand of yarn, which she crocheted into various forms. Eventually she discarded the crochet hook and taught herself to crochet only with her fingers and hands. Most recently Zittel has turned to the most basic of materials, unprocessed woolen fibers. Under the auspices of *A–Z Advanced Technologies*—which brings complexity of form together with pre-industrial know-how—she began felting wool to form primitive yet sophisticated attire. Begun in 2002, the *A–Z Fiber Form Uniform* has no seams and often takes on organic, abstract shapes.

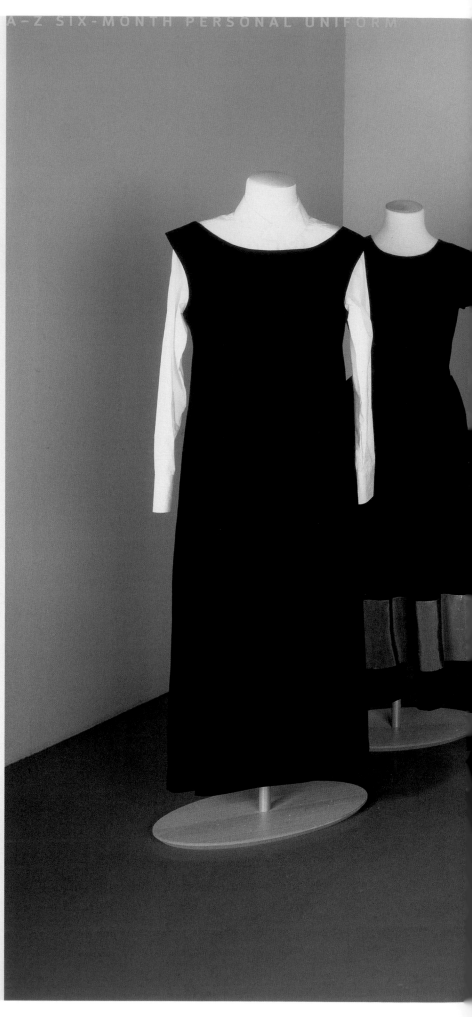

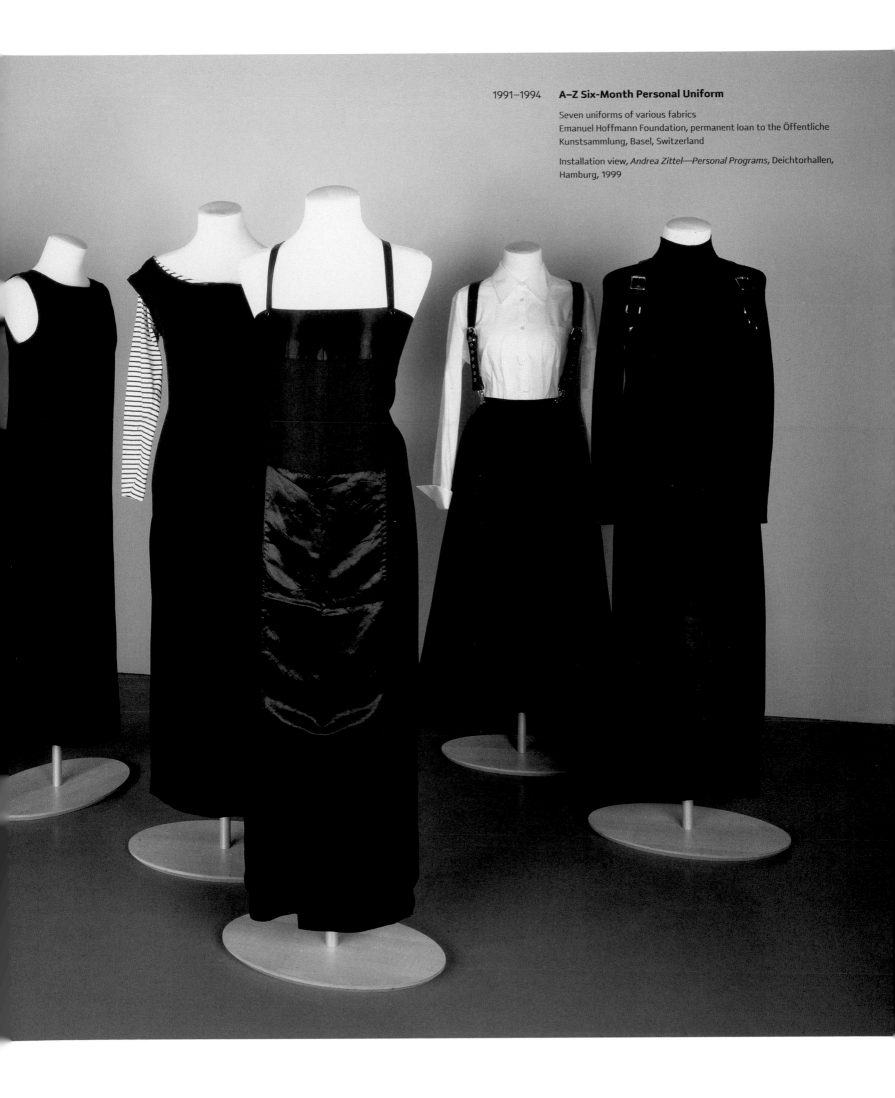

1991–1994 **A–Z Six-Month Personal Uniform**

Seven uniforms of various fabrics
Emanuel Hoffmann Foundation, permanent loan to the Öffentliche
Kunstsammlung, Basel, Switzerland

Installation view, *Andrea Zittel—Personal Programs*, Deichtorhallen,
Hamburg, 1999

Pencil on Strathmore Bristol board
4 drawings: 11 x 14 inches (28 x 36 cm) each
Courtesy of the artist and Galerie Monika Sprüth, Munich

Felix wearing *Prototype for A–Z Blanket Dress,* 1994.

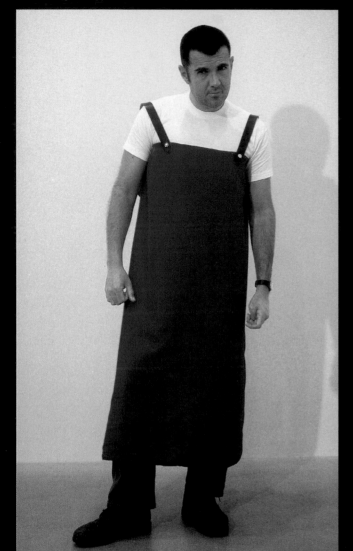

Most ordinary garments are made by cutting cloth into foreign shapes . . .

and then by sewing those shapes into yet a third hand form.

All A-Z Personal Panels are constructed from a basic rectangular pattern so that the fabric is used directly as it is woven.

Seven uniforms of various fabrics
Emanuel Hoffmann Foundation, permanent loan to the Öffentliche
Kunstsammlung, Basel, Switzerland

Installation view, *A–Z Uniforms 1991–2002,* Andrea Rosen Gallery,
New York, 2004

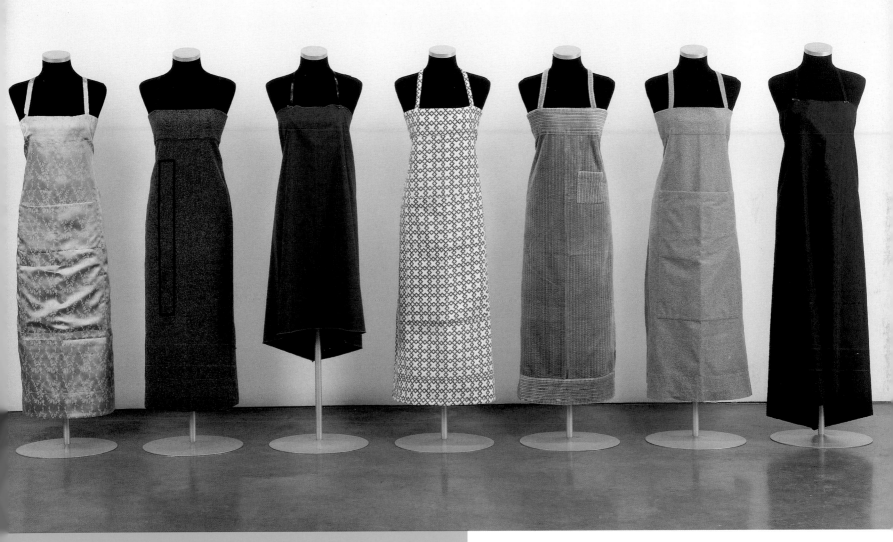

One influence on the *A–Z Personal Panel Uniform* series is the work of the Russian
Constructivists, who created garments in predominantly geometric shapes.
They felt that fabric, which is woven into flat rectangles, should not be cut and
sewn into shapes alien to its origin. In the *Personal Panel Uniform,* Zittel pushed
this principle to its most extreme conclusion, using only rectangular shapes
undifferentiated by stitching, gathering, or bias (angular) cuts.

1998 **A–Z Raugh Uniform (Red, Brown, Gray, and Navy Blue)**

Four uniforms of various fabrics
Courtesy of the artist and Sadie Coles HQ, London

Installation view, *A–Z Personal Panels: 1993–1998*, Sadie Coles HQ, London, 1998–1999

1998 **A–Z Raugh Skirt with A–Z Raugh Furniture**

Gouache on paper
15 x 20 inches (38 x 51 cm)
Private Collection, London

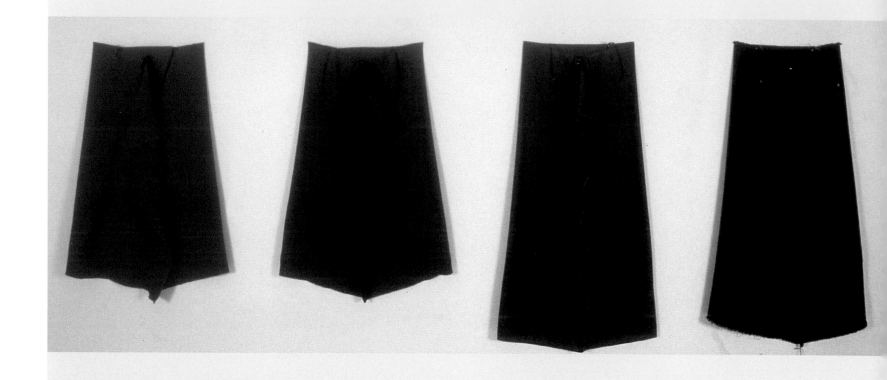

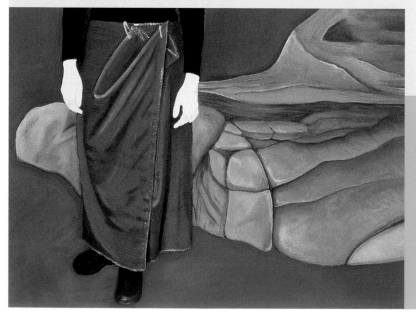

When I was developing my new technology, called Raugh, I realized that I could evolve the Personal Panel Uniform *to its most logical extreme by using only a rectangle of fabric literally torn from the bolt. This reduced my activity in making a dress to a few minute modifications, such as using safety pins to fasten a strap to fabric or stitching a single strategic seam. While the Raugh garments required no expertise in either conception or construction, it took skill to make designs that look sophisticated and attractive.*

Zittel wearing *A—Z Single-Strand Uniform (Summer 1999)* while crocheting *A—Z Single-Strand Carpet* at Erika and Rolf Hoffmann artist-in-residence studio, Berlin, 1999.

1998–2001 **A–Z Single-Strand Uniform**

Twenty uniforms of various fibers
Emanuel Hoffmann Foundation, permanent loan to the
Öffentliche Kunstsammlung, Basel, Switzerland

Installation view, *A–Z Uniforms 1991–2002*, Andrea Rosen Gallery,
New York, 2004

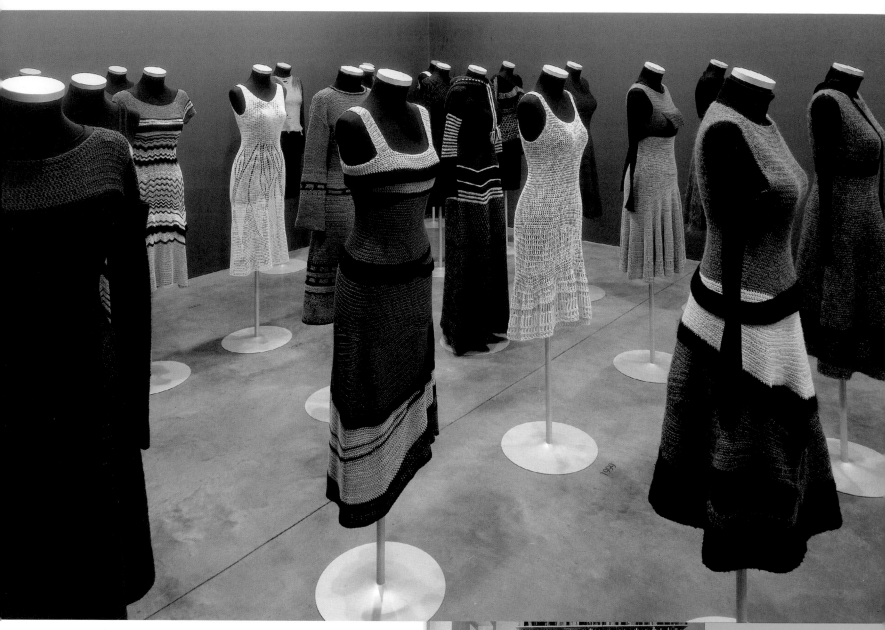

Zittel wearing *A–Z Single-Strand Uniform* at
the home of Asa Nacking, Copenhagen, 2000.

1999 A–Z Single-Strand Uniform (Spring)

Crocheted rayon yarn
Emanuel Hoffmann Foundation, permanent loan
to the Öffentliche Kunstsammlung, Basel, Switzerland

2001 A–Z Handmade Single-Strand Uniform (Fall)

Wool yarn
Emanuel Hoffmann Foundation, permanent loan
to the Öffentliche Kunstsammlung, Basel, Switzerland

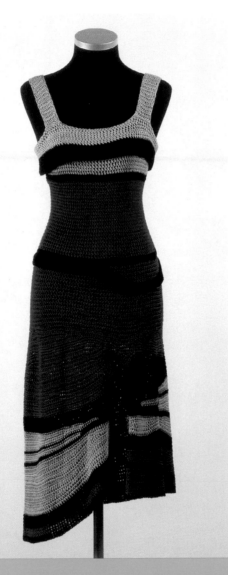

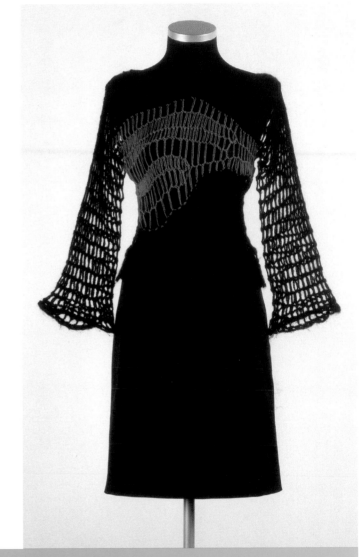

*These were crocheted one per quarterly season. I liked crochet because it
required the least number of implements possible, a single crochet hook.
[Eventually] I began to wonder if there was a way to link yarn directly off my
fingers without using any extraneous tools (other than my own body). I liked the
purity of the idea as it reminded me of an insect spinning its own cocoon. In the
Fall of 2001 I finally figured out a way to do this. The technique was simple but it
just required practice and precision to control the tension correctly. As I gained
skill, I started to make the patterns less linear and more abstract so that they
resembled the webs of uneven netting.*[2]

2002 **A–Z Fiber Form Uniform (Olive Shirt)**

Merino wool
Courtesy of the artist and Andrea Rosen
Gallery, New York

2002 **A–Z Fiber Form Uniform
(Green and White Dress)**

Merino wool and skirt pins
Courtesy of the artist and Andrea Rosen Gallery, New York

2002 **A–Z Fiber Form Uniform (Fall)**

Merino wool, belt, and black shirt
Emanuel Hoffmann Foundation, permanent loan to
the Öffentliche Kunstsammlung, Basel, Switzerland

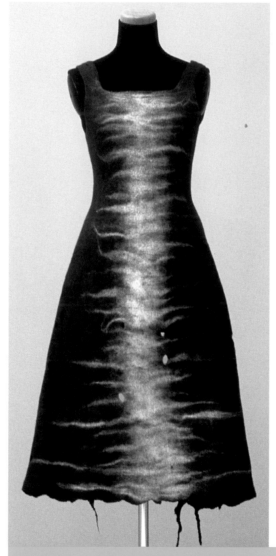

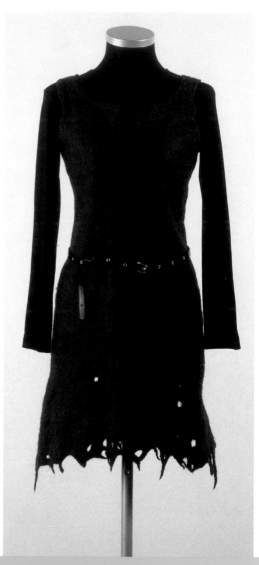

Washed and carded wool is felted directly into the shape of a shirt or dress.
Because the clothing is made as one piece, there are no seams, and if needed,
the wearer can use a safety pin to position the garment correctly on the body.

2002 **A–Z Advanced Technologies:**
Me in a Pink A–Z Fiber Form Uniform in Front of A–Z West

Gouache and pen on paper
12 x 9 inches (30 x 23 cm)
Private Collection

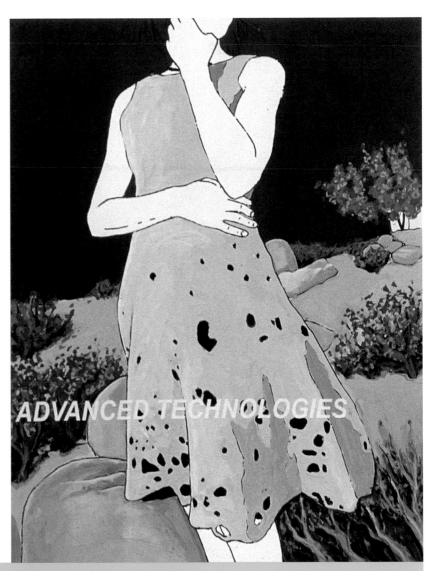

Zittel in A–Z Fiber Form Uniform, A–Z West, 2002.

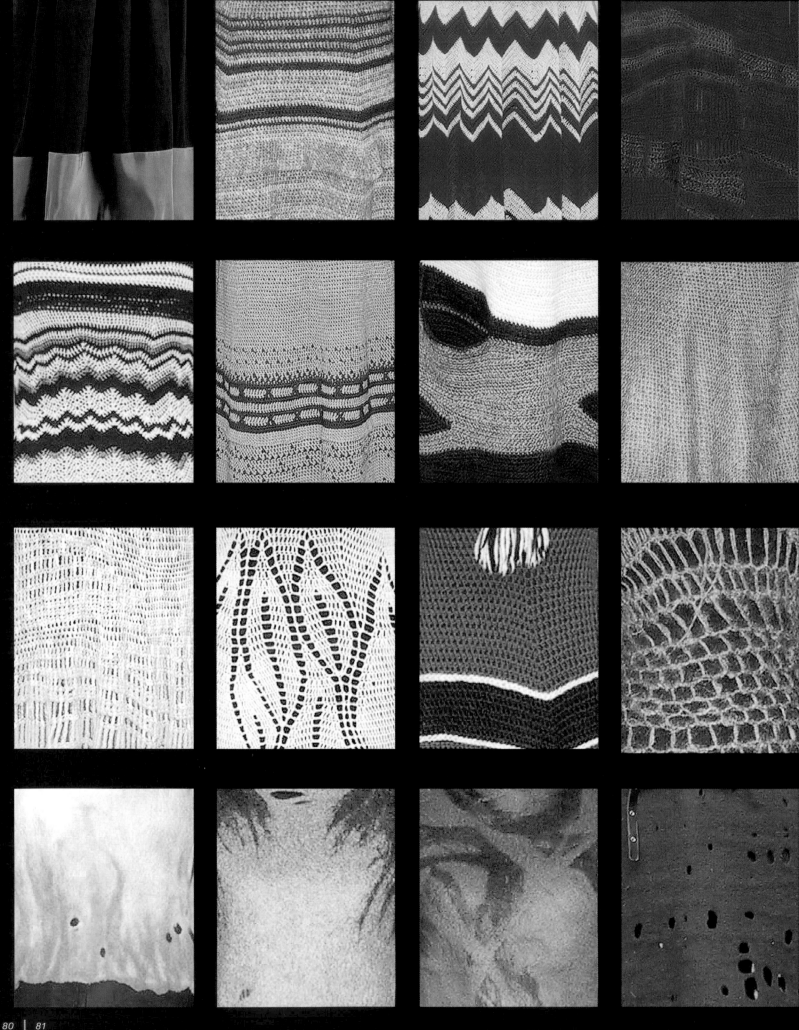

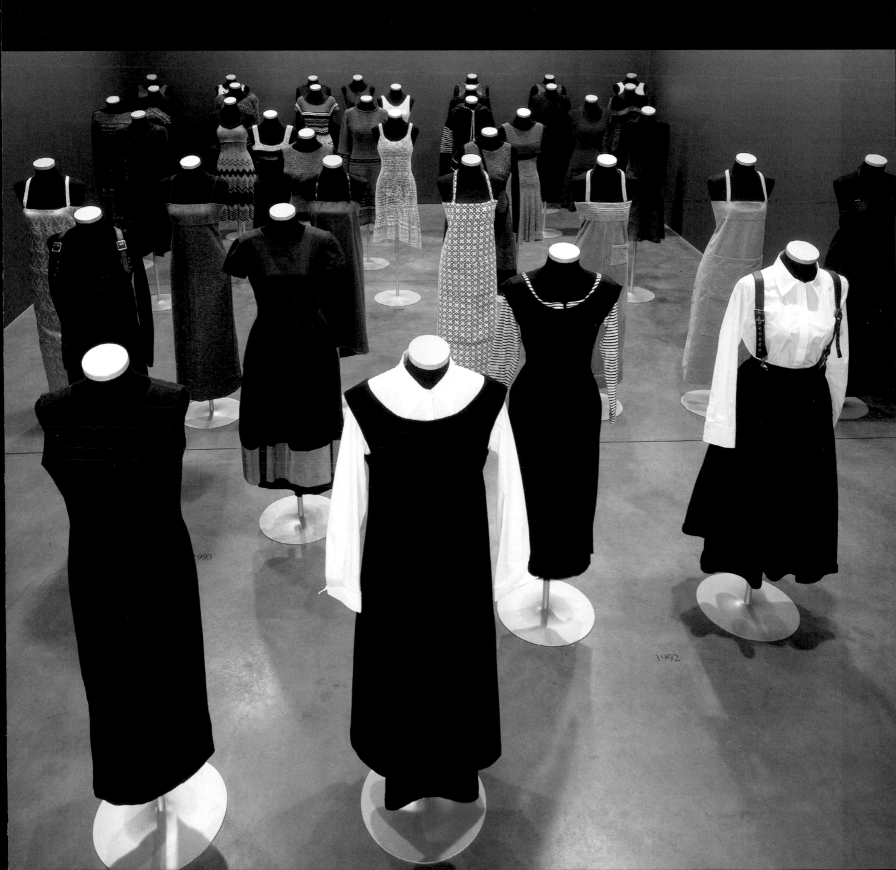

A–Z Personal Uniform (fabric details of sixteen uniforms), 1991–2002.

1991–2002 **A–Z Personal Uniform**

Thirty-nine uniforms of various fabrics
Emanuel Hoffmann Foundation, permanent loan to
the Öffentliche Kunstsammlung, Basel, Switzerland

Installation view, *A–Z Uniforms 1991–2002,* Andrea Rosen Gallery,
New York, 2004

1992 **A–Z Privacy/ Purity Robes**

Nylon and zipper
Edition of 3; 2 robes per edition
Courtesy of the artist and Andrea Rosen Gallery, New York

Collaborating with clients to gain an understanding of their lifestyles and specific needs, Zittel creates customized uniforms not unlike her own personal designs. To qualify for a made-to-order garment, clients must agree to wear the uniform exclusively, removing all other dresses or suits from their wardrobe. Although the duration of the uniform regime is a decision Zittel makes with the clients, her intent is to enhance their lives and sense of personal identity and to alter their perception of fashion, something she achieved with her own early *A–Z Personal Uniform*. The ultimate goal is to provide the owner with a multiuse garment suitable for the varied events of everyday life.

One example is the *A–Z Collector's Coat for Frank Kolodny*, which Zittel designed for the client to wear when attending art events and functions at galleries and museums. It incorporates a professional look with features that address precise needs, such as a large pocket for the monthly art trade directory *Gallery Guide*. Embellishments include a red crest on the coat's breast pocket. Similarly, *A–Z Uniform for Andy Stillpass* suits his career as the owner of a car dealership as well as his pastime collecting art. The conservative styling is appropriate for both activities, providing its owner with increased freedom and flexibility.

Purity Robe
1. White parachute fabric
2. Architectural in form
3. Identification lettering

for bride, cook, lab tech, dentist, priest, ghost, nurse

1993 **A–Z Uniform for Andy Stillpass**

Wool with rayon lining
Collection of Andy and Karen Stillpass

Thank you for making available the opportunity to own
the perfect garment and, concomitantly, a work of art
which, it is hoped, will improve my living conditions....
I have come to realize how disorganized have been my
wardrobe choices in functionally and symbolically
determining my identity. And now stripped of the idea
of needless diversity, I am looking forward to being
dressed anew.

—Andy Stillpass
Letter to A–Z, July 31, 1993

Exhibition brochure, *A–Z For You • A–Z For Me,* University
Art Gallery, San Diego State University, 1998.

1993 **Study for A–Z Collector's Coat for Frank Kolodny**

Pencil and ink on white tracing paper
11 x 8½ inches (28 x 22 cm)
Courtesy of the artist

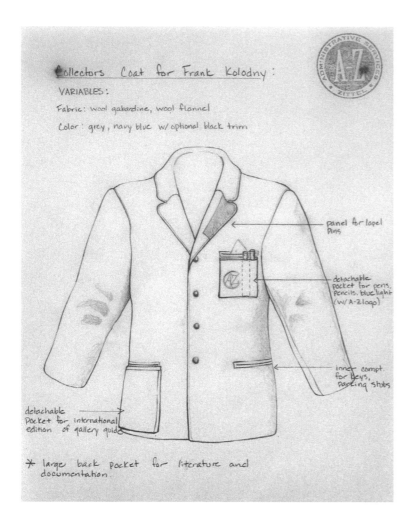

Kolodny demonstrating the back pocket of his *A–Z Collector's Coat.*

Kolodny and Zittel discussing the contract for his *A–Z Collector's Coat.*

1993 **A–Z Collector's Coat for Frank Kolodny**

Wool, polyester lining, and A–Z logo patch

There is no question that the experience of wearing
the uniform has serious psychological consequences....
I have spent all the times in the art world trying to
be anonymous.... [The uniform] made me aware...
I was not this silent art stalker any longer.
—Frank Kolodny,
Letter to A–Z, September 27, 1996

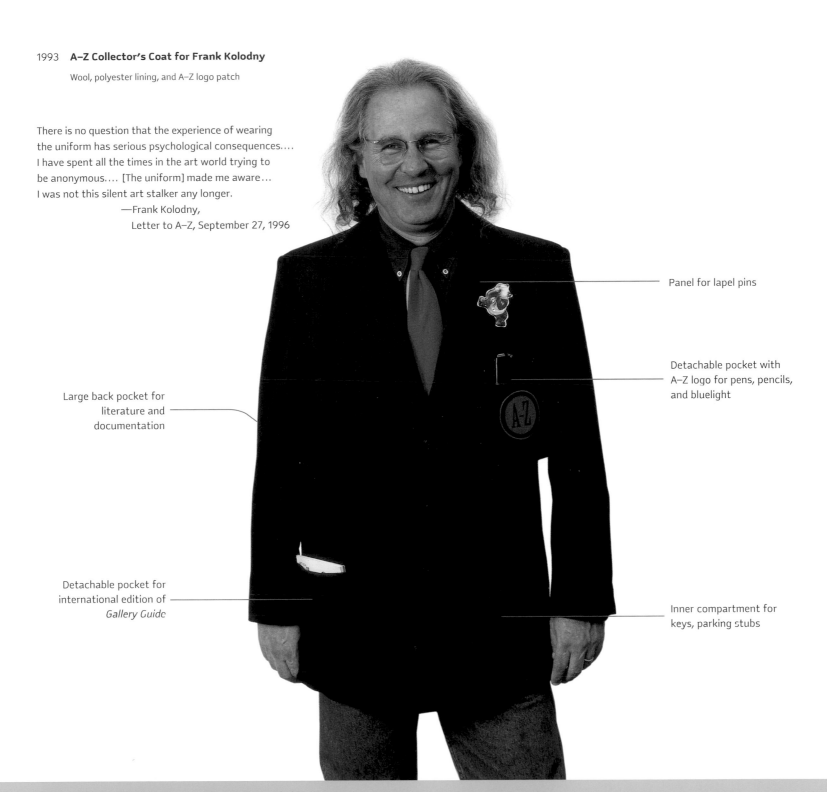

Panel for lapel pins

Detachable pocket with
A–Z logo for pens, pencils,
and bluelight

Large back pocket for
literature and
documentation

Detachable pocket for
international edition of
Gallery Guide

Inner compartment for
keys, parking stubs

Frank Kolodny commissioned a special coat to wear in his
role as a representative of the Jedermann Collection.

Situated in Brooklyn at 72 South 8th Street in 1991–1993, A–Z Administrative Services was Zittel's original enterprise. In the summer of 1993, the operation moved to Union Street and subsequently in January 1994 to 150 Wythe Avenue, where it was called The A–Z until 2003 when it was temporarily suspended. The A–Z was retroactively renamed A–Z East after the opening of a second A–Z site—called A–Z West—in California in fall 2000. Wares and prototypes rotated in and out of the space as Zittel's experiments evolved, the storefront serving as both a showroom and a test site. In 1996 and 1997, the *A–Z Personal Presentation Room* opened to the public for *Thursday Evening Personal Presentations at The A–Z*. These cocktail parties facilitated socialization among Zittel's Brooklyn community of artists and neighbors, alleviating the absence of intimacy and familiarity in metropolitan life.

The limitations of the premises inspired many of Zittel's early reflections on the functions of space. Earlier in the twentieth century, the Wythe Avenue building had served as a storefront business with a home in the back that sheltered three generations in its constricted area. An awareness of this history led Zittel to conceive of The A–Z as an arena of both professional and personal interactions, where the sleeping arrangements and furniture (*A–Z Bofa*, *Ottoman Furniture*, *Pit Bed* and *Platform Bed*, among others she designed) would inspire socialization as well as rest or privacy.

The sense of community fostered among participants in the A–Z lifestyle experiments and gatherings spurred the creation of the *A–Z Personal Profiles Newsletter* (1996–1997). Zittel invited those who were inspired by furniture designs to provide testimonials in this newsletter. The expanded following of The A–Z fueled solutions to the new problems created by this ongoing social activity.

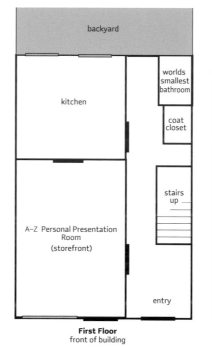

Plan of A–Z East, 150 Wythe Avenue, Brooklyn, 1994–2003 [a composite of rooms and projects over this nine-year period].

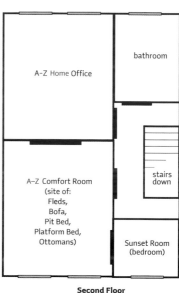

Zittel at the storefront entrance of A–Z East, 150 Wythe Avenue, Brooklyn, 1996.

Entranceway prior to renovations, A–Z East, 150 Wythe Avenue, Brooklyn, 1994.

Exterior, A–Z East, 150 Wythe Avenue,
Brooklyn, 1996.

1995–1998 **My Linoleum Floor** (detail)

Gouache on paper
2 panels: 11 x 15 inches (28 x 38 cm) each
Courtesy of the artist and Andrea Rosen Gallery,
New York

The sketch includes a biomorphic countertop
(never realized) for the *A–Z Personal
Presentation Room*.

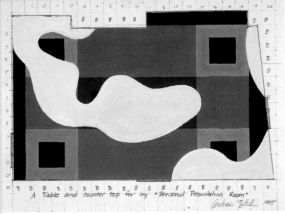

Bathroom with four units of *Prototype for A–Z Cabinet*, A–Z East, 1997.

1994 **Prototype for A–Z Cabinet (RB Pathology)**

Wood and glass
1 of 4 cabinets: 14 x 14 x 5 inches (36 x 36 x 13 cm) each
Courtesy of the artist

Over time the terminology of labels on the four *A–Z Cabinets* was changed on three occasions:

1) Psychology, Microbiology, Pathology, and Medicine

2) Addition, Subtraction, Tools and Implements, and Correction

3) Once A Day, Once A Week, Once A Month, and
 In Case of Emergency.

Bookcase in the *A–Z Home Office,* A–Z East, 1997.
Book spines were covered with green buckram tape.

A–Z Home Office, A–Z East, 1995.

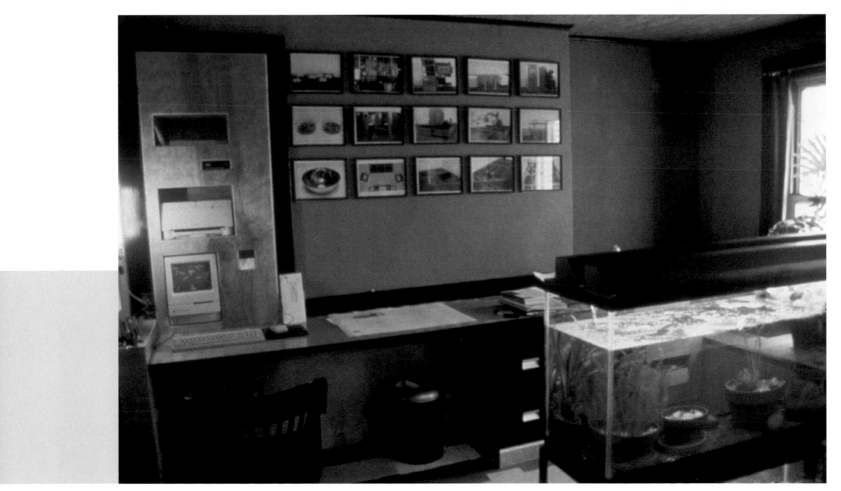

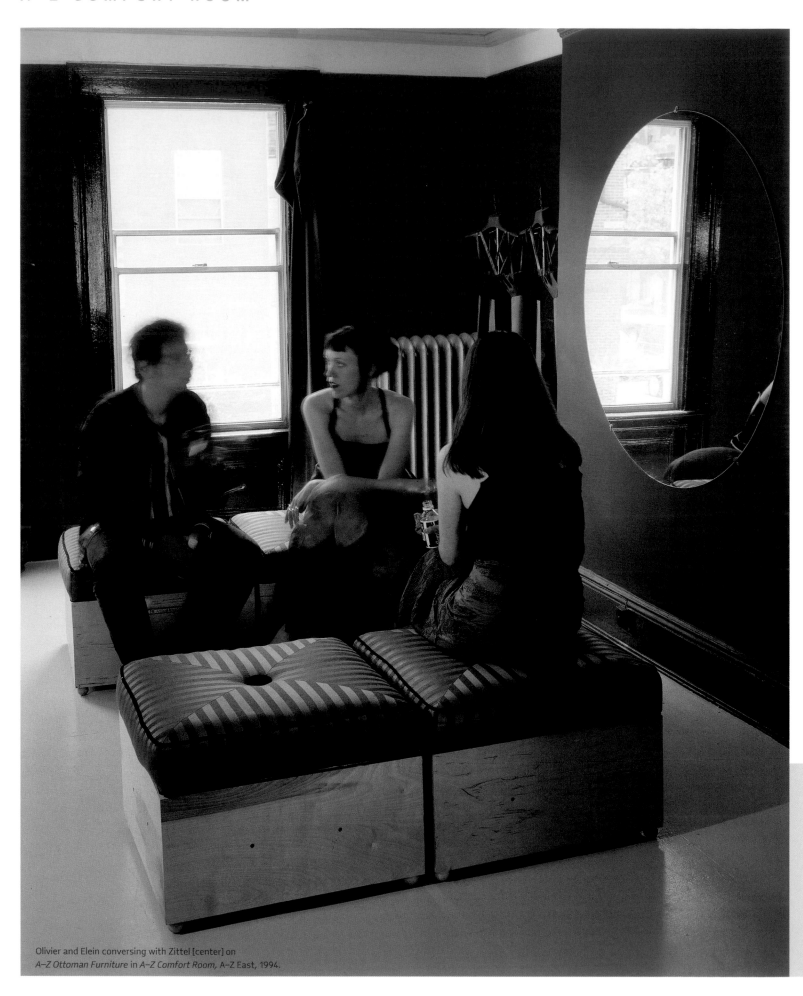

Olivier and Elein conversing with Zittel [center] on
A–Z Ottoman Furniture in *A–Z Comfort Room, A–Z East*, 1994.

1994 **Study for A–Z Ottoman Furniture**

Gouache on paper
9 x 12 inches (23 x 30 cm)
Collection of J. Whitney Stevens, New York

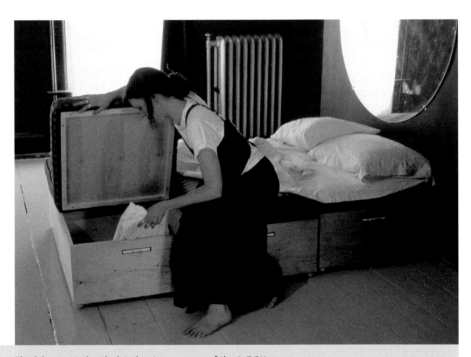

Zittel demonstrating the interior storage space of the *A–Z Ottoman Furniture* in *A–Z Comfort Room,* A–Z East, 1994.

Brochure for *A–Z Ottoman Furniture,* 1994.

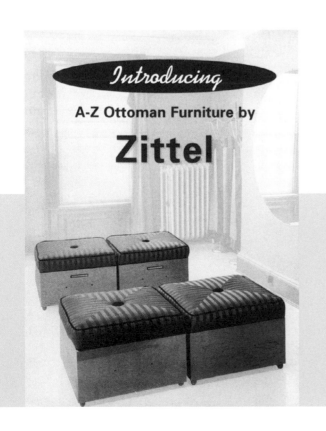

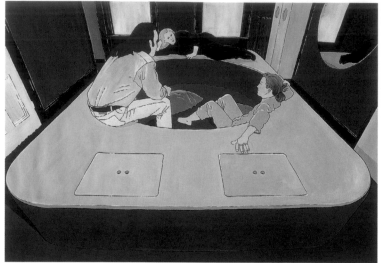

1999 **A–Z Pit Bed vs. Platform Bed** (detail)

Gouache on paper
2 parts: 24 3/8 x 34 3/8 inches (62 x 87 cm) each
Hort Family Collection, New York

Liisa and Jade conversing in *A–Z Bofa* in *A–Z Comfort Room,* A–Z East, 1997.

Jethro and Charles posing in *A–Z Bofa,* 1996.

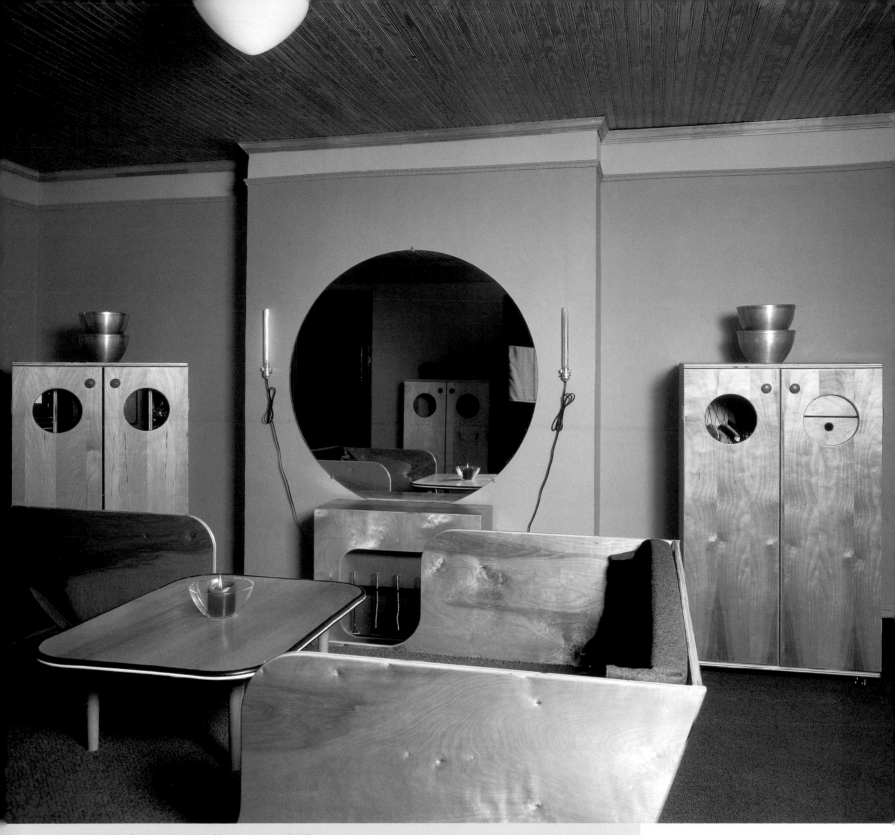

Four *A–Z Chamber Pots*, two *A–Z Cabinets*, *A–Z Warmth Unit*,
A–Z Bofa, and *A–Z Cover* in *A–Z Comfort Room*, *A–Z East*, 1998.

Zittel [center] with Maria and Daniel at a cocktail evening in *A–Z Personal Presentation Room,* A–Z East, 1996.

Dinner guests [clockwise from lower left] Mano, Bela, Allan, Bernie, another guest, Judith, and Jim in *A–Z Personal Presentation Room,* A–Z East, 1996.

Invitation to a cocktail evening held in *A–Z Personal Presentation Room* at A–Z East, 1997.

Storefront area, prior to remodeling as *A–Z Personal Presentation Room,* displaying eight examples of the *Prototype for A–Z Container III,* two *A–Z Chamber Pots, A–Z Clock* [right], *A–Z Covers,* and *A–Z Ottoman Furniture,* A–Z East, 1994.

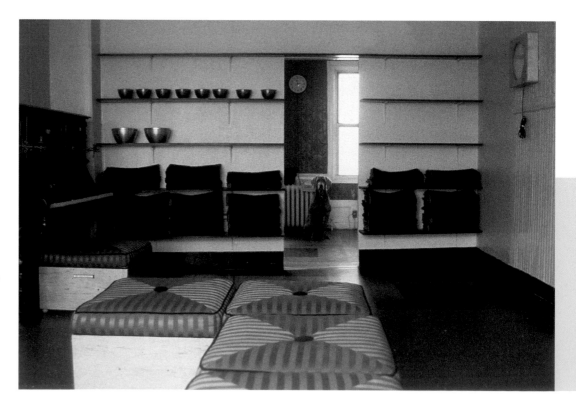

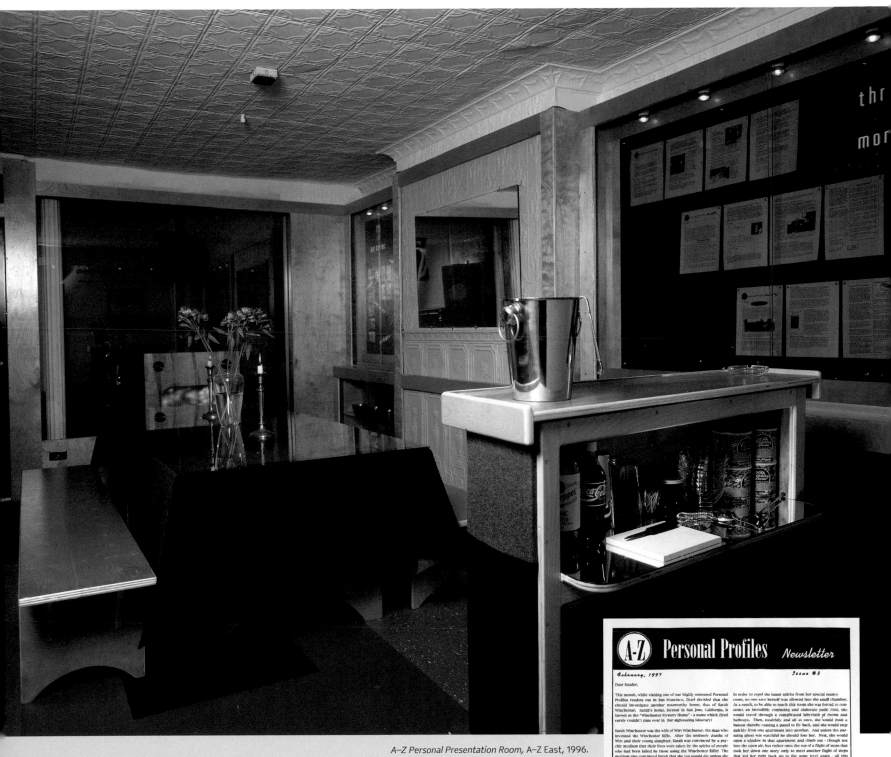

A–Z Personal Presentation Room, A–Z East, 1996.

Original cover layout of *A–Z Personal Profiles Newsletter,* February 1997.

A–Z West is located southeast of Los Angeles on twenty-five acres in the high desert of California next to Joshua Tree National Park. This region is the historical site of the Five-Acre Homestead Act: in the 1940s and 1950s, the American government gave people five free acres of land if they could improve it by building a minimal structure on the property. The result was a grid system of dirt roads that divides the desert region into squares of land, each with a shack, trailer, or other structure in the middle—most of them long since abandoned. In fall 2000, Zittel restored one of these homestead cabins located on the A–Z West premises, then gradually converted the entire compound into a testing ground for A–Z designs. She installed three shipping containers—another recurrent presence in the region—for her studio. She then installed a number of her portable living structures, which she uses as guesthouses. Among them are seventeen *A–Z Wagon Stations*, pods large enough for an individual to sleep that are undergoing progressive customization by collaborators and friends who spend time at the compound to work with Zittel, to develop *High Desert Test Sites*, or to join her in regular hiking trips.

This desert region originally appealed to Zittel for the open-ended character of its undisturbed space. With time she adjusted that initial assessment, becoming aware of the area's natural geographic and ecological constraints as well as the marks left by a colorful local history of renegades and optimists. What she found —along with the vast distances that exist between people—was a poignant clash of human idealism and harsh desert climate.

Among the investigations at A–Z West is *The Regenerating Field*. This system recycles garbage—another ubiquitous desert presence. Zittel uses sun-dried paper refuse mulch in her experimental prototypes, including blocks, interior paneling, and furniture.

A–Z West is also the site of a cultural convergence for annual events held since 2002 as part of the *High Desert Test Sites* (*HDTS*), which places artist installations and interventions indefinitely at locations provided by the various townships in the desert; new works are added yearly. Zittel is one of the founders and organizers of the *HDTS*.

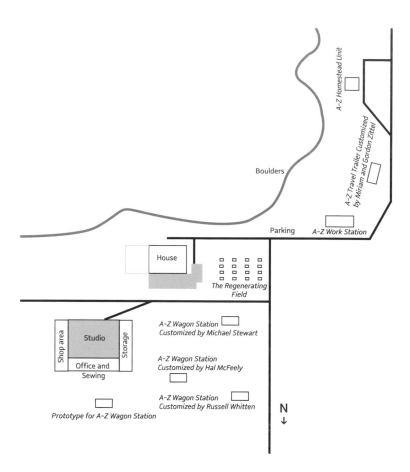

Site plan of A–Z West, Joshua Tree, California, spring 2004.

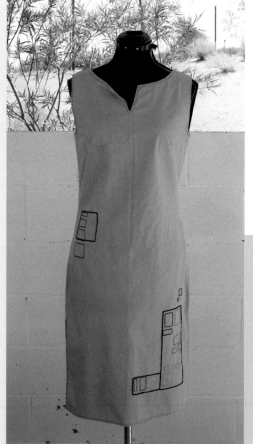

2003 **A–Z Personal Uniform (Spring/Summer)**

Cotton with embroidery
Emanuel Hoffmann
Foundation, permanent
loan to the Öffentliche
Kunstsammlung, Basel,
Switzerland

Zittel wearing *A–Z Fiber Form Uniform* behind A–Z West, 2004.

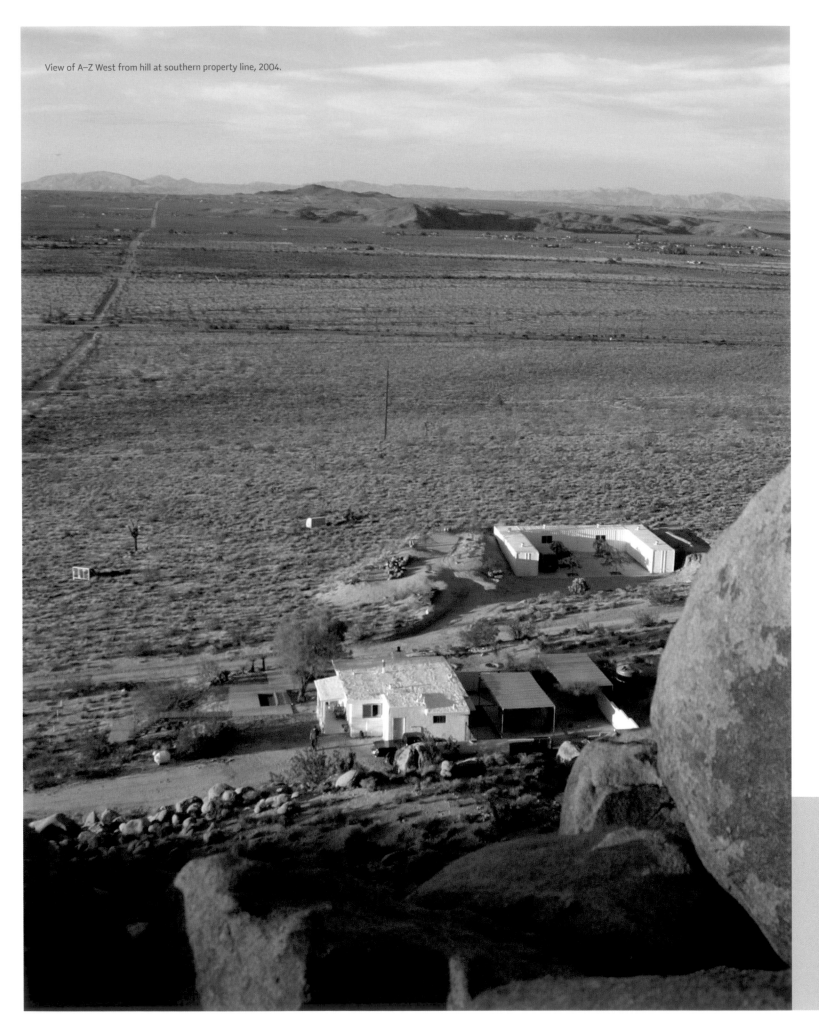

View of A–Z West from hill at southern property line, 2004.

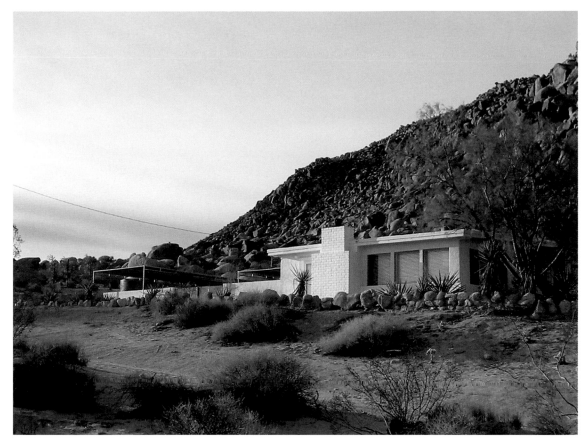

View of house, A–Z West, 2004.

View of back patio, A–Z West, 2004.

Plan of house, A–Z West, 2000–present.

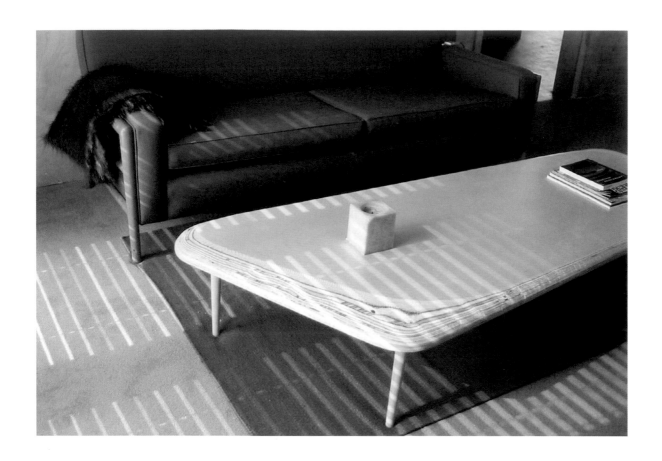

A–Z Raugh Coffee Table in living room, A–Z West, 2003.

Prototype for A–Z Fiber Form Container, A–Z West, 2004.

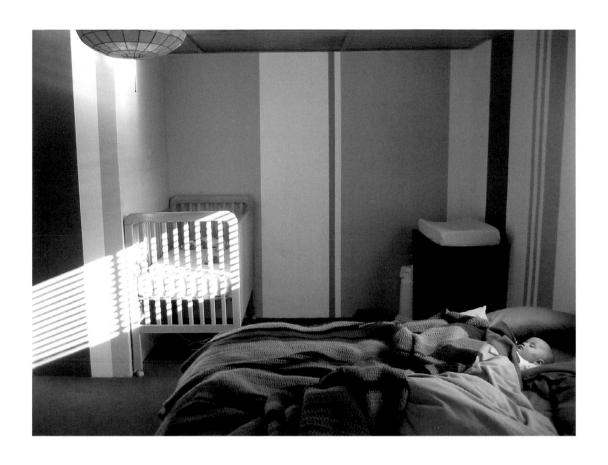

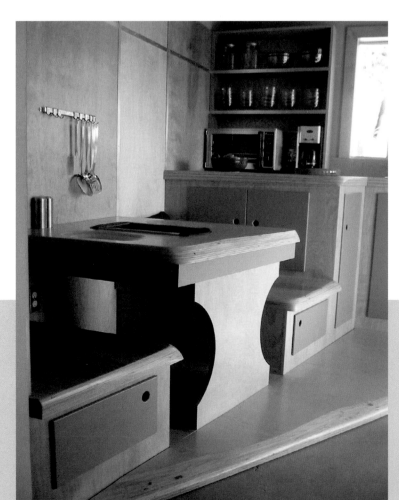

Emmett in bedroom with wall design and crocheted bedspread by Zittel, A–Z West, 2005.

A–Z Food Prep Station, A–Z West, 2004.

Preparing food at *A–Z Food Prep Station,* A–Z West, 2004.

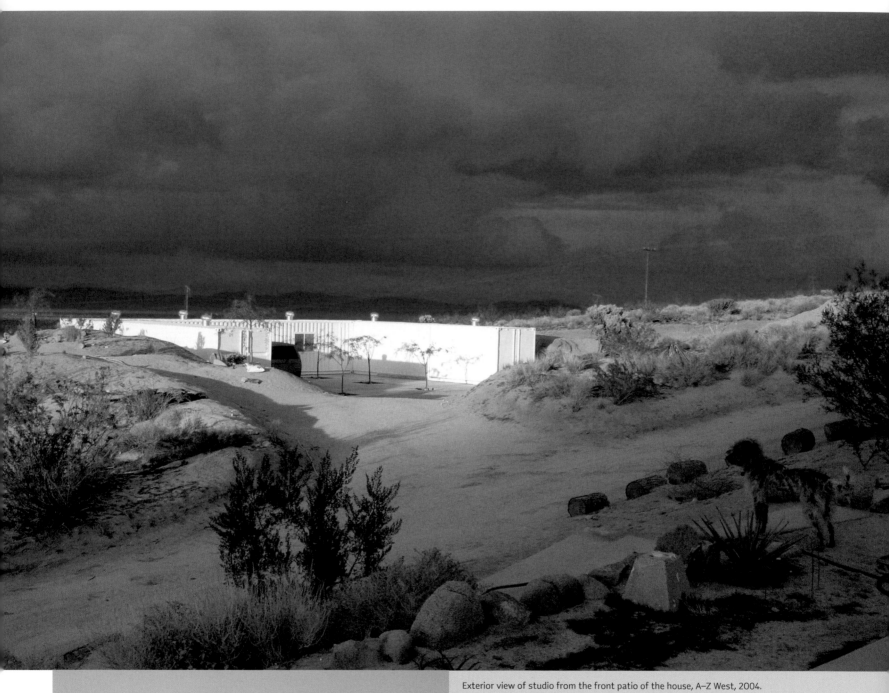

Exterior view of studio from the front patio of the house, A—Z West, 2004.

Delivery of storage containers for studio construction, A—Z West, 2003.

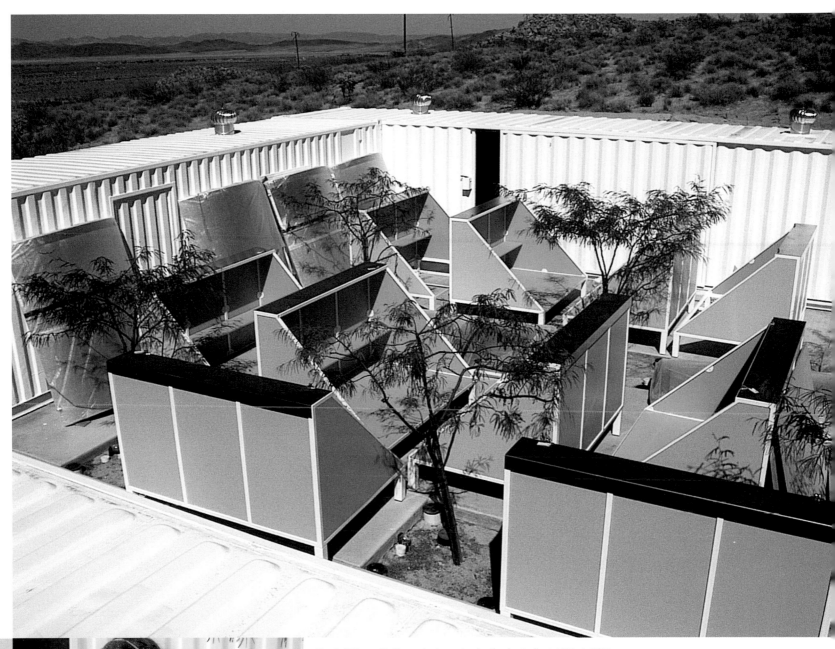

Ten *A–Z Wagon Stations* prior to customization in studio, A–Z West, 2004.

Zittel working on *A–Z Raugh Furniture* in studio area, A–Z West, 2004.

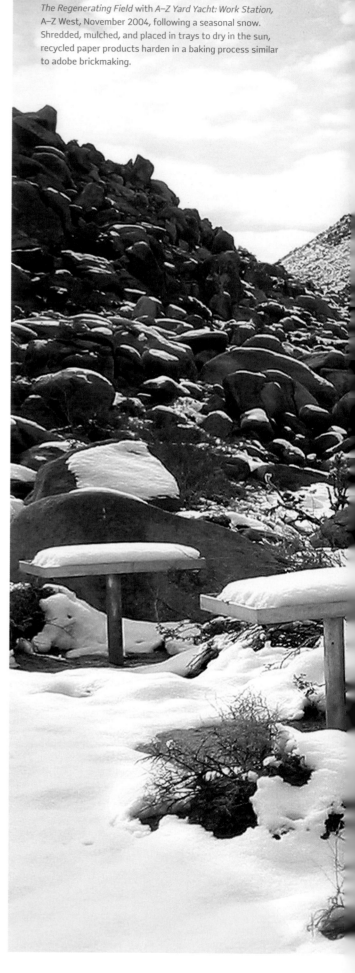

The Regenerating Field with *A–Z Yard Yacht: Work Station*, A–Z West, November 2004, following a seasonal snow. Shredded, mulched, and placed in trays to dry in the sun, recycled paper products harden in a baking process similar to adobe brickmaking.

2002 **sfnwvlei (Something for Nothing with Very Little Effort Involved) Study #4**

Gouache and pen on paper
9 x 12 inches (23 x 30 cm)
The Museum of Modern Art, New York; The Judith Rothschild Foundation Contemporary Drawings Collection

The drawing depicts Zittel holding an *A–Z Paper Pulp Panel* produced in *The Regenerating Field*.

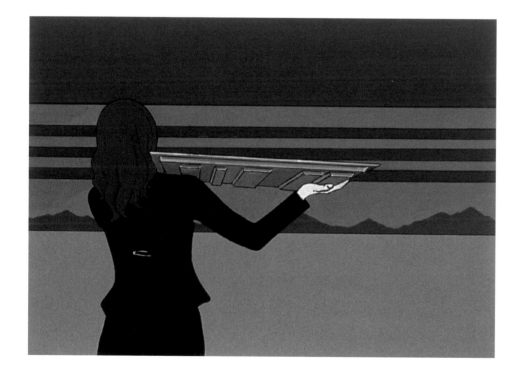

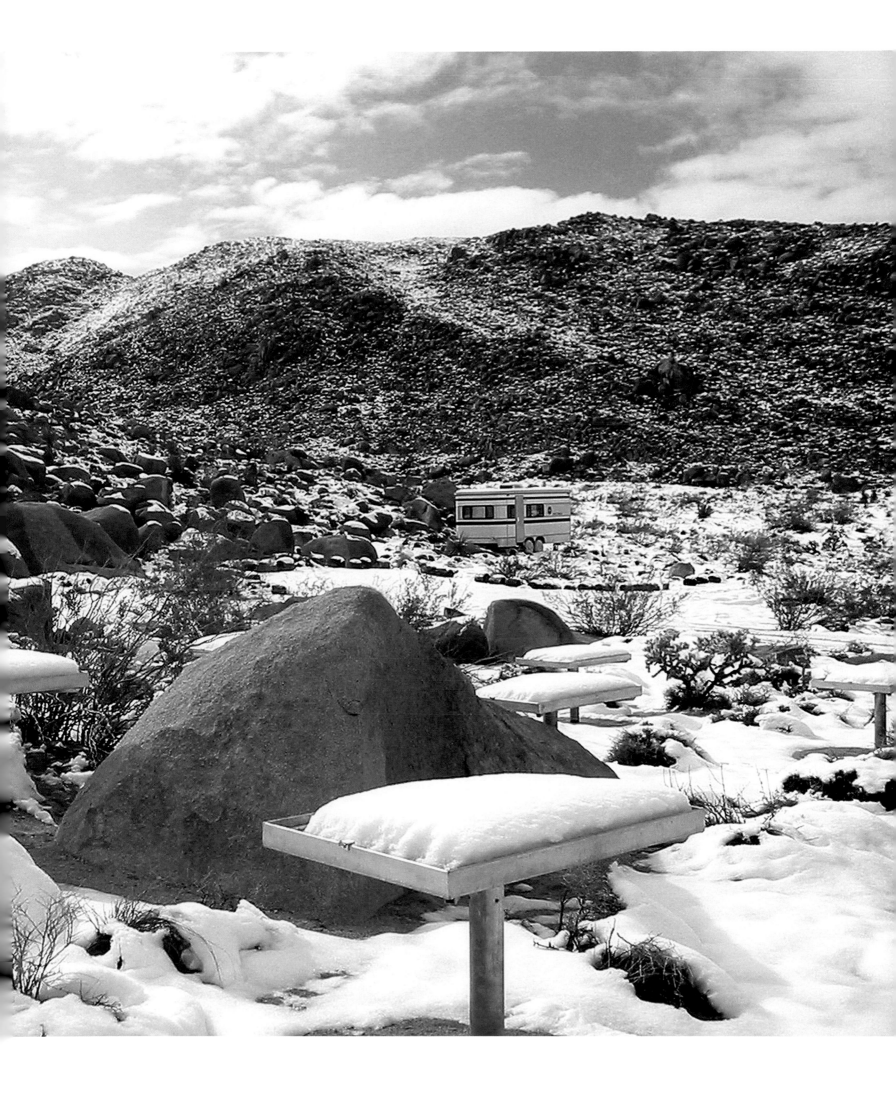

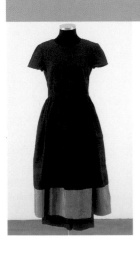

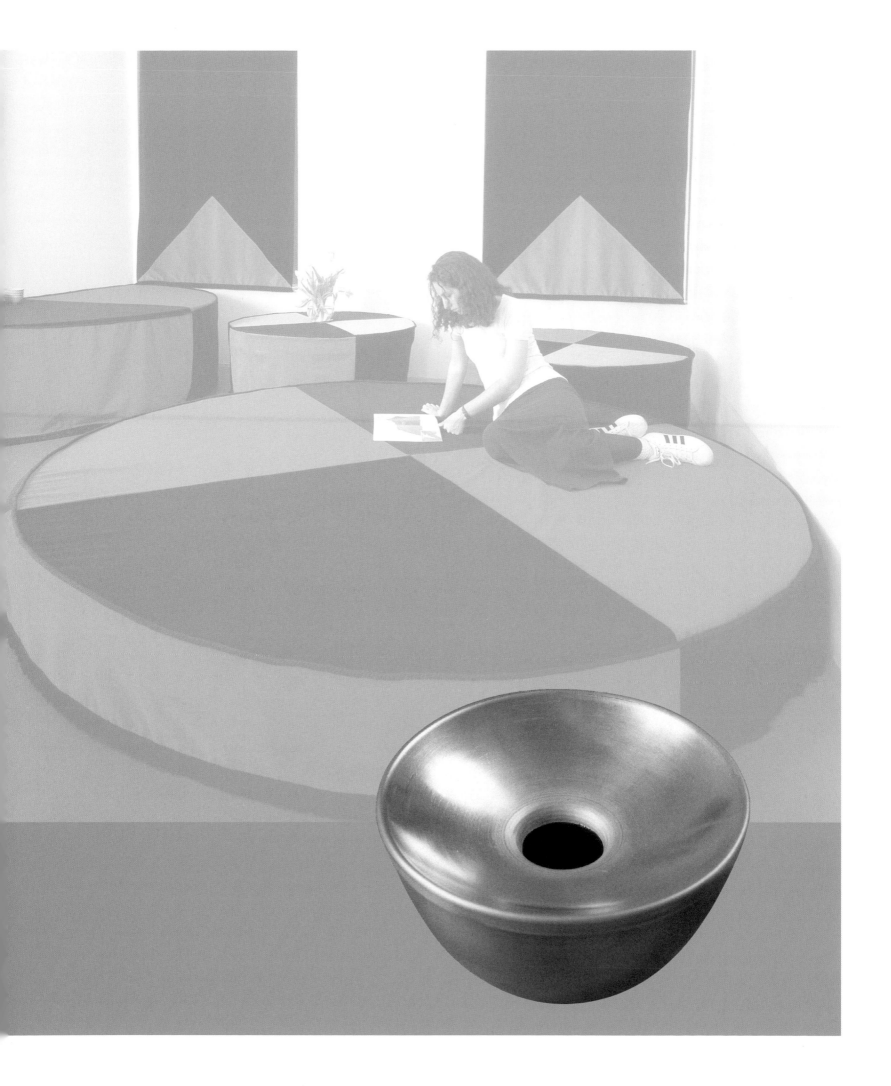

Design has a direct, if forced, consequence upon our lives. Every once in a while, good design may in some way improve our situation…. Even in the case of questionable or failed design, there is still beauty in the attempt. Modern design evokes the innocence of childhood when you would construct a house out of a blanket or fantasize about living in a dome-shaped structure or completely reconstructing the world, based on your own principle of geometry. It is the need to validate these early experiments that created the oppressive morality that we react to now.[3]

pp. 106–107

1993 **A–Z Six-Month Personal Uniform (Spring/Summer)**

Linen and taffeta dress and pants
Emanuel Hoffmann Foundation, permanent loan to the Öffentliche Kunstsammlung Basel, Switzerland

1995 **Prototype for A–Z Platform Bed**

Wood, foam, upholstery fabric, wheels, and trim
2 beds: 18 1/2 x 49 inches (47 x 124 cm) diameter, each;
1 bed: 25 x 97 inches (64 x 246 cm) diameter;
1 bed: 13 x 97 inches (33 x 246 cm) diameter
capc Musée d'art contemporain, Bordeaux, France

Installation view from *Andrea Zittel*, Andrea Rosen Gallery, New York, 1995

1993 **A–Z Chamber Pot**

Spun aluminum
1 of edition of 10
5 1/2 x 9 1/2 inches (14 x 24 cm) diameter
Courtesy of the artist and Andrea Rosen Gallery, New York

1991 **Repair Work [Wise Man]**

Papier-mâché and paint
Approx. 7 x 3 inches (18 x 8 cm)
Collection of Barbara and Howard Morse, New York

1991 **Repair Work [Bowl]**

Porcelain and glue
3 x 6 inches (8 x 15 cm) diameter
Collection of Barbara and Howard Morse, New York

1991 **Repair Work [Dish]**

Porcelain and glue
3/4 x 9 1/2 inches (2 x 24 cm) diameter
Collection of Barbara and Howard Morse, New York

1991 **Repair Work [Elephant]**

Plaster and glue
18 x 24 x 9 inches (46 x 61 x 23 cm)
Collection of Barbara and Howard Morse, New York

1992 **Study for A–Z Carpet Furniture (Dining Room with Conversation Area)**

Gouache and pencil on paper
11 x 14 inches (28 x 36 cm)
Private Collection

By combining the aesthetics of a decorative wall-hanging with the design of a rug that suggests the functionality of various types of furniture, Zittel produced *A–Z Carpet Furniture*. *A–Z Carpet Furniture* allows the user to alter a room's function in a matter of seconds, simply by switching the floor covering around. The carpets are geometrical renditions of aerial views of living room or bedroom furniture in which boxes and rectangles take the place of chairs and beds. Replacing traditional furniture with a flattened plane expands the airiness of a room and reduces clutter.

At once luxurious and practical, *A–Z Carpet Furniture* maintains the A–Z principles of unconventional efficacy. Sitting or reclining users are drawn into a mode where material volume is seemingly achieved by means of a playful conceptualism. When not in use, the multipurpose floor coverings can be hung on the wall as art, enriching the personality of a room and freeing valuable space. These features play off a recurring fantasy of dwellers in the restricted spaces of typical urban apartments.

1999 **My Neighbor Charles with His A–Z Carpet Furniture**

Gouache on paper
28¹/₂ x 40 inches (72 x 102 cm)
Collection of Martha Moriarty, Madrid

1993 A–Z Carpet Furniture (Dining Room Table with Extra Seating) [floor; see also p. 112] and **A–Z Carpet Furniture (Couch with End Table)** [wall]

Silk and wool dye on wool and acrylic carpet
Table and seating: 96 x 96 inches (244 x 244 cm);
couch and table: 48 x 96 inches (122 x 244 cm)
Collection of Thomas Solomon, Los Angeles

Installation view with Sandra, *Add Hot Water*, Sandra Gering Gallery, New York, 1993

1993 A–Z Carpet Furniture (Table with Two Chairs) [foreground] and
A–Z Carpet Furniture (Brown and Red Double Bed) [background]

Silk and wool dye on wool carpet
94 1/2 x 72 inches (240 x 183 cm) each
Private Collection

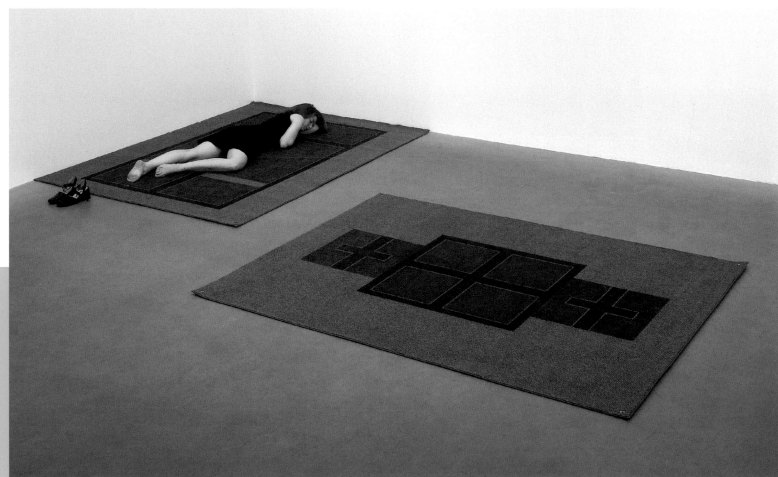

1992 **A–Z Carpet Furniture (Bed with Two Night Stands)** [foreground],
A–Z Carpet Furniture (Small Desk and Chair) [back right], and
A–Z Carpet Furniture (Chair and Table) [back left]

Silk and wool dye on wool carpet
Bed and night stands: 96 x 96 inches (244 x 244 cm); desk and chair: 48 x 48 inches
(122 x 122 cm); chair and table: 48 x 48 inches (122 x 122 cm)
Collection of Barbara and Howard Morse, New York

1993 **A–Z Carpet Furniture (Dining Room Table with Extra Seating)**
[floor; see also p. 111]

Silk and wool dye on wool and acrylic carpet
Table and seating: 96 x 96 inches (244 x 244 cm)
Collection of Thomas Solomon, Los Angeles

1993 **A–Z Carpet Furniture (Table with Two Chairs)** [left wall] and
A–Z Carpet Furniture (Twin Bed with Night Stand) [right wall]

Silk and wool dye on wool and acrylic carpet
Table and chairs: 72 x 72 inches (183 x 183 cm);
bed and night stand: 96 x 96 inches (244 x 244 cm)
Collection of Allison and Thomas Daniel, Honolulu

Installation view from Christopher Grimes Gallery, Santa Monica, California, 1993

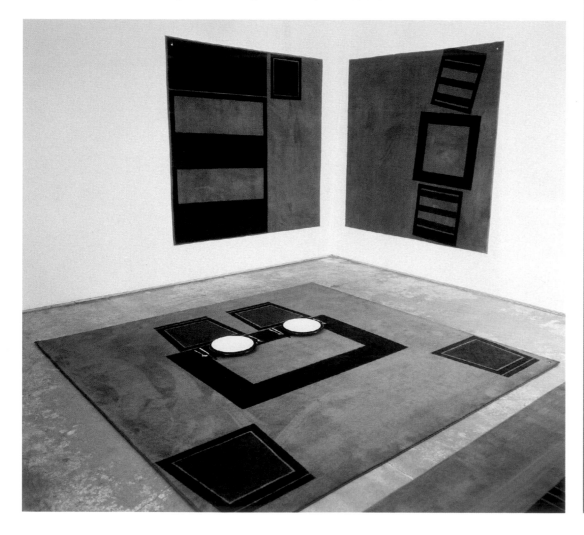

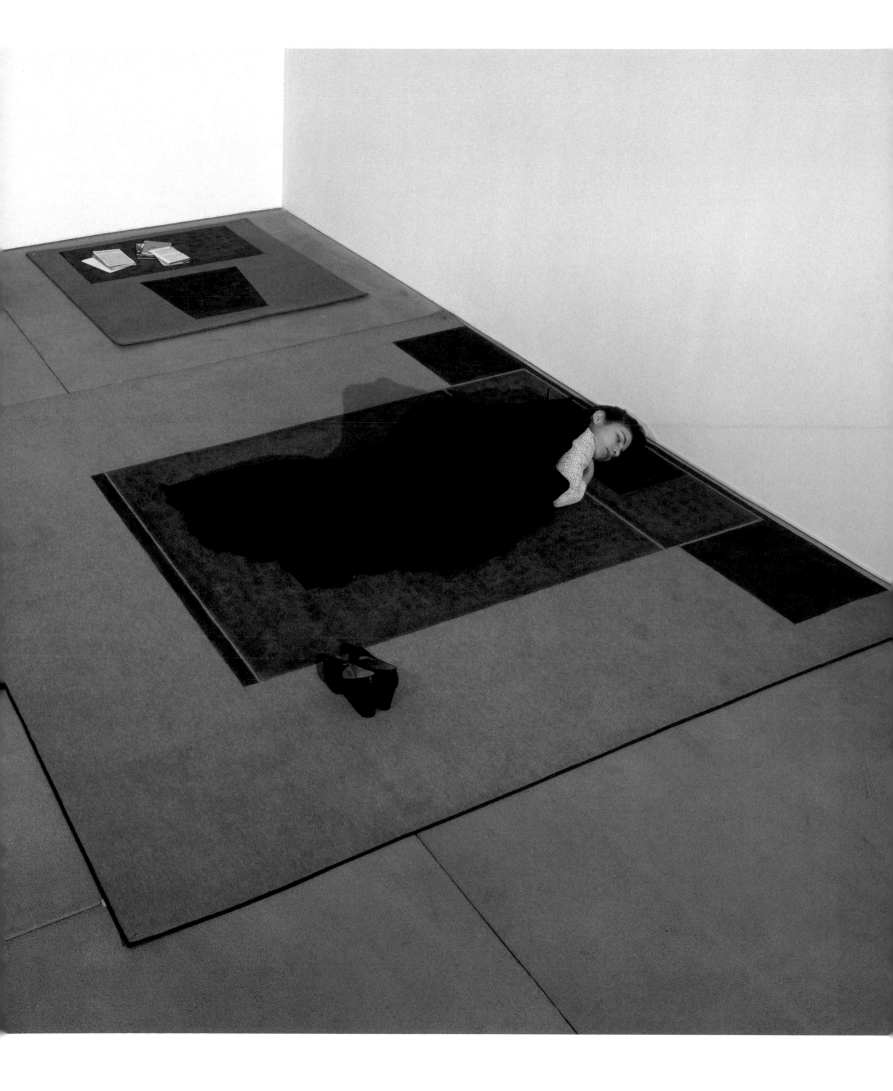

1995 **A–Z Purity Panel**

Embroidered linen
1 of an edition of 5
94 x 52 inches (239 x 132 cm), unfolded

Installation view, *Andrea Zittel: Purity*, Andrea Rosen Gallery, New York, 1993

Expanding her approach to include food consumption and bodily maintenance, Zittel brought the body's most elemental (yet often overlooked or private) physiological functions within the A–Z design scheme. Like much work by Zittel, *A–Z Purity* designs are responses to specific issues regarding personal needs and routines. However, instead of customizing established practices, Zittel drastically stripped down the existing notions of sanitation, nourishment, and shelter, leaving only basic, minimalist forms. Even foodstuffs are reduced to only the most basic sustenance. Each work in this group proposes an approach to living and the architectural distribution of space that reverses established (overcomplicated) norms of domestic hygiene. Whether through a low and chairless wooden dining table that has dishes built in, or a simple stainless steel chamber pot that replaces the superfluous modern toilet, or warm and cool chambers that maintain a perfect temperature in inhospitable rooms, the *Purity* works solve primary human needs with overtly fundamental design solutions. Cleanliness, hunger, and comfort are necessities humans consistently must deal with, but *A–Z Purity* introduces a fresh approach by creating simple models that eliminate the parceling out that modern architecture and design have increasingly imposed on the functions of the human body.

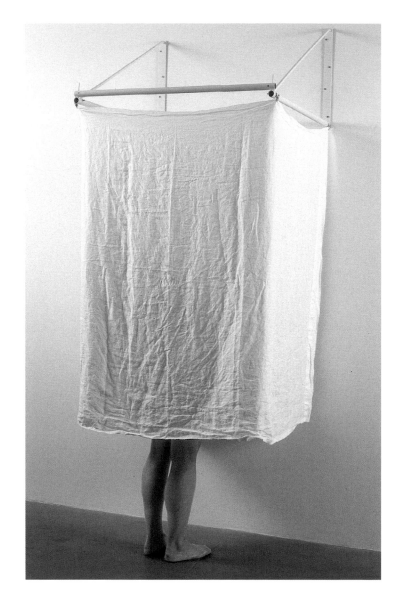

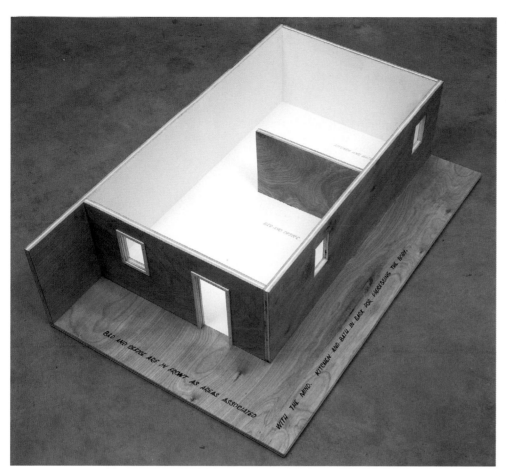

1993 **Domestic Model E**

Wood and paint
8 1/2 x 20 3/4 x 32 inches (22 x 53 x 81 cm)
Courtesy of the artist and Andrea Rosen Gallery, New York

1993 **Domestic Model D**

Wood and paint
8 1/2 x 20 3/4 x 32 inches (22 x 53 x 81 cm)
Courtesy of the artist and Andrea Rosen Gallery, New York

The *Domestic Models* present five plans that divide domestic space by function or furniture organization.

Model A: Cleaner<–>Dirtier: Counter, Table, Bed, Chair
Model B: Cleaner<–>Dirtier: Loft Bed, Mattress and Boxsprings, Futon
Model C: Recommended layout creating 4 specialized areas while maintaining long uncluttered stretches of vision.
Model D: Bed and bath are secluded in back as private areas. Kitchen and office are in front as public area.
Model E: Bed and office are in front as areas associated with the mind. Kitchen and bath in back for processing the body.

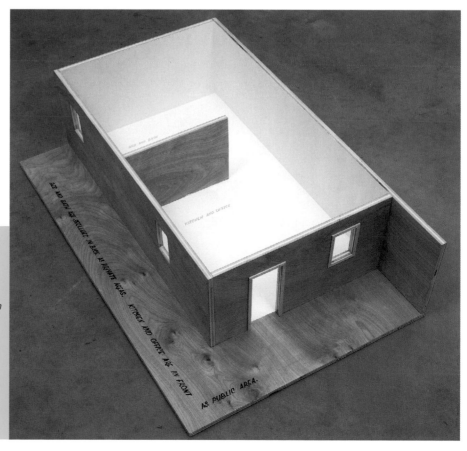

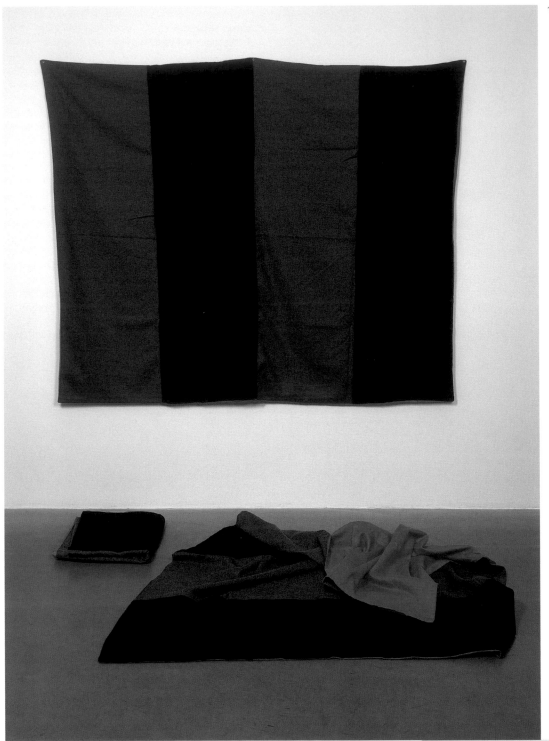

1993 **A–Z Cover**

Wool, velvet, and linen
1 of an edition of 30; 3 covers per edition
3 covers: 72 x 60 inches (183 x 152 cm) each
Courtesy of the artist and Andrea Rosen
Gallery, New York

Presentation photograph [left] and installation
view [bottom], *Andrea Zittel: Purity,* Andrea
Rosen Gallery, New York, 1993

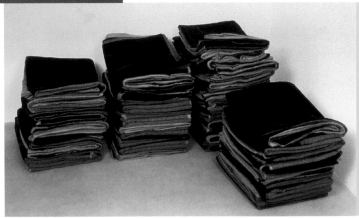

1994 **Prototype for A–Z Small Bed, Set # I**

Wood, foam, upholstery, and trim
4 beds: 17 ½ x 30 x 76 inches (44 x 76 x 193 cm) each

Installation view, A–Z East, 1994

1993 **Documentation for A–Z Cover In Use**

Black-and-white photographs
3 photographs: 7 x 5 inches (18 x 13 cm) each;
4 photographs: 5 x 7 inches (13 x 18 cm) each;
overall dimensions variable
Courtesy of the artist and Andrea Rosen Gallery, New York

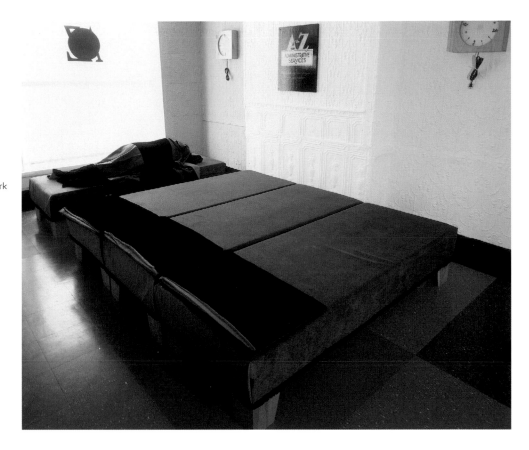

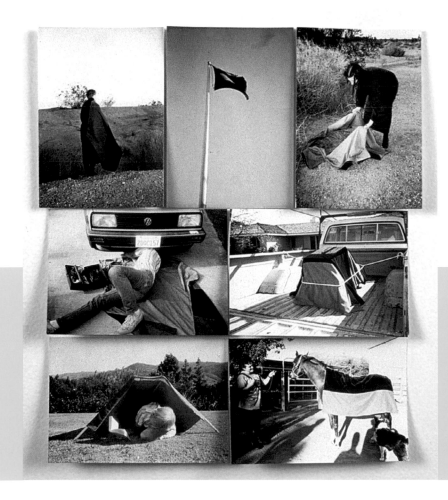

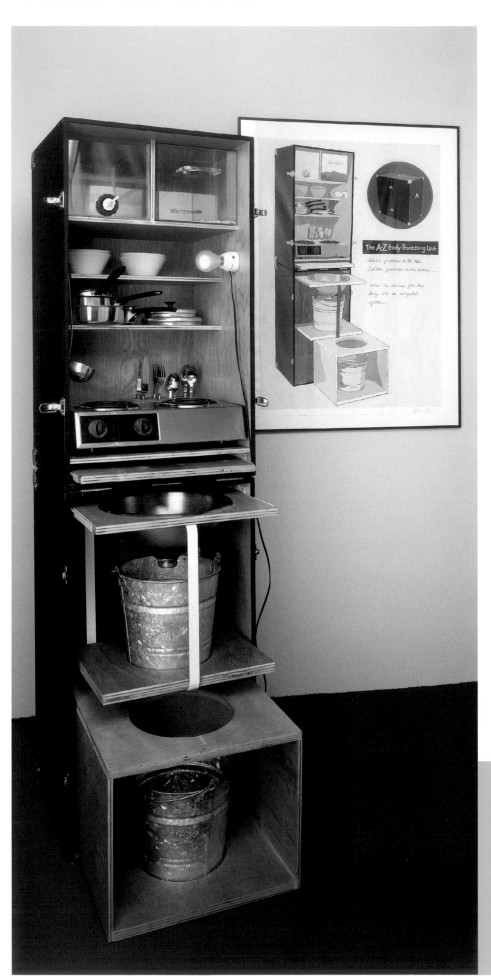

1993 A–Z Body Processing Unit [floor]

Wood, metal, Plexiglas, black vinyl, lighting fixture, stove top, sink, household objects, and *A–Z Food Group* sample
36 x 36 x 18 inches (91 x 91 x 46 cm) closed;
72 x 18 x 18 inches (183 x 46 x 46 cm) open
Private Collection, Turin, Italy
Courtesy Galleria Massimo De Carlo, Milan

1999 A–Z Body Processing Unit [framed drawing on wall]

Gouache on paper
40 x 28½ inches (102 x 72 cm)
Courtesy of the artist and Andrea Rosen Gallery, New York

Installation view, *Andrea Zittel—Personal Programs*, Deichtorhallen, Hamburg, 1999

Although the kitchen and the bathroom are similar to each other, traditional architecture always segregates them in the home. It always seemed that it would be more convenient to create an integrated but well-organized hygienic system: the A–Z Body Processing Unit. The intake functions are on the top and the outtake functions are on the bottom.

1993 A–Z Body Processing Unit [closed]

1993 **Prototype for A–Z Container III**

Spun copper with silver plating
8 containers: 3¹/₂ x 6 inches (9 x 15 cm) diameter, each
Courtesy of the artist and Andrea Rosen Gallery, New York

1993 **Prototype for A–Z Container**

Chromed spun copper
2¹/₂ x 6 inches (15 x 6 cm) diameter
Collection of the artist

*The A–Z Container is a single shape that serves many different containing
needs, for example, both drinking and eating. The original prototype
[right] was spun out of copper and then chromed. The subsequent design
[above], produced for actual use at The A–Z, was spun in copper with a
silver-plated interior. The final version of A–Z Container now in use is
actually an appropriated commercially made glass bowl—a fact that
self-reflexively comments on the nature of the experimental fabrication
process.*

1993 **A–Z Dishless Dining Table**

Wood, steel, and paint
Table: 29 1/8 x 36 x 36 inches (74 x 91 x 91 cm);
stool: 18 x 13 7/8 x 13 7/8 inches (46 x 35 x 35 cm)
Goetz Collection, Munich

Installation view, *Andrea Zittel—Personal
Programs*, Deichtorhallen, Hamburg, 1999

1993 **A–Z Food Group**

Dehydrated food
Dimensions variable
Courtesy of the artist and Andrea Rosen Gallery,
New York

A–Z Food Group

*A combination of twelve essential ingredients
comprising grains, legumes, fruits, and vegetables
is cooked and then dehydrated. The food group
can be eaten dry, cooked as a stew, formed into
patties, or baked as a loaf.*

2001 **A–Z Food Group: The Compounds of Life**

Gouache on paper
30 x 22 inches (76 x 56 cm)
Goetz Collection, Munich

2000 **A–Z Food Group Prep Unit**

Birch plywood, glass jars, refrigerator, cutting board,
knives, dehydrator, and dehydrated food
84 x 48 x 24 inches (211 x 122 x 61 cm)
Courtesy of the artist and Andrea Rosen Gallery, New York

Interior view, A–Z East, 2000

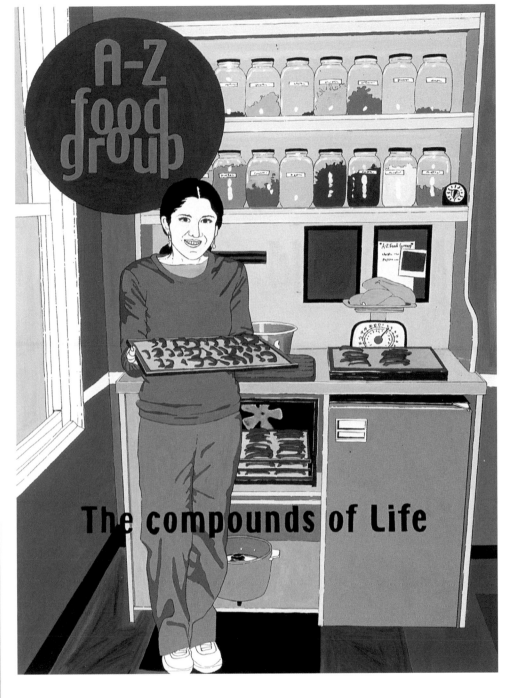

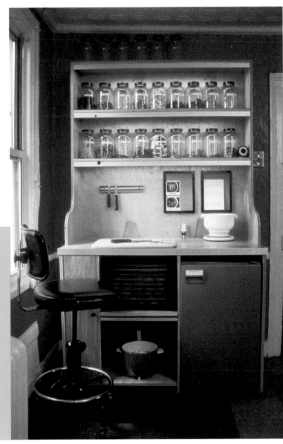

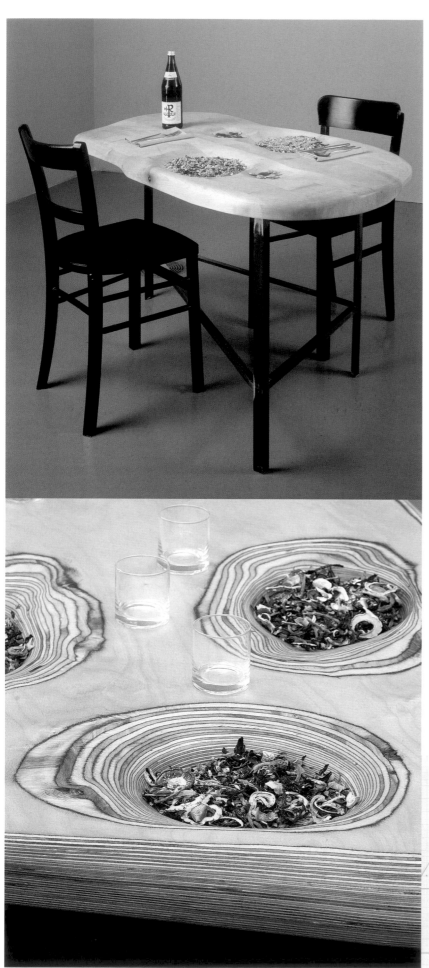

1999 **A–Z Raugh Dishless Dining Table**

Wood, metal, and paint
29 x 59 x 30 inches (74 x 150 x 76 cm)
Goetz Collection, Munich

Installation view, *Andrea Zittel—Personal Programs*, Deichtorhallen, Hamburg, 1999

2001 **A–Z Dishless Dining Terrain** (detail)

Wood, steel, carpet, and dehydrated food
91 x 39 x 12 inches (231 x 99 x 30 cm) overall
Courtesy of Galleria Massimo De Carlo, Milan

2000 **Study for A–Z Dishless Dining Terrain**

Pencil on graph paper
8½ x 11 inches (22 x 28 cm)
Courtesy the artist

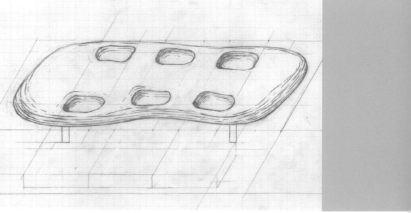

2001 A–Z Boxed Eating Terrain with Carpet

Wood, steel, carpet, and dehydrated food
118 x 118 x 12 inches (300 x 300 x 30 cm)
Private Collection, Padua, Italy

Installation view, *Everlasting and Complete: A–Z Food Group and
A–Z Eating Environments*, Galleria Massimo De Carlo, Milan, 2001

2001 A–Z Boxed Eating Terrain

Wood, steel, carpet, and dehydrated food
Structure: 47 x 47 x 12 inches (119 x 119 x 30 cm);
carpet: 118 x 118 inches (300 x 300 cm)
Collection of Pierluigi Mazzari, Milan

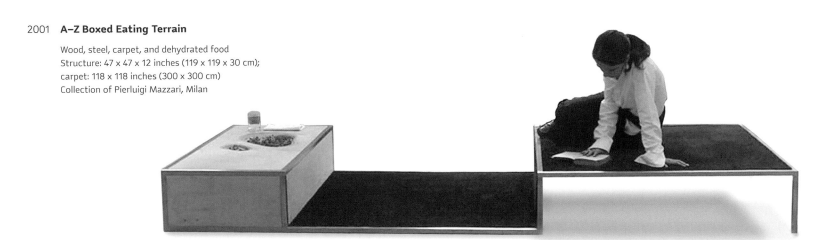

1993 **Prototype for A–Z Cool Chamber** [left]

Wood, steel, paint, air conditioner, and light
84 x 32 x 50 inches (213 x 81 x 127 cm)
Collection of David and Diane Waldman, Rancho Mirage, California

1993 **Prototype for A–Z Warm Chamber** [right]

Wood, steel, paint, heater, and light
84 x 32 x 50 inches (213 x 81 x 127 cm)
Private Collection, Courtesy of Galleria Massimo De Carlo, Milan

Installation view, *Andrea Zittel: Purity*, Andrea Rosen Gallery, New York, 1993

Jim in *Prototype for A–Z Warm Chamber*, Andrea Rosen Gallery, New York, 1993.

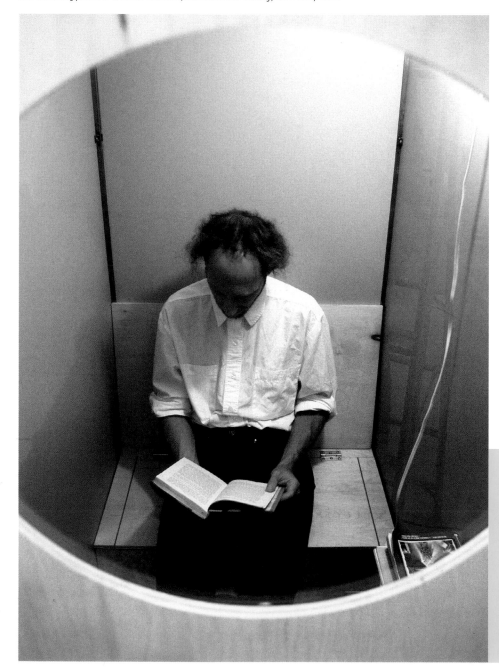

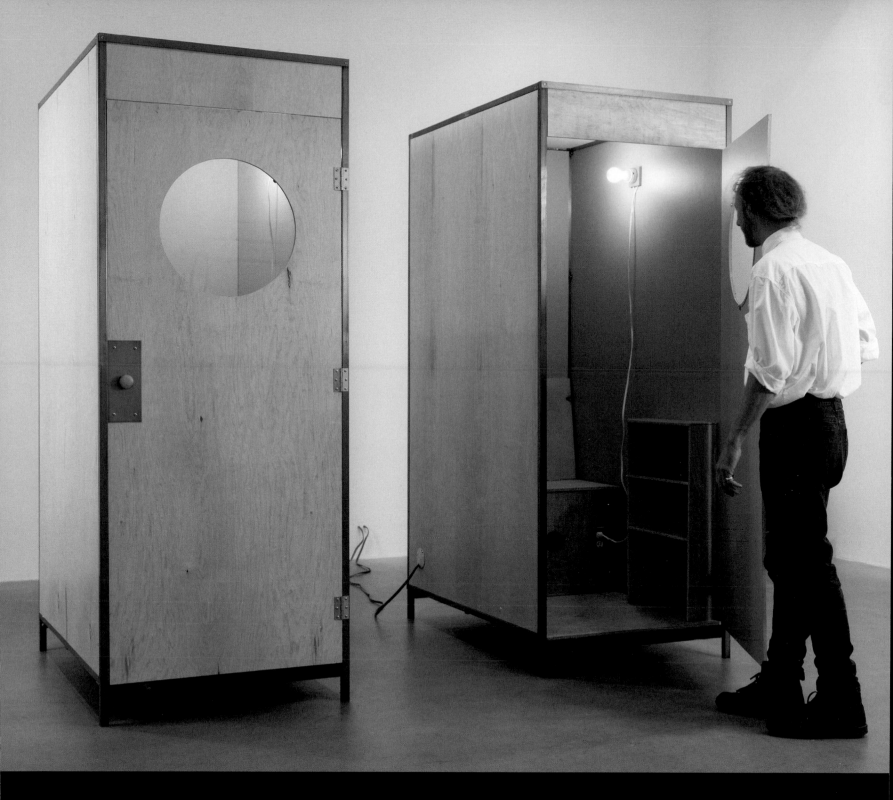

1993 **Prototype for A–Z Cleansing Chamber** [right and below]

Glass, wood, steel, paint, and cotton curtain
84 x 62 ¼ x 32 inches (213 x 158 x 81 cm)
San Francisco Museum of Modern Art;
Gift of Dare and Themistocles Michos,
San Francisco, in honor of Madeleine Grynsztejn

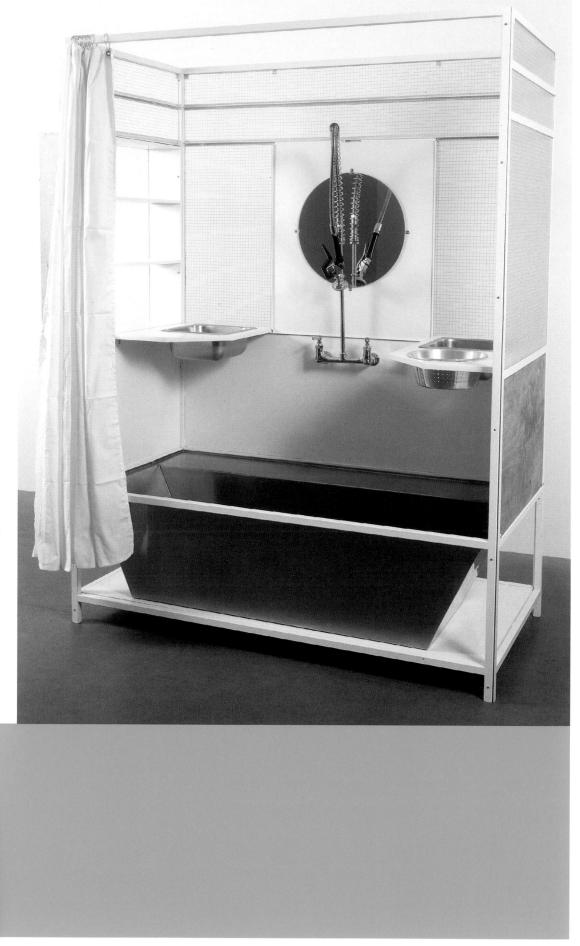

2002 **A–Z Wallens**

Two screen-printed cast aluminum and tempered
glass port lights and hardware in silk-screened
wooden crate
2 of an edition of 12
Lights: 14 inches (36 cm) diameter; with custom-made
crate: 22 x 39 x 10 inches (56 x 99 x 25 cm)
Courtesy of the artist and Editions Fawbush, New York

Interior views, private apartment [left] and
bathroom of Andrea Rosen Gallery, New York [bottom]

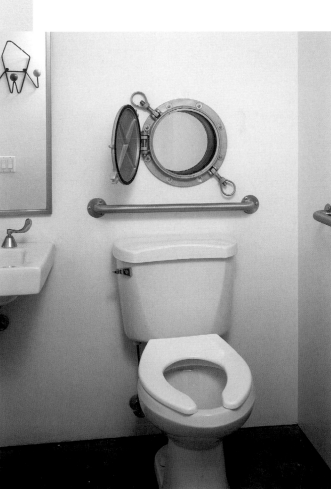

A–Z LIVING UNIT

Wanting to maximize the space in her 200-square-foot studio, Zittel used the *A–Z Management and Maintenance Unit* (1992) to coordinate her living functions into one three-dimensional grid that provided a simultaneous sense of home, freedom, and security. Extending this prototype to address the needs of others, Zittel began a prolific exploration into highly personalized and compact inhabitable structures that are intended to allow owner customization.

The *A–Z Living Unit* organizes everyday activities—eating, working, socializing, and resting—into streamlined experiences. An *A–Z 1993 Living Unit* is a compact system for personal activities, which folds into a trunklike format for transportation; it was manufactured to include closet and storage spaces with portable seating. The 1994 model developed into a more complex structure with integrated working and lounging areas.

With the added freedom of easy repositioning, the *Living Units* have been used in homes and offices, and have even traveled with owners. They are expressions of the recurring search for freedom found in Zittel's work. Seeking to transform limitations into luxuries, they are paradigms of the ideal A–Z lifestyle. Zittel later extended her investigation from the arena of utilitarian and comfortable living to the realm of fantasy (in such works as *A–Z Escape Vehicle* and *A–Z Pocket Property*), exploring its role in the ideas of home and landed property within the controlled structure of contemporary capitalist economies.

Prototype for A–Z Management and Maintenance Unit, A–Z Administrative Services, 72 South 8th Street, Brooklyn, 1992.

A–Z Administrative Services at 72 South 8th Street, Brooklyn. Zittel occupied the 200-square-foot storefront area of the red building.

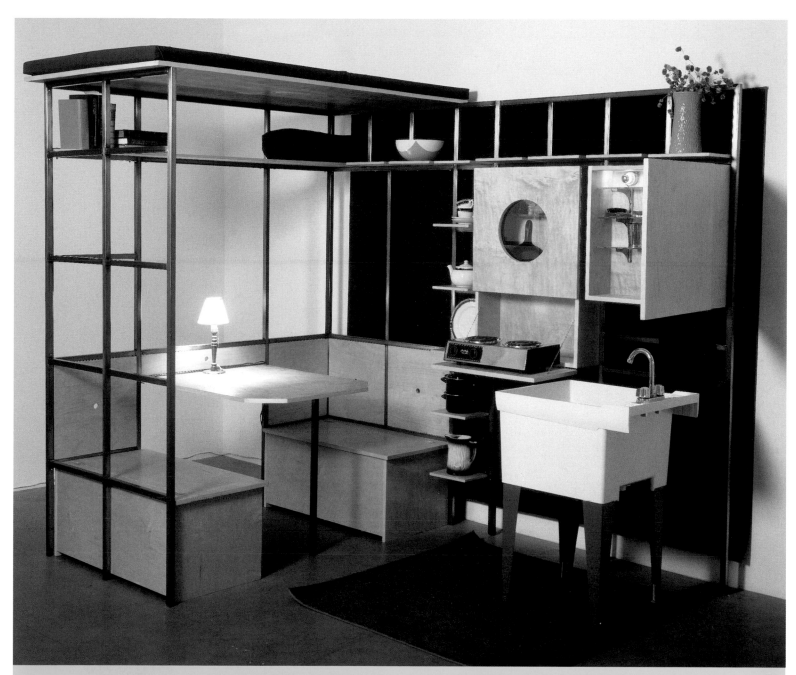

1992 **A–Z Management and Maintenance Unit, Model 003**

Steel, wood, carpet, plastic sink, glass, mirror, stovetop, and household objects
86 x 94 x 68 inches (218 x 239 x 173 cm)
Collection of Andrea Rosen, New York

A–Z 1993 Living Unit

Steel, wood, light, cot, stools, mirror, stovetop, toaster oven, and household objects
60 x 40 x 30 inches (152 x 102 x 76 cm) closed; 60 x 40 x 61 (152 x 102 x 155 cm) open
Milwaukee Art Museum; Gift of Contemporary Art Society, M2003.151

Second *A–Z 1993 Living Unit* (closed) in background.

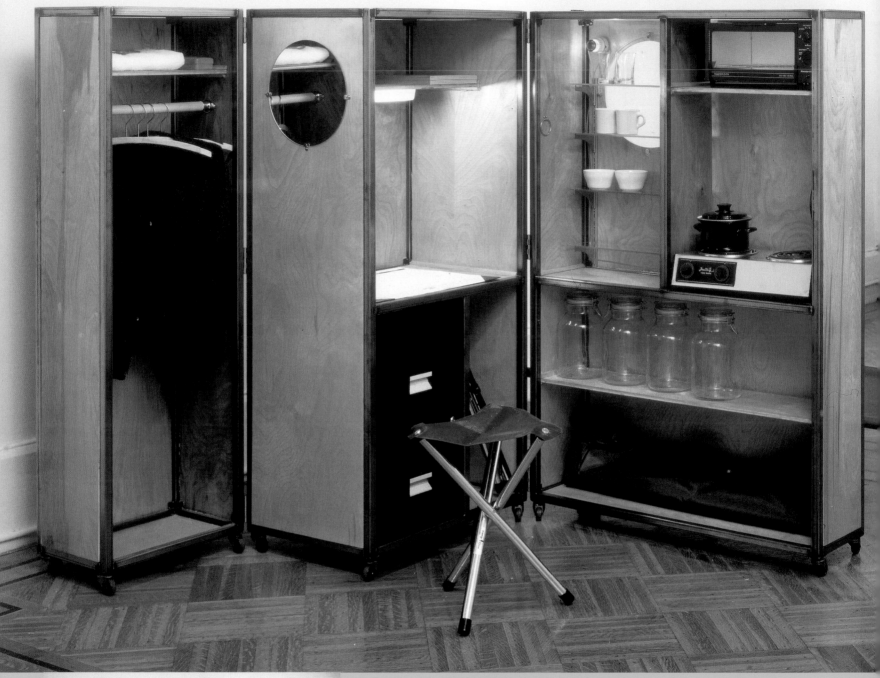

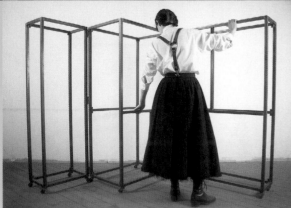

Zittel with frame for *A–Z 1993 Living Unit* prior to full assembly;
presentation photograph taken for brochure for Jack Hanley Gallery, 1993.

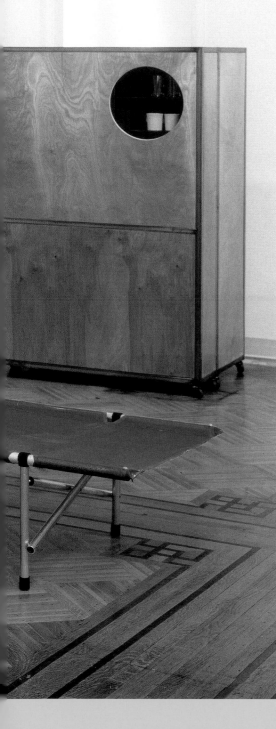

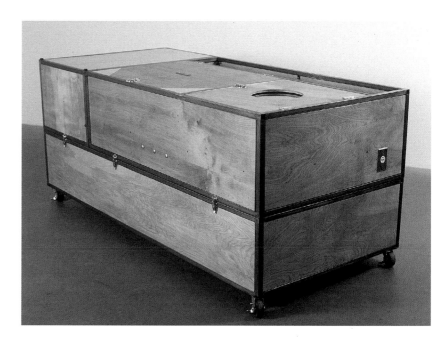

A–Z 1994 Living Unit [closed]

1994 **A–Z 1994 Living Unit**

Steel, birch plywood, metal, mattress, glass, mirror, lighting fixture,
stovetop, toaster oven, green velvet, and household objects
36¾ x 84 x 38 inches (93 x 213 x 96 cm) closed
Collection of Patrizia Sandretto Re Rebaudengo, Turin, Italy

View of open unit with John reading.

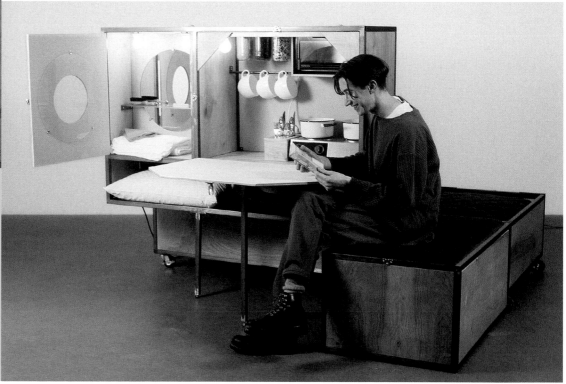

Steel, birch plywood, metal, mattress, glass, mirror, lighting fixture,
stovetop, toaster oven, green velvet, and household objects
57 x 84 x 82 inches open (145 x 213 x 208 cm) open
Collection of Patrizia Sandretto Re Rebaudengo, Turin, Italy

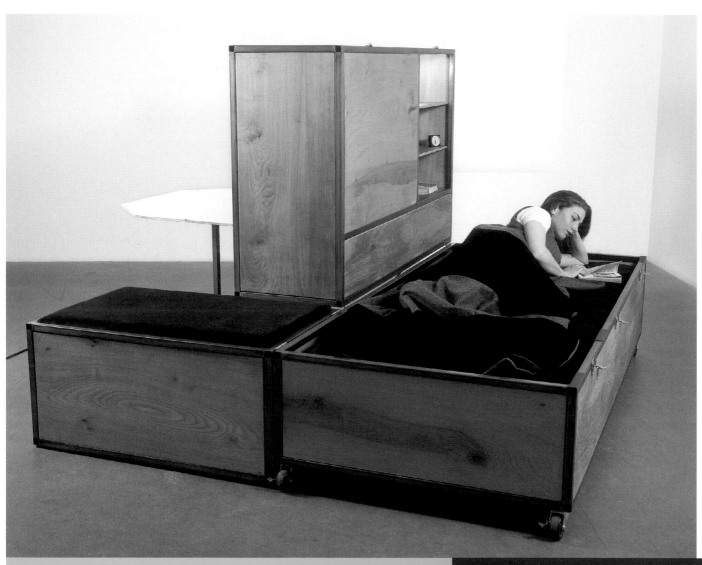

1994 **A-Z 1994 Living Unit Customized for Eileen and
Peter Norton** (detail)

Steel, birch plywood, paint, foam mattress, glass, mirror, lighting
fixture, upholstery fabric, appliances, and household objects
59 x 84 x 82 inches (150 x 213 x 208 cm) open
Collections of Eileen Harris Norton and Peter Norton,
Santa Monica, California

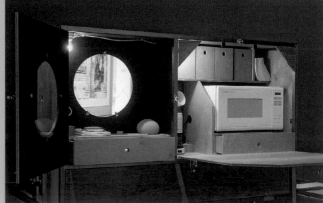

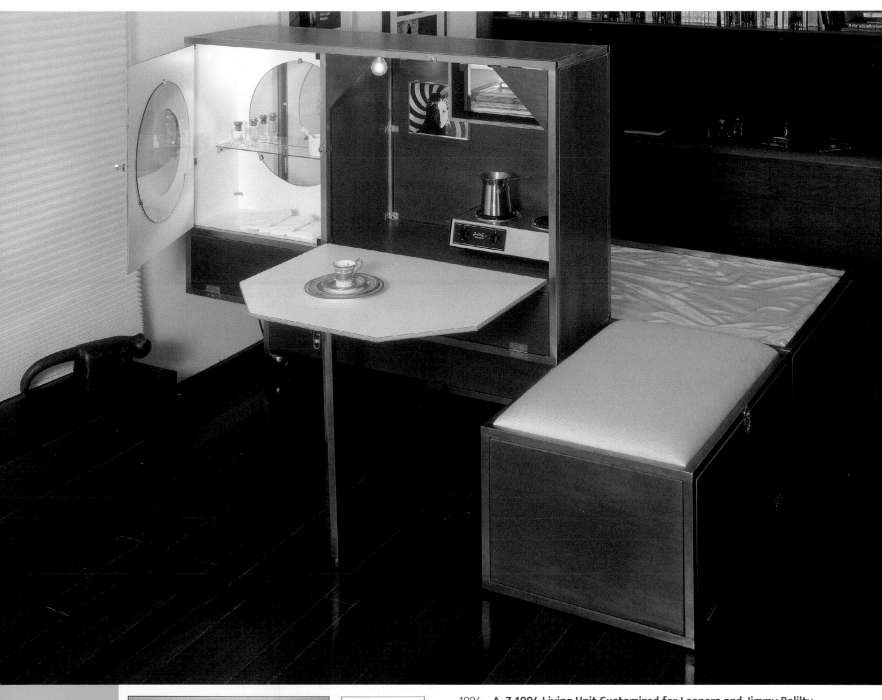

- The kitchen, vanity, and bookshelf/entertainment areas are internally lit, eliminating the need for additional lighting
- Integrated wiring allows the entire unit to be powered with a single cord
- A-Z provides each unit with a unique color scheme and other special features

Talk to us! **A-Z** will be happy to create an individual formula specific to your needs

1994 **A–Z 1994 Living Unit Customized for Leonora and Jimmy Belilty**

Steel, wood, mattress, glass, mirror, lighting fixture, stovetop, toaster oven, fabric, and household objects
57 x 84 x 82 inches (145 x 213 x 208 cm) open;
36 3/4 x 84 x 38 inches (93 x 213 x 96 cm) closed
Collection of Annibale and Marida Berlingieri

Brochure for *A–Z 1994 Living Unit* (detail), 1994.

1995 **A–Z Comfort Unit with Special Comfort Features by Dave Stewart: (Dining Service)** (detail)

Steel, birch plywood, velvet, Plexiglas, foam, audio/video equipment, and objects
Bed: 48 x 78 x 52 inches (122 x 198 x 132 cm);
4 service stations, 54 x 25 1/2 x 18 inches (137 x 65 x 46 cm) each
Collection of Tate Modern, London

Installation view, *1995 Whitney Biennial Exhibition*, Whitney Museum of American Art, New York, 1995

The A–Z Comfort Unit *features a large, fortlike bed with roll up service stations designed for writing, dining, or other requirements. With two carts docked at either side of the bed, two people can perform different activities in the* Comfort Unit *at the same time. One can perform all of the day's tasks without ever leaving the security and comfort of bed.*

Here Zittel explores the efficacy of a commonly held conceptual fantasy, staying in bed, by reshaping an environment into a workable physical solution for doing exactly that.

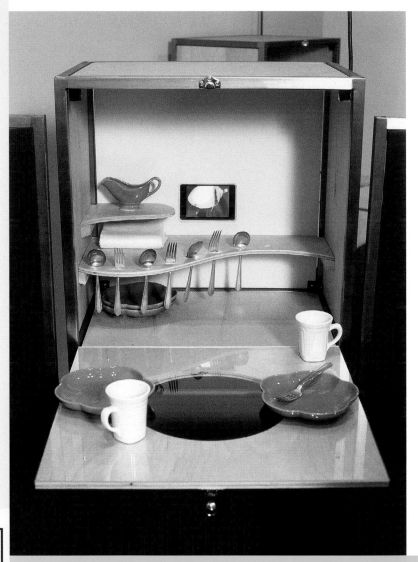

Brochure for *A–Z Comfort Unit* (detail), 1994.

A3 is committed to comfort. In order to satisfy this most basic human need we have developed the Comfort Unit.

- The Comfort Unit consists of five elements: a large comfortable bed and four mobile service units
- The functions of the service units are: dining, vanity, office and one additional unit for customization
- The units fit snugly into a side opening in the bed

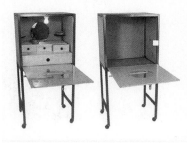
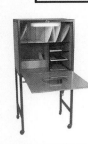
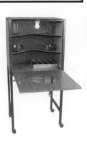

1994 A–Z Comfort Unit Customized for the Cincinnati Art Museum

Steel, birch plywood, velvet, Plexiglas, foam mattress, and objects selected by Museum
Bed: 48 x 78 x 52 inches (122 x 198 x 132 cm); 4 service stations: 54 x 25 ¹/₂ x 18 inches
(137 x 65 x 46 cm) each
Cincinnati Art Museum; Museum Purchase, Gift of RSM Co., by exchange

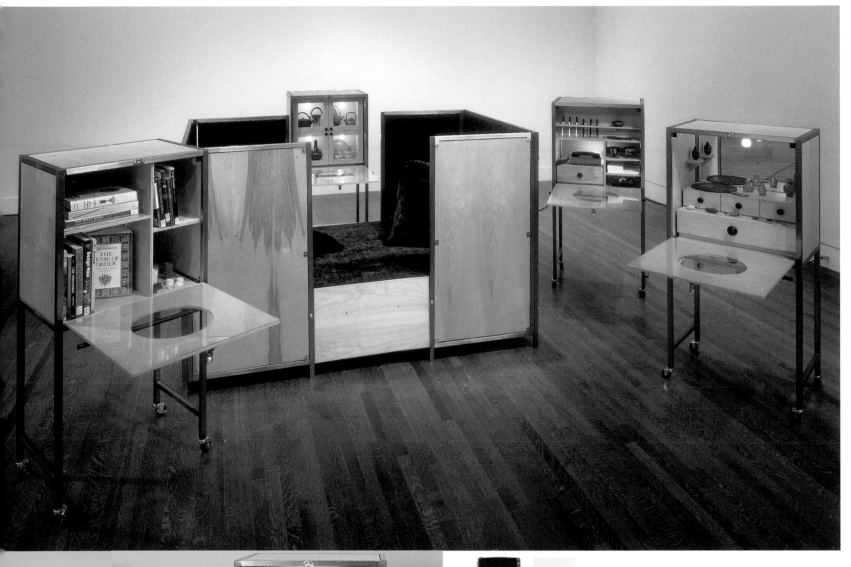

Letter Desk Service Unit #1 for *A–Z Comfort Unit* (detail).

Fabric and paint samples for *A–Z Comfort Unit with
Special Comfort Features by Dave Stewart*, 1995.

1995 **A–Z Perfected Pillows**

Gouache on paper
9 x 12 inches (23 x 30 cm)
Collection of Dorothy Spears, New York

As the designs for living progressed, Zittel decided that their requisite functionality and efficiency should further incorporate another fundamental need: comfort. Zittel maximized the confluence of function and comfort with the *A–Z Blanket Bed* (1993), which combines comforter, mattress, and sleeping bag into one versatile bedding that can also serve as curtains, carpeting, and so on, and with the *A–Z Fled* (1994) or the floor bed. Finally, the *A–Z Pit Bed* and the *A–Z Platform Bed* (both 1995) emphasize the experience of being, respectively, inside or on top of a bed. Though its nestlike confines can seem at times claustrophobic, the *Pit Bed* is more intimate and protective than earlier designs and promotes interpersonal relationships. The raised *A–Z Platform Bed* can glide from room to room, which allows an increased ease of social interaction. Ultimately an individual's sleeping arrangement may be easily altered by personal preference.

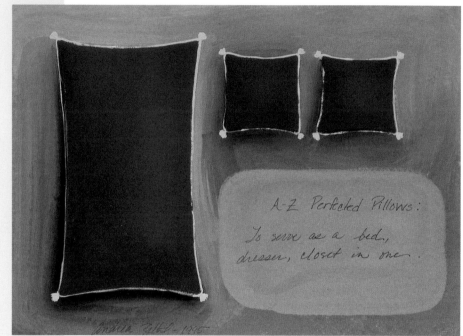

A–Z Perfected Pillows:
To serve as a bed,
dresser, closet in one.

The Small Bed
Isolation or socialization. As you desire

One as a set of four. Set apart fosters quiet seclusion.
Placed together several small beds create a situation of ease and interaction

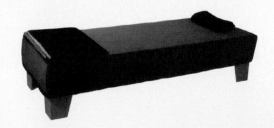

Artist's book, *Andrea Zittel, Selected Sleeping Arrangements: The A–Z Bed Book*, 1995.

1994 **A–Z Fled, Set #1**

Wood, foam, upholstery, buttons, and trim
Edition of 2; 6 fleds per edition
3 ¼ x 48 x 36 inches (8 x 122 x 91 cm) each
Destroyed

Installation view with Andrea, A–Z East, 1994

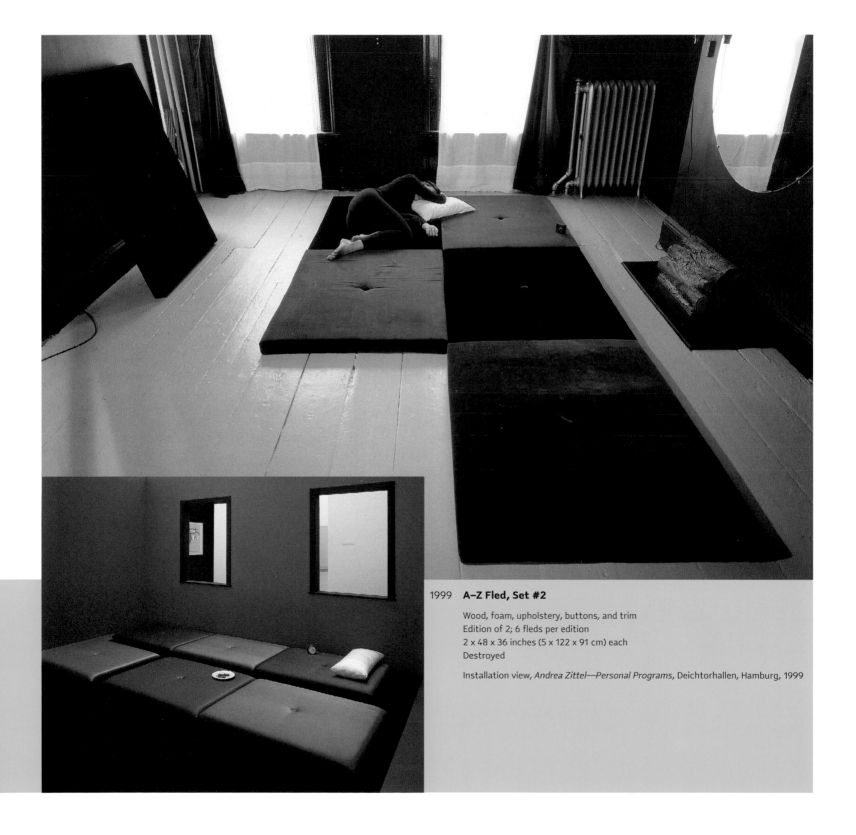

1999 **A–Z Fled, Set #2**

Wood, foam, upholstery, buttons, and trim
Edition of 2; 6 fleds per edition
2 x 48 x 36 inches (5 x 122 x 91 cm) each
Destroyed

Installation view, *Andrea Zittel—Personal Programs*, Deichtorhallen, Hamburg, 1999

1995 **Prototype for A–Z Platform Bed**

Wood, foam, upholstery fabric, wheels, and trim
25 x 97 inches (64 x 246 cm) diameter
capc Musée d'art contemporain, Bordeaux, France

Interior view with Tatiana and Charlie in
A–Z Comfort Room, A–Z East, 1995

1996 **A–Z Pit Bed Customized by Edward Lloyd
and Ron Cervasio**

Wood, carpet, foam, and hardware
18 x 96 x 144 inches (46 x 244 x 366 cm)
Courtesy of the artist and Andrea Rosen Gallery, New York

Installation view, *Social Fictions: Lari Pittman/Andrea Zittel,*
Barbara & Steven Grossman Gallery, School of the Museum
of Fine Arts, Boston, 1996

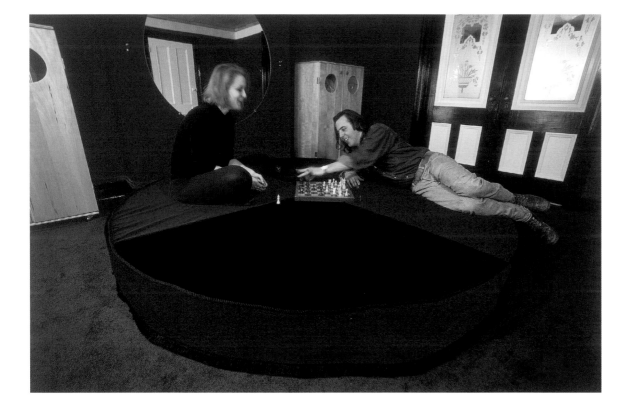

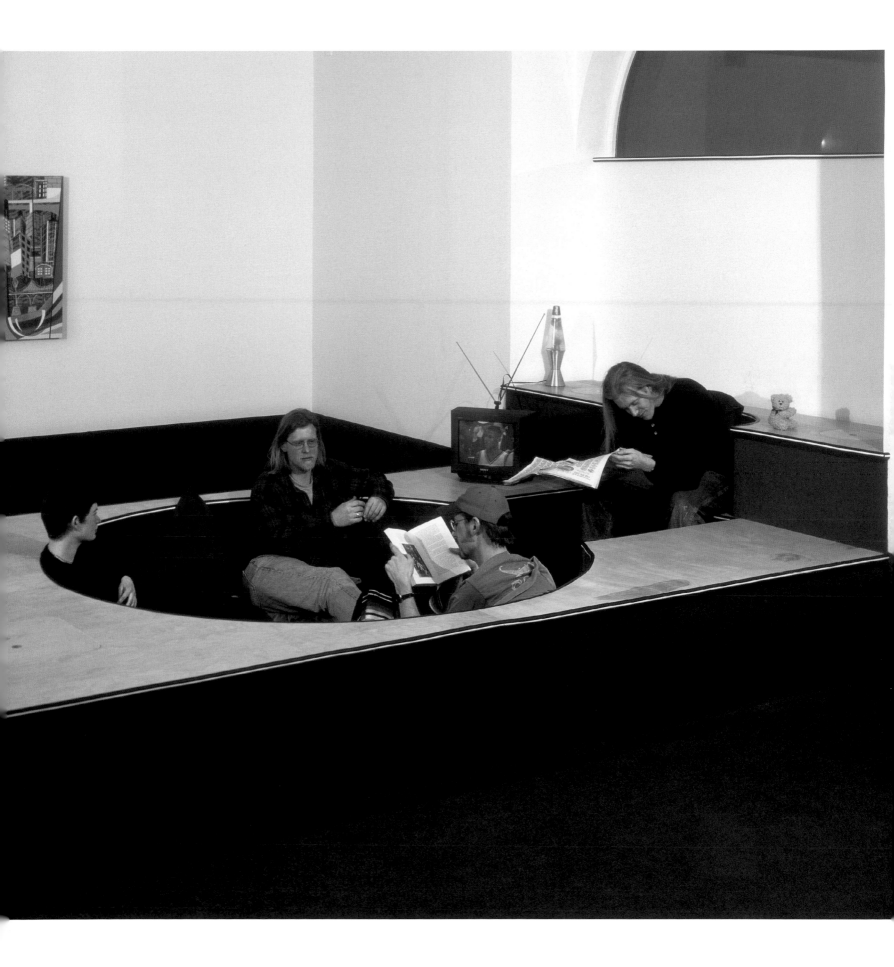

Investigate

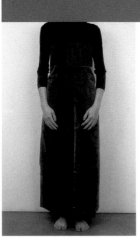

1991
Housefly Breeding Unit

A–Z Quail Breeding Unit

A–Z Bantam Breeding Project

1993
A–Z Breeding Unit for
Reassigning Flight

A–Z Breeding Unit for
Averaging Eight Breeds

1994
A–Z Clock
Model for the Timeless Chamber

1999
A–Z Time Trials

Free Running Rhythms and Patterns

2000
A–Z Time Tunnel

2001
A–Z Advanced Technologies

2002
A–Z Fiber Form Uniform

A–Z Paper Pulp Panel

The Regenerating Field

present

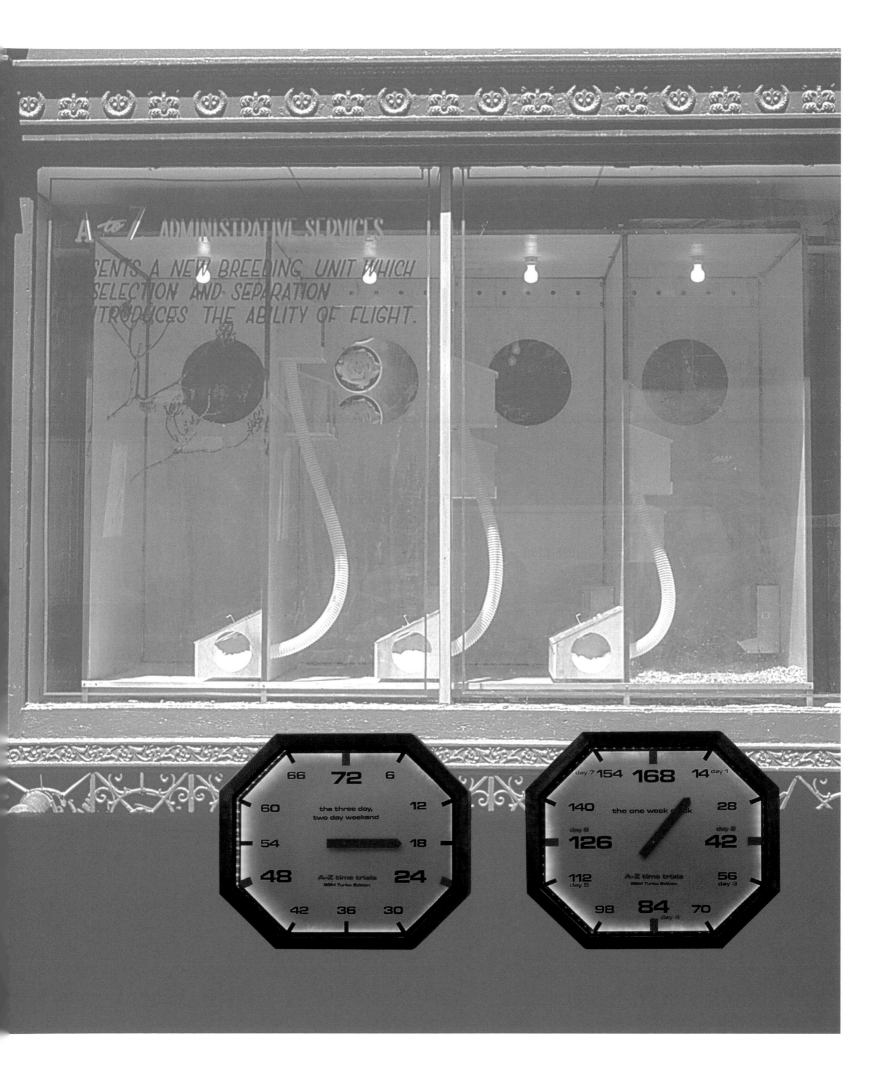

1991 **Missouri Egg Machine**

Graphite on vellum in plastic sleeve
11 7/8 x 15 1/8 inches (30 x 38 cm)
Courtesy of the artist and Andrea Rosen Gallery, New York

I'm much more interested in doing experiments to find out what happens if I do this, what happens if I do that. And obviously there are flaws. When I do my slide lecture, it's basically a discussion from one flaw to the next. Every single piece is flawed in some way, and it's that flaw that I work off of for the next piece. So making mistakes is a very optimistic process because it's like, "Oh yeah," I can fix this in the next piece.[4]

pp. 140–41

1995–1998 **"Window Pane" A–Z Personal Panel Uniform (Olive, Red, and Black)**

Velvet, wool, and lining with black elastic shoulder straps
Goetz Collection, Munich

1993 **A–Z Breeding Unit for Reassigning Flight**

Steel and birch plywood
170 x 20 x 60 inches (432 x 51 x 152 cm)
Courtesy of the artist

Installation view, *The Final Frontier*, New Museum of Contemporary Art, New York, 1993

1999 **A–Z Time Trials (BSM Turbo Edition)** [clocks]
(detail)

Wood and steel frames, clockwork, and electric motors
1 customized set of an edition of 7; 5 clocks per edition
26 x 29 7/8 x 2 3/8 inches (66 x 74 x 75 cm) each
Collection of Burton S. Minkoff

BREEDING WORKS

1991 **Family Tree Apartment Complex**

Vinyl and shrubbery
6 x 17 x 5½ inches (15 x 43 x 14 cm)
Collection of Barbara and Howard Morse, New York

The *Breeding Works* were inspired in part by the development of the modern ideal "purebred" that was introduced in the mid-eighteenth century. Zittel wanted to explore the ingrained social impulses that led to the creation of a hierarchy of lineage and exclusivity, as well as experiment with their expression in art and design. Houseflies and Cortunix quails were subjects of her first partially successful experiments. She then selected Bantam chickens for their miniature and manageable size, as well as their distinct genetic traits (such as fuzzy feathers, topknots, and a wide range of color variations).

Ultimately, the *Breeding Works* questioned the human desire to create artificial distinctions in the animals that are adopted as pets. Zittel later re-adapted her meticulous design of functional animal "management units" for the streamlining of breeding operations to her investigation of personal domestic conditions, leading by an indirect route to the *A–Z Living Unit* for *Homo sapiens*.

1991 **Ponds for Developing Amphibian Appendages**

Vinyl and shrubbery
2½ x 18½ x 7 inches (6 x 47 x 18 cm)
Collection of Barbara and Howard Morse, New York

Zittel tending houseflies.

Housefly pupae and liver.

1991 **Housefly Breeding Unit**

Medium density fiberboard, 80-gallon tank, larvae,
pupae, flies, water, liver, sugar, and milk
50 x 13 x 72 inches (127 x 33 x 183 cm)
Destroyed

The *Housefly Breeding Unit* housed successive generations of a contained
gene pool of common houseflies. It sought to find out if a new kind of
housefly would evolve (or be created) simply by breeding the offspring of
the same 150 houseflies over and over again. However, the mutations
tended to revert to their original state.

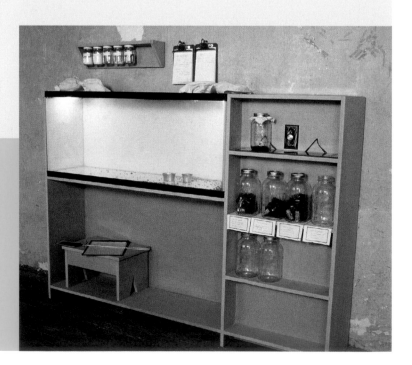

1992 **Lulu Advises**

Black Rosecomb Bantam chicken, hand-lettered sign, and stools
48 x 60 x 24 inches (122 x 152 x 61 cm)
Courtesy of the artist

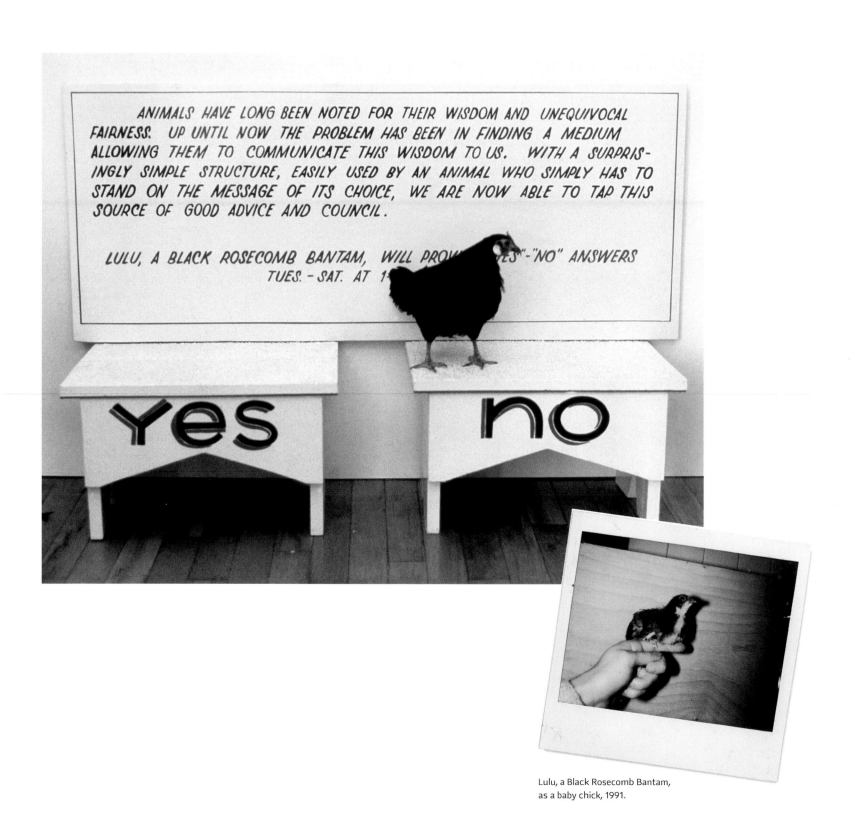

ANIMALS HAVE LONG BEEN NOTED FOR THEIR WISDOM AND UNEQUIVOCAL FAIRNESS. UP UNTIL NOW THE PROBLEM HAS BEEN IN FINDING A MEDIUM ALLOWING THEM TO COMMUNICATE THIS WISDOM TO US. WITH A SURPRISINGLY SIMPLE STRUCTURE, EASILY USED BY AN ANIMAL WHO SIMPLY HAS TO STAND ON THE MESSAGE OF ITS CHOICE, WE ARE NOW ABLE TO TAP THIS SOURCE OF GOOD ADVICE AND COUNCIL.

LULU, A BLACK ROSECOMB BANTAM, WILL PROV...YES"-"NO" ANSWERS TUES. - SAT. AT 1...

Yes no

Lulu, a Black Rosecomb Bantam,
as a baby chick, 1991.

Single-Egg Incubator

Medium density fiberboard, heating element, glass, metal mesh, and metal tray
1 of an edition of 2
11$\frac{1}{2}$ x 10$\frac{1}{2}$ x 10 inches (29 x 27 x 25 cm)

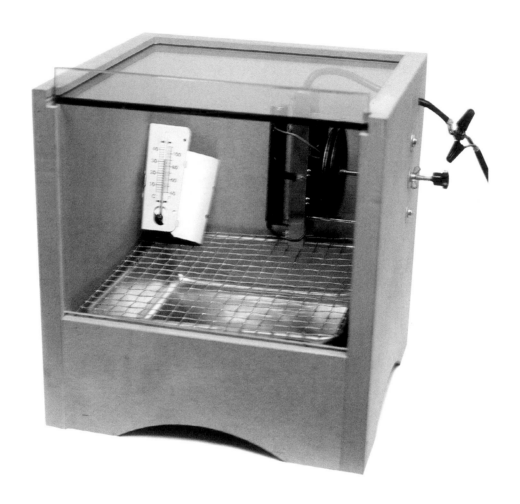

Typical incubators in systems of factory production hatch dozens of eggs at a time. The *Single-Egg Incubator* pointedly and drolly only incubates one egg at a time, relating a chicken breeding operation more closely to human reproduction.

1991 **A–Z Quail Breeding Unit**

Eight Cortunix quail, glass doors, medium density fiberboard, mesh, metal containers,
heating element, feeder, eggs, woodchips, incubator, lamp, and thermostat
60 x 72 x 24 inches (152 x 61 x 183 cm)
Destroyed

Installation view, *Plastic Fantastic Lover (object a)*, Blum Helman Warehouse, New York, 1991

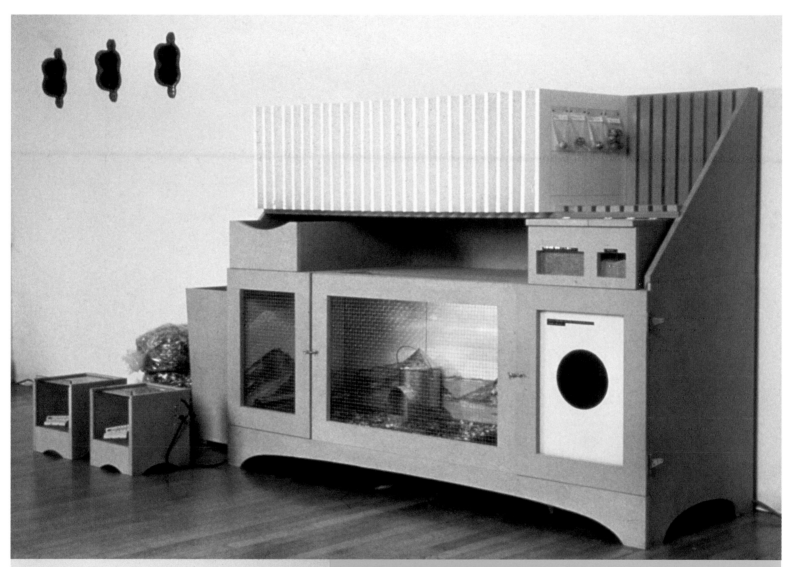

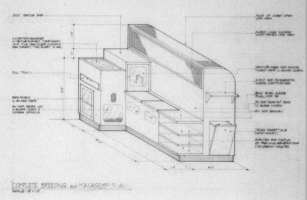

1991 **Study for A–Z Complete Breeding and Management Unit**

Pen on white tracing paper
30 x 35½ inches (76 x 90 cm)
Courtesy of the artist and Andrea Rosen Gallery, New York

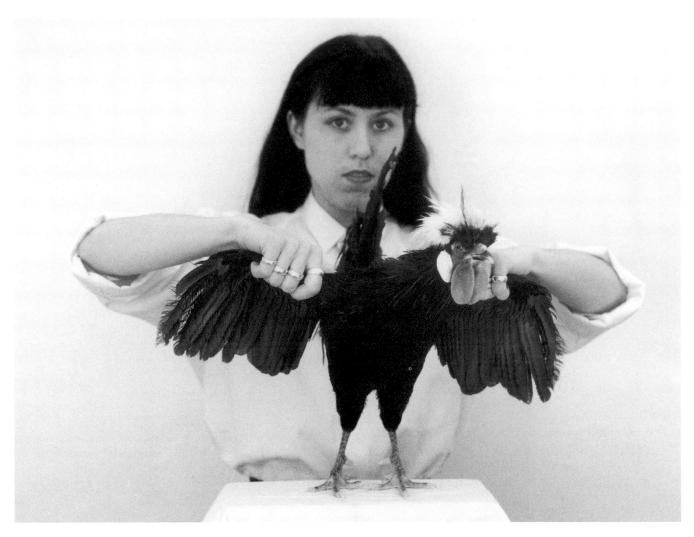

Zittel holding white-crested, black Polish Bantam chicken,
A–Z Bantam Breeding Project, 1991.

1992 **Model and Faulty Houdan Crests** (detail)

Graphite on paper
2 panels: 25 1/2 x 19 5/8 inches (65 x 50 cm) each
Private Collection, Courtesy of White Cube, London

Commercial brochure sources for *Breeding Works*, 1991.

MODEL HEAD OF HOUDAN FEMALE

Parent stock for *A–Z Bantam Breeding Project*: Black Cochin, Silver Sebright, and Black Silkie Bantam chickens, 1992.

Zittel chose Bantam chickens for several specific reasons:

1. Chickens hatch from eggs so there is complete authorship of the "creation."

2. Chickens have an amazing array of genetic possibilities; they possess many types of physical variations with which to work.

3. Bantams are "miniature" chickens used for "decoration and for exhibition."

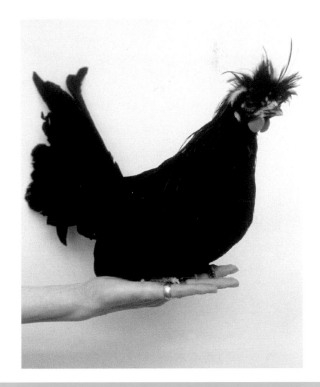

A–Z Bantam Breeding Project, A–Z Administrative Services, 72 South 8th Street, Brooklyn, 1991.

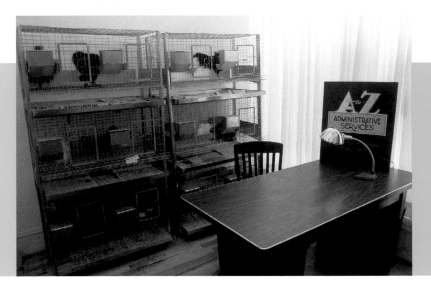

In one chicken breeding experiment, the artist identified the characteristics of the artificially created domestic breeds and set for herself the idealist goal of reducing a bird to its original traits. Successive cross-breeding demonstrated that the unique traits were recessive, vanishing as she achieved the "average chicken," which raised issues of control and organization, and notions of progress and creativity. In a longer-term and ongoing project, she sought to create her own breed of chicken after research suggested that this might be possible in the span of about five years.

1993 **A–Z Breeding Unit for Reassigning Flight**

Steel and birch plywood, paint, and chickens
170 x 20 x 60 inches (432 x 51 x 152 cm)
Courtesy of the artist

Installation view, *The Final Frontier*, New Museum of
Contemporary Art, New York, 1993

Chickens in first compartment of *A–Z Breeding Unit for
Reassigning Flight*, 1993.

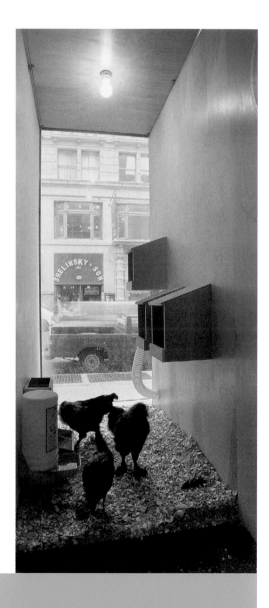

Installed in the front window of the New Museum of Contemporary Art in
New York, the *A–Z Breeding Unit for Reassigning Flight* was designed to evolve
chickens with functional wings that could reinstate the capacity of flight. The
unit channeled eggs only from the highest nest into the incubator in the next
compartment, where the resulting chicks would again be presented with nests
of greater heights to self-select for flying ability.

1993 **A–Z Breeding Unit for Averaging Eight Breeds**

Steel, glass, wood, wool, light bulbs, and electric wiring
72 x 171 x 18 inches (183 x 434 x 46 cm)
The Museum of Contemporary Art, Los Angeles; Gift of Donatella and Jay Chiat

1993 **Study for A–Z Breeding Unit for Averaging Eight Breeds**

Ink on paper
8^1/$_2$ x 11 inches (22 x 28 cm)
Collection of the artist

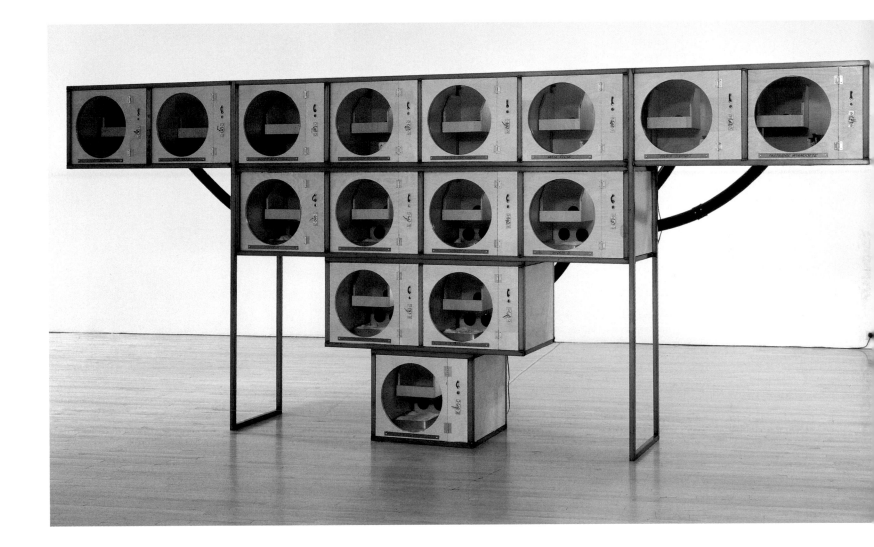

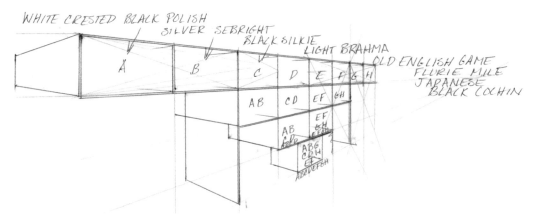

Features of the unit:

- Flexible Egg Channels

- Automatic Egg Turner

- Incubator/Brooder [heater] in each unit

- Through process of interbreeding, recessive traits resulting from domestication will be lost

- Final breed will retain dominant traits and will illustrate more original form of poultry

1994 **A–Z Clock** [below left and below, detail]

Wood, glass, plastic, paint, clockwork, and electric motor
1 of an edition of 4; 5 clocks per edition
14 x 14 x 4 inches (36 x 36 x 10 cm) each

The *A–Z Clock* suggests the appearance of a standard wall clock, but the clock's face divides time into unconventional segments. The durations include: 2 hours, 4 hours, 8 hours, 24 hours, and 168 hours. The clocks also dispense with the typical starting position of noon/midnight.

In the *A–Z Time Trials,* Zittel explored how cultural limitations control our natural reaction to temporal stimuli. In an attempt to discover her own personal concept of time and to give voice to her body's internal clock, Zittel conducted the *Free Running Rhythms and Patterns* [Berlin] experiment: she spent one week in an environment devoid of anything that could mark the passing of time. A time-lapse video monitored her behavior.

Zittel's interest in studying time and circadian cycles was sparked by earlier scientific studies of sleep and time deprivation. But the artist found those studies usually lacked a record of the subjects' personal and emotional responses. By conducting the experiment on herself, Zittel was able to ensure that the personal response would be factored into the results.

The notion of escaping time—a kind of taskmaster imposed by economic conventions and evolving cultural norms—led to the desire to create a physical escape from temporal systems. In both *A–Z Timeless Chamber* and *A–Z Time Tunnel* (both 2000), subjects can remove themselves entirely from the surrounding time-monitored environment, customizing their own new routines and leisure pursuits while ensconced in the unit. The underlying desire of the different components of the *A–Z Time Trials* was to escape the rigidity of time—to take a temporal vacation—questioning the "natural" patterns humans supposedly follow, while reformatting individual biorhythms into the model most appropriate for each person.

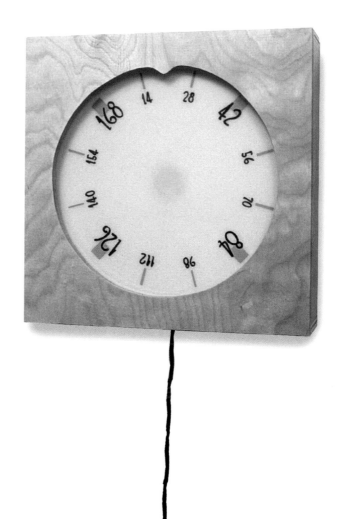

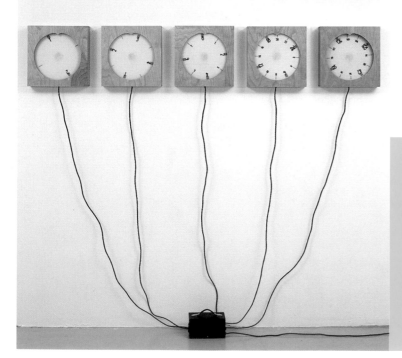

1999 **A–Z Time Trials (BSM Turbo Edition)** [clocks]
Wood and steel frame, clockwork, and electric motor
1 customized set of an edition of 7; 5 clocks per edition
26 x 29 7/8 x 2 3/8 inches (66 x 76 x 6 cm) each
Collection of Burton S. Minkoff

As their names suggest (such as "two-day clock, three-day weekend"), these clocks not only accurately record unconventional segments of time, but wryly comment on the contemporary obsession with time managing work and leisure activities. The *BSM Turbo Edition* is based on Porsche instrument styling and includes these other durations: the whole-day clock, ideal-day clock (36-hour and 24-hour day), one-week clock, and three-week clock (one-week vacation). The other sets in the edition were customized in consultation with the owners to reflect different time sequences and styling.

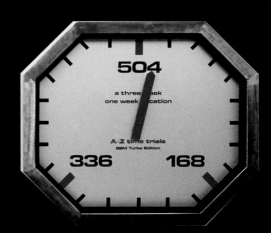

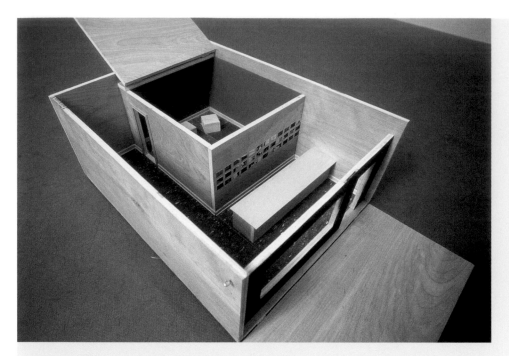

1994 **Model for A–Z Timeless Chamber**

Birch plywood, linoleum, paint, and photographs
10½ x 19 x 24⅞ inches (27 x 48 x 63 cm)
Courtesy of the artist and Andrea Rosen Gallery, New York

Zittel conducting *Free Running Rhythms and Patterns* [Berlin] experiment at Erika and Rolf Hoffmann artist-in-residence studio, Berlin, 1999.

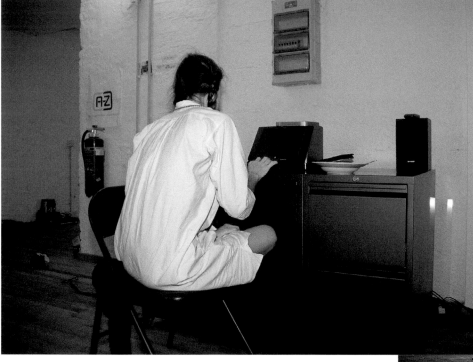

Free Running Rhythms and Patterns *[Berlin] was an experiment conducted from October 31 to November 6, 1999, when I lived for one week without any access to "external" time. This was accomplished by blocking out all sources of natural light and sound, clocks, and any other time referents such as TV, radio, or time settings on my computer. Living without time was exhilarating, exciting, and a little stressful. The A–Z Time Trials pushed my fantasy of a stressless environment so far that it became a challenging adventure in itself.*

2000 **A–Z Time Trials, Note #11** [diary panel]

Birch plywood, polyurethane, latex paint, oil-based paint, gouache, and pen
37¼ x 25 1/4 inches (94.6 x 64.1 cm)
Collection of Dean Valentine and Amy Adelson, Los Angeles

2000 **A–Z Time Trials, Note #14** [diary panel]

Birch plywood, polyurethane, latex paint, oil-based paint,
gouache, pen, and stain
37 1/4 x 25 1/4 inches (94.6 x 64.1 cm)
Goetz Collection, Munich

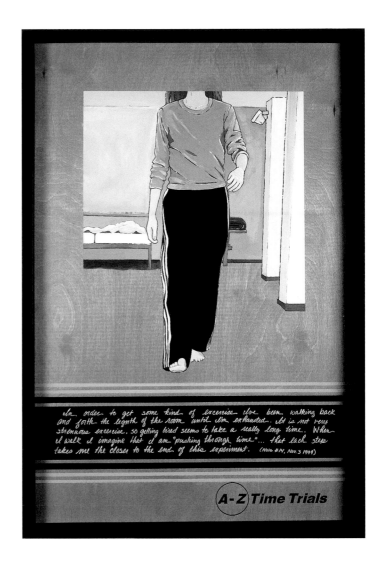

Following the *Free Running Rhythms and Patterns* [Berlin] experiment, Zittel compared her activities, such as eating, sleeping, thinking, and so on, with the video record of the time of day. The resulting data was colored-coded and organized on a series of drawings on wood panels also titled *Free Running Rhythms and Patterns*. A twelve-panel drawing, *Notes #1–#12* [above], records diary entries with illustrations of Zittel's activities. In addition, a chronological drawing (executed in two versions, *Version I* [twenty-five panels] and *Version II* [twenty-seven panels] both including a drawing for each hour of the day [pp. 157, 159]) documented the 168 hours of the experiment. Each drawing comprises seven horizontal colored bars corresponding to the seven days of the experiment and the activities Zittel performed in that hour on each day. The panels are installed consecutively so a viewer can follow the slow change of Zittel's routine as conventional time divisions became entirely irrelevant to her existence. Because the experiment was conducted in isolation, these drawings are a means of publicly conveying the results.

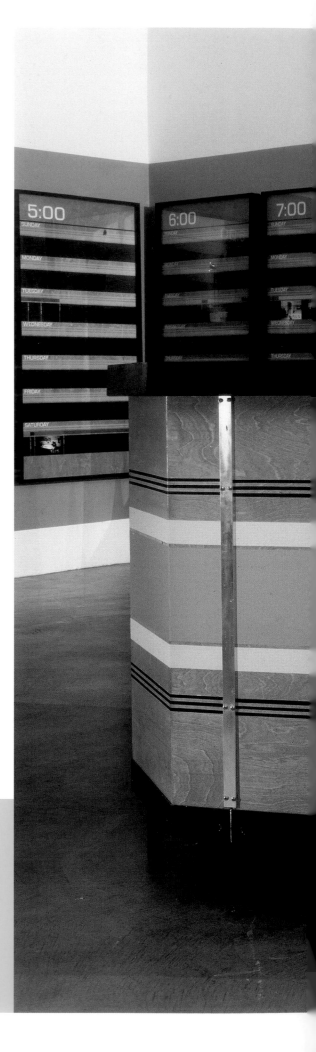

2000 **Free Running Rhythms and Patterns, Version I** [documentary panels, on wall]

Birch, plywood, wood stain, gouache, framed photos, and vinyl
24 panels: 61 x 31 inches (155 x 79 cm) framed, each; 1 panel: 43¼ x 31 inches (110 x 79 cm) framed
Goetz Collection, Munich

Installation view with *A–Z Timeless Chamber, Model 004* (foreground),
A–Z Time Trials: Free Running Rhythms, Regen Projects, Los Angeles, 2000

2000 **A–Z Timeless Chamber, Model 004** (interior [below] and exterior [right])

Birch, steel, carpet, aluminum, paint, vinyl, and adhesive
41 x 83 x 51¼ inches (104 x 211 x 130 cm)
Courtesy of the artist and Regen Projects, Los Angeles

The A–Z Timeless Chamber *is based on an unrealized proposal for an A–Z Vacation from
Time. This project examines the fundamental concept of freedom or liberation, and the irony
of how many of our ultimate leisure experiences associated with freedom are actually
created by establishing a set of limitations. One example is a sensory deprivation tank,
which is used to relieve stress and tension. But many other sorts of leisure time activities
such as ocean liner cruises or luxury resorts likewise limit the normal daily barrage of
sensory input, in order to construct a safe and sheltered environment.*

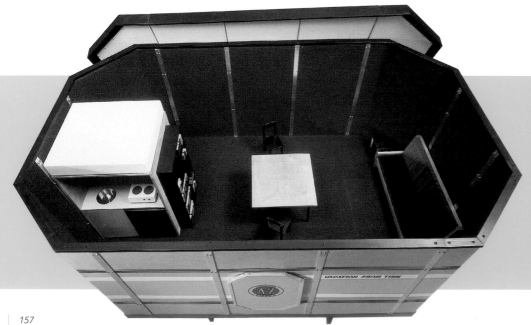

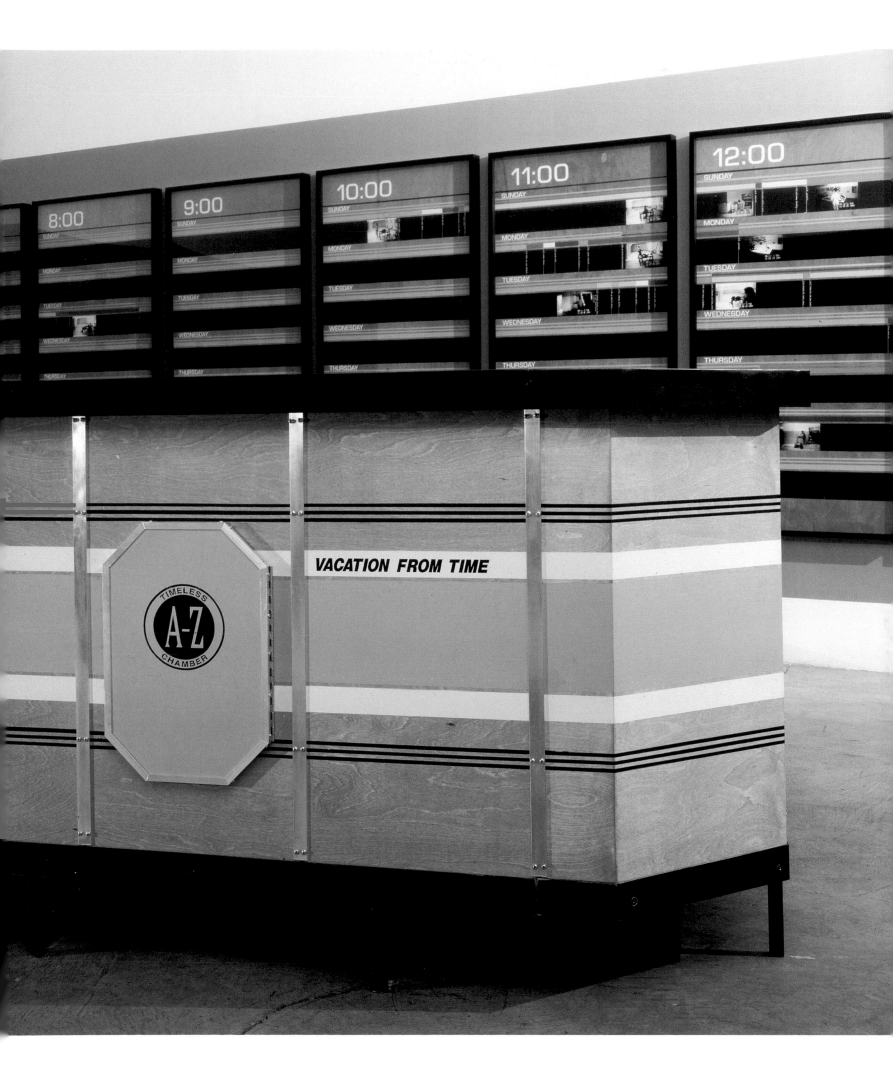

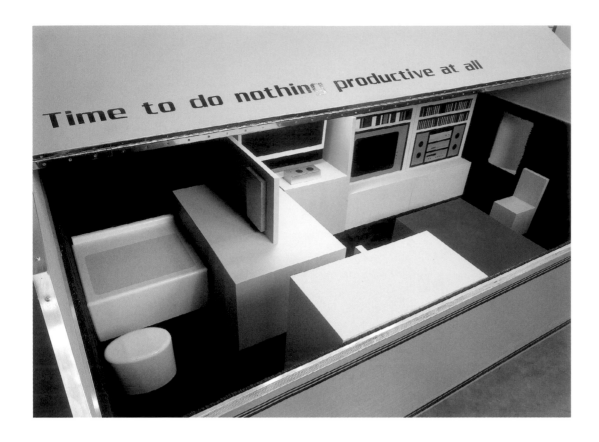

2000 **A–Z Time Tunnel: Time to Do Nothing Productive at All** [interior detail]

Aluminum, walnut, wood, steel, carpet, paint, vinyl adhesive, medium density fiberboard, electrical lighting, and sound machine
39 x 48 1/4 x 80 1/2 inches (99 x 123 x 204 cm)
closed without ladder
Courtesy of the artist and Andrea Rosen Gallery, New York

2000 **A–Z Time Tunnel: Time to Read Every Book I Ever Wanted to Read** [interior detail]

Aluminum, walnut, wood, steel, carpet, paint, vinyl adhesive, medium density fiberboard, electrical lighting, and sound machine
39 x 48 1/4 x 80 1/2 inches (99 x 123 x 204 cm)
closed without ladder
The Speyer Family Collection, New York

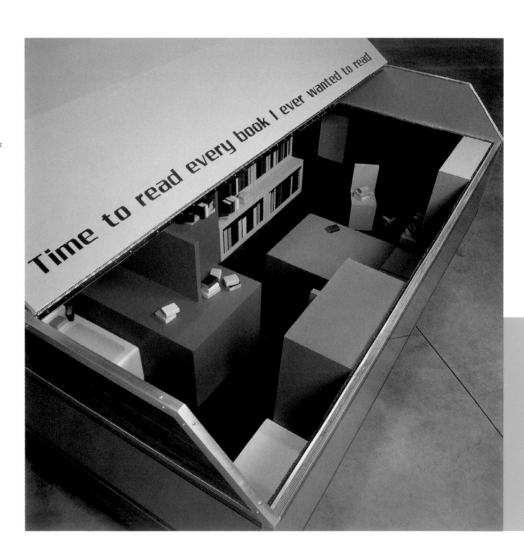

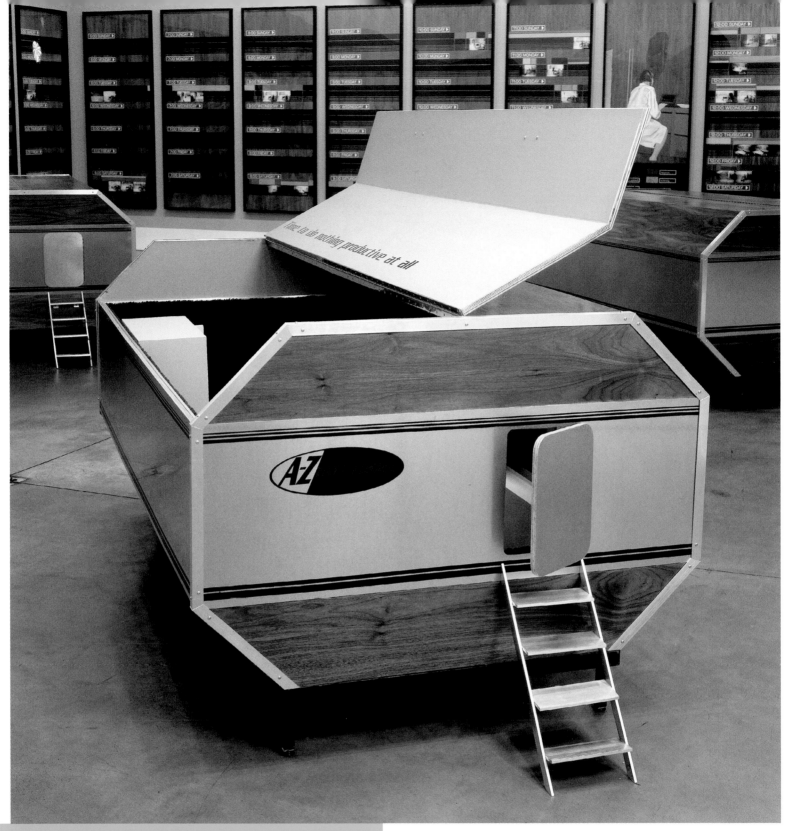

Is it possible that the invention of the clock and its corresponding timetable regulates all of us into a unified mass more perfectly than any physical structure? What if we were to approach time as yet another plastic element to be sculpted into creative formats? What psychological, emotional and social effects would result from this redesigned time? The four models of the Time Tunnel detail various leisure activities that could be accomplished in their time-free zones.

2000 **Free Running Rhythms and Patterns, Version II**
[documentary panels, on wall]

¼-inch walnut veneer panels, latex- and oil-based paint, vinyl lettering, and black-and-white photographs
27 panels: 79 x 31 5/8 x 2 inches (201 x 80 x 5 cm) each
Olbricht Collection

Installation view with *A–Z Time Tunnel* (foreground), *A–Z Time Trials*, Andrea Rosen Gallery, New York, 2000

The primary focus at A–Z West has been on prototype production and the development of new materials and new kinds of fabrication techniques— or, simply said, new technologies. Inspired by the unique potential offered by the climate and raw resources of the natural desert environment, these "advancements" carry a not-so-subtle message that regression to the most basic materials can lead to a progressive result. After she researched multiple possibilities, one of Zittel's decisions was to work with paper. As raw material, paper is recyclable, inexpensive, and lightweight, yet it can be made strong and fairly durable. It is also easily adapted and re-formed into various shapes and consistencies, demonstrated by the *A–Z Paper Pulp Panel,* which can serve both decorative and practical purposes. *The Regenerating Field* (2002) came about as Zittel made her panels in a constructed grid of metal frames with plastic trays: the regenerating process transforms what was once used up and discarded—including the artist's problematic mounds of newspaper and mail— into a useful new compound. Another *Advanced Technology* is the hand-felting of raw wool into the seamless *A–Z Fiber Form Uniform* (begun 2002).

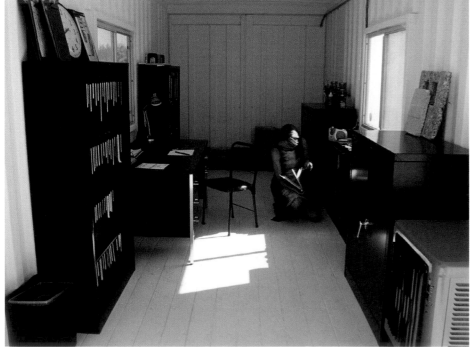

Collected paper refuse, Landers, California dump, near A–Z West, 2003.

Zittel in studio office, A–Z West, 2003.

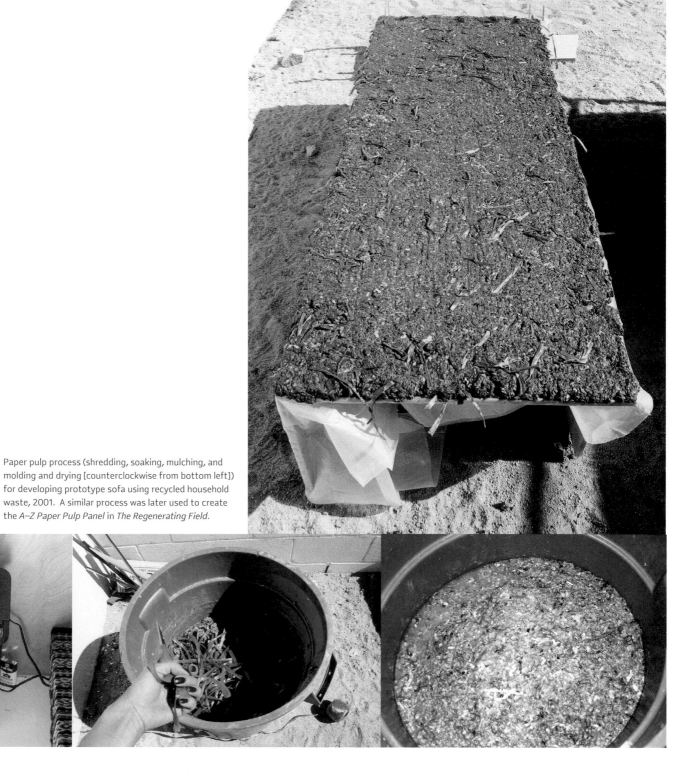

Paper pulp process (shredding, soaking, mulching, and molding and drying [counterclockwise from bottom left]) for developing prototype sofa using recycled household waste, 2001. A similar process was later used to create the *A–Z Paper Pulp Panel* in *The Regenerating Field*.

The Regenerating Field

Aluminum, stainless steel, and plastic
24 trays: 24 x x 25 x 37$^1/2$ inches (61 x 65 x 95 cm) each;
Approx. 26 x 48 feet (8 x 14.5 m) overall
Courtesy of the artist

Installation view, A–Z West, 2002

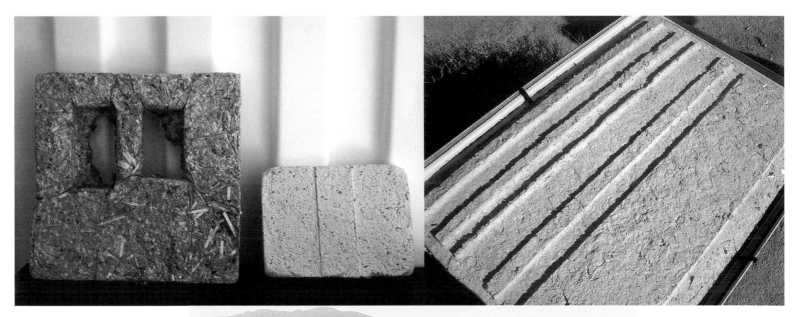

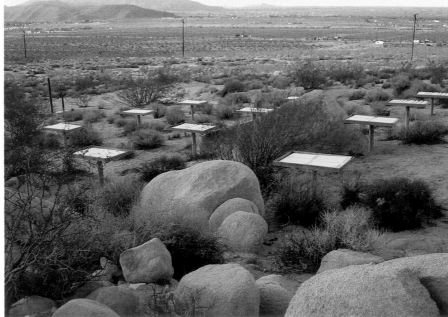

Prototypes for A–Z Paper Pulp Panel,
A–Z West, 2001.

A–Z Paper Pulp Panel in drying tray, in
The Regenerating Field, A–Z West, 2002.

The Regenerating Field, A–Z West, 2002.

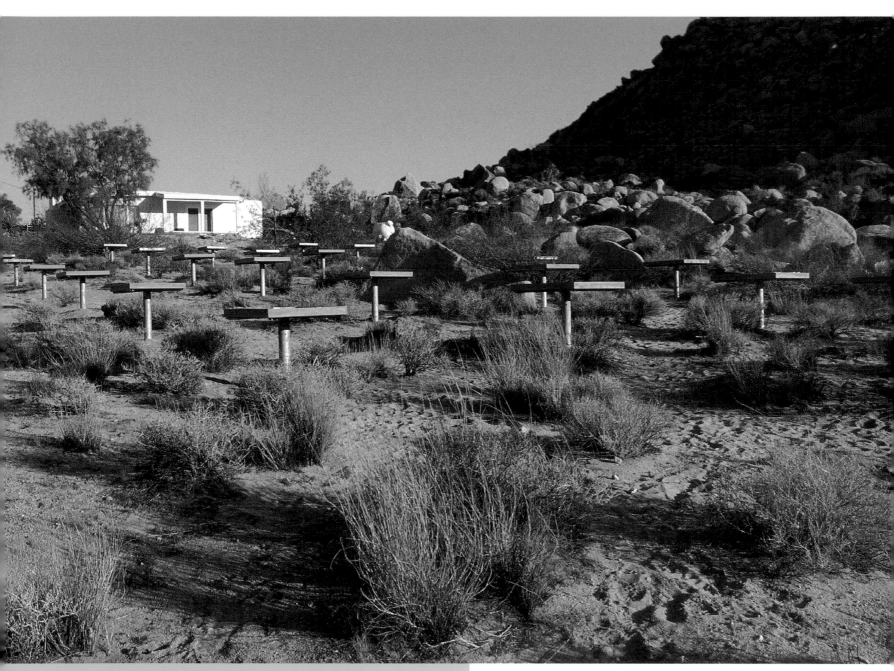

To turn paper into a moldable material, it is first shredded and pulped. Then it is packed into a series of plastic molds, which slide into a grid of steel frames so that the pulp can dry outdoors in the hot sun. The Regenerating Field *consists of a grid of 24 trays that spills down the hill in front of the A–Z West homestead. The work references both the aesthetics of earthwork installations and the industrialized format of modern-day agriculture.*

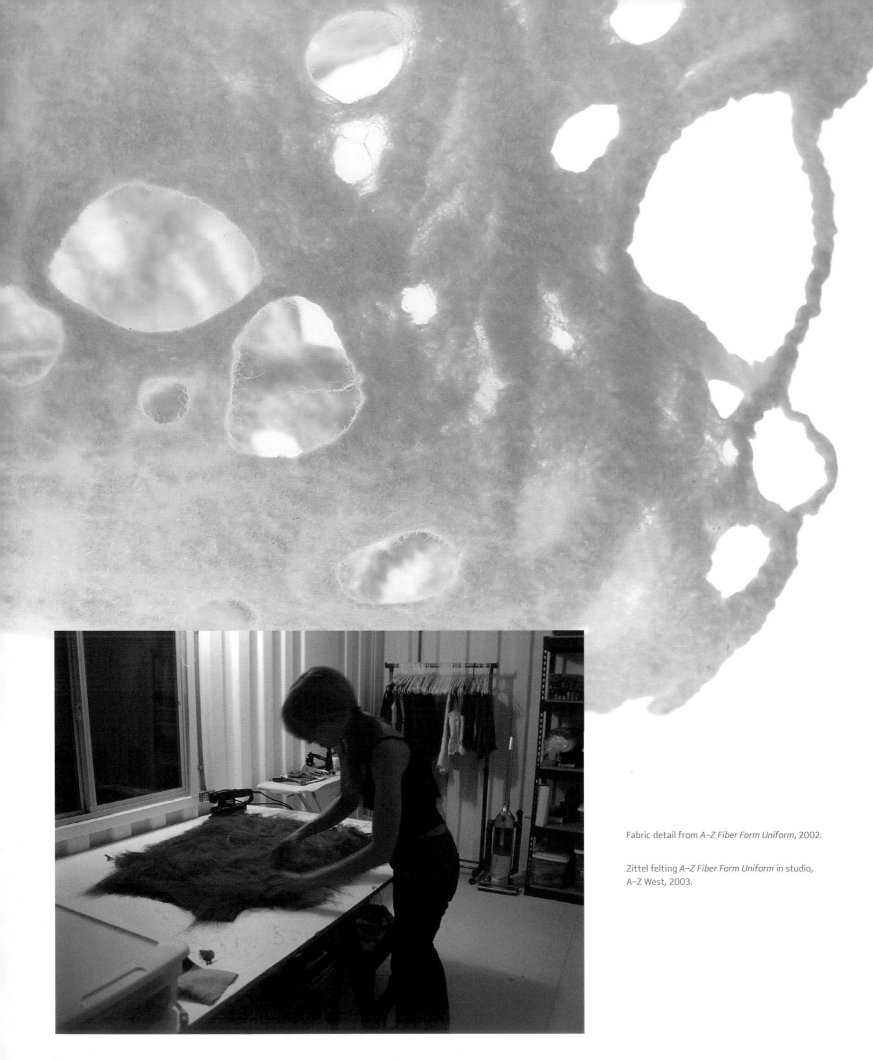

Fabric detail from *A–Z Fiber Form Uniform*, 2002.

Zittel felting *A–Z Fiber Form Uniform* in studio,
A–Z West, 2003.

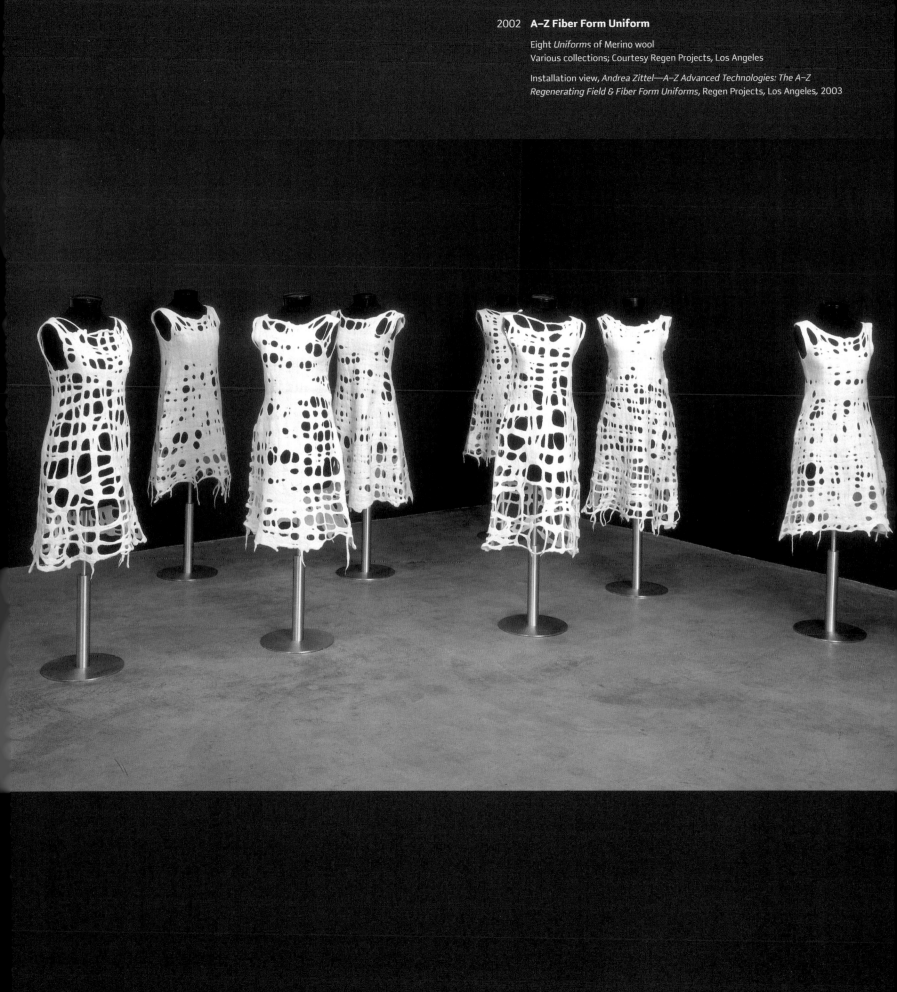

2002 **A–Z Fiber Form Uniform**

Eight *Uniform*s of Merino wool
Various collections; Courtesy Regen Projects, Los Angeles

Installation view, *Andrea Zittel—A–Z Advanced Technologies: The A–Z
Regenerating Field & Fiber Form Uniforms*, Regen Projects, Los Angeles, 2003

Locate

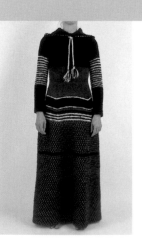

People are so caught up in the nuances of their own personal realm that they've lost real civic relationships with one another. We've lost the collective power. In that same sense, I am interested in how design is reflective, and how we have become so capsulated—especially in suburban areas such as where I come from in California—that experience where the frontier isolationist mentality has gone so far that your entire world is contained in your piece of property, in your house and [in] your automobile. Basically those three capsules are everything. And then what if someone could morph all three of those things into one perfect and infinitely reproducible capsule?[5]

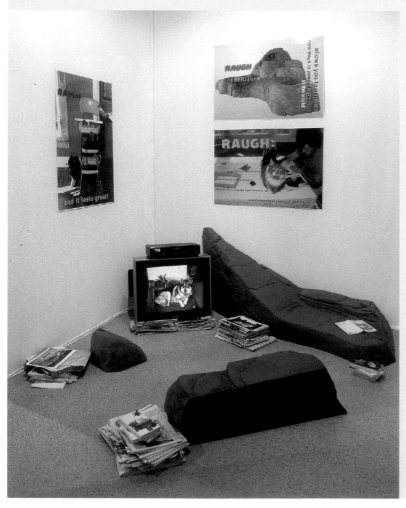

A–Z Raugh installation at Andrea Rosen Gallery booth, Basel Art Fair, Switzerland, 1998.

pp. 166–167

2000 **"Special Pocket Property"**
A–Z Single-Strand Uniform

Crocheted wool
Emanuel Hoffmann Foundation, permanent loan to the Öffentliche Kunstsammlung, Basel, Switzerland

1998 **A–Z Raugh Furniture**
(Jack and Lucinda)

Foam rubber
Jack: 101 1/2 x 296 x 214 1/2 inches
(258 x 752 x 545 cm); *Lucinda*: 60 1/2 x 141 x 102 inches (154 x 358 x 259 cm)
Courtesy of the artist and Andrea Rosen Gallery, New York

Installation view, *RAUGH*, Andrea Rosen Gallery, New York, 1998

2001 **A–Z Cellular Compartment Unit**

Steel, birch plywood, glass, and household objects
10 units: 48 x 96 x 48 inches
(10 x 20 x 10 cm) each
Courtesy of the artist and Andrea Rosen Gallery, New York

Interior view with Tom, Ikon Gallery, Birmingham, England, 2001

A–Z RAUGH FURNITURE

Pronounced "raw," this design derives from Zittel's interaction with traditional household upkeep; by embracing what she likes to call "natural order," *A–Z Raugh* creates an entirely new concept. Here Zittel inverted her earlier paradigm of streamlined efficiency to attempt to reconcile the usual human inclination toward disorder, even messiness, as well as to explore Western culture's subliminal desire to return to an original natural state.

Through flexible designs permitting multiple interpretations, *Raugh* illustrates the theory that ambiguity in shape and space ultimately serves a wider variety of needs: when the design of furniture isn't functionally fixed, it becomes multipurpose. Additionally, creating a suitably low-maintenance artificial object that complements the natural disorder of lived-in spaces is a logical extension of A–Z solutions.

Zittel's *Raugh* living environments are large, soft-sculpted arrangements that look like landscapes or rock formations. In *A–Z Raugh Furniture*— an expansive faux rock landscape—the line's large "landmasses" serve as multipurpose furniture to be sculpted as seen fit. Individual units are titled by individual first names such as *Jack* or *Lucinda*. Rather than provide the easy cleaning of the smooth surfaces of earlier works, the material, color, and form of *A–Z Raugh Furniture* simply conceal dirt.

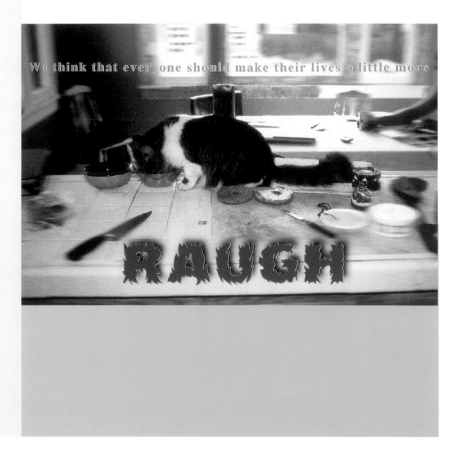

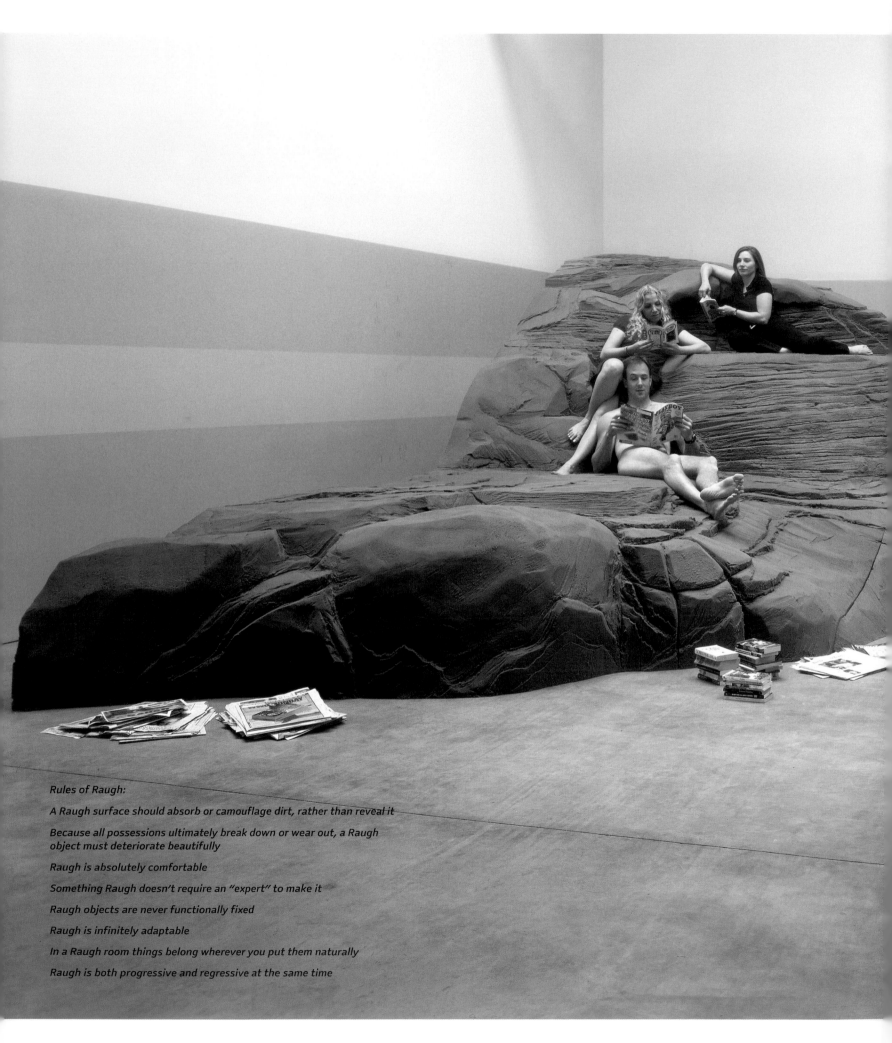

Rules of Raugh:

A Raugh surface should absorb or camouflage dirt, rather than reveal it

Because all possessions ultimately break down or wear out, a Raugh object must deteriorate beautifully

Raugh is absolutely comfortable

Something Raugh doesn't require an "expert" to make it

Raugh objects are never functionally fixed

Raugh is infinitely adaptable

In a Raugh room things belong wherever you put them naturally

Raugh is both progressive and regressive at the same time

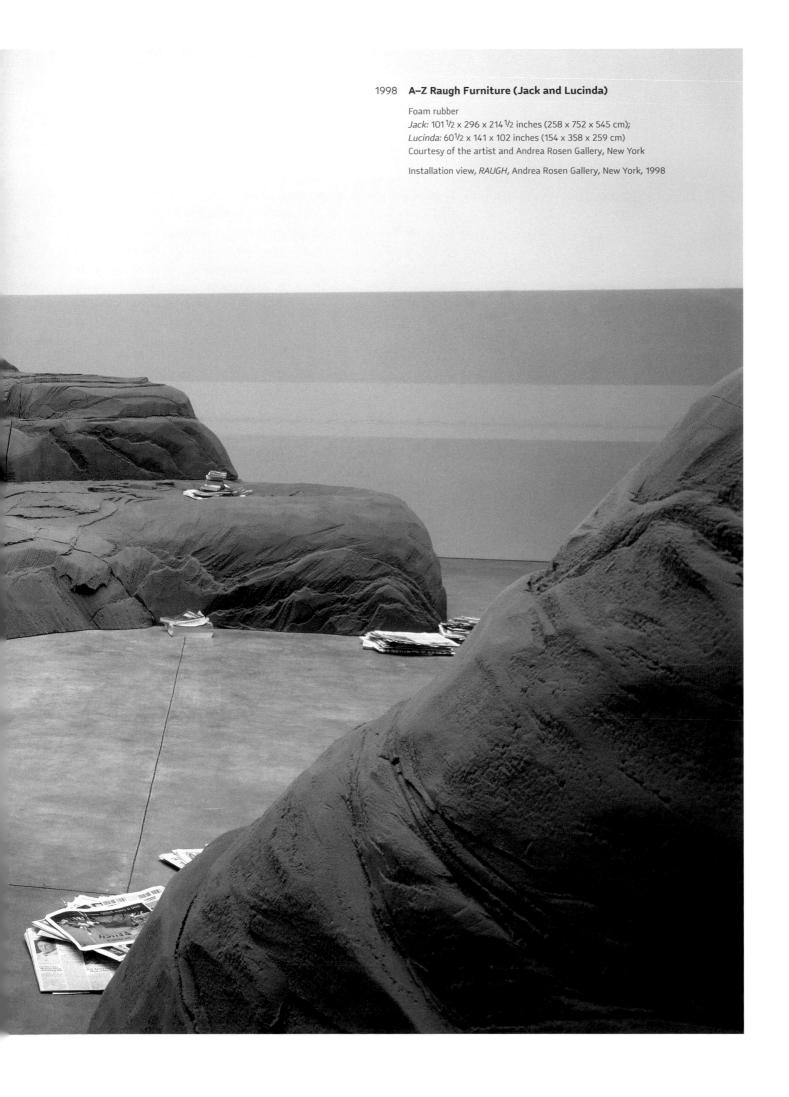

1998 **A–Z Raugh Furniture (Jack and Lucinda)**

Foam rubber
Jack: 101 1/2 x 296 x 214 1/2 inches (258 x 752 x 545 cm);
Lucinda: 60 1/2 x 141 x 102 inches (154 x 358 x 259 cm)
Courtesy of the artist and Andrea Rosen Gallery, New York

Installation view, *RAUGH*, Andrea Rosen Gallery, New York, 1998

2001 **Find New Ways to Position Yourself in the World**

Gouache on paper
30 x 22 inches (76 x 56 cm)
Courtesy of the artist and Andrea Rosen Gallery, New York

Prototype for A–Z Raugh Desk #1, A–Z East, 2001.

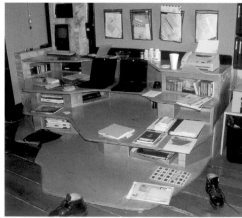

2001 **Prototype for A–Z Raugh Desk #2**

Medium density fiberboard, paint, polyurethane, fabric,
and foam cushion with miscellaneous accessories
28 x 126 x 126 inches (71 x 320 x 320 cm)
Emanuel Hoffmann Foundation, permanent loan to
the Öffentliche Kunstsammlung, Basel, Switzerland

Interior view, A–Z West, c. 2003.

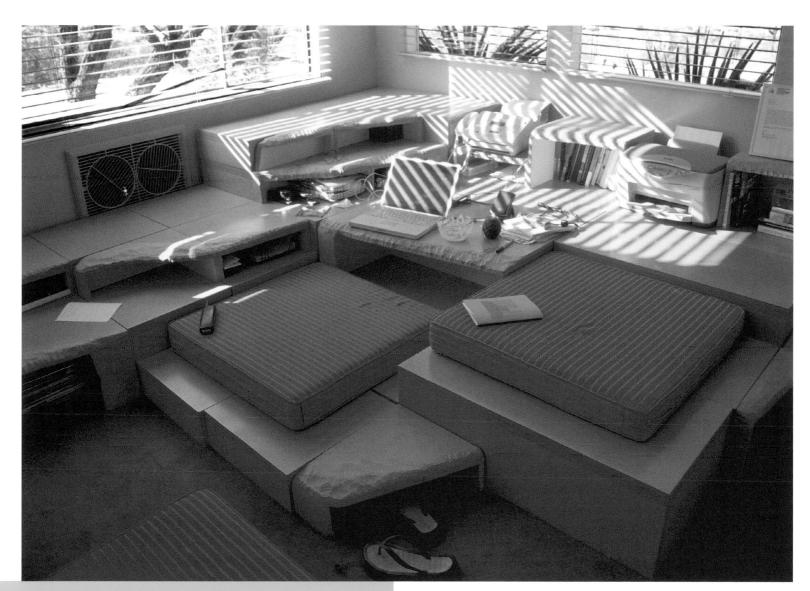

The two prototypes for a wood *A–Z Raugh Desk* are low to the ground and easily
rearranged, adapting to individual demands of order and convenience. Unlike
traditional, rigidly defined desks and chairs, the entire configuration adjusts to
personal circumstances and lifestyle.

POINT OF INTEREST:
AN A–Z LAND BRAND

The integration of Zittel's sculptural principles with her theories on the human
construction of terrain falls under the general heading of *A–Z Land Brands*.
Zittel defines "terrain" as neither furniture nor architecture nor environment,
but simply a location that the body may physically occupy. Terrain carries
psychological and social implications, and can range from the imagery of maps
to a fantasy landscape. *A–Z Land Brands* explore the conventions of human
interaction with the natural realm. Through her artificial conceptualizations
of nature, Zittel assesses contemporary ideas about outdoor habitation
and leisure.

Point of Interest, a temporary public sculpture in New York City's Central Park,
is a rendition of nature as "entertainment." It comprises two synthetic boulders
placed at the Park's southeast entrance to offer tourists a recreational post:
both a stage for themselves and the opportunity to break with the otherwise
narrow verticality of the city's urbanscape. At once overtly artificial yet
harmonious with its natural surroundings (Central Park itself is principally
a designed and engineered environment), the slabs toy with the viewer's
perception of nature.

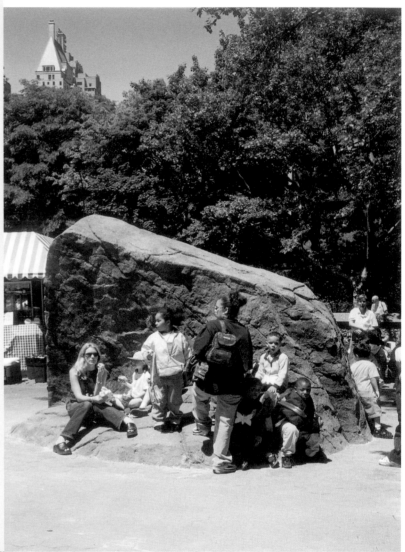

Point of Interest: An A–Z Land Brand under construction, Rock-n-Horse fabricators,
Virginia, 1999.

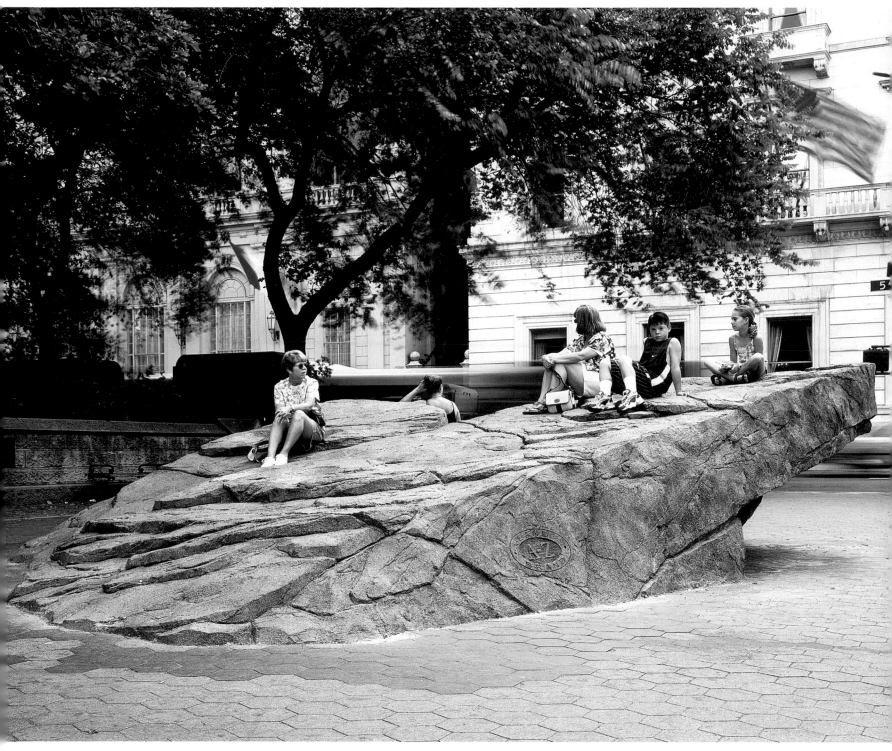

1999 **Point of Interest: An A–Z Land Brand** [detail]

Concrete and steel
Part 1 of three: 6 x 11 x 25 feet (1.8 x 3.4 x 7.6 m)
Part 2 of three: 5 x 7 x 15 feet (1.5 x 2.1 x 4.9 m)
Collection of Gilbert and Lila Silverman, Detroit

Installation view, *Point of Interest: An A–Z Land Brand*, Public Art Fund, Doris C.
Freedman Plaza, 5th Avenue at 60th Street, Central Park, New York, 1999–2000

1999 **The Beatific Point of Interest**

Pencil on paper
15 x 20 inches (38 x 50 cm)
Collection of Rebecca and Martin Eisenberg

1999 **The Scientific Point of Interest**

Pencil on paper
15 x 20 inches (38 x 50 cm)
Collection of Rebecca and Martin Eisenberg

1999 **The Recreational Point of Interest**

Pencil on paper
15 x 20 inches (38 x 50 cm)
Private Collection

2000 **Prototype for A–Z Pocket Property**

Concrete, steel, wood, dirt, and plants
10 x 30 x 60 feet (3 x 9.1 x 18.3 m); weight: 54 tons
Courtesy of the artist

Exterior view, anchored off the coast of Denmark
(in the Copenhagen harbor), 2000

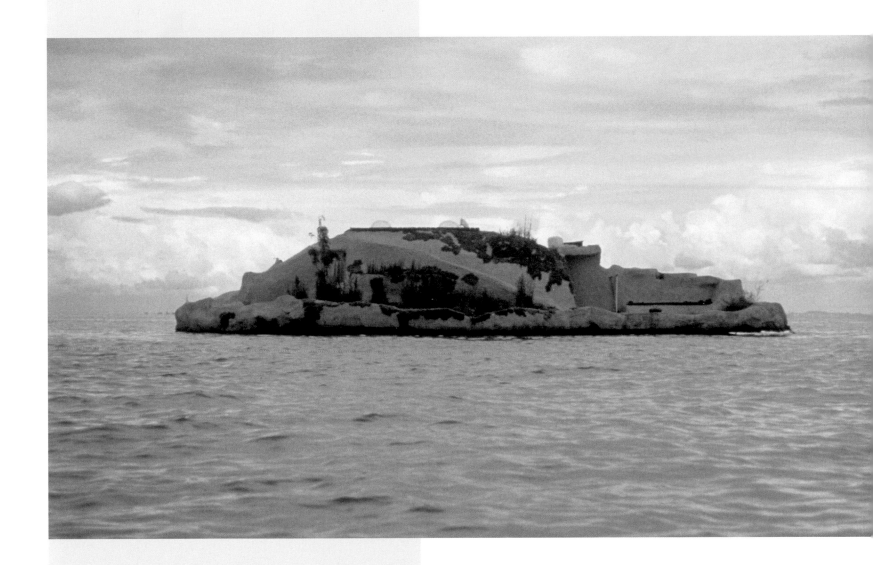

Zittel's studies of terrain led to the fabrication of a floating island in Helsingor,
Denmark, and Helsingborg, Sweden, and its launch off the coast near Copenhagen:
Prototype for A–Z Pocket Property. Zittel's one-month stint on the prototype
island failed to provide the serenity she intended as the demands of a docu-
mentary film project and the unanticipated curiosity of passing boaters drew
her into repeated social interaction.

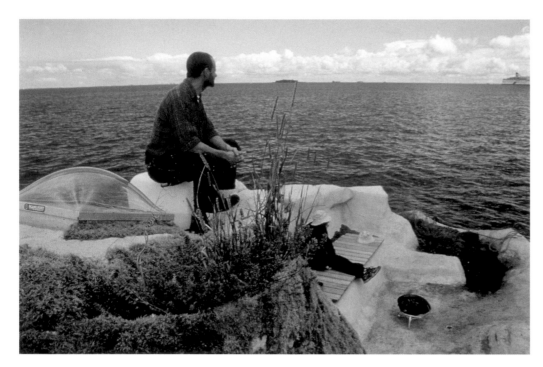

Paul on *Prototype for A–Z Pocket Property*, 2000.

Zittel wearing *Special Pocket Property A–Z Single-Strand Uniform* standing on the *Prototype for A–Z Pocket Property,* 2000.

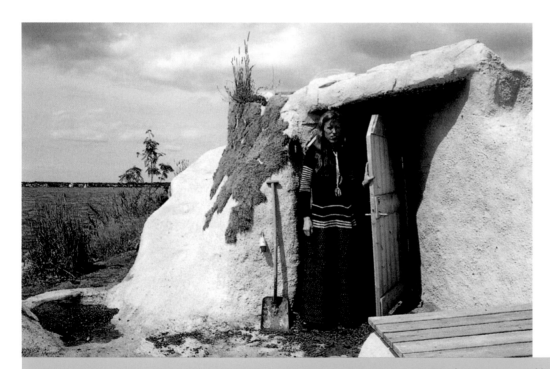

A–Z Pocket Property *combines your three most important possessions—your plot of land, your home, and your vehicle—into a hybrid prototype product. It is designed as a place with a unique potential for security, autonomy, and independence. As our world is increasingly opened up by convenient and affordable travel and communication breakthroughs, it is not surprising that the most human reaction is to try to shrink it back down into manageable proportions, and "go live on a deserted island," so to speak. In this case the ultimate luxury is not a limitless palette, but a small, intimate universe in which to explore the parameters of one's own personal options. This 54-ton floating concrete island is actually a hollow container for a comfortable, fully equipped home.*

Interior view looking toward
entrance, *Prototype for
A–Z Pocket Property*, 2000.

2001 **A–Z Homestead Unit**

Acrylic, gouache, and pen on paper
10½ x 13¼ inches (27 x 33 cm)
Courtesy of the artist and Sadie Coles HQ, London

The design for the *A–Z Homestead Unit* incorporates the search for freedom and the notion of frontier that are integral to the concept of the American West. Created in the tradition of the small cabins that dot the desert region surrounding A–Z West, the *A–Z Homestead Unit* (in contrast to the sprawling Western ranch home) combines contemporary perceptions of autonomy with the historical definition of homestead—plots of government land given to people for free in exchange for performing "improvements," such as constructing a minimal building or structure.

Because of today's building ordinances and construction regulations, a truly unadulterated architectural expression is rarely possible. But since the *A–Z Homestead Unit* is smaller than 120 square feet and completely portable, it does not require a building permit. This allowed Zittel to incorporate a wider independence into the unit's compact, transportable, reconfigurable design. *A–Z Homestead Units* are stand-alone structures that also can be used as rooms within a larger urban home, as in the case of *A–Z Homestead Office Customized for Lisa Ivorian Gray* (2003), an office with an attached doghouse.

Various abandoned trailers, Salton Sea, California, 2001.

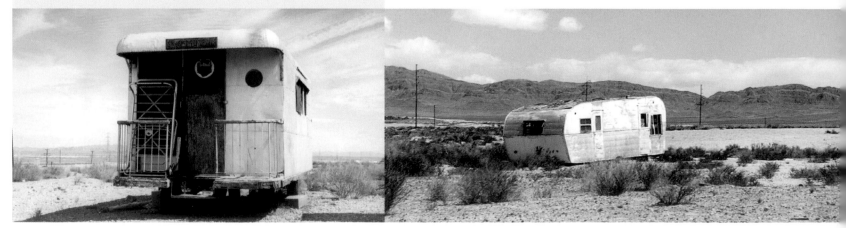

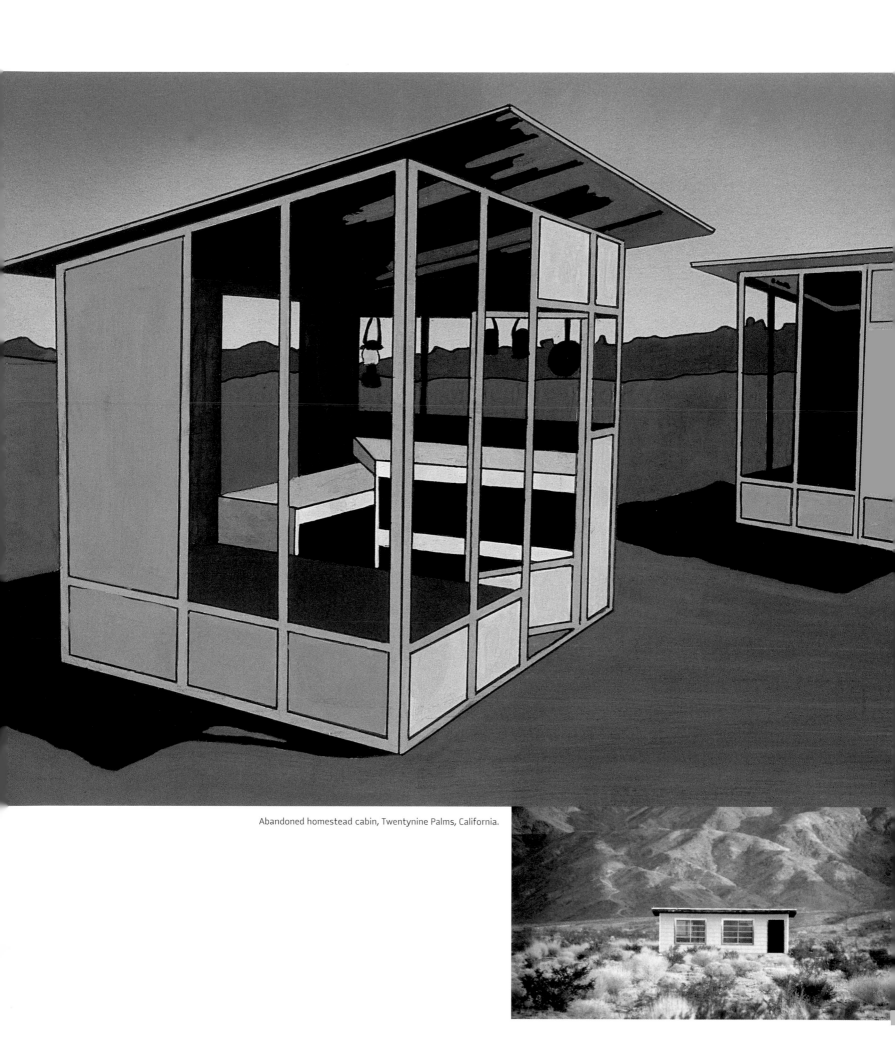

Abandoned homestead cabin, Twentynine Palms, California.

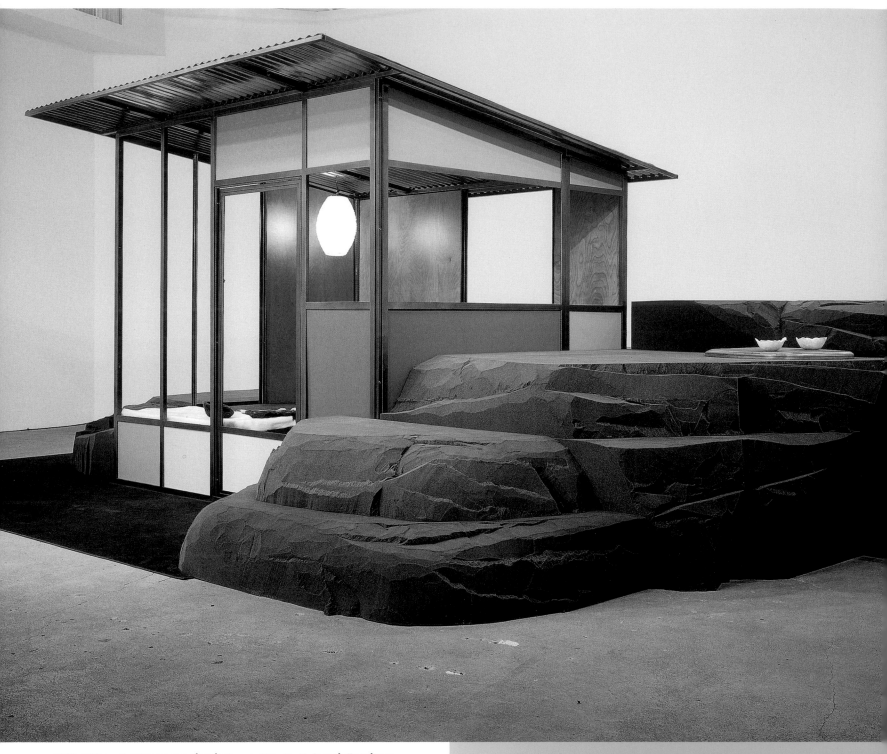

2001–2005 **A–Z Homestead Unit** [from A–Z West] with **Raugh Furniture**

Powder-coated steel, birch paneling with paint and polyurethane,
corrugated metal roof, sculpted foam furniture, fleece blanket, pillows
with pillowcases, camp stove with tea, and felted wool with *A–Z Fiber
Form Uniform* and *A–Z Container*
110 x 308 x 183 inches (279 x 782 x 465 cm) overall:
Courtesy of the artist and Regen Projects, Los Angeles

Installation view, *Western Evolutions*, Regen Projects, Los Angeles, 2004

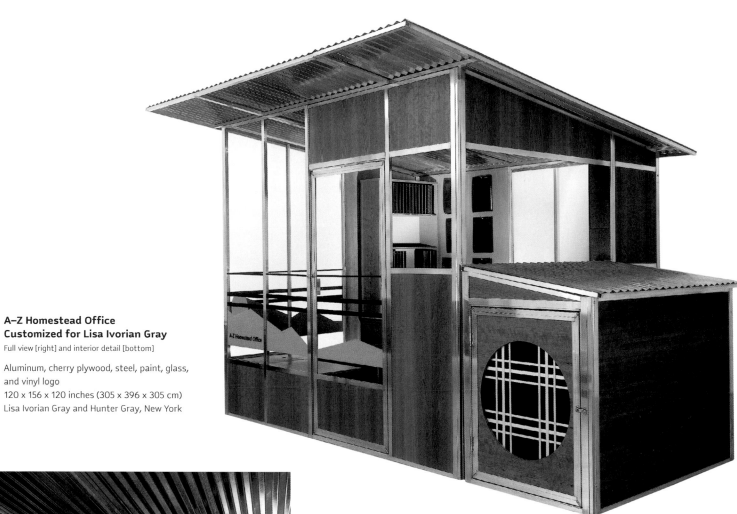

**2003 A–Z Homestead Office
Customized for Lisa Ivorian Gray**
Full view [right] and interior detail [bottom]

Aluminum, cherry plywood, steel, paint, glass,
and vinyl logo
120 x 156 x 120 inches (305 x 396 x 305 cm)
Lisa Ivorian Gray and Hunter Gray, New York

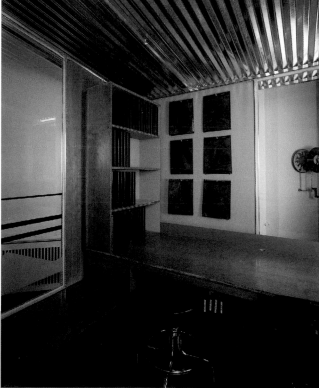

A–Z Homestead Unit, A–Z West, 2003.

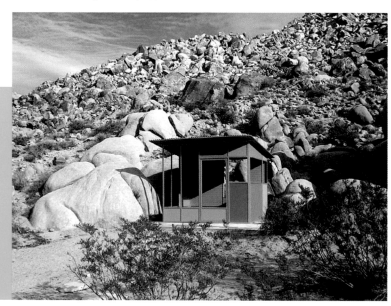

Using a flexible modular structure, the *A–Z Cellular Compartment Units* optimize a room's volume and utility by turning a one-room space or apartment into a ten-room habitat. The units are created from interconnected boxes where each human need or desire receives its own designated space; Zittel developed this design as a personal living experiment (assuming, as she often does, a guinea pig role), and she lived in the units for a period of time in order to research their feasibility. Structurally, the units comment on urban architecture's trend toward stacking and the resultant compacting of time, space, and function (expressed further by Zittel in multi-unit configurations that she produced in a series of panel drawings entitled *A–Z Cellular Compartment Unit Communities*).

But the compartments, customized to satisfy every activity from sleeping and eating to reading and computer use, in any combination, also lend the idea of home and lifestyle new shadings. The increasing divisions and categories within a room, home, or building ultimately influence the division of labor or the level of engagement the inhabitant has with various tasks and pastimes. For example, the creation of a single room just for reading or a small nook for meditating can result in an adjustment of the inhabitant's goals and well-being.

The *A–Z Cellular Compartment Units* thus pose a circular question: does architecture control our conception and use of time and space, or do our aspirations or ideas about time and space management affect architectural design?

Exhibition brochure, *A–Z Cellular Compartment Units,* Ikon Gallery, Birmingham, England, 2001.

background:

2001 **Sketch for A–Z Cellular Compartment Units**

Ink on paper
11 x 8¹⁄₂ inches (28 x 22 cm)
Courtesy of the artist

Plan - Sample layout

Sleep - Sample layout

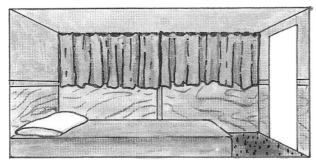

Clean - Sample Layout

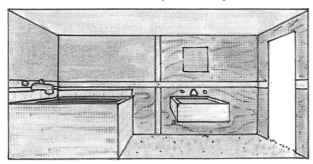

2001 **Study for 3 Sample Layouts of
A–Z Cellular Compartment Units**

Ink and colored marker on paper
11 x 8¹/2 inches (28 x 22 cm)
Courtesy of the artist

2001 **Study for Breakdown of
A–Z Cellular Compartment Unit**

Ink and colored marker and label tape on
graph paper
8¹/2 x 11 inches (22 x 28 cm)
Courtesy of the artist

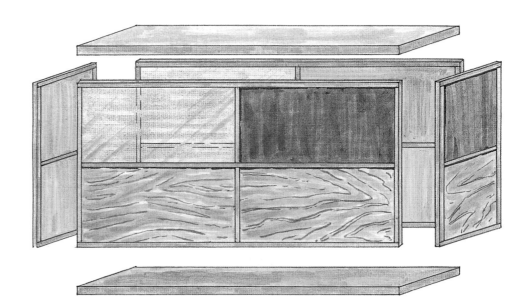

Nigel in bedroom of *A–Z Cellular Compartment Units*, Ikon Gallery, Birmingham, England, 2001.

2001 **Study for Framework of A–Z Cellular Compartment Unit**
[drawn by Justin Beal]

Ink on paper
8½ x 11 inches (22 x 28 cm)
Courtesy of the artist

2001 **A–Z Cellular Compartment Units**

Stainless steel, birch plywood, glass, and household objects
10 units: 48 x 48 x 96 inches (122 x 122 x 244 cm) each;
96 x 144 x 192 inches (244 x 366 x 488 cm) overall
Courtesy of the artist and Andrea Rosen Gallery, New York

Installation view, *A–Z Cellular Compartment Units*, Andrea Rosen Gallery, New York, 2002.

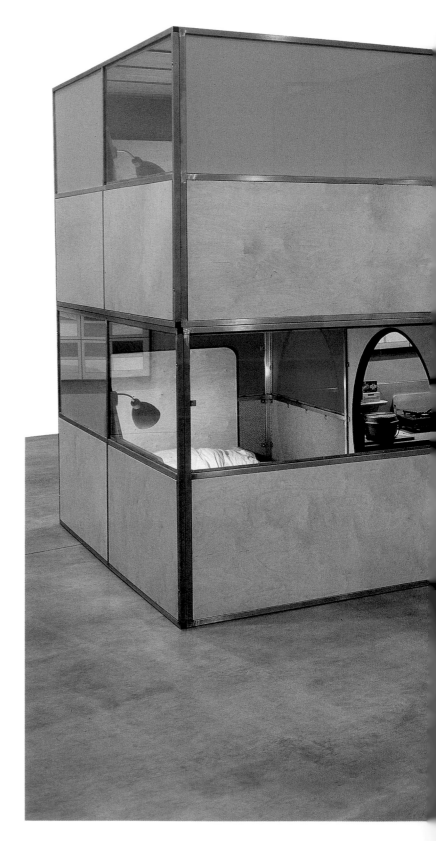

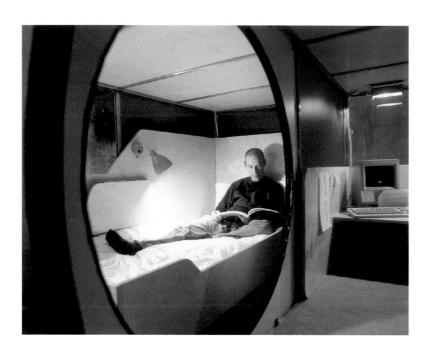

2001 **A–Z Cellular Compartment Units**

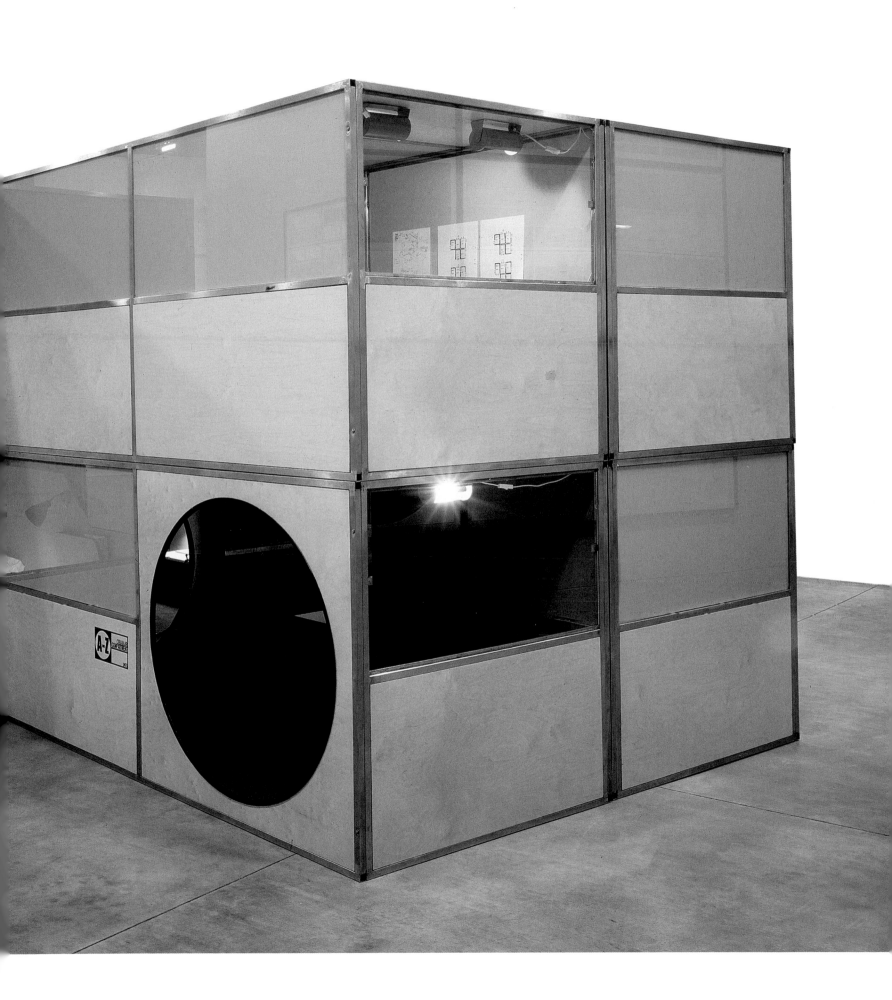

2002 **Study for A–Z Cellular Compartment Unit #6**

Gouache and ink on paper
16^1/$_2$ x 16 inches (30 x 41 cm)
Courtesy of the artist and
Andrea Rosen Gallery, New York

2002 **A–Z Cellular Compartment Unit Communities #1**
[detail]

Latex paint, tape, and pen on birch
2 parts: 49^3/$_8$ x 97^3/$_8$ inches (125 x 247 cm) each;
98^5/$_8$ x 97^3/$_8$ inches (251 x 247 cm) overall
Courtesy of the artist and Andrea Rosen Gallery, New York

Study for A–Z Cellular Compartment Unit #6

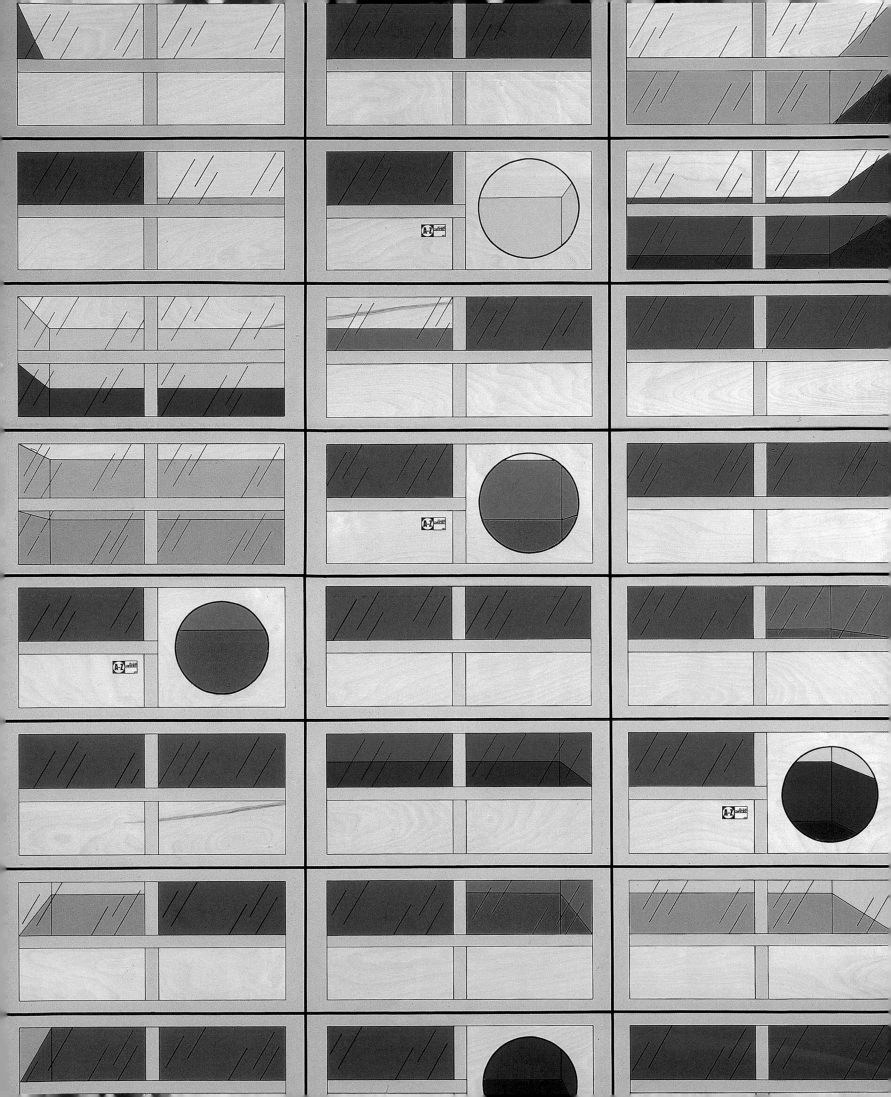

A–Z SPRAWL

This graphic adaptation of satellite imagery from the industrial and residential landscapes outside Las Vegas represents a customizable art piece. The mundane environment of suburbia is abstracted. Comprising sixteen parts (fifteen prints and a unique gouache) of varying coloration—eight of them mirror images— *A–Z Sprawl* can be reassembled into an expansive configuration, showing a continuum of man-made interventions in the desert's natural topology.

2001 **Sprawl #1** (detail)

Gouache and ink on paper
1 unique gouache and 15 inkjet prints
16 sheets, 10 x 7 inches (25 x 18 cm) each;
40 x 28 inches (102 x 71 cm) overall
Courtesy of the artist and Andrea Rosen Gallery, New York

2001 **Sprawl #3**

Gouache and ink on paper
1 unique gouache and 15 inkjet prints
16 sheets, 10 x 7 3/4 inches (25 x 20 cm) each;
40 x 31 inches (102 x 79 cm) overall
Collection of Diane and Hal Brierley, Dallas

Escape

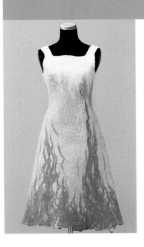

1995 A–Z Travel Trailer Unit

1996 A–Z Escape Vehicle

1997 A–Z Thundering Prairie Dog

 A–Z Deserted Islands

1998 A–Z Yard Yacht

2002 A–Z Wagon Station

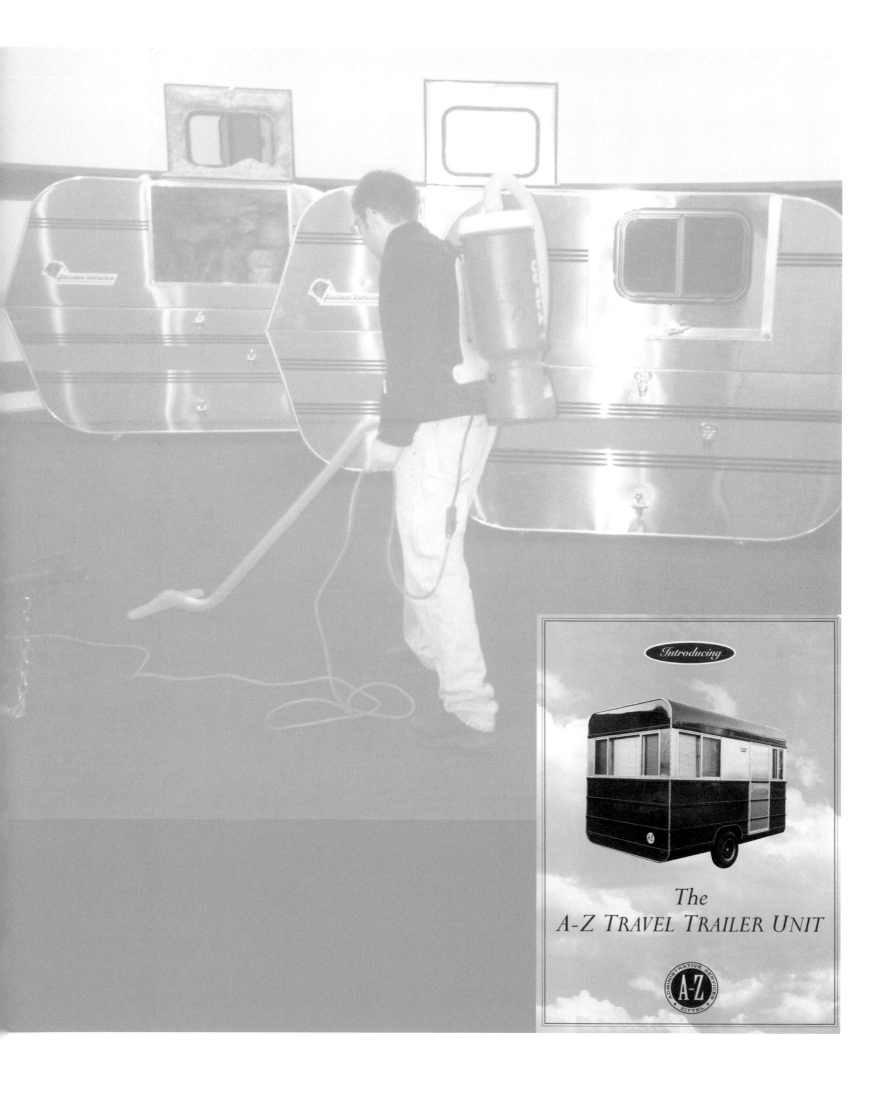

Introducing

The
A-Z Travel Trailer Unit

The common thread in most of my artworks is also the common thread in my own life. The best way that I can define it is by saying that I am always looking for the gray area between freedom (which can sometimes feel too open-ended and vast) and security (which may easily turn into confinement). I am fascinated by the way a quality which initially appears to be liberating can suddenly turn out to be confining, and vice versa.[6]

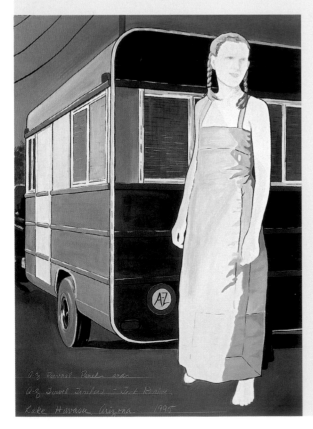

1995 **A–Z Personal Panel, Lake Havasu, Arizona**

Gouache and pencil on Strathmore Bristol board
30 x 22 inches (76 x 56 cm)
Courtesy of Sadie Coles HQ, London

pp. 192–193

2002 **A–Z Fiber Form Uniform
(Gold, Yellow, and White Dress)**

Wool and two 3-inch skirt pins
Courtesy of the artist and Andrea Rosen
Gallery, New York

Danny cleaning up before the opening of
Andrea Zittel: A–Z Escape Vehicles, Andrea
Rosen Gallery, New York, 1996.

Brochure cover, *A–Z Travel Trailer Unit*, 1995.

After living in the confines of the stationary environment at A–Z East, Zittel sought the freedom encapsulated by the *A–Z Travel Trailer Unit*, a variation on the modern recreational vehicle that promotes the lure of tourism and travel in contemporary America—especially the West. The portable living units connect suburban American ideals of mobility with the efficiency and clean design first proposed by the utopian, but ultimately flawed, premises of early European modernism. Fabricated on commission at Callen Camper Company in southern California, this A–Z icon of extra-urban travel—unlike the uniform and often bland decors of off-the-shelf trailer designs—provides a customizable interior. Able to cater to each individual client, an *A–Z Travel Trailer Unit* can accommodate a range of requirements and tastes, from expansive kitchens and whimsical cabinetry to baby changing stations and nautical touches.

A–Z Travel Trailer Unit prior to its installation in *Andrea Zittel: New Work* at the San Francisco Museum of Modern Art, 1995.

Model of prototype for mobile living unit, Zittel's DAAD residency studio, Berlin, 1995.

1995 **Proposal for A–Z Travel Trailer Unit**

Pencil and marker on white tracing paper
19½ x 25½ inches (50 x 65 cm)
Private Collection, Los Angeles

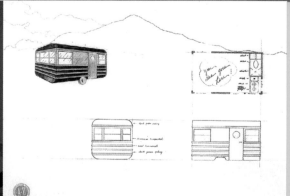

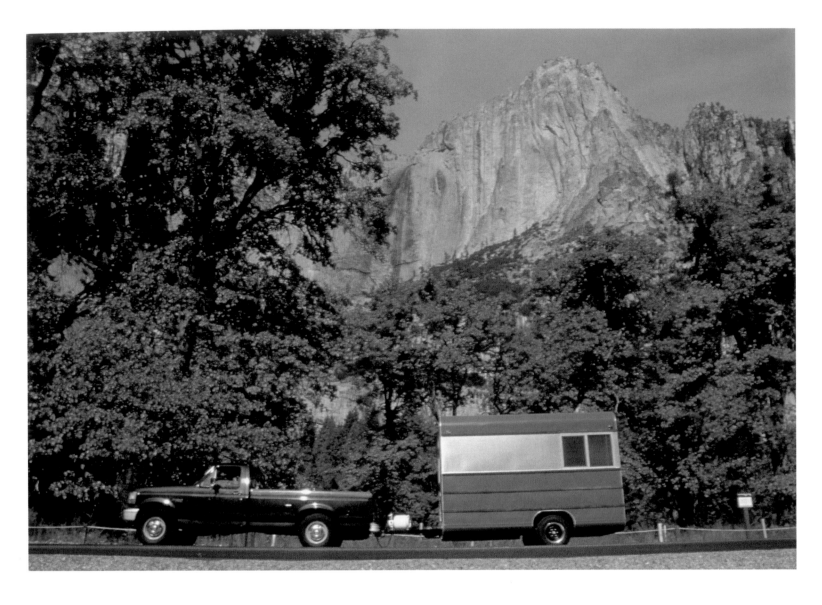

A–Z Travel Trailer Unit Customized by Andrea Zittel,
Yosemite National Park, California, 1995.

*A–Z Travel Trailer Unit Customized by Miriam and Gordon
Zittel,* El Cajon, California, 1995.

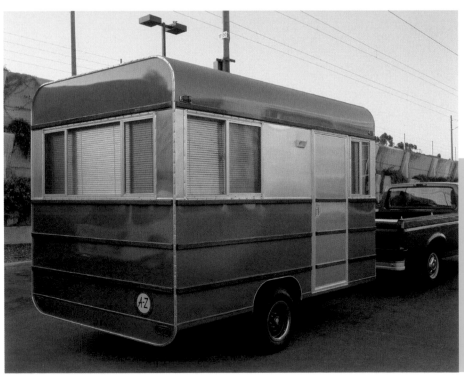

1995 **A–Z Travel Trailer Unit Customized by Todd and Kristin Kimmell**
[interior details]

Steel, wood, glass, carpet, aluminum, and household objects
93 x 93 x 192 inches (236 x 236 x 488 cm)
Louisiana Museum of Modern Art, Humlebaek, Denmark

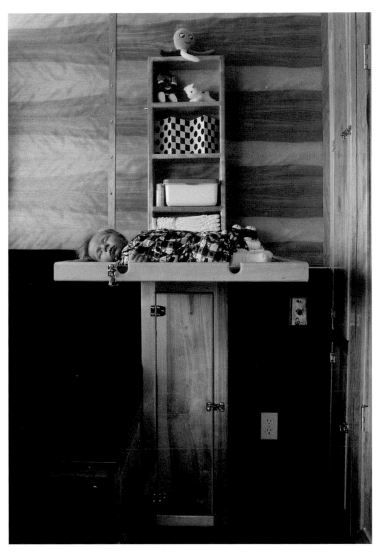

Todd and Kristin Kimmell are the producers of Lost Highways, *the classic trailer magazine. The Kimmels used their A–Z Travel Trailer Unit to explore, among other areas, Palm Springs. As Todd explained, many of the totally outrageous, one-off trailer designs produced to impress crowds at 1940s and 1950s trailer shows somehow wound up in Palm Springs.*

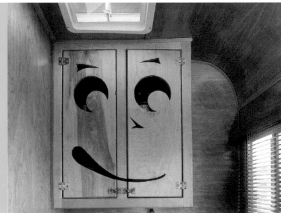

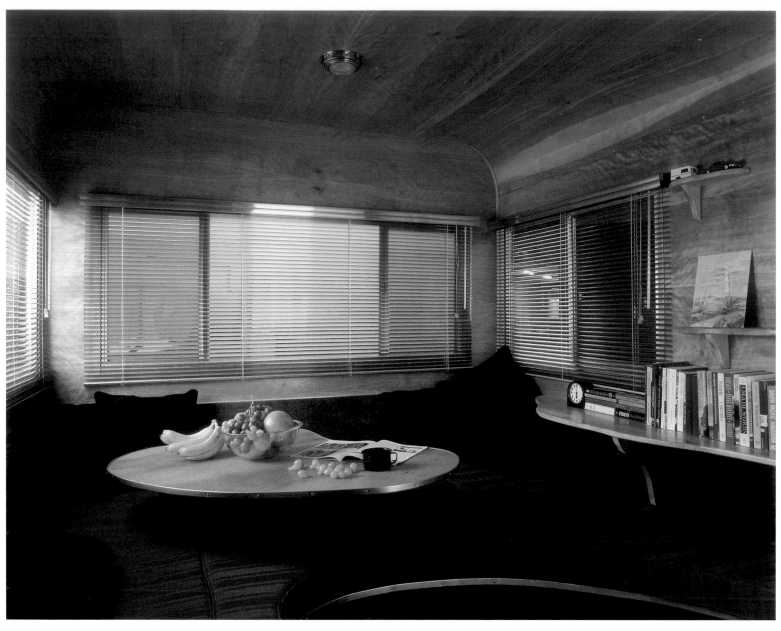

1995 **A–Z Travel Trailer Unit Customized by Andrea Zittel** [detail]

Steel, wood, glass, carpet, aluminum, and objects
93 x 93 x 192 inches (236 x 236 x 488 cm)
San Francisco Museum of Modern Art; Accessions Committee Fund purchase: gift of
Collectors Forum, Jean and Jim Douglas, Evelyn Haas, Diane M. Heldfond, Pam and Dick
Kramlich, Byron R. Meyer, and Judy and John Webb

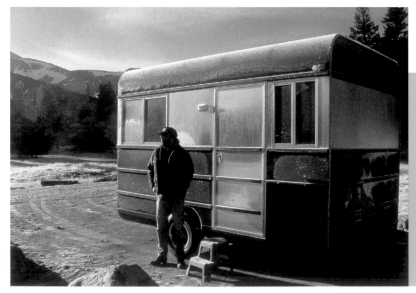

Charlie, who helped customize the unit, in front of *A–Z Travel
Trailer Unit Customized by Andrea Zittel*, Tioga Pass, Yosemite
National Park, California, 1995.

A–Z Travel Trailer Unit Customized by Gordon and Miriam Zittel, on the road, Pacific Coast Highway, 1995.

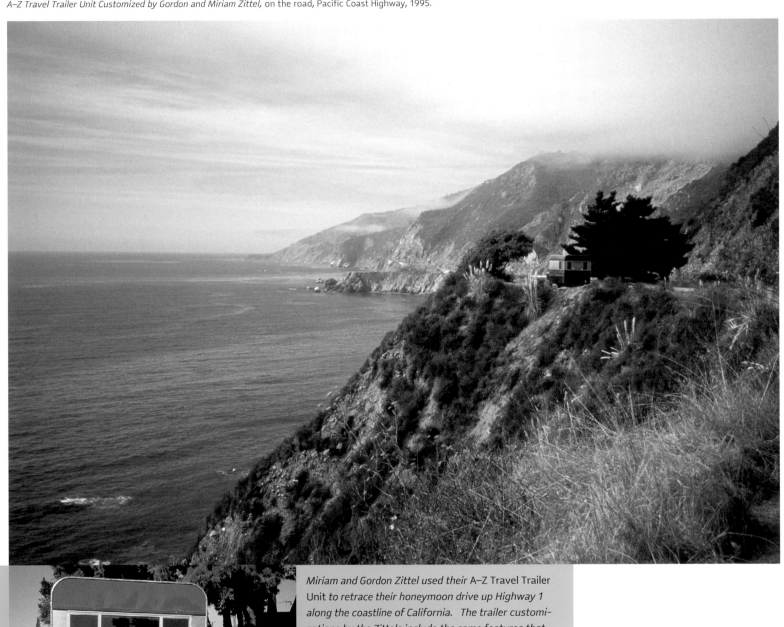

Miriam and Gordon Zittel used their A–Z Travel Trailer Unit to retrace their honeymoon drive up Highway 1 along the coastline of California. The trailer customizations by the Zittels include the same features that they find handy aboard their boat. The overall aesthetic, of course, reflects their love of the ocean and their anticipation of southern tropical coastlines.

Gordon showing Aunt Bettie and Uncle Herman the *A–Z Travel Trailer Unit,* Carpinteria, California, 1995.

Escape for Zittel implies breaking constraints imposed by social conventions and cultural practices. The idea of home does not necessarily equate with four walls and a roof, while the concept of relaxation and paradise varies according to the individual.

The *A–Z Escape Vehicle* is a 100-cubic-foot refuge from public interaction. Although modeled on conventional mobile RV units, the capsule is stationary while in use (though it is transportable). The interior is intended to be entirely customized by the owner. Designed to accommodate one or two people, the space provides isolation for personal reveries, whether a swanky limousine-like interior complete with bar and sound system or naturalistic grotto with colored waterfall.

1996 **The A–Z Escape Vehicle...**

Gouache on paper
16¹/₂ x 22 inches (42 x 56 cm)
Hort Family Collection, New York

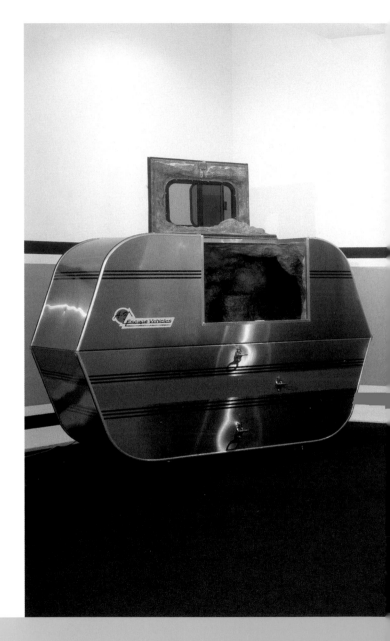

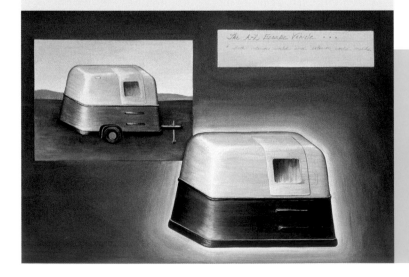

1996 **A–Z Escape Vehicle Customized by Andrea Zittel**;
A–Z Escape Vehicle Owned and Customized by Andrea Rosen;
A–Z Escape Vehicle Owned and Customized by Robert Shiffler

3 vehicles of various media
60 x 40 x 84 inches (152 x 102 x 213 cm) each
Various collections

Installation view, *Andrea Zittel: A–Z Escape Vehicles*, Andrea Rosen Gallery, New York, 1996

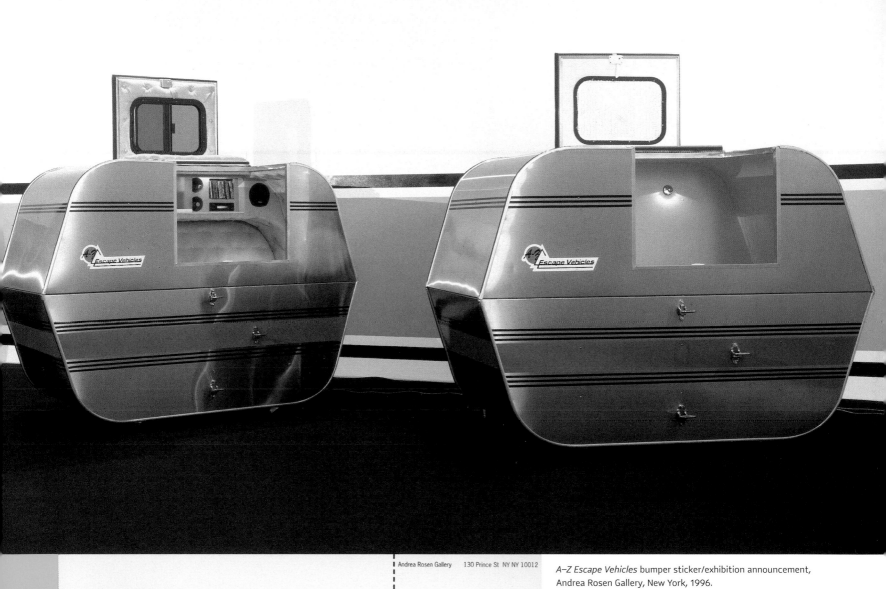

Andrea Rosen Gallery 130 Prince St NY NY 10012

ANDREA ZITTEL
November 1-December 7, 1996
Opening November 1, 6-8 PM

tel: 212 941 0203 fax: 212 941 0327

A–Z Escape Vehicles bumper sticker/exhibition announcement, Andrea Rosen Gallery, New York, 1996.

1996 **A–Z Escape Vehicle Customized by Andrea Zittel** [interior]

Shell: steel, insulation, wool, and glass; interior: colored lights, water, fiberglass, wood, pebbles, papier-mâché, and paint
60 x 40 x 84 inches (152 x 102 x 213 cm)
The Museum of Modern Art, New York; The Norman and Rosita Winston Foundation, Inc. Fund and an anonymous fund, 1997

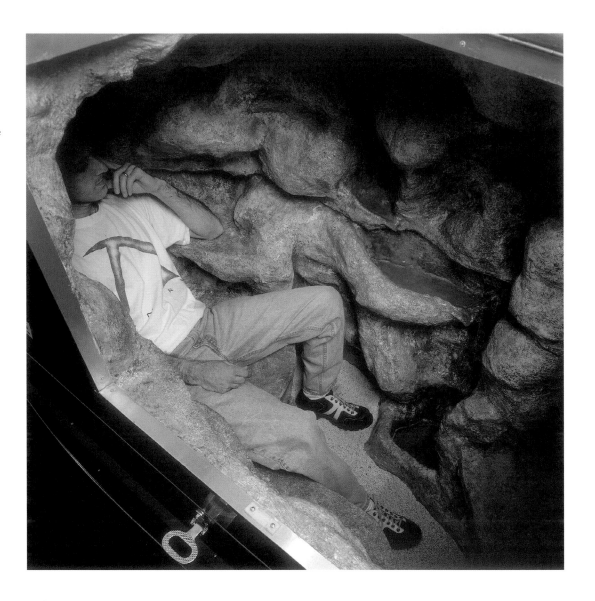

A–Z Escape Vehicle frames under construction, Callen Camper Company, El Cajon, California, 1996.

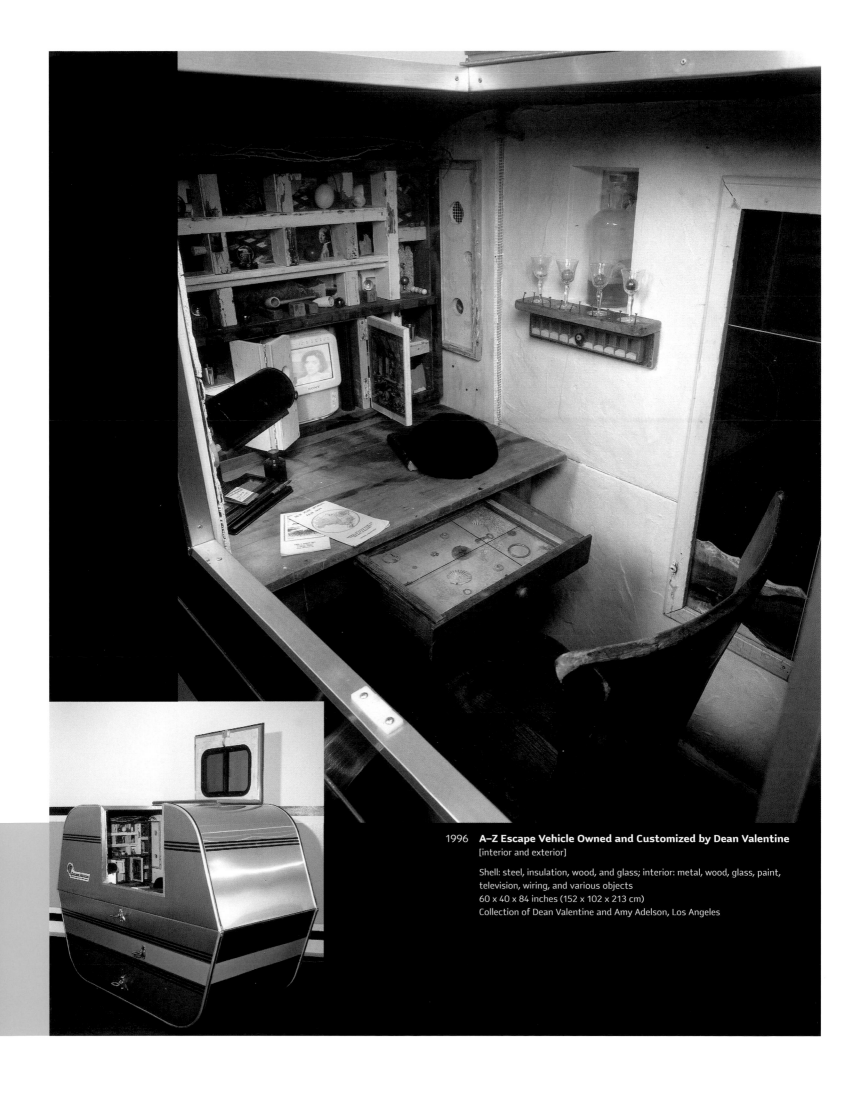

1996 A–Z Escape Vehicle Owned and Customized by Dean Valentine
[interior and exterior]

Shell: steel, insulation, wood, and glass; interior: metal, wood, glass, paint,
television, wiring, and various objects
60 x 40 x 84 inches (152 x 102 x 213 cm)
Collection of Dean Valentine and Amy Adelson, Los Angeles

1996 A–Z Escape Vehicle Owned and Customized by Andrea Rosen [interior]

Shell: steel, insulation, wood, and glass; interior: velvet, mirror, and glass
60 x 40 x 84 inches (152 x 102 x 213 cm)
Collection of Andrea Rosen, New York

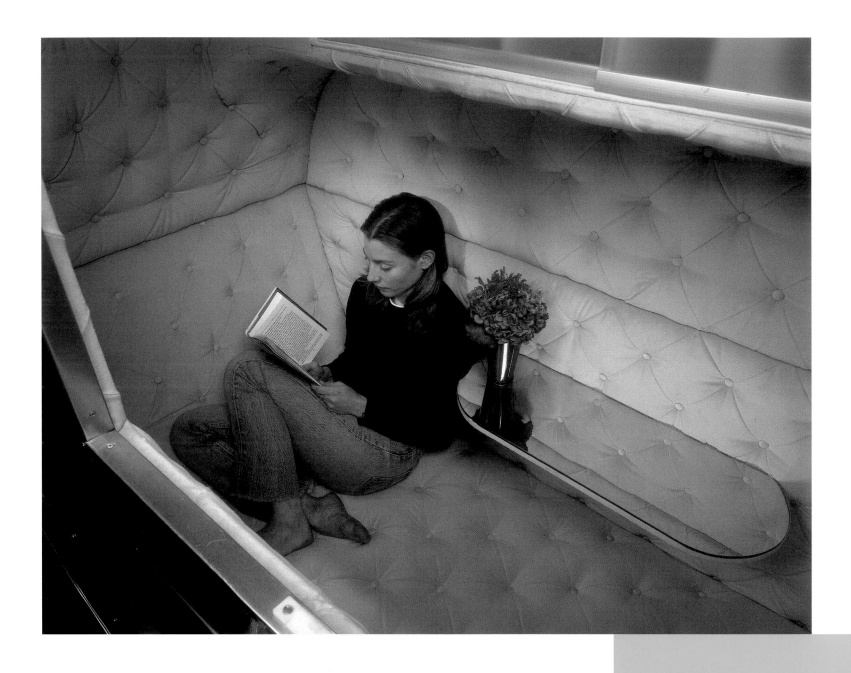

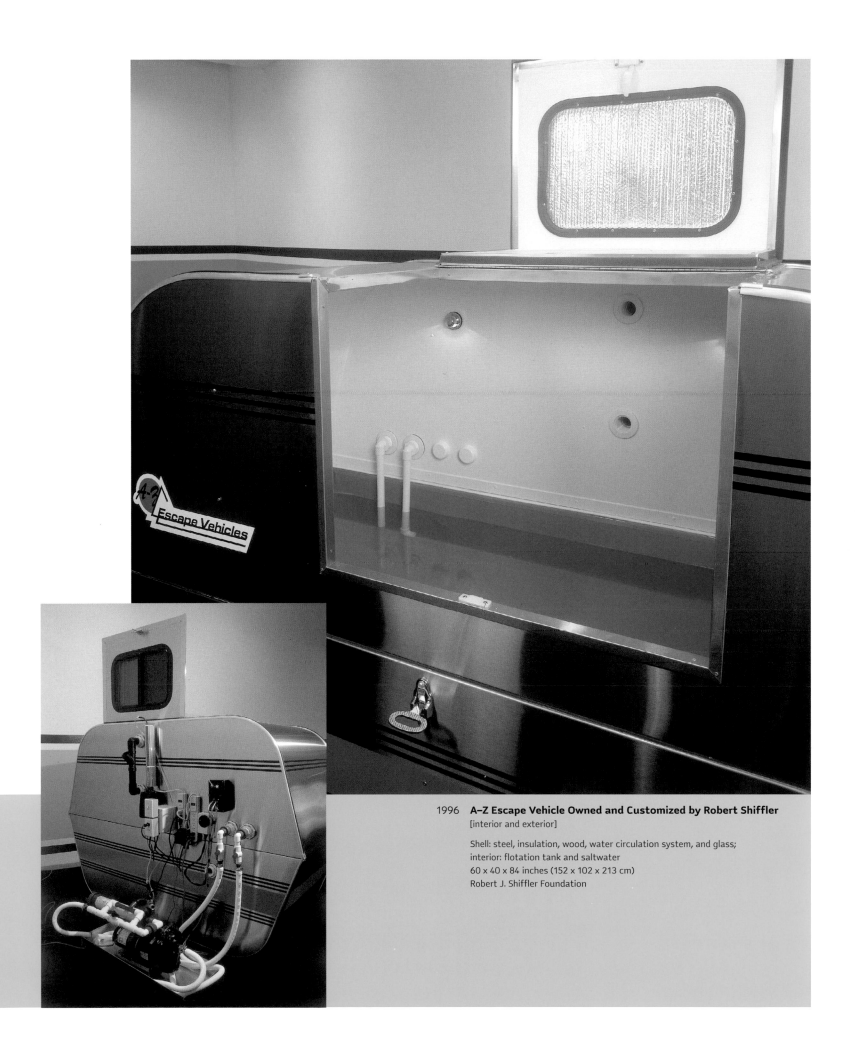

1996 **A–Z Escape Vehicle Owned and Customized by Robert Shiffler**
[interior and exterior]

Shell: steel, insulation, wood, water circulation system, and glass;
interior: flotation tank and saltwater
60 x 40 x 84 inches (152 x 102 x 213 cm)
Robert J. Shiffler Foundation

1997 **A–Z Thundering Prairie Dog (Russet, Buff, and Brown)**

3 units. Shell: steel, insulation, wood, and glass; interior: wood, metal, wiring, microphone, amplifier, and loudspeaker
72½ x 35½ x 91 inches (184 x 90 x 213 cm) each
Courtesy of Philomene Magers Projekte, Munich

Installation view, *Culbutes. Oeuvre d'impertinence*, Musee d'art contemporain de Montreal, Canada, 2000

1997 **A–Z Thundering Prairie Dog**

Shell: steel, insulation, wood, and glass; interior: wood, metal, wiring, microphone, amplifier, and loudspeaker
72½ x 35½ x 91 inches (184 x 90 x 213 cm)
Courtesy of the artist and Philomene Magers Projekte, Munich

Installation view, *Media and Human Body: Fukui Biennial 7*, Fukui City Art Museum, Japan, 1997

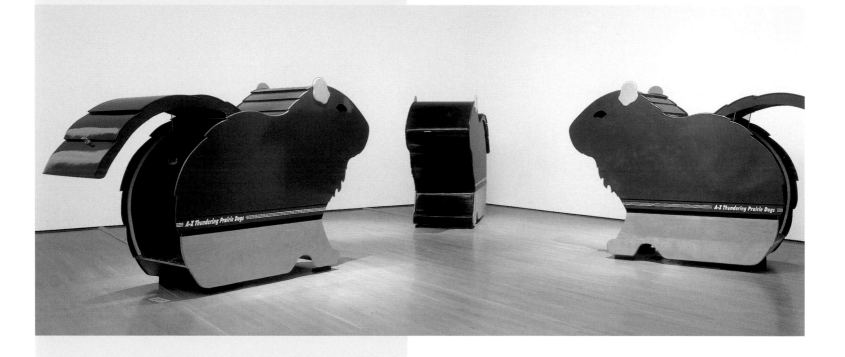

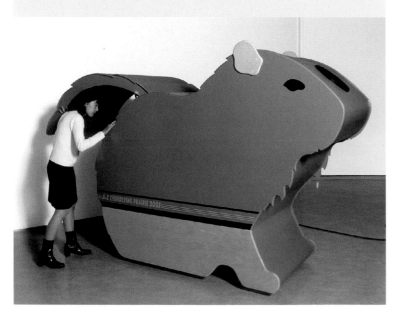

The *A–Z Thundering Prairie Dog* was conceived as a follow-up to the *A–Z Escape Vehicle*. Similar in design, the wooden units have customized exterior finishes while their gigantic anthropomorphism suggests a fifties sci-fi movie mutation. Each unit includes a microphone and amplifier combination that allows the enclosed speaker to distort his or her projected voice, preserving anonymity. A combination playhouse, Trojan horse, and mobile unit, the capsule with its interactive loudspeaker wittily reveals the difficulty of completely secluding oneself from contemporary communication modes. A two-toned allusion to America's automobile culture and to oversized roadside vernacular attractions, the *A–Z Thundering Prairie Dog* observes how drivers use their vehicles to project themselves outward, not only through physical space but also as showy personifications demanding attention.

1997 **A–Z Deserted Island**

Fiberglass, wood, plastic, flotation tank, vinyl seat, and vinyl logo
1 of an edition of 10
36 x 90 x 90 inches (91 x 229 x 229 cm)

With the *A–Z Deserted Islands*, Zittel fulfills the fantasy of isolation and escape, and explores the lure of distance and isolation, but within a "safe and predictable environment." Reminiscent of tourist paddleboats but lacking self-propulsion and tethered to an anchor, the large single-occupant fiberglass rafts play off the mix of recreation and tranquility associated with life on an island. The islands, while providing a sense of individualism and personal isolation, can also be grouped and floated close together to form an intimate but isolated community.

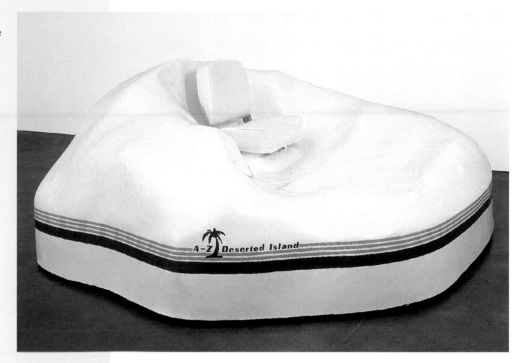

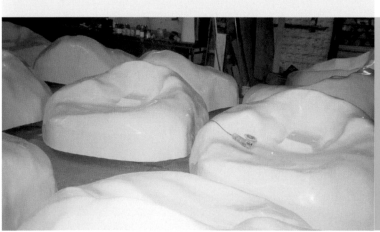

A–Z Deserted Islands under construction, M. B. Winston, Brooklyn, 1997.

Cover of instruction manual, *Everything You Ever Needed to Know About the Deserted Islands* [drawings by Rob Lemmon].

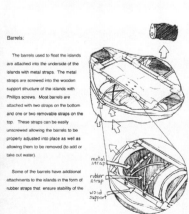

Everything You Ever Needed to Know About
the Deserted Islands

Barrels:

The barrels used to float the islands are attached into the underside of the islands with metal straps. The metal straps are screwed into the wooden support structure of the islands with Phillips screws. Most barrels are attached with two straps on the bottom and one or two removable straps on the top. These straps can be easily unscrewed allowing the barrels to be properly adjusted into place as well as allowing them to be removed (to add or take out water).

Some of the barrels have additional attachments to the islands in the form of rubber straps that ensure stability of the

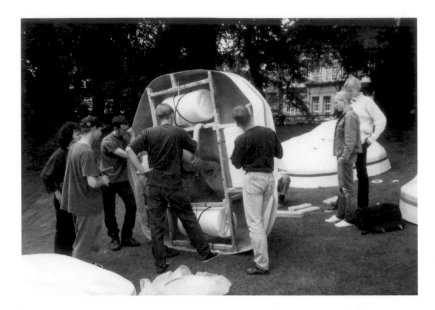

Three views of the installation of *A–Z Deserted Islands*, Münster park, for *Skulptur: Projekte in Münster 1997*, Westfälisches Landesmuseum für Kunst und Kulturgeschichte, Münster, Germany, 1997.

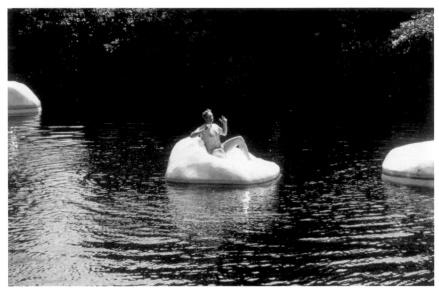

A–Z Deserted Islands I–X in *A–Z Deserted Islands*, Public Art Fund, Central Park Pond, New York, 1997.

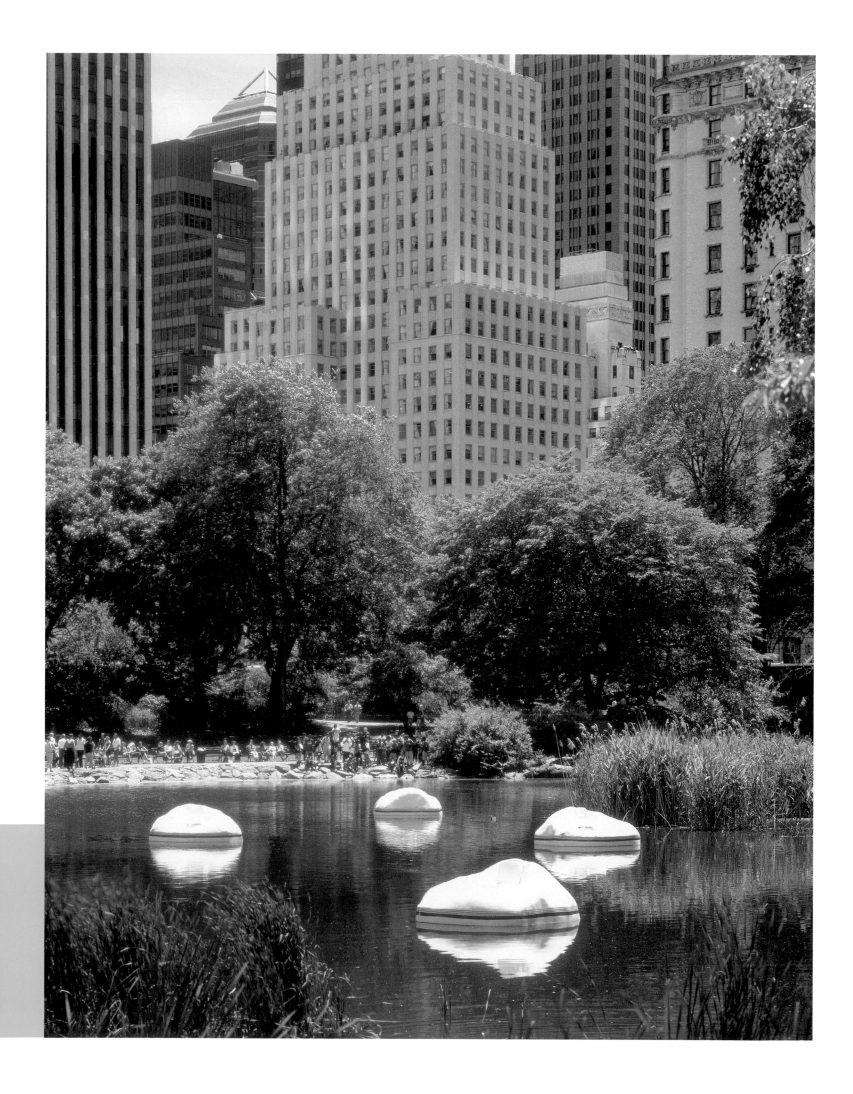

Reminiscent of the streamlined American trailer home, the *A–Z Yard Yacht* is a stand-alone mobile structure that can serve as home or personal office. Although portable, the large vehicle is not intended for extended travel and though its iconic design suggests mobility it is, in fact, semipermanent. Zittel incorporated client Andy Stillpass's suggestions into the first example, *A–Z Yard Yacht: Stillpass Suites*; here, the interior is customized with beds and a living area to accommodate overnight guests to his residence. Later she used a nearly identical design for the outer shell of the *Yard Yacht: Work Station,* a temporary office for herself after her return to the West Coast in 1997.

A–Z Yard Yacht: Stillpass Suites under construction, parked with recreational vehicles, Callen Camper Company, El Cajon, California, 1998.

A–Z Yard Yacht: Work Station logo, 1998.

Multi-unit trailer "hotel" visited by Gordon and Miriam Zittel on a European trip, 1995.

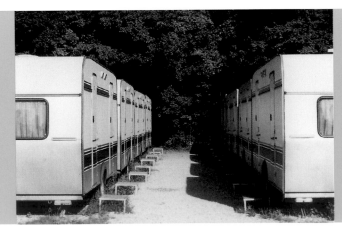

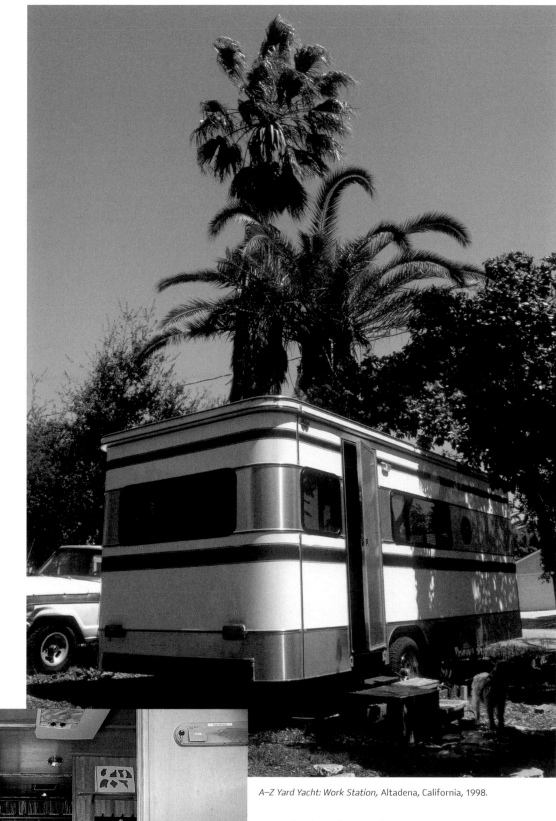

A–Z Yard Yacht: Work Station, Altadena, California, 1998.

A–Z Yard Yacht: Work Station, interior, 1998.

1998 A–Z Yard Yacht: Stillpass Suites [interior details]

Steel, wood, glass, carpet, aluminum, and household objects
120 x 298 x 101 ¼ inches (305 x 757 x 257 cm)
Collection of Andy and Karen Stillpass

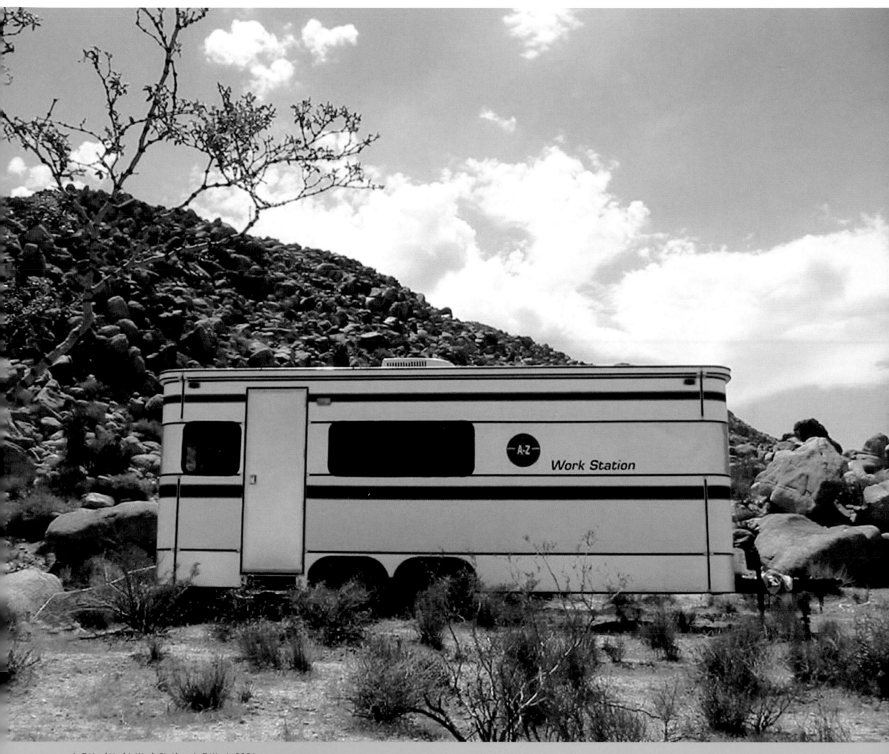

A–Z Yard Yacht: Work Station, A–Z West, 2004.

2003 **A–Z Wagon Station Customized by Jonas Hauptman**

Powder-coated steel, aluminum, medium density fiberboard, birch plywood, Lexan, and Rhino coating with woodburning stove
Approx. 84 x 106 x 84 inches (213 x 269 x 213 cm)
Courtesy of Andrea Zittel

Installation view, A–Z West, 2003

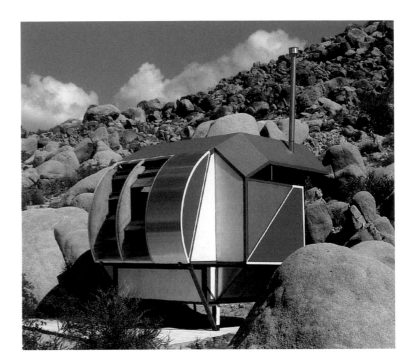

Part mythical Conestoga and part standard automobile, the *A–Z Wagon Station* is large enough to house possessions and to function as a personal shelter. It is a twenty-first-century evocation of Old West covered wagons, with the functionality of a suburban station wagon interior—but lacking wheels. Though intended to serve as additional living units on a property, in fact the *A–Z Wagon Station* can be broken down into five components and easily transported to a new locale. As with the *A–Z Homestead Unit*, the small size of the *A–Z Wagon Station* avoids the regulatory control of bureaucratic restrictions such as building codes. The unit offers occupants the freedom to easily establish quarters in the middle of a desert (or elsewhere). Customizations of the *A–Z Wagon Station* make use of its curvature and unusual aesthetic. Some current permutations are clearly inspired by custom car culture, with flames and similar decorations, while others delve into more traditional art realms, incorporating the colored wood and found signage of assemblage art. An *A–Z Wagon Station* unit can resemble anything from the sidecar of a motorcycle to a stained-glass greenhouse.

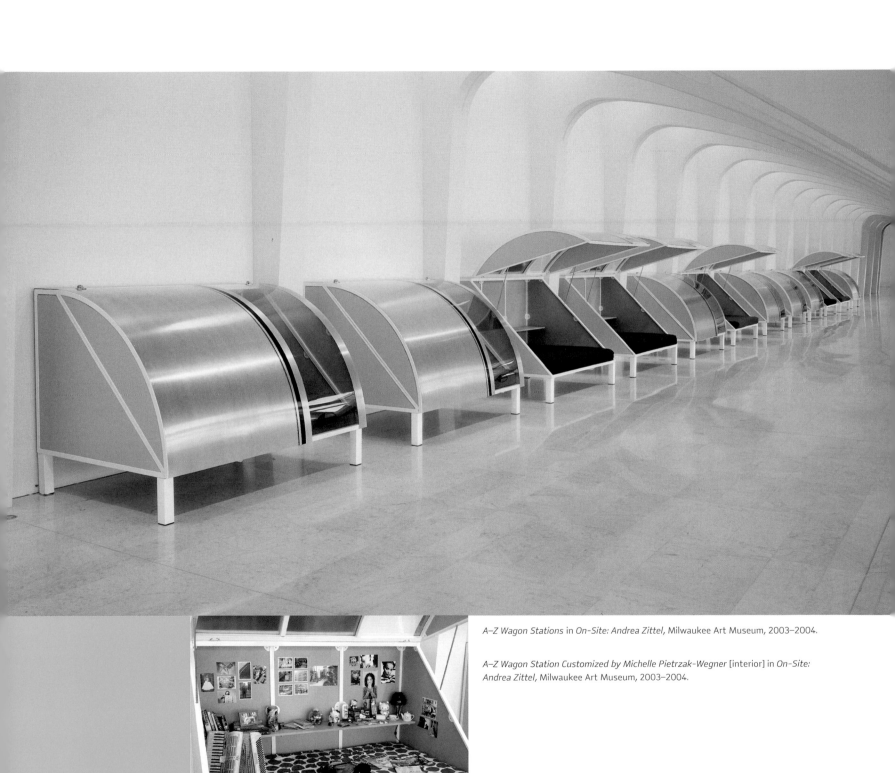

A–Z Wagon Stations in *On-Site: Andrea Zittel*, Milwaukee Art Museum, 2003–2004.

A–Z Wagon Station Customized by Michelle Pietrzak-Wegner [interior] in *On-Site: Andrea Zittel*, Milwaukee Art Museum, 2003–2004.

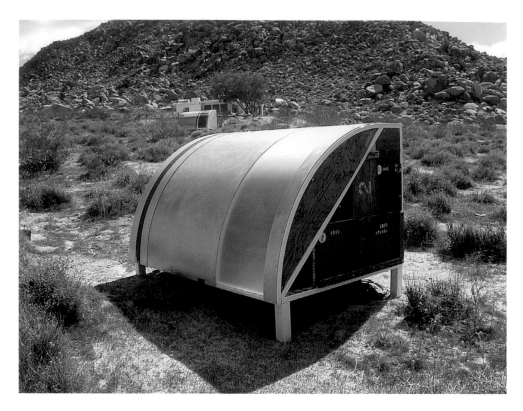

2002 **A–Z Wagon Station Customized by Hal McFeely**

Powder-coated steel, aluminum, medium density
fiberboard, Lexan, and salvaged wood
60 x 70 x 60 inches (152 x 178 x 152 cm)
Courtesy of Andrea Zittel

Installation view, A–Z West, 2002.

A–Z Wagon Stations, A–Z West, 2005.

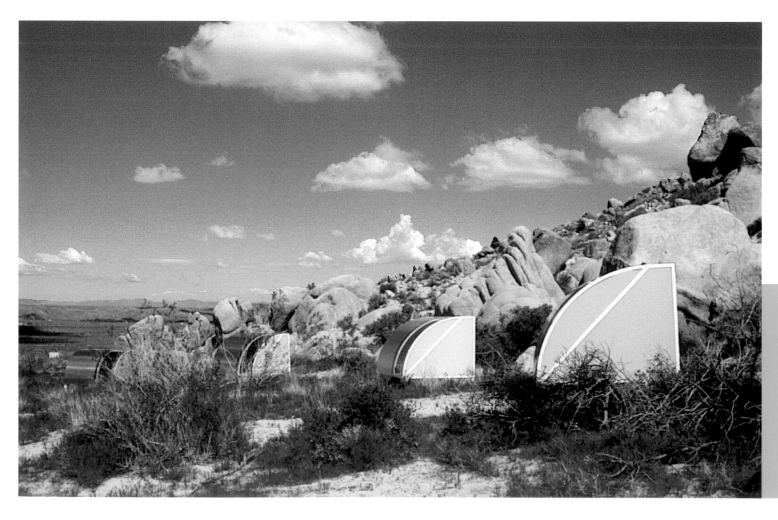

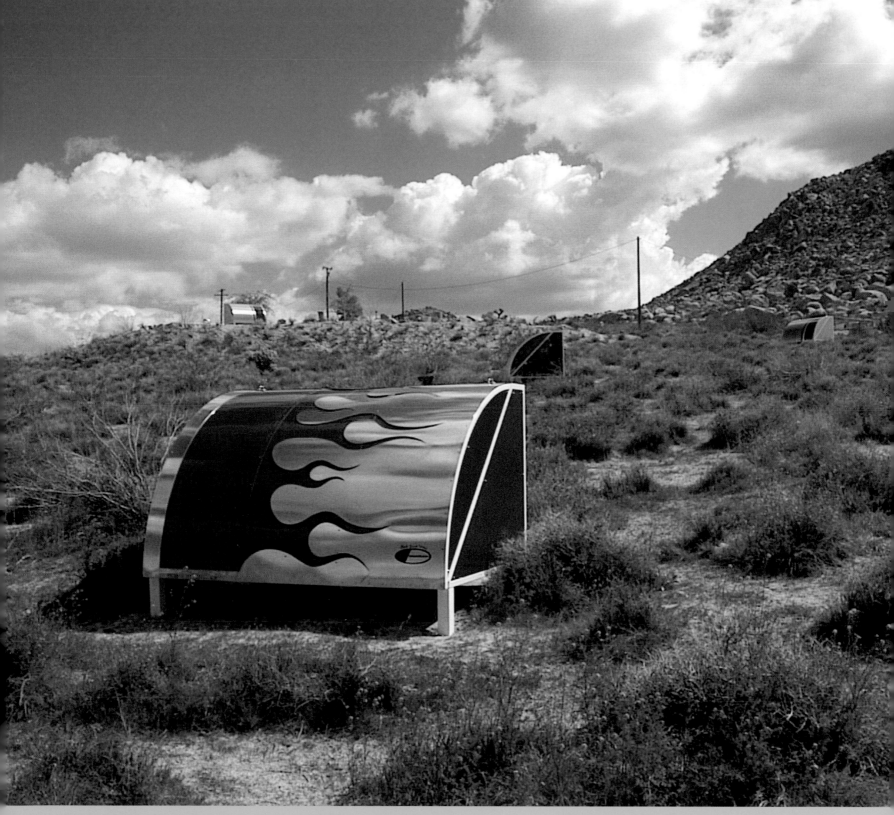

2003 **A–Z Wagon Station Customized by Russell Whitten**

Powder-coated steel, aluminum, medium density fiberboard, Lexan, and paint
60 x 70 x 60 inches (152 x 178 x 152 cm)
Collection of the artist

Installation view, A–Z West, 2003.

PLATE ENDNOTES

1. Andrea Zittel, quoted in Benjamin Weil, "Home Is Where the Art Is: Andrea Zittel," *Art Monthly*, November 1994, p. 22.

2. Andrea Zittel, "A Brief History of A–Z Garments," in *A–Z Advanced Technologies: Fiber Forms*, artist's brochure (Tokyo: Gallery Side 2, 2002), n.p.

3. Zittel, quoted in Weil, p. 22.

4. Andrea Zittel, quoted in Stefano Basilico, "Andrea Zittel," *Bomb*, Spring 2001, p. 76.

5. Zittel, quoted in Basilico, p. 74.

6. Andrea Zittel, quoted in Theodora Vischer, "Questions Addressed to Andrea Zittel," in *Andrea Zittel: Living Units*, exh. cat. (Basel, Switzerland: Museum für Gegenwartskunst, and Graz, Austria: Neue Galerie am Landesmuseum Joanneum, 1996), p. 17.

Catalogue of the Exhibition

Selected Biography
and Bibliography

Catalogue of the Exhibition

Height precedes width precedes depth. Illustrated works are cross-referenced by the page or figure number following the title.

Family Tree Apartment Complex, 1991 *p. 143*
Vinyl and shrubbery
6 x 17 x 5 1/2 inches (15 x 43 x 14 cm)
Collection of Barbara and Howard Morse, New York

Hisex Brown, 1991
Graphite on paper in plastic sleeve
11 1/8 x 30 1/8 inches (28 x 77 cm)
Courtesy of the artist and Andrea Rosen Gallery, New York

Lanson Industries, 1991
Graphite on vellum in plastic sleeve
11 7/8 x 15 1/8 inches (30 x 38 cm)
Courtesy of the artist and Andrea Rosen Gallery, New York

Missouri Egg Machine, 1991 *p. 142*
Graphite on vellum in plastic sleeve
11 7/8 x 15 1/8 inches (30 x 38 cm)
Courtesy of the artist and Andrea Rosen Gallery, New York

Nicholas Turkey, 1991
Graphite on vellum in plastic sleeve
11 1/8 x 30 1/8 inches (28 x 77 cm)
Courtesy of the artist and Andrea Rosen Gallery, New York

Ponds for Developing Amphibian Appendages, 1991 *p. 143*
Vinyl and shrubbery
2 1/2 x 18 1/2 x 7 inches (6 x 47 x 18 cm)
Collection of Barbara and Howard Morse, New York

Repair Work [Bowl], 1991 *p. 109*
Porcelain and glue
3 x 6 inches (8 x 15 cm) diameter
Collection of Barbara and Howard Morse, New York

Repair Work [Cup], 1991
Porcelain and glue
2 1/2 x 5 inches (6 x 13 cm) diameter
Collection of Barbara and Howard Morse, New York

Repair Work [Cup], 1991
Porcelain and glue
3 x 6 inches (8 x 15 cm) diameter
Collection of Barbara and Howard Morse, New York

Repair Work [Elephant], 1991 *p. 109*
Plaster and glue
18 x 24 x 9 inches (46 x 61 x 23 cm)
Collection of Barbara and Howard Morse, New York

Repair Work [Floor], 1991
Tiles and plaster
4 x 48 x 23 inches (10 x 122 x 58 cm)
Collection of Barbara and Howard Morse, New York

Repair Work [Hub Cap], 1991
Steel
16 1/2 inches (42 cm) diameter
Collection of Barbara and Howard Morse, New York

Repair Work [Dish], 1991 *p. 109*
Porcelain and glue
3/4 x 9 1/2 inches (2 x 24 cm) diameter
Collection of Barbara and Howard Morse, New York

Repair Work [Table], 1991 *fig. 36*
Wood and glue
22 x 18 x 13 inches (56 x 46 x 33 cm)
Collection of Barbara and Howard Morse, New York

Repair Work [Wise Man], 1991 *p. 109*
Papier-mâché and paint
Approx. 7 x 3 inches (18 x 8 cm)
Collection of Barbara and Howard Morse, New York

Tatum Farms, 1991
Graphite on vellum in plastic sleeve
11 1/8 x 30 1/8 inches (28 x 77 cm)
Courtesy of the artist and Andrea Rosen Gallery, New York

A–Z Personal Uniform, 1991–present *p. 81*
Various fabrics
45 handmade dresses
Dimensions variable
Emanuel Hoffmann Foundation, permanent loan to the
Öffentliche Kunstsammlung, Basel, Switzerland

A–Z Jon Tower Life Improvement Project *p. 69*
Portfolio, 1991–92
Ink on paper in plastic sleeves in aluminum notebook
11 x 8$\frac{1}{2}$ inches (28 x 22 cm) each page
Courtesy of the artist and Andrea Rosen Gallery, New York

A–Z Management and Maintenance Unit, *p. 129*
Model 003, 1992
Steel, wood, carpet, plastic sink, glass, mirror, stovetop,
and household objects
86 x 94 x 68 inches (218 x 239 x 173 cm)
Collection of Andrea Rosen, New York

A–Z Purity/Privacy Robe Drawing II, 1992
Graphite on vellum
14 x 17 inches (36 x 43 cm)
Courtesy of the artist and Andrea Rosen Gallery, New York

Men, from the **Clone Series**, 1992 *fig. 10*
Graphite, vellum, and polyester
33 x 19$\frac{1}{2}$ x 1$\frac{1}{2}$ inches (84 x 50 x 4 cm) framed
Collection of Barbara and Howard Morse, New York

Rabbits, from the **Clone Series**, 1992
Graphite, vellum, and polyester
33 x 19$\frac{1}{2}$ x 1$\frac{1}{2}$ inches (84 x 50 x 4 cm) framed
Collection of Barbara and Howard Morse, New York

Teacups, from the **Clone Series**, 1992
Graphite, vellum, and polyester
33 x 19$\frac{1}{2}$ x 1$\frac{1}{2}$ inches (84 x 50 x 4 cm) framed
Collection of Barbara and Howard Morse, New York

Study for A–Z Carpet Furniture, 1992
Gouache on paper
11 x 14 inches (28 x 36 cm)
Courtesy of the artist and Andrea Rosen Gallery, New York

Study for A–Z Carpet Furniture, 1992
Gouache on paper
11 x 14 inches (28 x 36 cm)
Hort Family Collection, New York

A–Z Body Processing Unit, 1993 *p. 118*
Wood, metal, Plexiglas, black vinyl, lighting fixture, stove top,
sink, household objects, and *A–Z Food Group* sample
36 x 36 x 18 inches (91 x 91 x 46 cm) closed;
72 x 18 x 18 inches (183 x 46 x 46 cm) open
Private Collection, Turin, Italy
Courtesy Galleria Massimo De Carlo, Milan

A–Z Breeding Unit for Averaging *p. 151*
Eight Breeds, 1993
Steel, glass, wood, wool, light bulbs, and electric wiring
72 x 171 x 18 inches (183 x 434 x 46 cm)
The Museum of Contemporary Art, Los Angeles;
Gift of Donatella and Jay Chiat

A–Z Chamber Pot, 1993 *p. 107*
Spun aluminum
3 of an edition of 10
5$\frac{1}{2}$ x 9$\frac{1}{2}$ inches (14 x 24 cm) each
Courtesy of the artist and Andrea Rosen Gallery, New York

A–Z Chamber Pot, 1993
Spun aluminum
2 of an edition of 10
5$\frac{1}{2}$ x 9$\frac{1}{2}$ inches (14 x 24 cm) each
Collection of Steven Johnson and Walter Sudol, New York

A–Z Cover, 1993 *p. 116*
Wool, velvet, and linen
1 of an edition of 30; 3 covers per edition
72 x 60 inches (183 x 152 cm) each
Courtesy of the artist and Andrea Rosen Gallery, New York

A–Z Food Group, 1993 *p. 120*
Dehydrated food: rice, oats, couscous, chickpeas, black
beans, pinto beans, broccoli, spinach, onions, mushrooms,
bell pepper, carrots, sunflower seeds, pumpkin seeds
Courtesy of the artist and Andrea Rosen Gallery, New York

A–Z 1993 Living Unit, 1993 *p. 130*
Steel, wood, light, cot, stools, mirror, stovetop,
toaster oven, and household objects
60 x 40 x 30 inches (152 x 102 x 76 cm) closed;
60 x 40 x 61 inches (152 x 102 x 155 cm) open
Milwaukee Art Museum; Gift of Contemporary Art Society,
M2003.151

Documentation for A–Z Cover In Use, 1993 *p. 117*
Black-and-white photographs
3 photographs: 7 x 5 inches (18 x 13 cm) each;
4 photographs: 5 x 7 inches (13 x 18 cm) each;
overall dimensions variable
Courtesy of the artist and Andrea Rosen Gallery, New York

Domestic Model A, 1993
Wood and paint
8 1/2 x 30 x 19 inches (22 x 76 x 48 cm)
Private Collection, Courtesy of White Cube, London

Domestic Model B, 1993
Wood and paint
8 1/2 x 24 x 19 inches (22 x 61 x 48 cm)
Courtesy of the artist and Andrea Rosen Gallery, New York

Domestic Model C, 1993
Wood and paint
8 1/2 x 30 1/2 x 32 inches (22 x 77 x 81 cm)
Private Collection, Courtesy of White Cube, London

Domestic Model D, 1993 *p. 115*
Wood and paint
8 1/2 x 20 3/4 x 32 inches (22 x 53 x 81 cm)
Courtesy of the artist and Andrea Rosen Gallery, New York

Domestic Model E, 1993 *p. 115*
Wood and paint
8 1/2 x 20 3/4 x 32 inches (22 x 53 x 81 cm)
Courtesy of the artist and Andrea Rosen Gallery, New York

Prototype for A–Z Cool Chamber, 1993 *p. 125*
Wood, steel, paint, air conditioner, and light
84 x 32 x 50 inches (213 x 81 x 127 cm)
Collection of David and Diane Waldman, Rancho Mirage, California

Prototype for A–Z Warm Chamber, 1993 *p. 125*
Wood, steel, paint, heater, and light
84 x 32 x 50 inches (213 x 81 x 127 cm)
Private Collection, Courtesy of Galleria Massimo De Carlo, Milan

A–Z Comfort Unit Customized for *p. 135*
the Cincinnati Art Museum, 1994
Steel, birch plywood, velvet, Plexiglas, foam mattress, and
objects selected by the Museum
Bed: 48 x 78 x 52 inches (122 x 198 x 132 cm); 4 service
stations: 54 x 25 1/2 x 18 inches (137 x 65 x 46 cm) each
Cincinnati Art Museum; Museum Purchase, Gift of RSM Co.,
by exchange

A–Z 1994 Living Unit Customized for *p. 132*
Eileen and Peter Norton, 1994
Steel, birch plywood, paint, foam mattress, glass, mirror,
lighting fixture, upholstery fabric, appliances, and
household objects
59 x 84 x 82 inches (150 x 213 x 208 cm) open
Collections of Eileen Harris Norton and Peter Norton, Santa
Monica, California

A–Z Personal Panel, Brooklyn, 1994
Gouache on paper
30 x 22 inches (76 x 56 cm)
Private Collection, London

A–Z Carpet Furniture (Bed), 1995
Wool and synthetic wool blend carpet
96 x 96 inches (244 x 244 cm)
Courtesy of the artist and Andrea Rosen Gallery, New York

A–Z Escape Vehicle Customized *p. 202*
by Andrea Zittel, 1996
Shell: steel, insulation, wood, and glass; interior: colored lights,
water, fiberglass, wood, pebbles, papier-mâché, and paint
60 x 40 x 84 inches (152 x 102 x 213 cm)
The Museum of Modern Art, New York; The Norman and
Rosita Winston Foundation, Inc. Fund and an anonymous
fund, 1997

A–Z Cellular Compartment Unit, 2001 *pp. 186–87*
Stainless steel, plywood, glass, and household objects
10 units: 48 x 48 x 96 inches (122 x 122 x 244 cm) each
96 x 144 x 192 inches (244 x 366 x 488 cm) overall
Courtesy of the artist and Andrea Rosen Gallery, New York

A–Z Food Group, 2001
Gouache on paper
30 x 22 inches (76 x 56 cm)
Goetz Collection, Munich

A–Z Food Group: The Compounds of Life, 2001 *p. 121*
Gouache on paper
30 x 22 inches (76 x 56 cm)
Goetz Collection, Munich

A–Z Homestead Unit, 2001
Acrylic, gouache, and pen on paper
10 1/2 x 13 1/4 inches (27 x 34 cm)
Courtesy of the artist and Sadie Coles HQ, London

A–Z Homestead Units #1, 2001
Acrylic, gouache, and pen on paper
18 1/8 x 23 1/4 inches (46 x 59 cm)
Courtesy of the artist and Sadie Coles HQ, London

Find New Ways to Position Yourself *p. 172*
in the World, 2001
Gouache on paper
30 x 22 inches (76 x 56 cm)
Courtesy of the artist and Andrea Rosen Gallery, New York

A–Z Homestead Unit, 2001–2005 *p. 182*
Powder-coated steel, birch paneling with paint and
polyurethane, and corrugated metal roof
120 x 156 x 120 inches (305 x 396 x 305 cm)
Courtesy of the artist and Regen Projects, Los Angeles

A–Z Cellular Compartment Unit Communities #5, 2002
Latex paint, tape, and pen on birch
5 parts: 49 3/4 x 97 3/8 inches (127 x 247 cm) each;
147 3/4 x 194 3/4 inches (376 x 495 cm) overall
Courtesy of the artist and Andrea Rosen Gallery, New York

A–Z Fiber Form Uniform *back cover*
(White Felted Dress #7), 2002
Wool
Courtesy of the artist and Regen Projects, Los Angeles

A–Z Wallens, 2002 *p. 127*
Two screen-printed cast aluminum and tempered glass port
lights and hardware in silk-screened wooden crate
2 of an edition of 12
Lights: 14 inches (36 cm) diameter; with custom-made crate:
22 x 39 x 10 inches (56 x 99 x 25 cm)
Courtesy of the artist and Editions Fawbush, New York

sfnwvlei (Something for Nothing with
Very Little Effort Involved) *Note #1*, 2002
Acrylic polyurethane, gouache, and pen on birch panel
25 1/8 x 37 x 4 1/4 inches (64 x 94 x 11 cm) framed
Courtesy of the artist and Regen Projects, Los Angeles

sfnwvlei (Something for Nothing with
Very Little Effort Involved) *Note #2*, 2002
Acrylic polyurethane, gouache, and pen on birch panel
25 1/8 x 37 x 4 1/4 inches (64 x 94 x 11 cm) framed
Courtesy of the artist and Regen Projects, Los Angeles

sfnwvlei (Something for Nothing with
Very Little Effort Involved) *Note #3*, 2002
Acrylic polyurethane, gouache, and pen on birch panel
25 1/8 x 37 x 4 1/4 inches (64 x 94 x 11 cm) framed
Courtesy of the artist and Regen Projects, Los Angeles

sfnwvlei (Something for Nothing with
Very Little Effort Involved) *Note #4*, 2002
Acrylic polyurethane, gouache, and pen on birch panel
25 1/8 x 37 x 4 1/4 inches (64 x 94 x 11 cm) framed
Courtesy of the artist and Regen Projects, Los Angeles

Carving New Raugh Furniture, A–Z West, October 2004,
2004
Gouache and pen on paper
9 x 12 inches (23 x 30 cm)
Courtesy of the artist and Andrea Rosen Gallery, New York

Filing System, Joshua Tree, March 2004, 2004
Gouache and pen on paper
9 x 12 inches (23 x 30 cm)
Courtesy of the artist and Andrea Rosen Gallery, New York

Snow on Regenerating Field, A–Z West, November 2004,
2004
Gouache and pen on paper
9 x 12 inches (23 x 30 cm)
Courtesy of the artist and Andrea Rosen Gallery, New York

Sufficient Self, 2004
DVD projection
17 minutes, 29 seconds
Courtesy of the artist and Regen Projects, Los Angeles

A–Z Paper Pulp Panel #4, #5, and #6, 2005
Powder-coated steel frames, adhesive, and paper pulp panels
#4: 96 x 72 inches (244 x 183 cm);
#5: 84 x 72 inches (213 x 183 cm);
#6: 72 x 72 inches (183 x 183 cm)
Courtesy of the artist and Regen Projects, Los Angeles

**First Flaw in New Raugh Furniture at A–Z West,
January 2005**, 2005
Gouache and pen on paper
9 x 12 inches (23 x 30 cm)
Courtesy of the artist and Andrea Rosen Gallery, New York

Selected Exhibition History and Bibliography

Biography

Born September 6, 1965, Escondido, California

BFA, Painting and Sculpture, San Diego State University, 1988

MFA, Sculpture, Rhode Island School of Design, Providence, 1990

Lives and works in Los Angeles and Joshua Tree, California

ONE-PERSON EXHIBITIONS AND BIBLIOGRAPHY

1987

Rotunda, San Diego Museum of Art.

1988

Drawings and Constructions, Flor y Canto Gallery, San Diego State University.

1989

Landscape, Sol Koffler Graduate Student Gallery, Rhode Island School of Design, Providence.

1993

The A–Z Administrative Services 1993 Living Unit, Jack Hanley Gallery, San Francisco, March 31–May 1. Brochure, text by Andrea Zittel.

Baker, Kenneth. "Galleries: 'Living Units' at Jack Hanley." *San Francisco Chronicle,* April 22, 1993, p. E4.

Christopher Grimes Gallery, Santa Monica, California, April 1–May 15.

Andrea Zittel: Purity, Andrea Rosen Gallery, New York, September 11–October 16.

"Goings On About Town: Andrea Zittel at Andrea Rosen Gallery." *The New Yorker,* October 11, 1993, p. 26.

Smith, Roberta. "Andrea Zittel." *The New York Times,* October 8, 1993, p. C30.

1994

Comfort, Anthony d'Offay Gallery, London, September 3–October 15.

Andrea Zittel: Three Living Systems, The Carnegie Museum of Art, Pittsburgh, October 8–December 31. Brochure, text by Richard Armstrong.

Olson, Kristina. "Andrea Zittel: Three Living Systems, Forum Gallery, Carnegie Museum of Art." *New Art Examiner,* January 1995, p. 40.

1995

Andrea Zittel, Andrea Rosen Gallery, New York, March 4–April 8.

Cotter, Holland. "Andrea Zittel at the Andrea Rosen Gallery." *The New York Times,* March 31, 1995, p. C25.

Levin, Kim. "Andrea Zittel at Andrea Rosen Gallery." *The Village Voice,* March 28, 1995, p. 9.

Andrea Zittel: New Work, San Francisco Museum of Modern Art, November 8–February 4, 1996. Brochure, text by Andrea Zittel.

"Andrea Zittel: New Work." *SFMOMA News,* November–December 1995, p. 6.

Helfand, Glen. "Road Runners: Andrea Zittel's Trailers Blur the Line between Art and Utility." *The San Francisco Weekly,* November 8–14, 1995, p. 37.

Novakov, Anna. "Andrea Zittel: A–Z Travel Units." *Art Press,* February 1996, pp. 66–67.

Thym, Jolene. "Happy Trailers: Artist Andrea Zittel Brings Her Innovatively Furnished Trailer Homes to the Bay Area." *Oakland Tribune,* November 11, 1995, pp. B1, B5.

1996

New Art 6: Andrea Zittel, Cincinnati Art Museum, March 17–May 30. Brochure, text by Andrea Zittel.

Findsen, Owen. "Zittel Exhibit Example of Art You Can Live With." *The Cincinnati Enquirer,* March 17, 1996, p. D5.

The A–Z Travel Trailer Units, Louisiana Museum of Modern Art, Humlebaek, Denmark, April 12–May 12.

Zittel, Andrea. "The A–Z Travel Trailer Units." *Performing Arts Journal,* September 1996, pp. 71–75.

Andrea Zittel—Living Units, Museum für Gegenwartskunst, Basel, Switzerland, October 26–February 2, 1997. Traveled to Neue Galerie am Landesmuseum Joanneum, Graz, Austria, March 13–April 27, 1997. Catalogue, text by Jennifer Flay, Andrea Rosen, Theodora Vischer, Peter Weibel, Andrea Zittel, et al.

Volkart, Yvonne. "Dan Graham's The Suburban City and Andrea Zittel's Living Units." *Flash Art International,* Summer 1997, p. 97.

A–Z Escape Vehicles, Andrea Rosen Gallery, New York, November 1–December 7.

Alhadeff, Gini. "Lettera da New York." *Elle* (Italy), January 1997, pp. 76–77.

Allerholm, Milou. "Soho Galleries on the Move: Go West, Young Man!" *Material,* Winter 1997, p. 4.

"Andrea Zittel at Andrea Rosen." *The New Yorker,* November 25, 1996, p. 32.

Mendelsohn, John. "The Artnet Hit List: Andrea Zittel at Andrea Rosen Gallery." *Artnet* (online magazine), available at http://www.artnet.com/magazine_pre2000/reviews/mendelsohn/zittel.asp (December 13, 1996).

Rego de la Torre, Juan Carlos. "Andrea Zittel, A–Z Escape Vehicles (A–Z EV)." *Noticias de Arte,* December 1996–January 1997, pp. 26–27.

Sand, Olivia J. "Andrea Zittel, Andrea Rosen Gallery, New York." *Artis,* February–March 1997, p. 69.

Smith, Roberta. "'Escape Vehicles' for Carrying Out Fantasies." *The New York Times,* November 15, 1996, p. C21.

1998

A–Z For You • A–Z For Me, University Art Gallery, San Diego State University, April 13–May 13. Brochure, text by Andy Stillpass, Tina Yapelli, and Andrea Zittel.

Pincus, Robert. "Zittel Hitches Her Functional Artwork to a Driving Vision." *The San Diego Union-Tribune,* April 26, 1998, pp. E1, E12.

RAUGH, Andrea Rosen Gallery, New York, May 28–July 10.

"The Cool 'RAUGH' World of A–Z." *RISD Views,* Spring–Summer 1998.

"Goings On About Town." *The New Yorker,* June 22 and 29, 1998, p. 26.

Jaeger, Jack. "In the Meantime." *Metropolis,* October–November 1998, pp. 56–57.

Johnson, Ken. "Andrea Zittel 'Raugh.'" *The New York Times,* June 19, 1998, p. E39.

Levin, Kim. "Voice: Choices." *The Village Voice,* June 30, 1998, p. 108.

Nahas, Dominique. "Andrea Zittel's Raugh." *Artnet* (online magazine), available at http://www.artnet.com/magazine_pre2000/reviews/nahas/nahas7-21-98.asp (July 21, 1998).

Nicholson, Stewart. "Andrea Zittel: Andrea Rosen Gallery." *Cover*, vol.12, 1998, p. 47.

Pederson, Victoria. "Gallery Go 'Round." *Paper*, July 1998, p. 105.

"Purple Interiors #1: Andrea Zittel, Raugh 'n' Ready." *Purple*, Winter 1998–99.

Schwendener, Martha. "Andrea Zittel: 'RAUGH.'" *Time Out New York*, June 18–25, 1998, p. 56.

Sillen, Kim. "Andrea Zittel RAUGH." *NY Arts Magazine*, July–August 1998, p. 11.

"Talent: Raugh Power." *New York Magazine*, June 29–July 6, 1998.

Volk, Gregory. "Andrea Zittel at Andrea Rosen." *Art in America*, December 1998, p. 94.

A–Z Personal Panels: 1993–1998, Sadie Coles HQ, London, December 4–January 25, 1999.

"Andrea Zittel at Sadie Coles." *Flash Art*, January–February 1999.

"Exhibitions: Andrea Zittel." *The Guide* (London), November 28–December 4, 1998.

"Hot Tickets." *Evening Standard* (London), December 3, 1998.

O'Rorke, Imogen. "Andrea Zittel." *Scene*, December 1998, p. 34.

"Roundup: Art of Necessity." *Space*, December 4, 1998.

1999

A–Z Deserted Islands, Public Art Fund, Central Park South Pond, New York, May 26–September.

"Andrea Zittel in Central Park." *Inprocess*, Summer 1999.

"A Day for Buoyant Artwork." *The New York Times*, July 10, 1999, p. B3.

Johnson, Ken. "A Fertile Garden of Sculptures." *The New York Times*, August 13, 1999, p. E33.

Laster, Paul. "Brooklyn Spice." *Artnet* (online magazine), available at http://www.artnet.com/magazine_pre2000/features/laster/laster6-29-99.asp (September 20, 1999).

"Synthetic Archipelago?" *New York Newsday*, May 20, 1999.

Point of Interest: An A–Z Land Brand, The Public Art Fund, Central Park Southeast Entrance, Doris C. Freedman Plaza, New York, May 26–April 2000.

Johnson, Ken. "A Fertile Garden of Sculptures." *The New York Times,* August 13, 1999, p. E33.

Jones, Ronald. "Preview: Idyll Time." *Artforum*, January 1999, p. 40.

Laster, Paul. "Brooklyn Spice." *Artnet* (online magazine), available at http://www.artnet.com/magazine_pre2000/features/laster/laster6-29-99.asp (September 20, 1999).

Pinchbeck, Daniel. "For Sale: Cyber Art and Public Art Rocks in Central Park." *The Art Newspaper*, January 1999, p. 73.

Turner, Grady T. "Art Talk: On the Rocks." *ARTnews*, May 1999, p. 36.

Vogel, Carol. "Inside Art: Nod to Olmstead and the Ice Age." *The New York Times*, December 25, 1998, p. E40.

Volk, Gregory. "Andrea Zittel's Point of Interest." *Inprocess*, Winter 1999.

A–Z Time Trials, Galerie Franck + Schulte, Berlin, September 30–November 13.

Fichtner, Heidi. "Andrea Zittel: Franck + Schulte." *Flash Art International*, January–February 2000, p. 120.

Herstatt, Claudia. "Der Anti-Lifestyle." *Handelsblatt*, April 29, 2000.

Lamm, April. "Berlin Art Diary." *Artnet* (online magazine), available at http://www.artnet.com/magazine_pre2000/reviews/lamm/lamm12-15-99.asp (December 15, 1999).

Andrea Zittel—Personal Programs, Deichtorhallen, Hamburg, November 19–February 27, 2000. Catalogue, text by Jan Avgikos and Zdenek Felix.

Bals, Ulrike. "Unsichtbares Selbst." *Die tageszeitung Tas Hamburg*, December 13, 1999, p. 23.

Böker, Carmen. "Nachttopf in idealer Erscheinung." *Berliner Zeitung*, November 24, 1999, Section Feuilleton, pp. 6, 12.

Briegleb, Till. "Baustelle Kunst." *Die Woche*, November 25, 1999.

Cold, Gyde. "Komprimiertes Wohnen." *Hamburger Rundschau*, December 16, 1999, p. 5.

Dürkoop, Wilfried. "Manipulie Rte/Dylle." *Berliner Morgenpost*, November 23, 1999, p. 9.

Globe, Julia. "Seltsalie Wesen + Fremde Welten." *Cosmopolitan* (Germany), November 1999, p. 5.

Heil, Tanja. "Felsen zum Kuscheln." *Rhein Main Press Journal*, February 12, 2000.

Hofmann, Isabelle. "Frauenpower im Dreierpack." *Hamburger Morgenpost*, November 19, 1999, p. 15.

Jahn, Wolf. "Kunstwerke als Lebensträume." *Hamburger Abendblatt*, November 20, 1999, p. 7.

Klaas, Heiko, and Nicole Büsing. "Brutkasten für Erwachsene." *Neue Osnabrücker Zeitung*, December 18, 1999, p. 12.

Kruse, Maren. "Die Zeit, Der Raum, Die Seele." *Kieler Nachrichten*, November 20, 1999, p. 9.

Maak, Niklas. "In der halle des kunststoffkonigs." *Süddeutsche Zeitung*, November 30, 1999, p. 22.

"News: Deichtorhallen." *Tema Celeste*, January–February 2000, p. 102.`

Ronnau, Jens. "Hanne Darboven, Andrea Zittel, Inez van Lamsweerde: 3 Ausstellugen in der nördlichen Deichtorhalle, Hamburg, 18.11.1999–27.2.2000." *Kunstforum International*, January–March 2000, pp. 341–43.

Tietenberg, Annette. "Edel sei die kunst, hilfreich unn tue nicht gut." *Frankfurter Augemeine Zeitung*, February 11, 2000.

Wiensowski, Ingeborg. "Andrea Zittel." *Spiegel*, November 11, 1999, Section Kultur.

2000

A–Z Time Trials: Free Running Rhythms, Regen Projects, Los Angeles, February 5–March 4.

"Andrea Zittel: A–Z Time Trials Free Running Rhythms and Patterns." *Los Angeles Times*, February 24, 2000.

Marie, Annika. "Andrea Zittel at Regen Projects." *Art Issues*, Summer 2000, p. 50.

Muchnic, Suzanne. "Andrea Zittel: Regen Projects." *ARTnews*, June 2000, p. 151.

Pagel, David. "Charts and Graphs: Andrea Zittel." *Los Angeles Times*, February 18, 2000, p. F34.

A–Z Time Trials, Andrea Rosen Gallery, New York, April 22–May 27.

"A–Z Time Trials." *The New Yorker*, May 29, 2000, p. 26.

Robinson, Walter. "Mid-week Update." *Artnet* (online magazine), available at http://www.artnet.com/magazine/reviews/robinson/robinson4-26-00.asp (April 26, 2000).

2001

Everlasting and Complete: A–Z Food Group and A–Z Eating Environments, Galleria Massimo De Carlo, Milan, February 19–March 26.

A–Z 2001 Homestead Units, Sadie Coles HQ, London, October 29–December 8.

Gleeson, David. "Andrea Zittel: Sadie Coles HQ, London; Ikon Gallery, Birmingham." *Frieze,* March 2002, pp. 85–86.

Gleeson, David. "Andrea Zittel." *Frieze,* November 3, 2001.

"Home of the Free: Artist Andrea Zittel Builds the New American Dream House." *V Magazine,* November–December 2001.

Lyle, Kristen. "Andrea Zittel: Sadie Coles HQ, London." *Make, the magazine of women's art,* no. 92, 2002, p. 28.

Safe, Emma. "Andrea Zittel: Sadie Coles HQ, London; 43a Commercial Street, Birmingham." *Art Monthly,* December 2001–January 2002, pp. 40–41.

A–Z Cellular Compartment Units, Ikon Gallery, Birmingham, England, October 31–December 2. Brochure, text by Nigel Prince.

"A–Z Cellular Compartment Units: Review." *What's on,* November 2001.

Cowan, Amber. "Andrea Zittel: Ikon Gallery." *The London Times Supplement,* November 3–9, 2001, p. 24.

Freak, Dave. "Boxing Clever on Home Plans." *Evening Mail* (Birmingham), November 23, 2001, p. 43.

Freak, Dave. "Rooms to Maneuver." *City Living,* 2001, pp. 29, 31.

Gleeson, David. "Andrea Zittel: Sadie Coles HQ, London; Ikon Gallery, Birmingham." *Frieze,* March 2002, pp. 85–86.

Kinsman, Chloe. "Andrea Zittel: Ikon Gallery." *Tema Celeste,* January–February 2002, p. 88.

Lack, Jessica. "Going Out: Picks of the Week: Exhibition: 'A–Z Cellular Compartment Units.'" *The Guardian* (London), November 12, 2001.

Safe, Emma. "Art Review: A–Z: Cellular Compartment Units." *Metro Life,* November 6, 2001.

A–Z Sorting Trays, Susan Inglett Gallery, New York, November 7–December 15.

Johnson, Ken. "Art Guide: Andrea Zittel: A–Z Sorting Trays." *The New York Times,* November 23 and 30, 2001, p. E38.

The City of Tomorrow, European Housing Expo, Malmö, Sweden.

2002

A–Z Cellular Compartment Units, Andrea Rosen Gallery, New York, May 10–June 15.

"Andrea Zittel: A–Z Cellular Compartment Units." *Time Out New York,* May 16–23, 2002, p. 76.

Halkin, Talya. "Small Housing and Big Sculptures in Chelsea." *The New York Sun,* May 30, 2002, p. 11.

Levin, Kim. *The Village Voice,* June 18, 2002, p. 97.

A–Z Advanced Technologies: Fiber Forms, Gallery Side 2, Tokyo, September 6–October 4. Brochure, text by Andrea Zittel.

Fujimori, Manami. "Andrea Zittel." *BT Magazine,* October 2002, pp. 125–31.

A–Z West: The Regenerating Fields, Regen Projects, Los Angeles, November 23–December 15.

Myers, Terry. "Enlightening Field." *Tate,* March–April 2003, pp. 40–44, cover.

Andrea Zittel—A–Z Advanced Technologies: The A–Z Regenerating Field & Fiber Form Uniforms, Regen Projects, Los Angeles, December 7–January 18, 2003.

2003

The A–Z Uniform Series: 1991–2002, Monika Sprüth Philomene Magers, Munich, May 15–June 28.

Hoffmann, Justin. "Andrea Zittel: 'The A–Z Uniform Series: 1991-2002': Monika Sprüth Philomene Magers, Munchen." *Kunstforum International,* August–October 2003, pp. 372–73.

Andrea Zittel, Sammlung Goetz, Munich, May 18–November 8. Catalogue, text by Ingvild Goetz, Rainald Schumacher, Mimi Zeiger, and Andrea Zittel.

On Site: Andrea Zittel, Milwaukee Art Museum, May 2003–August 2004.

Andrea Zittel: A–Z Mobila rumsenheter (A–Z Mobile Compartment Units), Konstmobilen Moderna Museet c/o Riksutställningar, Stockholm, June 2003. Catalogue, text by Ann-Sofi Noring and Ulrika Sten.

2004

A–Z Uniforms: 1991–2000, Andrea Rosen Gallery, New York, January 23–February 21.

Western Evolutions, Regen Projects, Los Angeles, December 18, 2004–January 29, 2005.

Miles, Christopher. "Andrea Zittel at Regen Projects." *Artforum,* March 2005, pp. 243–44.

2005

Andrea Zittel: A–Z Advanced Technologies, Andrea Rosen Gallery, New York, May 6–June 18.

GROUP EXHIBITIONS AND BIBLIOGRAPHY

1988

Art for Nicaragua, Installation Gallery, San Diego.

1989

SDSU Choice: Alumni Invitational, University Art Gallery, San Diego State University, February 11–March 29.

1990

Graduate Thesis Exhibition, The Rhode Island School of Design Museum of Art, Providence, Spring.

On Target '90: Zephyr Gallery Third Annual Invitational, Zephyr Gallery, Louisville, Kentucky, November 2–28. Catalogue, text by Sallie Bingham, Meg Higgins, Frances Kratzok, Mario M. Muller, Andrea Zittel, et al.

> Heilman, Diane. "On Target '90 at Zephyr Gallery." *The Louisville Courier-Journal*, November 18, 1990.

1991

Home for June, Home for Contemporary Theater and Art, New York, June.

Decorous Beliefs, Natalie Rivera, New York, July.

> Levin, Kim. "Choices: Decorous Beliefs." *The Village Voice*, July 9, 1991.

Warp and Woof: Comfort and Dissent, Artists Space, New York, September 26–November 9. Catalogue, text by Cornelia Butler.

Plastic Fantastic Lover (object a), Blum Helman Warehouse, New York, October 12–November 9. Catalogue, text by Catherine Liu.

> "Goings On About Town: Plastic Fantastic Lover (object a)." *The New Yorker*, October 28, 1991.

> Levin, Kim. "Choices: Plastic Fantastic Lover." *Village Voice*, October 30, 1991.

> Mahoney, Robert. "Reviews: Plastic Fantastic Lover." *Arts Magazine*, January 1992, p. 81

From Sculpture, BACA Downtown, Brooklyn, New York.

Ornament: Ho Hum All Ye Faithful, John Post Lee Gallery, New York

1992

One Leading to Another, 303 Gallery, New York, closed March 14.

> "Goings On About Town: One Leading to Another." *The New Yorker*, March 16, 1992, p. 14.

The Radio Show, Artists Space, New York, May 3.

One + One, La Galerie Du Mois, Paris, October.

Home Improvements, 209 West 97 Street, Apartment 7B, New York, October 4–November 10. Curated by Gavin Brown.

Simon Leung, Andrea Zittel, Andrea Rosen Gallery, New York, October 23–November 28.

> "Goings On About Town: Simon Leung/Andrea Zittel." *The New Yorker*, November 30, 1992, p. 26.

> Levin, Kim. "Choices: Simon Leung, Andrea Zittel, 'Tattoo Collection.'" *The Village Voice*, November 17, 1992, p. 79.

Insignificant, 10 East 39 Street, Suite 525, New York. Curated by Gavin Brown.

Writing on the Wall, 303 Gallery, New York.

> Levin, Kim. "Choices: Writings on the Wall." *The Village Voice*, 1992.

1993

Documentario: Privacy, Spazio Opus, Milan, January.

Add Hot Water, Sandra Gering Gallery, New York, February 20–March 20.

The Final Frontier, New Museum of Contemporary Art, New York, May 7–August 15. Brochure, text by Lisa Cartwright, France Morin, Celeste Olalquiaga, Alice Yang, and Mimi Young.

> "Flash Art News: Final Frontier at the New Museum." *Flash Art*, Summer 1993, p. 134.

> Smith, Roberta. "The Body and Technology: The Final Frontier." *The New York Times*, July 30, 1993, p. C26.

Eau de Cologne, Monika Sprüth Philomene Magers, Cologne, June 5–September 18.

Just what is it that makes today's home so different, so appealing?, Galerie Jennifer Flay, Paris, June 3–July 17.

> "Just what is it that makes today's homes so different, so appealing? at Galerie Jennifer Flay." *Purple Prose*, Summer 1993, p. 89.

Aperto '93: Emergency, XLV Biennale di Venezia, Venice, June 13–October 10. Catalogue, text by Akira Asada, Jeffrey Deitch, Helena Kontova, Achille Bonito Oliva, et al.

> Salvioni, Daniela. "Flash Art News: Aperto–A Stroll Through the Emergency." *Flash Art*, October 1993, pp. 67–68.

> Sandqvist, Tom. "Venice: From the Palazzo Grassi to a Chicken Coop." *Siksi: The Nordic Art Review*, 1993, pp. 40–42.

Real Time, Institute of Contemporary Arts, London, June 19–July 18. Catalogue, text by Gavin Brown, Emma Dexter, and Herbert Read.

> Dannatt, Adrian. "Real Time at ICA." *Flash Art*, November–December 1993, p. 116.

> "Flash Art News: Real Time." *Flash Art*, May 1993, p. 100.

> Kent, Sarah. "Real Time at the ICA." *Time Out London*, July 7, 1993.

Mac Adams, Ping Chong, Andrea Zittel, Art Awareness, Lexington, New York, July 24–September 5.

Guest Room with Andrew Ong, Achim Kubinski Gallery, New York, October 29–December 4.

Galleria Massimo De Carlo, Milan, November 29–January 29, 1994.

1994

Don't Look Now, Thread Waxing Space, New York, January 22–February 26. Catalogue, text by Joshua Decter.

Camping, Galerie Jennifer Flay, Paris, January 25–February 3.

L'hiver de l'amour (The Winter of Love), Musee d'Art Moderne de la Ville de Paris, February 10–March 13. Catalogue, text by Elein Fleiss and Olivier Zahm. Traveled to P. S. 1 Museum, Long Island City, New York, October 13–January 8, 1995.

> Verzotti, Giorgio. "'L'Hiver de L'Amour' at Musee d'Art Moderne de la Ville de Paris." *Artforum*, October 1994, p. 112.

Lost in Thought, Manes Gallery, Prague, February 20–March 30.

Are you experienced?, Andrea Rosen Gallery, New York, March 11–April 9.

Don't Postpone Joy or Collecting Can Be Fun!, Neue Galerie, Graz, Austria, March 18–April 24. Traveled to Austrian Cultural Institute, New York, May 26–June 24.

> Steffen, Barbara. "Don't Postpone Joy or Collecting Can Be Fun." *Austria Kultur*, May–June 1994, p. 11.

Sammlung Volkmann, Kasper König, Berlin, March 19–July 2.

SOHO at Duke V: Living in Knowledge–An Exhibition About Questions Not Asked, Duke University Art Museum, Durham, North Carolina, April 8–May 29. Catalogue, text by Rebecca Katz, Jane McFadden, and Michael Philip Mezzatesta.

Full Service, HEREart, New York, May 7–June 30.

>Levin, Kim. "Voice Listings: Full Service." *The Village Voice*, June 21, 1994, p. 83.

Drawing on Sculpture, Cohen Gallery, New York, June 9–July 28.

>Smith, Roberta. "Drawing on Sculpture." *The New York Times*, July 15, 1994, p. C23.

Sense and Sensibility: Women Artists and Minimalism in the Nineties, The Museum of Modern Art, New York, June 16–September 11. Catalogue, text by Lynn Zelevansky.

>Avgikos, Jan. "Sense and Sensibility: Museum of Modern Art." *Artforum*, October 1994, pp. 98–99.

>Heartney, Eleanor. "Sense and Sensibility." *Art Press*, October 1994, pp. ii–iii.

>Jones, Ronald. "Sense and Sensibility: Women Artists and Minimalism in the 90's." *Frieze*, September–October 1994, pp. 59–60.

>Pedersen, Victoria. "Gallery Go 'Round: Sense and Sensibility." *Paper*, Summer 1994, p. 38.

>Smith, Roberta. "Space Is Spare for Women's Work at the Modern." *The New York Times*, June 24, 1994, p. C26.

esprit d'amusement (Spirit of Diversion), Grazer Kunstverein, Graz, Austria, October 1–30. Catalogue, text by Joshua Decter, Susanne Gargerle, Mario Klarer, Christian G. Triebel, Thomas Trummer, et al.

John Currin and Andrea Zittel, Andrea Rosen Gallery, New York, October 25–29.

Naked City, Galleria Massimo De Carlo, Milan, December 7–January 31, 1995.

1995

Light for the Dark Days of Winter, A/D Gallery, New York, January 6–February 15.

About Place: Recent Art of the Americas, The Art Institute of Chicago, March 11–May 21. Catalogue, text by Madeleine Grynsztejn, Dave Hickey, and James N. Wood.

>Cubitt, Sean. "Dispersed Visions: 'About Place.'" *Third Text*, Autumn 1995, pp. 65–74.

>Kirschner, Judith Russi. "About Place: Recent Art of the Americas." *Artforum*, October 1995, p. 106.

>Meyers, Todd. "'About Place: Recent Art of the Americas' at the Art Institute of Chicago." *Poliester*, Summer 1995, pp. 52–53.

>Sherlock, Maureen. "'About Place: Recent Art in the Americas' at the Art Institute of Chicago." *Trans>*, November 1995, pp. 110–13.

1995 Whitney Biennial Exhibition, Whitney Museum of American Art, New York, March 15–June 11. Traveled to Veletrzní palác, Museum of Modern Art, Prague, September 21–December 3; Statens Museum for Kunst, Copenhagen, May 31, 1996–August 11, 1996. Catalogue, text by John Ashbery, Gerald M. Edelman, John G. Hanhardt, Klaus Kertess, David A. Ross, et al.

>Corn, A. "Whitney Biennial." *ARTnews*, May 1995, p. 147.

>Kimmelman, Michael. "A Quirky Whitney Biennial: A Show Concerned with Relating Works, Not with Haranguing." *The New York Times*, March 24, 1995, pp. C1, C23.

Trust, Tramway, Glasgow, May 7–June 18.

Nutopi (Nowtopia), Rooseum Center for Contemporary Art, Malmö, Sweden, June 3–August 27. Catalogue, text by Lars Nittve.

Living with Contemporary Art, The Aldrich Museum of Contemporary Art, Ridgefield, Connecticut, October 1–January 7, 1996. Catalogue, text by Harry Philbrick and Andrea Zittel.

>Merkling, Frank. "Living with Contemporary Art." *The Danbury (Connecticut) News-Times*, October 26, 1995, p. C1.

>Zimmer, William. "Adventurous Homeowners, Modern Look." *The New York Times*, December 3, 1995, p. CN28.

1996

Urgence: Nan Goldin, Noritoshi Hirakawa, Jack Pierson, Wolfgang Tillmans, Andrea Zittel, capc Musée d'art contemporain de Bordeaux, France, January 26–March 24. Catalogue, text by Jean-Louis Froment and Abdellah Karroum.

RE:formations/design directions at the end of a century, Chandler Gallery, Davis Museum and Cultural Center, Wellesley College, Massachusetts, February 2–June 9. Catalogue, text by Constantin Boym, Tunji Dada, Judith Hoos Fox, Steven Skov Holt, Andrea Zittel, et al.

>Holt, Steven, and Gregory Hom. "Infoscape: Reformations and Deconstructions: This Is Not a Time of Clarity, but of Opportunity." *Graphis,* March–April 1996, pp. 152–55.

>Lloyd, Ann Wilson. "Wellesley, MA–'Re:Formations/Design Directions at the End of a Century.'" *Sculpture*, July–August 1996, pp. 57–58.

Collezionismo a Torino: Le opere di sei collezionisti d'Arte Contemporanea (Collectionism at Turin: The Work of Six Collectors of Contemporary Art), Castello di Rivoli, Museo d'Arte Contemporanea, Turin, Italy, February 15–April 21. Catalogue, text by Ida Gianelli.

Social Fictions: Lari Pittman/Andrea Zittel, Barbara & Steven Grossman Gallery, School of the Museum of Fine Arts, Boston, February 21–March 17. Catalogue, text by Leilia Amalfitano and Terry R. Myers.

>Unger, M. "School of the Museum of Fine Arts/Boston: Social Fictions: Lari Pittman and Andrea Zittel." *Art New England*, June–July 1996, p. 57.

Sammlung Volkmann zeigt: Faustrecht der Freiheit, Kunstsammlung Gera, Germany, April 13–May 27. Catalogue, text by Bruno Brunnet, Peter Friese, Rainald Goetz, Ulrike Rüdiger, Herbert Volkmann, et al. Traveled to Neues Museum Weserburg Bremen, Germany, June 22–September 15.

Nach Weimar (After Weimar), Kunstsammlung Zu Weimar/Neues Museum Weimar, Germany, June 26–July 28. Catalogue, text by Klaus Biesenbach, Joshua Decter, Nicolaus Schafhausen, et al.

Multiple Application, Klosterfelde, Berlin, June 28–September 4.

Space, Mind, Place, Andrea Rosen Gallery, New York, July 8–August 7.

>Arning, Bill. "'Space, Mind, Place' at Andrea Rosen Gallery." *Time Out New York*, July 31–August 7, 1996, p. 28.

>Levin, Kim. "Space, Mind, Place." *The Village Voice*, July 30, 1996, p. 9.

>Smith, Roberta. "'Space, Mind, Place.'" *The New York Times*, July 19, 1996, p. C26.

Living Units, Macdonald Stewart Art Centre, Guelph, Ontario, Canada, September 26–November 10.

Just Past: The Contemporary in MOCA's Permanent Collection, 1975–96, MOCA at The Geffen Contemporary, Museum of Contemporary Art, Los Angeles, September 29–January 19, 1997.

1997

Discovery Collection, capc Musée d'art contemporain de Bordeaux, France, January 31–May 23.

Accrochage: Seth Edenbaum, Jackie Ferrara, Senga Nengudi, Andrea Zittel, Thomas Erben Gallery, New York, February 22–March 22.

Selections from the Collection, The Museum of Modern Art, New York, May 29–August 19.

Documenta X, Kassel, Germany, June 21–September 28. Catalogues, *Documenta X: The Short Guide,* text by Yan Ciret, Catherine David, Bettina Funcke, Volker Heise, and Paul Sztulman; *Politics, Poetics: Documenta X, The Book,* text by Sandra Alvarez de Toledo, Andrea Branzi, Benjamin Buchloh, Jean-François Chevrier, Catherine David, et al.

Fletcher, Annie. "Documenta Discipline." *Circa*, Autumn 1997, pp. 43–45.

Gregston, Brent. "Avant-garde Art Out of Control." *Salon* (online magazine), available at http://archive.salon.com/july97/wanderlust/postmark970715.html (July 15, 1997).

Johnson, Ken. "A Post-Retinal Documenta." *Art in America*, October 1997, pp. 80–88.

Kimmelman, Michael. "Few Paintings or Sculptures, but an Ambitious Concept." *The New York Times*, June 23, 1997, p. C9.

Kirchner, Constanze. "Was interessiert Kinder und Jugendliche an zeitgenössischer Kunst? Die documenta als pädagogische Chance." *Kunst + Unterricht*, June 1997, pp. 50–53.

Levin, Kim. "Not the UN: Documenta X Defeats the Pleasure Principle." *The Village Voice*, July 22, 1997, p. 77.

Morgan, Stuart. "The Human Zoo: Stuart Morgan on Documenta X." *Frieze*, September–October 1997, pp. 70–77.

"News: Galerien: New York Goes Documenta X." *Architektur & Wohnen*, Special 2–New York–Der metropolen Guide, 1997, pp. 124–25.

Restany, Pierre. "Documenta X: Un libro sulla poetica della politica e le sue pagine utili." *D'Ars*, July 1997, pp. 44–49.

"What Documenta Meant to Them." *The New York Times*, June 2, 2002, Section 2, pp. AR29, AR35.

Skulptur: Projekte in Münster 1997 (Sculpture: Project in Münster 1997), Westfälisches Landesmuseum für Kunst und Kulturgeschichte Münster, Germany, June 22–September 28. Catalogue.

Bonami, Francesco. "Territories of Mood: The PCA Circuit." *Flash Art*, October 1997, p. 88.

Buchloh, Benjamin H. D. "Sculpture Projects in Münster." *Artforum*, September 1997, pp. 114–17.

Cooke, Lynne. "Münster Sculptur. Projekte 97." *Burlington Magazine*, September 1997, pp. 649–51.

Dimling Cochran, Rebecca. "Skulptur: Projekte in Münster 1997." *Art Papers: Artists Books, Print Era and After*, November–December 1997.

Fioravante, Celso. "Münster se torna museu a céu aberto." *Folhau ilustrada* (São Paulo), December 12, 1997, p. 36.

Kimmelman, Michael. "Site-Specific Means Soon-To-Be-Forgotten." *The New York Times*, August 24, 1997, p. 35.

Pesch, Martin. "Martin Pesch on 'Sculpture. Projects in Münster.'" *Frieze*, September–October 1997, pp. 82–83.

"Reif für die Insel? Eisberge mitten im Skulptur-Sommer." *Westfälische Nachrichten* (Münster), June 31, 1997.

Saltz, Jerry. "Merry-Go-Round." *Flash Art*, October 1997, pp. 84–87.

"Skulptur: Projeckte in Münster 1997, Ein Foto-Rundgang von Wolfgang Träger." *Kunstforum International*, 1997, pp. 362–63.

Vischer, Theodora. "Andrea Zittel: Units of Freedom." *Kunstforum International*, June–August 1997, pp. 304–309.

Welti, Alfred. "A–Z: Zittels Traum." *ART: Das Kunstmagazin*, October 1997, pp. 72–81.

Zaya, Octavio. "Münster'97: Pedaling Nowhere." *Art Nexus*, October–December 1997, pp. 86–87.

Best of the Season: Works from 1996–97 Gallery Exhibitions, The Aldrich Museum of Contemporary Art, Ridgefield, Connecticut, September 14–January 4, 1998. Brochure.

Staging Surrealism: Succession of Collections 2, Wexner Center for the Arts, Ohio State University, Columbus, September 19–January 4, 1998. Catalogue, text by Mary Ann Caws, Donna De Salvo, and Sherri Geldin.

Check in! Eine Reise im Museum für Gegenwartskunst (Check In! A Journey in the Museum für Gegenwartskunst), Museum für Gegenwartskunst, Basel, Switzerland, October 4–March 8, 1998. Catalogue, text by Theodora Vischer.

Patrick Painter Editions, Lehmann-Maupin Gallery, New York, October 18–November 29.

P. S. 1 Contemporary Art Center, Long Island City, New York, October 24–February 28, 1998.

Kunst…Arbeit (Art…Work), Südwest LB, Stuttgart, Germany, November 15–January 11, 1998. Catalogue.

Media and Human Body: Fukui Biennale 7, Fukui City Art Museum, Japan, November 15–December 7. Catalogue, text by Andrea Zittel.

"Exhibitions." *BT Magazine*, vol. 50, no. 752, 1998, p. 155.

1998

Eins, zwei, drei! Haus dabei! (One, Two, Three! Presto House!), Landschaftsverband Rheinland–Rheinisches Industriemuseum, Oberhausen, Germany, March 29–October 4.

Wild/Life or the Impossibility of Mistaking Nature for Culture, Weatherspoon Art Museum, Greensboro, North Carolina, April 26–July 26. Catalogue, text by Amy Cappellazzo.

Travel & Leisure, Paula Cooper Gallery, New York, May 2–June 26.

Cotter, Holland. "A Tour Through Chelsea, The New Center of Gravity." *The New York Times*, May 15, 1998.

Blue Horizon Art Collection, Berry House, Clarkenwell, England, May–June 1998.

Inglenook, Feigen Contemporary, New York, June 19–July 31.

Johnson, Ken. "'Inglenook.'" *The New York Times*, July 24, 1998, p. E39.

Modelle (Models), Atelier Augarten, Zentrum für zeitgenössische Kunst der Österreichischen Galerie Belvedere, Vienna, Austria, July 9–October 11.

Krumpl, Doris. "Künstlerische Lebenshilfen." *Der Standard*, July 17, 1998, p. 12.

Kunstzeitung, August 1998.

"Parallelentwürfe, Lebensmodelle." *Die Presse*, no. 27, 1998.

Pühringer, Alexander. "Modelle." *Noema Art Journal*, October–November 1998.

Schmutz, Hemma. "Modelle." *Springerin*, March 1998, p. 74.

Sotriffer, Kristian. "Kultur und Medien." *Die Presse*, August 13, 1998.

Weh, Vitus H. "Modelle: Tom Burr, Christine & Irene Hohenbuchler, Florian Pumhosl, Andrea Zittel: Atelier im Augarten, Wien." *Kunstforum International*, October–December 1998, pp. 443–44.

Weh, Vitus H. "Wie im richtigen Leben." *Falter*, no. 31, 1998.

"Weltbinder einst & jetzt." *Kronenzeitung*, August 9, 1998.

"Wenn die Welt der Baukunst ihre Probe halt." *Der Standard*, May 1998.

Inglenook II, State University of Illinois at Normal University Galleries, August 19–September 27.

Berlin/Berlin, Berlin Biennale für zeitgenössische Kunst e.v., September 30–January 3, 1999.

Propos mobiles (Mobile Words), Association Projet 10, Paris, October 24–November 15. Catalogue, text by Denis Gaudel.

Emotion—Junge Britische und Amerikanische Kunst aus der Sammlung Goetz (Emotion—Young British and American Art from the Goetz Collection), Deichtorhallen, Hamburg, October 30–January 17, 1999. Catalogue, text by Daniel Birnbaum, Iwona Blazwick, Yilmaz Dziewior, Zdenek Felix, Carl Freedman, and Friedrich Meschede.

1999

Weird Science: A Conflation of Art and Science, Cranbrook Art Museum, Bloomfield Hills, Michigan, January 30–April 3. Catalogue, text by Michelle Grabner, Irene Hofmann, David Wilson, and Gregory Wittkopp.

Formulas for Revelation, The Rotunda Gallery, Brooklyn, New York, April 8 –May 22.

> Johnson, Ken. "Formulas for Revelation." *The New York Times*, May 14, 1999, p. E38.

> "Prepare for a 'Revelation.'" *Brooklyn Heights Courier*, March 29, 1999.

Comfort Zone: Furniture by Artists, PaineWebber Art Gallery, New York, April 15 –June 25. Brochure, text by Tom Eccles, Susan K. Freedman, and Amy Wolf.

> Deitz, Paula. "Making What's Public Private, and Private Public." *The New York Times*, May 2, 1999, Section 2, p. AR29.

Threshold: Invoking the Domestic in Contemporary Art, John Michael Kohler Arts Center, Sheboygan, Wisconsin, April 30–August 15. Traveled to Contemporary Art Center of Virginia, Virginia Beach, September 29–November 26, 2000. Brochure, text by Andrea Inselmann.

> Dorsey, Catherine. "There's No Place Like Home." *Port Folio Weekly*, October 24, 2000.

> Erickson, Mark St. John. "Exhibit That Gets You Where You Live." *Newport News Daily Press*, October 15, 2000, p. 14.

Styrian Regional Exhibition 1999: Traffic, Knittelfeld, Land of Styria Department of Cultural Affairs, Styria, Austria, May 1–October 31.

> Dienes, Gerhard M. "Über das Meer..." *Verkehr: Knittelfeld, Die Steirische Landausstellung*, 1999, p. 301.

I'm the Boss of Myself, Sara Meltzer's on View, New York, May 5–June 12.

Micro Space/Global Time: An Architectural Manifesto, MAK Center for Art and Architecture L.A., Schindler House, Los Angeles, and MAK–Austrian Museum of Applied Arts, Vienna, June 2–July 11. Catalogue, text by Peter Noever and Saskia Sassen.

H99, Helsingor, Denmark, and Helsingborg, Sweden, July 16–August 30.

Art in Public Places at the Miami Design District, Dacra Companies, Miami Beach, Florida, Summer.

> "Art Goes Public." *Flash Art International*, Summer 1999, p. 78.

In the Midst of Things, Bournville, Birmingham, England, August 4–September 18.

Culbutes: Oeuvre d'impertinence (Head Over Heels: A Work of Impertinence), Musée d'Art Contemporain de Montréal, Québec, November 17–April 23, 2000.

> Bérubé, Stéphanie. "Question de rire un peu..." *La Presse*, November 20, 1999, p. D18.

> Crevier, Lyne. "Dialogue avec les anges." *Ici*, November 25, 1999, p. 41.

> Granda, John. "Head Over Heels: A Work of Impertinence." *Sculpture*, April 2000, pp. 74–75.

> Houle, Alain. "Culbutes. Oeuvre d'impertinence: sisyphe artiste." *L'humaniste Combatant*, Winter 2000, pp. 18–19.

> Lamarche, Bernard. "Éloge de la fraîcheur." *Le Devoir* (Montreal), November 20, 1999, p. B9.

> Lamarche, Bernard. "L'irréverence faite oeuvre." *Le Devoir* (Montreal), November 27, 1999, Section L'agenda, p. 3.

> Mavrikakis, Nicolas. "Nos Choix." *Voir* (Montreal), August 26, 1999, pp. 65, 67.

2000

A Salon for the 21st Century, John Weber Gallery, New York, January 8–February 5.

Quotidiana (Daily), Castello di Rivoli, Museo d'Arte Contemporanea, Turin, Italy, February 4–May 21. Catalogue, text by Marcella Beccaria, Emanuela De Cecco, Ida Gianelli, Nicholas Serota, David Ross, Giorgio Verzotti, and Jonathan Watkins.

> Fanelli, Franco. "Quotidiana: Gli antieroi del '900." *Il giornale dell' arte*, Speciale Castello di Rivoli, pp. 1–2.

Against Design, Institute of Contemporary Art, University of Pennsylvania, Philadelphia, February 5–April 16. Catalogue, text by Steven Beyer, Melissa Brookhart, and Mark Robbins. Traveled to Palm Beach Institute of Contemporary Art, Lake Worth, Florida, June 18–September 3; Museum of Contemporary Art San Diego, La Jolla, California, January 21–May 9, 2001; Kemper Museum of Contemporary Art, Kansas City, June 22–September 2, 2001.

> Hamilton, William L. "New Art's Interior Motive." *The New York Times*, February 3, 2000, p. F1.

> Knight, Christopher. "The Everyday on a Pedestal." *Los Angeles Times*, January 31, 2001, pp. F1, F8.

> Raczka, R. "'Against Design': Institute of Contemporary Art." *Sculpture*, June 2000, pp. 78–79.

> Sozanski, Edward. "Along the Fuzzy Boundary between Design and Art." *The Philadelphia Inquirer*, February 13, 2000, p. 11.

Tänk om: Konst på gränsen till arkitektur och design (What If: Art on the Verge of Architecture and Design), Moderna Museet, Stockholm, May 6–September 3. Catalogue, text by Keller Easterling, Liam Gillick, Rebecca Gordon Nesbitt, Sara Ilstedt Hjelm, Ulrika Karlsson, Maria Lind, and Jeremy Millar.

> "Gränslandets konst." *Arbetarbladet*, October 6, 2000.

> Gunnert, Anna. "Tänk om på Moderna Museet." *Konsttidningen*, September 10, 2000.

> Olss, Thomas. "Moderna museet tänker." *Bohusläningen med Dals Dagblad*, September 5, 2000.

> Schloemann, Johan. "Bau mir einen Schuhladen." *Frankfurter Allgemeine Zeitung*, July 24, 2000.

HausSchau: Das Haus in der Kunst (HausSchau: The House in Art), Deichtorhallen, Hamburg, May 12–September 17. Catalogue, text by Ludwig Seyfarth and Zdenek Felix.

> Kunz, Sabine. "Stoff-Iglu und Museum." *ART: Das Kunstmagazin*, June 2000, p. 89.

> Ronnau, Jens. "HausSchau: Das Haus in der Kunst." *Kunstforum International*, October–December 2000, pp. 314–16.

Elysian Fields, Centre Georges Pompidou, Paris, May 24–July 24. Catalogue.

> Arkhipoff, Elizabeth. "En route pour la gloire." *Nova Magazine*, June 2000.

> "Elysian Fields." *Aden*, June 28–July 4, 2000.

> Leguillon, Pierre. "Purple Horizon." *Beaux Arts Magazine*, July 2000, pp. 40–45.

Of The Moment: Contemporary Art from the Permanent Collection, San Francisco Museum of Modern Art, June 30–August 29.

Taxi: Contemporary Art in Seven Taxis in Copenhagen, sponsored by Navin Gallery, Bankok, and One-Percent for the Arts, Copenhagen, September 1–30.

Kulturbro 2000 (Culture Festival 2000), Malmö, Sweden, September 15–December 15.

Made in California: Art, Image and Identity, 1900–2000, Los Angeles County Museum of Art, October 22–February 25, 2001. Catalogue, text by Stephanie Barron, Sheri Bernstein, Michael Dear, Howard N. Fox, Janice Taper Lazarof, et al.

Full Serve: Celebrating Ten Years of Shows Curated by Kenny Schachter, Kenny Schachter/Rove, New York, October 25–December 3.

2001

Pyramids of Mars, Barbican Center, London, February 8–March 25.

> Farquharson, Alex. "Pyramids of Mars." *Art Monthly*, March 2001, pp. 33–35.

Sammlung DaimlerChrysler: Februar 2001, Neuerwerbungen (Collection of DaimlerChrysler: February 2001, New Work), DaimlerChrysler Contemporary, Berlin, February 8–April 1. Catalogue, text by Renate Wiehager.

Comfort: Reclaiming Place in a Virtual World, Cleveland Center for Contemporary Art, March 9–May 20. Catalogue, text by Kristin Chambers, Jill Snyder, and Michael Sorkin.

> Litt, Steven. "A Spunky Vision of Domestic Future in the Modern Age." *The Cleveland Plain Dealer*, April 27, 2001.
>
> Rizk, Mysoon. "Comfort: Reclaiming Place in a Virtual World." *New Art Examiner*, July–August 2001, p. 90.
>
> Spaid, Sue. "Reviews: Comfort." *Artext*, no. 74, 2001, p. 82.

Vi-Intentional Communities, Rooseum Center for Contemporary Art, Malmö, Sweden, May 11–August 12. Traveled to Contemporary Art Centre, Vilnius, Lithuania, November 28–January 13, 2002.

> Steiner, Shepherd. "Vi-Intentional Communities." *Parachute*, October–December 2001, Supplement, pp. 7–8.

Just what is it that makes trailer homes so different, so appealing?, Center for Curatorial Studies, Bard College, Annandale-on-Hudson, New York, May 13–27.

A New Domestic Landscape, Galeria Javier Lopez, Madrid, May 19–April.

American Art from the Goetz Collection, Munich, Galerie Rudolfinum, The Centre of Contemporary Art, Prague, May 24–September 2. Catalogue, text by Ursula Frohne, Ingvild Goetz, Rainald Schumacher, and Noemi Smolik. Traveled to Kunstverein Weiden, Germany, May 3–June 9, 2002.

Drawings, Regen Projects, Los Angeles, May 26–July 19.

Plug-In: Einheit und Mobilität (Plug-In: Unity and Mobility), Westfälisches Landesmuseum für Kunst und Kulturgeschichte, Münster, Germany, June 2–July 29. Catalogue, text by Marcus Heinzelmann, Carsten Krohn, Angelika Nollert, Ortrud Westheider, et al.

> Carter, Stephan. "8 Quadratmeter für Kommunisten," *Weser-Kurier*, June 27, 2001.
>
> Corris, Michael. "Plug-in: Unity and Mobility." *Art Monthly*, September 2001, pp. 37–39.
>
> Dobbe, Martina. "Kunst zum Klettern und zum Staunen." *Westfälische Nachrichten* (Münster), June 5, 2001.
>
> Hoetzel, Dagmar. "Plug-in: Einheit und Mobilitat." *Bauwelt*, July 6, 2001.
>
> Imdahl, Georg. "Was fur ein Typ ist eigentlich der Prototyp?" *Frankfurter Allgemeine Zeitung*, July 16, 2001, pp. 1–2.
>
> Leske, Marion. "Plug-in: Visionen vom Wohnen und vom Reisen." *Die Welte*, July 10, 2001.
>
> Luddemann, Stefan. "Neue Nomaden in der globalen Welt." *Neue Osnabrücker Zeitung*, June 28, 2001.
>
> Meis, Hannelore. "Abgeklärtheiten." *Ultimo*, June 18–July 1, 2001.
>
> Muller, Sabine. "Zwischen Kunst und Kompost-Klo." *Ruhr-Nachrichten*, June 1, 2001.

> Posca, Claudia. "Plug-in: Einheit und Mobilitat: Westfälisches Landesmuseum Münster." *Kunstforum International*, August–October 2001, pp. 391–93.
>
> "Raumlösungen für Nomaden." *Kreiszeitung Sykek Zeitung*, June 22, 2001.
>
> Schön, Wolf. "Nomaden machen mobil." *Rheinischer Merkur*, June 22, 2001.
>
> Stiftel, Ralf. "Bunker für Stadt-Nomaden." *Westfälischer Anzeiger*, June 7, 2001.
>
> "Über alles: beweglich: Plug-In." *Deutsche Bauzeitschrift*, July 2001.

Ohne Zögern: Die Sammlung Olbricht Teil 2 (Without Hesitation: The Olbricht Collection, Part 2), Neues Museum Weserburg Bremen und Gesellschaft für Aktuelle Kunst, Germany, June 3–September 16. Catalogue, text by Thomas Deecke, Peter Friese, Thomas Olbricht, Christine Breyhahn, Eva Schmidt, and Anja Zimmermann.

> Puvogel, Renate. "Ohne Zogern: Die Sammlung Olbricht Teil 2: Neues Museum Weserburg und Gesellschaft fur Aktuelle Kunst, Bremen." *Kunstforum International*, November–December 2001, pp. 307–10.

Works on Paper From Acconci to Zittel, Victoria Miro Gallery, London, June 27–September 15.

Work: Shaker Design and Recent Art, The Tang Teaching Museum and Art Gallery–Skidmore College, Saratoga Springs, New York, July 7–September 16.

The (Ideal) Home Show, Gimpel Fils Ltd., London, July 11–September 8.

Everything Can Be Different, Jean Paul Slusser Gallery, University of Michigan School of Art in Ann Arbor, September 11–November 5. Catalogue, text by Maria Lind and Judith Olch Richards. Independent Curators International (ICI) traveling exhibition to The Art Museum of the University of Memphis, March 1–April 13, 2002; California Center for the Arts, Escondido, September 14–December 8, 2002; Boise Art Museum, Idaho, July 19–October 19, 2003; Maryland Institute College of Art, Baltimore, November 3–December 19, 2003.

> Arbor, Ann. *Art Papers*, March–April 2002.
>
> Hall, David. "Head Games." *Memphis Flyer*, March 14–20, 2002, p. 43.
>
> Phelps-Fredette, Suzannah. "Viewers' Experiences Bring Conceptual Work to Fruition." *The Commercial Appeal*, March 2, 2002, pp. E1, E6.

New to The Modern: Recent Acquisitions from The Department of Drawings, The Museum of Modern Art, New York, October 25–January 8, 2002.

Active Ingredients, American Center for Wine, Food and the Arts, Napa, California, November 18–April 22, 2002. Catalogue, text by Peggy Loar and Margaret Miller.

2002

Passasjer: Betrakteren som deltaker (Passenger: The Viewer as Participant), Astrup Fearnley Museet for Moderne Kunst, Oslo, January 19–April 21. Catalogue, text by Gunnar B. Kvaran and Oystein Ustevdt.

Surrounding Interiors: Views inside the Car, Davis Museum and Cultural Center, Wellesley College, Massachusetts, February 21–June 9. Catalogue, text by Paul Arthur, Adam Bartos, Giuliana Bruno, Lucy Flint-Gohlke, Judith H. Fox, et al.

InSite: Nine Contemporary Artists, Addison Gallery of American Art, Phillips Academy, Andover, Massachusetts, May 4–July 31.

SiteLines: Art on Main, Addison Gallery of American Art, Phillips Academy, Andover, Massachusetts, May 4–September 29. Brochure.

> Glueck, Grace. "Youth and Experience Transforming a Town." *The New York Times*, August 9, 2002, p. E32.

New Prints 2002–Summer, International Print Center, New York, May 8–July 27.

Print Publisher's Spotlight, Barbara Krakow Gallery, New York, June 8–July 31.

Tempo, The Museum of Modern Art, New York, June 29–September 9. Catalogue, text by Miriam Basilio, Paulo Herkenhoff, Glenn D. Lowry, and Roxana Marcoci.

> Kimmelman, Michael. "Queens, the New Modern Mecca." *The New York Times*, June 28, 2002, p. E31.

> Robinson, Walter. "Weekend Update." *Artnet* (online magazine), available at http://www.artnet.com/magazine/reviews/robinson/robinson6-28-02.asp (June 28, 2002).

> Simenc, Christian. "Le tempo de l'art." *Beaux Arts Magazine*, July 2002, Supplement, p. 53.

Inside Cars: Surrounding Interiors, Frederick R. Weisman Museum, University of Minnesota, Minneapolis, September 7–December 29, 2002.

Public Affairs: Von Beuys bis Zittel: Das Öffentliche in der Kunst (Public Affairs: From Beuys to Zittel: The Public in Art), Kunsthaus Zürich, September 13–December 1. Catalogue, text by Bice Curiger and Boris Groys.

Die Wohltat der Kunst—Post\Feministische Positionen der neunziger Jahre aus der Sammlung Goetz (Post-Feminist Positions of the Nineties from the Goetz Collection), Staatliche Kunsthalle Baden-Baden, Germany, September 14–November 10. Catalogue, text by Diana Ebster, Fritz Emslander, Ingvild Goetz, Rainald Schumacher, Matthias Winzen, et al. Traveled to Sammlung Goetz, Munich, December 2–March 15, 2003; and under the title *Just Love Me: Post\Feminist Positions of the 1990s from the Goetz Collection,* traveled to Bergen Kunstmuseum, Norway, August 23–October 26, 2003; and Fries Museum Leeuwarden, The Netherlands, April 25–June 21, 2004.

> Meinhardt, Johannes. "Die Wohltat Der Kunst: Post/Feministische Positionen der neunziger Jahre aus der Sammlung Goetz: Kunsthalle Baden-Baden." *Kunstforum International*, November–December 2002, pp. 352–53.

Married by Powers, 11 choix à partir de la collection du Frac, par Bik Van der Pol plus 10 (Married by Powers, 11 Choices Starting from the Frac Collection, by Bik Van der Pol, Plus 10), Centre d'art TENT, Rotterdam, October 17–November 17.

Touch Relational Art from the 1990's to Now, San Francisco Art Institute, October 17–December 14.

> "New This Month in U.S. Museums." *Artnet* (online magazine), available at http://www.artnet.com/magazine/news/ntm2/ntm10-1-02.asp (October 1, 2002).

L'Image Habitable (The Livable Image)—Version D: Imaginary Constructs, Centre pour l'image contemporaine, Geneva, November 2–December 15.

> Perra, Daniele. "Spazi di Suggestione." *Ottagono*, February 2003, p. 126.

> Perra, Daniele. "L'Image Habitale." *Tema Celeste*, February–March 2003, p. 111.

Trans_positions: œuvres de la collection du Fonds Régional d'Art Contemporain du Nord–Pas de Calais (Trans_positions: Works from the Collection of Fonds Régional d'Art Contemporain du Nord–Pas de Calais), Centre d'art Passerelle, Brest, France, December 14–March 8, 2003.

> Ramade, Benedicte. "Trans_positions." *L'Oeil*, February 2003, p. 104.

2003

Inaugural Exhibition, Regen Projects, Los Angeles, January 5–March 1.

Micropolítiques I: Art I quotidianitat: 2001–1989, Espai d'Art Contemporani de Castelló, Spain, January 10–March 30. Catalogue.

> Parcerisas, Pilar. "Art I quotidianitat a l'Espai d'Art Contemporani de Castelló." *Diari Avui*, March 13, 2003, p. 18.

Cloudless, Center for Curatorial Studies, Bard College, Annandale-on-Hudson, New York, March 16–30.

Strangely Familiar: Approaches to Scale in the Collection of the Museum of Modern Art, New York, New York State Museum, Albany, April 6–June 29.

20th Anniversary Show, Monika Sprüth Philomene Magers, Cologne, April 25–October 18.

The DaimlerChrysler Collection, Museum für Neue Kunst ZKM, Karlsruhe, Germany, May 24–August 31. Traveled to several venues; Zittel's work traveled in retitled *DaimlerChrysler Collection: Classical Modernism to Minimalism* to Pretoria Art Museum, South Africa, March 21–June 27, 2004.

Living Units, Triple Candie, Harlem, New York, June 15–July 27.

> Cotter, Holland. "Living Units." *The New York Times*, July 18, 2003, p. E33.

In Full View, Andrea Rosen Gallery, New York, July 18–September 13.

> Buckley, Craig. "In Full View." *Parachute*, January–March 2004, Supplement, p. 6.

I.C. Editions: A Survey from Bloom to Zittel, Susan Inglett Gallery, New York, October 16–November 15.

2004

Female Identities? Artists of the Goetz Collection, Neues Museum Weserburg Bremen, Germany, February 1–December 31.

Multiple Räume (1): Seele—Konstruktionen des Innerlichen in der Kunst (Multiple Areas (1): Soul–Constructions of the Internal in Art), Staatliche Kunsthalle Baden-Baden, Germany, February 14–April 18. Catalogue, text by Johannes Bilsten, Heike Behrend, Micha Brumlik, Fritz Emslander, Matthias Winzen, et al.

2004 Whitney Biennial Exhibition, Whitney Museum of American Art, New York, March 11–June 13. Catalogue, text by Maxwell L. Anderson, Susan Buck-Morss, Chrissie Iles, Shamim M. Momin, Debra Singer, et al.

> Cameron, Dan. "American Pie: Whitney Biennial." *Frieze*, May 2004, pp. 64–69.

> Diez, Renato. "Alla Biennale del Whitney—Torna la Pittura," *Arte*, April, p. 110.

> Heartney, Eleanor. "The Well-Tempered Biennial." *Art in America*, June–July 2004, pp. 70–77.

> Kimmelman, Michael. "Touching All Bases at the Biennial." *The New York Times*, March 12, 2004, pp. E27, E38.

> Milroy, Sarah. "Art in a Tremulous Time." *The Globe and Mail* (Toronto), March 17, 2004, p. R1.

> Rothkopf, Scott. "Subject Matters." *Artforum*, May 2004, pp. 176–77, 233.

Die Zehn Gebote (The Ten Commandments), Deutches Hygiene-Museum, Dresden, Germany, June 19–December 5. Catalogue, text by Klaus Biesenbach.

Needful Things: Recent Multiples, Cleveland Museum of Art, September 19, 2004–January 2, 2005

70/90: Engagierte Kunst (70/90: Engaged Art), Neues Museum, Nuremberg, Germany, October 12–January 16, 2005.

Last One On is a Soft Jimmy, Paula Cooper Gallery, New York, November 6–December 18.

Editions Fawbush: A Selection, Sandra Gering Gallery, New York, December 11–January 4, 2005.

2005

Logical Conclusions: 40 Years of Rule-Based Art, PaceWildenstein, New York, February 18–March 26. Catalogue, text by Marc Glimcher.

ART–ROBE: Women Artists at the Nexus of Fashion and Art, UNESCO Headquarters, Paris, March 7–March 25.

EXHIBITIONS IN PRINT

"Cash and Carry Art." *Shock*, Winter 2002, p. 26.

ARTIST'S CURATORIAL PROJECTS

Artists Select: Part I, Artists Space, New York, November 20, 1993–January 15, 1994.

High Desert Test Sites (HDTS), Pioneer Town, Yucca Valley, Joshua Tree, and Twentynine Palms, California, November 23–24, 2002. Catalogue by Lisa Anne Auerbach, text by Artists on Tour, Daniel Marlos, Louis Marchesano, Lisi Raskin, Andrea Zittel, et al.

High Desert Test Sites 2 (HDTS2), Pioneer Town, Yucca Valley, Joshua Tree, and Twentynine Palms, California, May 24–25, 2003. Catalogue by Lisa Anne Auerbach, text by Bay Area Crew, Justin Beal, Chris Bears, Kathy Chenoweth, Allen Compton, et al.

> Nelson, Arty. "Birth of a Nation." *LA Weekly,* May 23–29, 2003, available at http://www.laweekly.com/ink/03/27/art-nelson.php.
>
> Timberg, Scott. "Shimmers in the Desert." *Los Angeles Times*, May 25, 2003, p. E8.

High Desert Test Sites 3 (HDTS3), Pioneer Town, Yucca Valley, Joshua Tree, and Twentynine Palms, California, October 25–26, 2003. Catalogue by Lisa Anne Auerbach, text by Allen Compton, Jacob Dyrenforth, Shannon Ebner, Kathleen Johnson, Mark Klassen, et al.

High Desert Test Sites 4 (HDTS4), Pioneer Town, Yucca Valley, Joshua Tree, and Twentynine Palms, California, October 23–24, 2004. Catalogue by Lisa Anne Auerbach.

BIBLIOGRAPHY

ARTIST'S PUBLICATIONS AND PROJECTS

The A–Z Administrative Services 1993 Living Unit, artist's brochure. San Francisco: Jack Hanley Gallery, 1993.

Introducing the A–Z Administrative Services 1994 Living Unit by Zittel, artist's brochure. New York: Museum of Modern Art, 1994.

Introducing the A–Z Administrative Services Comfort Unit by Zittel, artist's brochure. London: Anthony d'Offay Gallery, 1994.

Introducing A–Z Ottoman Furniture by Zittel, artist's brochure. Pittsburgh: Carnegie Museum of Art, and Graz, Austria: Grazer Kunstverein, 1994.

Andrea Zittel Selected Sleeping Arrangements: The A–Z Bed Book, artist's book. Dundee, Scotland: University of Dundee, with *Transcript: A Journal of Visual Culture*, 1995. Accompanied work exhibited at Andrea Rosen Gallery, New York; *Whitney Biennial Exhibition*, Whitney Museum of American Art, New York; and *Nutopi (Nowtopia)*, Rooseum Center for Contemporary Art, Malmö, Sweden.

Perfected Pillow. New York: Artists Space, 1995.

Andrea Zittel: New Work, artist's brochure. San Francisco: San Francisco Museum of Modern Art, 1996.

Zittel, Andrea, and Daniel Wineman. *A–Z Personal Profiles Newsletter*.

> No. 1, September 1996.
>
> No. 2, October 1996.
>
> No. 3, November 1996.
>
> No. 4, December 1996.
>
> No. 5, January 1997.
>
> No. 5 [6], February 1997.
>
> No. 7, March 1997.
>
> No. 8, April 1997.
>
> Nos. 9–10, May–June 1997.
>
> Nos. 11–13, July–August 1997.

In the Midst of Things. Bournville, Birmingham, England, August 4–September 18, 1999. Project with Sebastian Clough.

Diary: Andrea Zittel. Diary, ed. Simona Vendrame, No. #01. Milan: Tema Celeste Editions, 2002.

ARTIST'S WRITINGS

"Striving for Perfection." In *Aperto '93: Emergency*, exh. cat., p. 456. Venice: XLV Biennale di Venezia, 1993.

"Andrea Zittel–Auto Interview." *Transcript: A Journal of Visual Culture*, Summer 1995, pp. 34–36.

"Homeowner's Statement." In *Living with Contemporary Art*, exh. cat., p. 56. Ridgefield, Conn.: Aldrich Museum of Contemporary Art, 1996.

"Presenting Three Generations of A–Z Units by Andrea Zittel." In *New Art 6: Andrea Zittel*, artist's brochure. Cincinnati: Cincinnati Art Museum, 1996.

RE:formations–design directions at the end of a century, exh. cat. Wellesley, Mass.: Chandler Gallery, Davis Museum and Cultural Center, Wellesley College, 1996.

"Andrea Zittel." *Purple Fashion*, no. 2, 1997, p. 23.

"A–Z Deserted Islands." In *Skulptur: Projekte in Münster 1997*, exh. cat., pp. 470–73. Münster, Germany: Westfälisches Landesmuseum für Kunst und Kulturgeschichte Münster, 1997.

"A–Z Thundering Prairie Dogs." In *Media and Human Body: Fukui Biennale 7*, exh. cat. Fukui City, Japan: Fukui City Art Museum, 1997.

"A Brief History of A–Z Garments." In *A–Z Advanced Technologies: Fiber Forms*, artist's brochure. Tokyo: Gallery Side 2, 2002.

"A–Z Uniforms." *Sleek Magazine*, no. 2, 2003, pp. 56–63.

"Shabby Clique." *Artforum*, Summer 2004, p. 211.

BOOKS, INTERVIEWS, AND ARTICLES

1991

"News: Hidden at Home." *Flash Art*, October 1991, p. 163.

1992

Cameron, Dan. "Don't Look Now." *Frieze*, February–March 1992, pp. 4–8.

Kocaurek, Lisa. "Everyday Objects, New Aesthetic." *Ms.*, January–February 1992, p. 69.

"New York: News—'Gavin Brown's Open House.'" *Flash Art*, October 1992, p. 127.

Pandiscio, Richard. "Richard Pandiscio's Ones to Watch." *Andy Warhol's Interview*, vol. 22, no. 3, March 1992, p. 18.

Weil, Benjamin. "Areas of Investigation." *Purple Prose*, Autumn 1992, pp. 30–32.

1993

"America's Top One Hundred Collectors." *Art & Antiques*, March 1993, pp. 43–78.

Amokkoma, Journal Oriental, vol. 1, no. 4, November 1993, p. 3.

Cornand, Brigitte. "Le style 'pendouille.'" *Le Jour*, June 12–13, 1993.

Cuvelier, Pascaline. "Les jeunes artistes et la maison." *Liberation*, June 26, 1993, p. 30.

Filipovna, Valerie. "Breeding As Art." *Paper Magazine*, Summer 1993, p. 20.

"Flash Art News: USA in Brief." *Flash Art*, May 1993, p. 110.

Gimelson, Deborah. "Rebels with a Cause." *Self Magazine*, June 1993, pp. 124–27, 167.

Graw, Isabelle. "Abwesenheit durch Anwesenheit Eau de Cologne 1983–1993." *Texte zur Kunst*, September 1993, pp. 193–98.

Heartney, Eleanor. "Galleries: The Emerging Generation—New York, The Art of Survival." *Art Press*, 1993, pp. 24–28, E7–E10.

Jacques, Alison Sarah. "Andrea Zittel." *Flash Art Daily*, June 13, 1993, p. 8.

Levin, Kim. "Choices." *The Village Voice*, September 8, 1993.

Levin, Kim. "Choices." *The Village Voice*, October 12, 1993, p. 71.

Pedersen, Victoria. "Gallery Go 'Round." *Paper*, May 1993, p. 27.

Pinchbeck, Daniel. "High Fliers." *The New Yorker*, June 21, 1993, p. 34.

Saltz, Jerry. "Braver New Art World?" *Art & Auction*, November 1993, pp. 134–39.

Saltz, Jerry. "10 Artists for the Nineties." *Art & Auction*, May 1993, pp. 122–25, 155.

Vogel, Carol. "Inside Art–The Fall Season in SoHo Begins with a Night of Simultameous Openings." *The New York Times*, September 10, 1993, p. C24.

Weil, Benjamin. "Ouverture: Andrea Zittel." *Flash Art International*, January–February 1993, p. 80.

Weil, Benjamin. "Souvenirs des Immateriaux." *Purple Prose*, Summer 1993, pp. 66–68.

1994

"Art: Seven Sisters." *The New Yorker*, July 18, 1994, p. 12.

Avgikos, Jan. "Andrea Zittel at Andrea Rosen." *Artforum*, January 1994, p. 88.

Birnbaum, Daniel, and Thomas Nordanstad. "Konstvarlden ar den enda riktiga varlden...." *Material*, no. 5, August 1994, cover and p. 13.

Dannatt, Adrian. "Andrea Zittel." *London Sunday Times Magazine*, September 11, 1994, p. 11.

Dorment, Richard. "A Pure Shaft of American Sunlight." *The Daily Telegraph* (London), September 7, 1994, p. 21.

"Flash Art." *Tatler*, September 1994, p. 30.

"Flash Art News: Galleries USA." *Flash Art*, June 1994, p. 61.

Gimelson, Deborah. "New Kids on the Art Block Make Gramercy Art Fair a Hit." *The New York Observer*, May 16, 1994, p. 20.

Hollenstein, Roman. "Eine neue Kunstszene in West Chelsea? von Artschwaer bis Zittel." *Neue Zurcher Zeitung*, November 19–20, 1994, p. 47.

"Introducing A–Z Administrative services 1994 Living Unit by Zittel." *Jahresring*, no. 41, 1994, pp. 194–98.

Karcher, Eva. "Die nuenziger jahre: Kunstler als Forscher." *art*, July 1994, pp. 50–59.

Marsh, Tim. "Commercial Artists." *The Face*, September 1994, p. 25.

Melrod, George. "Reviews: New York, New York." *Sculpture*, November–December 1994, pp. 46–47.

Newsom, John Martin. "Connections." *Manhattan File*, 1994, pp. 66–71.

Planca, Elisabetta. "Donne sull'orlo di una crisi di identità." *Arte*, July–August 1994, pp. 54–61.

Pozzi, Lucio. "Le case chiuse della Zittel." *Il giornale dell'arte*, October 1994, p. 57.

Robinson, Walter. "Gramercy Art Fair: Rooms with a View." *Art in America*, June 1994, p. 29.

Saltz, Jerry. "Andrea Zittel at Andrea Rosen." *Art in America*, June 1994, pp. 100–101.

Schenk-Sorge, J. "Andrea Zittel at Andrea Rosen." *Kunstforum International*, January–February 1994, pp. 380–82.

Schneider, Christiane. "Editorial." *Jahresring 41*, 1994, pp. 10–22.

Schwartzman, Allan. "There Are Signs of Life at the Bottom of the Art World, Where Promise Can Be Bought for a Few Thousand Dollars." *The New York Times*, October 2, 1994, p. H1.

Silverthorne, Jeanne. "On the Studio's Ruins." *Sculpture*, November–December 1994, pp. 26–29.

Tobier, Nicholas. "Andrea Zittel at Andrea Rosen Gallery." *Juliette*, December 1993–January 1994, p. 60.

Tully, Judd. "Galeries de New York: Etes vous SoHo ou Uptown?" *Beaux Arts Magazine*, June 1994, pp. 54–61.

T.v.T. "Tuten werden zu Hornern gedreht." *Kolner Stadt-Anzeiger Dienstag*, March 22, 1994, p. 20.

Twardy, Chuck. "Answers Unsought." *Raleigh News and Observer*, August 15, 1994, p. 23.

"Vogue Notices Art." *British Vogue*, September 1994.

Weil, Benjamin. "Home Is Where the Art Is: Andrea Zittel." *Art Monthly*, November 1994, pp. 20–22.

1995

Aukeman, Anastasia. "Rising Stars Under 40." *ARTNews*, October 1995, pp. 30–32, 34, 36, 38, 41.

Avgikos, Jan. "Kathleen Schimert." *Artforum*, September 1995, pp. 84–85.

Babias, Marius. "Mobile Plattformen für das Umsetzen von Obsessionen schaffen." *Kunstforum International*, November 1995–January 1996, pp. 408–10.

Bamberger, Nicole. "Andrea Rosen: La galerie d'Art en pointe." *Jardin des Modes*, Winter 1995–1996, p. 71.

Birnbaum, Daniel. "International Style for Lilliputians." *Material*, no. 26, 1995, p. 7.

Cameron, Dan. "Critical Edge: Kertess's List." *Art & Auction*, February 1995, pp. 58–60.

Decter, Joshua. "Andrea Zittel at Andrea Rosen Gallery." *Artforum*, Summer 1995, p. 105.

Frankllin, Dot. "Stepping Out: What Goes 'Buloop, Buloop'?" *Ridgefield Press*, November 15, 1995, pp. 7, 12.

"Goings On About Town." *The New Yorker*, March 20, 1995, p. 28.

Holmqvist, Karl. "Hemma hos Andrea." *Expressen*, February 28, 1995, p. 28.

Kabak, Joanne. "Art at Home: Museum Explores How We Live with Art." *The Advocate*, December 28, 1995, pp. B1, B2.

Klawans, Stuart. "Machine Dreams." *Mirabella*, March 1995, pp. 64–65.

Kuchinskas, Susan. "Zittel: Bringing the Quotidian to Light in a New Way." *The San Francisco Examiner*, November 15, 1995, pp. 1, 4.

Pacheco, Patrick. "America's Top 100 Collectors." *Art & Antiques*, March 1995, pp. 63–92, 100–11.

Pedersen, Victoria. "Gallery Go 'Round: Andrea Zittel at Andrea Rosen Gallery." *Paper*, March 1995, p. 105.

"People Whose Gifts Are Changing the Present." *Andy Warhol's Interview*, December 1995, pp. 110–15.

Pinchbeck, Daniel. "Genetic Aesthetics." *World Art*, no. 2, 1995, pp. 52–55, 57.

Pitts, Priscilla. "When I Found a Real Bird House, It Looked like a Modernist Home . . ." *Midwest*, no. 7, 1995, pp. 46–52.

"Project with Rudi Molacek." *Der Standard*, May 24–25, 1995, pp. 10–11.

Schneider, Christiane. "Nuttige kunst: Over de gebruikswaarde van sculptuur." *Metropolis M*, June 1995, pp. 40–43.

Smith, Roberta. "Charles Long at Tanya Bonakdar Gallery." *The New York Times*, March 17, 1995, p. C29.

Sorkin, Michael, et al. "Take Me to Nike Town." *Artforum*, Summer 1995, pp. 9–10.

Spector, Nancy. "Back to the Future: Utopia Revisited." *Guggenheim Magazine*, Winter 1995–1996, pp. 11–13.

Withers, Jane. "Interni concettuali." *Casa Vogue*, April 1995, pp. 130–35.

1996

Birnbaum, Daniel. "IKEA at the End of Metaphysics: Daniel Birnbaum on Art and the IKEA Spirit." *Frieze*, November–December 1996, pp. 33–36.

Bonami, Francesco, Jeffery Rian, Jen Budley, Keith Seward, Neville Wakefield, and Mark Van de Walle. *Echoes: Contemporary Art at the Age of Endless Conclusions*. New York: Monacelli Press, 1996.

Coutts Contemporary Art Awards 1996: Per Kirkeby, Boris Michajlov, Andrea Zittel. Zurich: Coutts Contemporary Art Foundation, 1996.

Dault, Gary Michael. "In Search of an 'Ism' for Our Times." *The Globe and Mail* (Toronto), November 9, 1996, p. E7.

Favermann, Mark. "Design: End-of-the-Century Designs." *Art New England*, June–July 1996, p. 9.

Fujimori, Manami. "Andrea Zittel." *BT Magazine*, June 1996, pp. 30–32, 45–47.

Gith, Peter. "Don Quichotte zu Besuch bei Herrn Goethe." *Frankfurter Allgemeine*, June 26, 1996.

Grusz, Frank. "Autotitat tendiert gegen Null." *Der Tagesspiegel*, June 18, 1996.

Herbstrueth, Peter. "Autorität tendiert gegen Null: Andrea Zittel, Künstlerin." *Der Tagesspiegel*, July 18, 1996.

Herbstrueth, Peter. "Scauder des Glucks." *Der Tagesspiegel*, June 25, 1996.

Höller, Christian. "Transiträume: Die Politik der Hybriditat." *Springer*, October–November 1996, pp. 18–23.

Liebsw, Holger. "Moblierter Rohbau." *Suddeutsche Zeitung*, July 20–21, 1996.

McQuaid, Cate. "Recycling Meets Cutting-Edge Design." *The Boston Sunday Globe*, April 7, 1996.

Melrod, George. "Bio-Perversity." *World Art*, no. 4, 1996, pp. 70–74.

Nelkin, Dorothy. "The Gene as a Cultural Icon: Visual Images of DNA." *Art Journal*, Spring 1996, pp. 56–61.

Pacheco, Patrick. "The Top 100 Collectors in America." *Art & Antiques*, February 1996, p. 102.

Pall, Ellen. "The Do-It-Yourself Dealers." *The New York Times*, September 1, 1996, Section 6, p. 29.

Pascucci, Ernest. "Andrea Zittel's Travel & Leisure." *Artforum*, October 1996, pp. 100–103.

Pollack, Barbara. "Bringing Home the Bread." *ARTnews*, March 1996.

Rowlands, Penelope. "Andrea Zittel at Home." *Metropolis*, May 1996, pp. 104–107, 141, 143.

Schreiber, Susanne. "Biographisch kodiert." *Handelsblatt*, July 5–6, 1996.

Servetar, Stuart. "Art: Andrea Rosen Gallery." *New York Press*, July 17–23, 1996, p. 72.

"A to Z Domestic Prototypes." In *STUD: Architectures of Masculinity*, ed. Joel Sanders, pp. 78–85. Princeton, N.J.: Princeton Architectural Press, 1996.

Welchman, John C. "Parametrology: From the White Cube to the Rainbow Net." *Artext*, January 1996, pp. 58–65.

Wulffen, Thomas. "Erschopfte Avantgarde." *neue bildende kunst*, no. 4, 1996.

1997

"Andrea Zittel." *Trans>*, vols. 1–2, nos. 3–4, 1997, pp. 185–90.

Cortes, Petra. "Andrea Zittel." *Poliester*, vol.6, no. 18, 1997, pp. 42–47.

Decter, Joshua. "Taking It on the Road." *Kunstforum International*, February–May 1997, pp. 172–73.

Dornberg, John. "Art Above All." *Art & Antiques*, September 1997, pp. 96–98.

Frain, Rose. "Artists: Is It Better in Europe?—Rose Frain Takes a Look Around New York and Asks the Question." *Make, the magazine of women's art*, February–March 1997, p. 13.

Fujimori, Manami. "Pursuit of Functional Beauty." *Japanese Lifestyle USA*, Summer 1997, pp. 24–27.

Fujimori, Manami. "World: Andrea Zittel." *Geijutsu Shincho*, no. 1, 1997, p. 101.

Karcher, Eva. "In 100 Tagen um die Welt." *Elle* (Germany), June 1997, pp. 74–78.

Kock, Gerhard Heinrich. "Urlaubsträume in Fiberglas." *Westfälische Nachrichten* (Münster), July 23, 1997.

Marcoci, Roxana, Diana Murphy, and Eve Sinaiko, eds. *New Art*, pp. 157–58. New York: Harry N. Abrams, 1997.

Muller, Silke. "Ruckzug in den schalldichten Stahltank." *Art*, June 1997, p. 26.

Murphy, Megan. "Andrea Zittel Escape Vehicles." *Surface*, Spring 1997, pp. 44–45.

"News: Kunst des Wohnens." *Architektur & Wohnen*, April–May 1997, p. 200.

Pagel, David. "My European Art Pilgrimage (or What I Did on My Summer Vacation)." *Art Issues*, September–October 1997, pp. 28–31.

Pedersen, Victoria, and Tim Griffin. "Art & Commerce." *Paper*, January 1997, pp. 101–106.

Philippi, Anne. "Ein kleines Universum macht frei." *Suddeutsche Zeitung Magazin*, May 16, 1997, pp. 46–49.

Princenthal, Nancy. "Andrea Zittel: The Comforts of Home." *Artext*, February–April 1997, pp. 64–69.

Rian, Jeff. "Working the Room." *Interior View*, January 1997, pp. 74–77.

Riche, Rhonda. "Rogue's Gallery." *Images*, Fall 1997, p. 97.

Robert, Suzanne. "In der Schürze liegt die Würze." *Cosmopolitan* (Germany), May 1997, pp. 74, 76, 78.

Rohr-Bomgard, Linde, and Margaretha Hamm. "Schonste Geldanlage." *Wirtschaftswoche*, July 3, 1997, pp. 100–102, 105–106.

Sandonà, Annamaria. "Le grandi mostre in Europa." *Op. cit*, September 1997, pp. 33–45.

Schwartzman, Allan. "At the Edge: Andy Stillpass." *Art & Auction*, May 1997, p. 135.

Sherlock, Maureen. "The Sentimental Education of a Solitary Walker." *New Art Examiner*, September 1997, pp. 25–31, 69.

Smith, Roberta. "To See, and Spend the Night In." *The New York Times*, September 5, 1997, p. C24.

Solomon, Deborah. "The Stay-at-Home Life as Muse." *The New York Times*, March 20, 1997, p. C1.

Toppila, Paula. "Munsterin mukavat paikat." *Taide*, vol. 37, no. 4, 1997, pp. 26–27.

Ullmann, G. "Ein akteller Versuch, Kunst zu vermitteln." *Werk, Bauen + Wohnen*, October 1997, p. 56.

Weinstein, Jeff. "Art in Residence." *Artforum*, March 1997, pp. 60–67.

Welti, Alfred. "Münster tut gut." *ART: Das Kunstmagazin*, August 1997, pp. 42–49.

Welti, Alfred, Axel Hecht, Heinz Peter Schwerfel, Silke Muller, Gunter Engelhard, and Alfred Nemeczek. "Schweine hinter Glas und andere starke Stucke." *ART: Das Kunstmagazin*, September 1997, pp. 56–59.

1998

Battista, Kathy. "The Great Escape." *Make, the magazine of women's art*, June–August 1998, pp. 16–17.

Codrington, Andrea. "Public Eye." *The New York Times*, January 15, 1998, p. F2.

Comelato, Serena. "Lourve metropolitano: Piu grande e piu bello, e rinato il P. S.#1." *Arte*, May 1998, p. 79.

Debord, Matthew. "LA Casual + NY Critical = A New Urbanity." *Siksi: The Nordic Art Review*, Summer 1998, pp. 56–61.

Frank, Peter. "Seasoned Premiere." *Art & Antiques*, September 1998, pp. 62–63.

Grimsby, Kari. "Art on The Edge and Over." *Women Artist News Book Review*, 1998, pp. 11–12.

Hamaide, Chantal, and Cristina Morozzi. "Nomadic Spaces: Andrea Zittel: The Unit Dwelling." *Intramuros*, April–May 1998, p. 33.

Hamilton, William. "Living Lens: Self-Portraits of Home." *The New York Times*, January 15, 1998, pp. F1, F2.

Hildebrandt, Stefan. "Lifeforms." *Statements 002.98: Bath Couture*, February 1998.

Januszczak, Waldemar. "What Is Art?" *Le Millenium*, no. 25, 1998.

Johnson, Ken. "Jason Dodge at Casey Kaplan." *The New York Times*, May 1, 1998, p. E43.

Nemeczek, Alfred. "Kunst als Dienstleistung." *ART: Das Kunstmagazin*, May 1998, pp. 26–37.

O'Rorke, Imogen. "Andrea Zittel." *Scene*, December 1998, p. 34.

Ritchie, Matthew. "Love, Sweat, and Tears: Ann Hamilton, Jason Rhoades, Brian Tolle, Andrea Zittel." *Flash Art International*, November–December 1998, pp. 78–81.

Smith, Roberta. "Tom Sachs: Thomas Healy Gallery." *The New York Times*, May 8, 1998, p. E33.

Thomas, Karin. *Bis Heute Stilgeschichte der bildenden Kunst im 20: Jahrhundert*, p. 407. Cologne: DuMont Publishers, 1998.

Vaillant, Alexis. "No Parking, Please!" *Kunst-Bulletin*, November 1998, pp. 28–29.

"006. Zittel Trailer." *Wallpaper*, January–February 1998.

1999

Albrethsen, Pernille. "Ø-leir." *Kunstmagasinet 1%*, February 1999, p. 15.

Avgikos, Jan. "Andrea Zittel: Have Habitat, Will Travel." *Parachute*, October–December 1999, pp. 36–41.

Babias, Marius. "Die Kunst uberschreitet die Popkultur." *Kunstforum International*, May–June 1999, pp. 425–28.

Cotter, Holland. "The Annotated Listings—Art." *The New York Times*, September 12, 1999, Section 2, p. 94.

Cotter, Holland. "Jim Isermann–'Fifteen.'" *The New York Times*, October 29, 1999, p. E39.

Dunne, Anthony. *Hertzian Tales: Electronic Products, Aesthetic Experience and Critical Design*, pp. 51–52. London: Royal College of Art, 1999.

Grosenick, Uta, and Burkhard Riemschneider, eds. *Art at the Turn of the Millennium*, pp. 554–57. Cologne: Taschen, 1999.

Kaplan, Renée. "And on Another Furniture Front." *New York Newsday*, April 11, 1999.

Kent, Sarah. "Andrea Zittel." *Time Out London*, January 13–20, 1999, p. 45.

Lamarche, Bernard. "Dix ans par-ci dix ans par-là." *Le Devoir* (Montreal), October 7, 1999.

Morris, Bob. "Footnotes." *The New York Times*, June 27, 1999, Section 6, p. 50.

Phillips, Christopher. "Art for an Unfinished City." *Art in America*, January 1999, pp. 62–69.

Sanders, Joel. "Frames of Mind." *Artforum*, November 1999, pp. 126–31, 157.

"Stardust: Review of Exhibitions." *Geijutsu Shincho*, no. 8, 1999.

Tietenberg, Annette. "The Art of Design." *Form*, November–December 1999, pp. 64–73.

The Village Voice, August 4–10, 1999.

"What Is Art?" *Beaux Arts Magazine*, December 15, 1999, pp. 230–31.

2000

A, B. "De A à Zittel." *Numéro*, September 2000, pp. 208–13.

Blazwick, Iwona, and Simon Wilson, eds. *Tate Modern: The Handbook*. London: Tate Gallery, 2000.

The Collections of the Cincinnati Art Museum, p. 316. Cincinnati: Cincinnati Museum of Art, 2000.

Connelly, John, "Corporate Affair." *Surface Magazine*, Summer 2000, pp. 88–90, 164.

Debord, Matthew. "No Wallflower." *Artforum*, May 1999, p. 67.

Fehrenkamp, A. "Public Art Fund: New York, NY." *Sculpture*, January–February 2000, pp. 14–15.

Gompertz, Will, ed. *ZOO, Issue 6*. London: Friary Press, 2000.

Händler, Ruth. "Wohn-Kartons." *Elle* (Germany), January 2000.

Kimmelman, Michael. "Ilya and Emilia Kabakov 'The Palace of Projects.'" *The New York Times*, June 23, 2000, p. E33.

Kimmelman, Michael. "A Temple of Modern Art and Spectacle." *The New York Times*, May 10, 2000, p. E1.

Levy, Anne. "Sans Toit Ni Loi." *Ikea Room*, Summer 2000, pp. 42–44.

MacAdam, Barbara A. "A Salon for the 21st Century." *ARTnews*, May 2000, pp. 232–33.

Nemeczek, Alfred. "Regie führt das Leben." *ART: Das Kunstmagazin*, September 2000, pp. 40–50.

"Rogues Gallery." *Artnet* (online magazine), available at http://www.artnet.com/magazine/people/beckwith/beckwith6-5-00.asp (June 5, 2000).

Schmid, Lydia. "Kunst-Kiez Brooklyn." *Elle* (Germany), August 2000, pp. 42–50.

Siegel, Katy. "Island life." *Artforum*, December 2000, pp. 116–17.

Steinberg, Claudia. "Andrea Zittel's A–Z Administration." *Architektur & Wohnen*, December–January 2000, pp. 183–92.

Thorson, Alice. "How to Spend $1.000.000 on Art." *The Kansas City Star*, February 20, 2000, pp. K1, K3.

"Vox Pop. " *Make, the magazine of women's art*, March–May 2000, p. 24.

2001

"Andrea Zittel." *Frame*, May–June 2001, p. 65.

"Andrea Zittel: Uniformi, case e isole galleggianti." *Arte*, November 2001, p. 224.

Basilico, Stefano. "Andrea Zittel." *Bomb*, Spring 2001, pp. 70–76.

Buck, Louisa. "Artist's Interview, London: Andrea Zittel: Home, Sweet Unit." *The Art Newspaper*, November 2001, p. 24.

Casciani, S. "Down with Design." *Domus*, March 2001, pp. 18–21.

Celant, Germano. "Andrea Zittel: Un design autobiografico." *Interni*, May 2001, pp. 177–82.

Dalton, Trinie. "Los Carpinteros." *Bomb*, Winter 2001–2002, pp. 60–65.

Douglas, Sarah. "A Miracle! Apparently There Are No Influences on the Art of Now." *The Art Newspaper*, October 2001, p. 41.

Egan, Maura. "Artist in Residence." *Details*, April 2003, pp. 162–65.

Falconer, Morgan. "Live-In Art." *Art Review*, November 2001, p. 56.

Grosenick, Uta, and Burkhard Riemschneider, eds. *Art Now*. Cologne: Taschen, 2001.

Larson, Kay. "Savoring the Slowness of Art at the Speed of Television." *The New York Times*, September 9, 2001, p. 77.

Princenthal, Nancy. "The Laws of Pandemonium." *Art in America*, May 2001, pp. 144–49.

Ramade, Benedicte. "La Beaute: Negociations; L'Oeuvre Collective." *Parachute*, January–March 2001, Supplement, pp. 2–3.

Rigney, R. "Confessions of an 'Art Freak.'" *ARTnews*, March 2001, pp. 101–102.

Scanlan, Joe, and Neal Jackson. "Please, Eat the Daisies." *Art Issues*, January–February 2001, pp. 26–29.

Schaernack, Christian. "Die Kunst-Gemeinde von Brooklyn." *ART: Das Kunstmagazin*, February 2001, pp. 26–37.

Storr, Robert, et al. *Art 21: Art in the 21st Century*, introduction by Susan Sollins, pp. 186–94. New York: Harry N. Abrams, 2001.

Thompson, Nato. "Chimerical Miracle Whip: Into the Border Lands with the Wild Kingdom." *New Art Examiner*, March 2001, pp. 30–35.

Viladas, Pilar. "This Is Not a Dresser." *The New York Times*, January 14, 2001, Section 6, p. 39.

2002

Bard, Elizabeth. "One Man Show." *Contemporary*, June–August 2002, pp. 62–67.

Bayliss, Sarah. "Big Art on Campus." *ARTnews*, May 2002, p. 54.

Brown, Patricia Leigh. "Fine Terrain for Scorpions and Artists." *The New York Times*, August 29, 2002, Section F, pp. D1, D6.

"Exhibit Features Artists' Visions Inspired by Car Interiors." *Antiques & the Arts Weekly*, February 8, 2002.

Finch, Charlie. "The Queen Returns." *Artnet* (online magazine), available at http://www.artnet.com/magazine/features/finch/finch9-13-02.asp (September 13, 2002).

Flores, Andrea E. "Examining an Everyday Interior." *The Harvard Crimson*, 2002, pp. B1, B3.

From Arkhipov to Zittel: Selected Ikon Off-Site Projects 2000–2001, pp. 64–67. Birmingham, England: Ikon Gallery, 2002.

Grosenick, Uta. "Women Artists in the 20th and 21st Century." *Icons*, 2003, pp. 186–89.

Grosenick, Uta, and Burkhard Riemschneider. "Andrea Zittel." In *Art Now: 137 Artists at the Rise of the New Millennium*. Cologne: Taschen, 2002, pp. 552–55.

Heartney, Eleanor. "Speaking for Themselves." *Art in America*, February 2002, pp. 53, 55.

Hirsch, Faye. "Working Proof: Andrea Zittel." *Art on Paper*, September–October 2002, p. 89.

MacAdam, Barbara A. "MoMA QNS." *ARTnews*, September 2002, p. 149.

Miller, Glen. "On the Freeway at MOA." *Riverwalk Arts & Entertainment Guide*, 2001–2002.

Muller, Silke. "Die neunziger Jahre–oder: Kein Licht am Ende des Tunnels." *ART: Das Kunstmagazin*, April 2002, pp. 46–48.

Photography Transformed: The Metropolitan Bank and Trust Collection, essay by Klaus Kertess, p. 222. New York: Harry N. Abrams, 2002.

Prince, Nigel. "Designs for Living." *Untitled*, Spring 2002, p. 25.

Ramade, Benedicte. "L'architecture et autres avatars." *L'Oeil*, November 2002, p. 113.

Riley, Terence, Kynaston McShine, and Anne Umland, eds. *MoMA QNS Boxed Set*. New York: Museum of Modern Art, 2002.

Rose, Matthew. "The World as a Murphy Bed: Andrea Zittel." *NY Arts Magazine*, 2002, p. 59.

Silver, Joanne. "Auto Motives." *Boston Herald*, March 1, 2002.

Smith, Courtenay, and Sean Topham. *Xtreme Houses*. Munich and New York: Prestel, 2002.

Smith, Roberta. "The Armory Show, Grown Up and in Love with Color." *The New York Times*, February 22, 2002, p. E38.

Smith, Roberta. "Toland Grinnell—'A Mobile Home and Other Necessities.'" *The New York Times*, September 13, 2002, p. E31.

Smith, Roberta. "A Wrap That's Almost Human." *The New York Times*, May 17, 2002, p. E29.

Timberg, Scott. "All Alone, Creating a World." *Los Angeles Times*, December 14, 2002, pp. E26–E27.

Waxman, Lori. "Andrea Zittel." *Tema Celeste*, September–October 2002, p. 92.

Yañez, Isabel. "ArteMóvil." *Neo2*, January–February 2002, p. 125.

Zeiger, Mimi. "Living A-to-Z." *Dwell*, December 2002, cover and pp. 60–67.

2003

"Andrea Zittel." *Flash Art International*, July–September 2003, p. 107.

Bartolucci, Marisa. *Living Large in Small Spaces: Expressing Personal Style in 100–1,000 Square Feet*. New York: Harry Abrams, 2003.

DeCarlo, Tessa. "A Place to Hang Out and Learn a Thing or Two." *The New York Times*, April 23, 2003, p. G16.

Fichtner, Heidi. "Andrea Zittel." *Flash Art International,* 2003, p. 107.

Freudenheim, Susan. "A Most Personal Gallery." *The Los Angeles Times*, May 8, 2003, p. F14.

Gabrielli, Paolo. "Art as Fashion." *Art Review*, vol. 54, September 2003, pp. 50–55.

Guyton, Wade. "Desert Storm." *V Magazine*, vol. 25, September–October 2003, n.p.

Händler, Ruth. "Die Design-Kunstler." *Häuser*, April 2003, pp. 104–10.

Hudson, Kirsten. "Materials for Living: An Interview with Andrea Zittel." *Ten By Ten*, Winter 2003, pp. 20–23.

Israel, Nico. "Under the Sun." *Artforum*, September 2003, pp. 47, 49–50.

Lloyd, Ann Wilson. "The Art That's Living in the House Hadid Built." *The New York Times*, June 8, 2003, Section 2, p. 29.

Martinez, Chus, et al. "Sculpture Forever: Contemporary Sculpture (Part II)." *Flash Art*, July–September 2003, pp. 100–107.

Mitchell, Claire. "Nomad's Land." *Nylon*, May 2003, pp. 86–89.

Myers, Terry. "Enlightening Field." *Tate*, March–April 2003, pp. 40–44.

Selinger-Morris, Samantha. "The Happy Wanderers." *Sunday Life,* magazine of *The Sun Herald* (Sydney), June 29, 2003, pp. 24–26.

Sheets, Hilarie M. "There's No Piece Like Home." *ARTnews*, December 2003, pp. 102–103.

Smith, Roberta. "A Bread-Crumb Trail to the Spirit of the Times." *The New York Times*, January 17, 2003, p. E41.

Smith, Roberta. "A Space Reborn, with a Show That's Never Finished." *The New York Times*, April 4, 2003, p. E37.

Ulmer, Brigitte. "Leben in Utopia." *Bolero*, August 2003, pp. 22–26.

Verhagen, Marcus. "Micro-utopianism." *Art Monthly*, December–January 2004, pp. 1–4.

2004

Griffin, Tim. "Out of the Past." *Artforum*, January 2004, pp. 57–59.

Kahn, Eve. "A Combination Peanut Gallery, Violin Garage, Closet and Cat Gym." *The New York Times*, April 1, 2004, p. F3.

Kaplan, Cheryl. "Social Study: An Interview with Andrea Zittel." *db artmag* (online magazine), available at http://www.deutsche-bank-kunst.com/art/2004/1/e/ (January 29–March 11, 2004).

Maekawa, Akane. "A–Z West." *Studio Voice Magazine*, September 2004, p. 47.

Peltomaki, Kirsi. "Common Good, Personal Pleasure." *Framework*, no. 2, 2004, pp. 28–29.

Pincus, Robert. "Art Infused with 'All Aspects of Day-to-Day Life." *The San Diego Union-Tribune*, April 18, 2004, pp. F1, F4.

Saltz, Jerry. "The OK Corral." *The Village Voice*, March 15, 2004.

"Sufficient Self." *Purple Fashion*, Fall–Winter 2004, p. 38.

2005

Berger, Shoshana. "HDYGTFAJ? How Did You Get That Fu*&%ing Awesome Job?" *ReadyMade*, January–February 2005, pp 34–35.

Miles, Christopher. "Andrea Zittel at Regen Projects." *Artforum*, March 2005, pp. 243–44.

O'Neill-Butler, Lauren. "Domestic Disturbances." *Bitch*, Winter 2005, pp. 50, 60.

Trainor, James. "Don't Fence Me In." *Frieze*, April 2005, pp. 88–93.

Trainor, James. "State of the Art." *Frieze*, January–February 2005, p. 59.

Zissu, Alexandra, Maura Egan, and Pilar Viladas. "The Originals." *The New York Times Style Magazine*, Spring 2005, p. 115.

Photographic Credits

Every effort has been made to seek permission to reproduce those images whose copyright does not reside with the publishers and we are grateful to the individuals and institutions that have assisted in this task. Any omissions are entirely unintentional, and the details should be addressed to the Contemporary Arts Museum Houston.

Unless otherwise specified in the following list, all photographs are courtesy of Andrea Rosen Gallery, New York.

Exhibition curated by Nigel Prince, photo by Adrian Burrows, courtesy of Andrea Rosen Gallery, New York, reproduced by permission of the Ikon Gallery, Birmingham, England, pages 167 bottom, 184 bottom left, and 186 top left

Photo by Blaise Adilon, © Atelier Van Lieshout and Blaise Adilon, courtesy of Tanya Bonakdar Gallery, New York, page 39 right

Photo by Borkur Arnason, courtesy of Tanya Bonakdar Gallery, New York, Galerie Klosterfelde Berlin, and Galleri Nicolai Wallner, Copenhagen, page 60 bottom

Photo by John Cliett, © Dia Art Foundation, New York, page 21

Photo by Christina Dilger, courtesy of artdoc.de, and Andrea Rosen Gallery, New York, page 208 bottom left

Photo by David Dodge, courtesy of the artist, pages 102 top, and 164 bottom

Photo by Elaine Dodge, courtesy of the artist, pages 100 bottom, and 103 bottom

Photo by Judith Eisler, courtesy of the artist, page 75

Photo by Ulrikka Gernes, courtesy of the Estate of Poul Gernes, page 61 bottom

Photo by John R. Glembin, courtesy of the Milwaukee Art Museum, front cover, and page 215 top and bottom

Photo by Paula Goldman, courtesy of Andrea Rosen Gallery, New York, reproduced by permission of The Museum of Contemporary Art, Los Angeles, page 151 top

Photo by Joachim Hamou, courtesy of the artist, page 178 bottom

Photo by Marian Harders, courtesy of Public Art Fund, New York, and Andrea Rosen Gallery, New York, pages 175 and 209

Photo by Giovanni Jance, courtesy of the artist, page 97

Photo by Jason Mandella, courtesy of Andrea Rosen Gallery, New York, page 183 top and bottom left

Photo by Chris Moore, courtesy of Andrea Rosen Gallery, New York, page 85

Photo by Peter Muscato, courtesy of the artist, page 148 top

Photo by Peter Muscato, courtesy of Andrea Rosen Gallery, New York, page 149 top, center, and bottom

Photo by Peter Muscato, courtesy of Andrea Rosen Gallery, New York, reproduced by permission of the San Francisco Museum of Modern Art, page 126 right

Photo by Wilfried Petzi, courtesy of the Goetz Collection, Munich, page 95 bottom

Photo by Jens Rathmann, Hamburg, courtesy of Andrea Rosen Gallery, New York, page 211 bottom left

Photo by Andrea Rosen, courtesy of the artist, page 174 right

Photo by Oren Slor, courtesy of Andrea Rosen Gallery, New York, pages 73, 76 top, 81, 106, and 191

Photo by Kentaro Takioka, courtesy of the artist, page 79 top

Photo by Kentaro Takioka, courtesy of Andrea Rosen Gallery, New York, page 78

Photo by Richard-Max Tremblay, courtesy of Andrea Rosen Gallery, New York, reproduced with permission of the Musée d'art contemporain de Montreal, page 206 top

Photo by Joshua White, courtesy of Regen Projects, Los Angeles, back cover, and pages 165 and 182

Photo by Nickolai Zeldovich, courtesy of the photographer, page 57

Photo by Andrea Zittel, courtesy of the artist, pages 30, 33, 40, 44, 46–47, 49, 52, 67 bottom right, 69 top, 86 bottom right, 87 top, 92 center and bottom, 94 center, 96, 98–99, 100 top, 101, 102 bottom, 105, 128 bottom and top, 145 bottom right, 160–63, 172 bottom, 173, 174 bottom, 180 bottom left and right, 181 bottom, 195 bottom left, 196 top, 202 bottom, 207 bottom left, 208 top, 210 top, 211 top, 213, and 214 top

Photo by Andrea Zittel, courtesy of Lisi Raskin, page 59

Photo by Andrea Zittel, courtesy of Andrea Rosen Gallery, New York, pages 89 top, 177, 178 top, 179, and 198 bottom

Photo by Gordon Zittel, courtesy of the artist, pages 58, 103 top, 183 bottom, 210 bottom right, 216 top and bottom, and 217

Photo by Gordon Zittel, courtesy of Andrea Rosen Gallery, New York, page 199 top

Photo by Miriam Zittel, courtesy of Andrea Rosen Gallery, New York, page 199 bottom

Photo © Gerald Zugmann/MAK—Austrian Museum of Applied Arts/ Contemporary Art, Vienna, page 62

Photo © Bernard Boyer, courtesy of the artist, page 23 top

Photo © 1999 The Estate of Glen Seator, page 60 top

Photo © 2005 Joseph Kosuth/Artists Rights Society (ARS), New York, © Digital Image © The Museum of Modern Art/Licensed by SCALA / Art Resource, NY, page 20

Photo © Cal Kowal, courtesy of Andrea Rosen Gallery, New York, page 83 top

Photo © The Museum of Modern Art/Licensed by SCALA/Art Resource, NY, pages 38 and 104 left

Photo © Rodchenko & Stepanova Archive, pages 22 top right and 24 right

Photo courtesy of the artist, pages 15, 68, 76 bottom, 86 bottom left, 94 top, 122 bottom right, 154 center and bottom, 184 background, 185, 186 bottom left, and 207 bottom right

Photo courtesy of the artist and Luhring Augustine, New York, page 27

Photo courtesy of the artist, reproduced by permission of the San Francisco Museum of Modern Art, page 193 bottom right

Photo courtesy of Galleria Massimo De Carlo, Milan, pages 122 bottom left, and 123

Photo courtesy of Eames Office, Santa Monica, California, page 41

Photo courtesy of Marian Goodman Gallery, New York, page 19

Photo courtesy of the Library of Congress Prints and Photographs Division, Washington, D.C., page 22 bottom

Photo courtesy of Barbara and Howard Morse, New York, pages 23 bottom, 63, 109, and 143 top and bottom

Photo courtesy of N55, page 61 top

Photo courtesy of Andrea Rosen Gallery, New York, and Sadie Coles HQ, London, pages 16, 74 top, 181 top, and 194

Photo courtesy of Andrea Rosen Gallery, New York, and Editions Fawbush, New York, page 127

Photo courtesy of Andrea Rosen Gallery, New York, and Christopher Grimes Gallery, Santa Monica, California, page 112

Photo courtesy of Andrea Rosen Gallery, New York, reproduced by permission of the Cincinnati Art Museum, page 135 top

Photo courtesy of Andrea Rosen Gallery, New York, reproduced by permission of the Milwaukee Art Museum, page 130 top

Photo courtesy of Andrea Rosen Gallery, New York, reproduced by permission of the San Francisco Museum of Modern Art, pages 126 left, 195 top, 196 bottom, 197, and 198 top

Photo courtesy of White Cube, London, page 148 bottom right

Editorial direction: Paola Morsiani, Trevor Smith,
and Angeli Sachs (Prestel Verlag)

Editor: Polly Koch

Design: Don Quaintance, Public Address Design, Houston

Design/Production Assistant:
Elizabeth Frizzell, Public Address Design, Houston

Production: Paola Morsiani, Contemporary Arts Museum Houston,
and Andrea Mogwitz, Prestel Verlag

Typography: composed in Gareth Hague's Anomoly

Color separations and prepress: ReproLine mediateam, Munich

Printing and binding: Print Consult, Munich

Contributors

Cornelia Butler is curator at The Museum of Contemporary Art, Los Angeles, where she has curated numerous exhibitions, including *Afterimage: Drawing Through Process* (2000), *Flight Patterns* (2001), *Willem de Kooning: Tracing the Figure* (2002), *Robert Smithson* (2004), *Rodney Graham: A Little Thought* (2004), and the forthcoming *WACK! Art and the Feminist Revolution*. Butler has written extensively on contemporary art with contributions to numerous catalogues and has lectured at many universities and art institutions.

Beatriz Colomina is professor of architecture and founding director of the Program in Media and Modernity at Princeton University. She is the author of *Architectureproduction* (1988), *Sexuality and Space* (1992), *Privacy and Publicity: Modern Architecture as Mass Media* (1994), and *Cold War Hothouses: Inventing Postwar Culture from Cockpit to Playboy* (2004). Currently she is completing a book on the relationships between war and modern architecture in the context of the United States in the years following World War II, entitled *Domesticity at War: 1945–61*, and a collection of essays on art entitled *Double Exposure: Architecture Through Art.*

Robert Cook is associate curator of contemporary art at the Art Gallery of Western Australia. He received his PhD in 1998 from Curtin University of Technology, Perth. Cook's research and writing interests are in the ways that our impulse for self-narration transforms our physical relation to the world, as articulated in design, pop and sub cultures, the visual arts and other, more vernacular, creative pursuits. He has explored these issues in a series of articles in *Broadsheet* and numerous other Australian and international journals over the last few years.

Paola Morsiani is curator at the Contemporary Arts Museum Houston, where she has curated numerous exhibitions, including *Subject Plural: Crowds in Contemporary Art* (2001), *When 1 is 2: The Art of Alighiero e Boetti* (2002), *Pertaining to Painting* (2002), *Perspectives 139: Abraham Cruzvillegas* (2003), *Fade In: New Film and Video* (2004), and the forthcoming survey exhibition of the work of Pipilotti Rist. She has contributed essays to exhibition catalogues and periodicals internationally.

Don Quaintance, the graphic designer of this publication and principal of Public Address Design, Houston, has designed major catalogues for several touring retrospectives including *Edward and Nancy Reddin Kienholz* (Whitney Museum of American Art, New York, 1996), *Robert Rauschenberg* and *James Rosenquist* (both Solomon R. Guggenheim Museum, New York, 1997 and 2003), *Barnett Newman* (Philadelphia Museum of Art and Tate Modern, London, 2002), and *Max Ernst* (Metropolitan Museum of Art, New York, 2005). His most recent book design is *Peggy Guggenheim and Frederick Kiesler: The Story of Art of This Century* (Peggy Guggenheim Collection, Venice, 2005). He has also contributed art historical essays to several books.

Trevor Smith is curator at the New Museum of Contemporary Art in New York. Prior to his arrival in New York in 2003, Smith was based in Australia where he was director of the Canberra Contemporary Art Space before becoming curator of contemporary art at the Art Gallery of Western Australia in 1997. Among his curatorial endeavors have been a touring survey of the work of Robert MacPherson and *The Divine Comedy: Francisco Goya, Buster Keaton, William Kentridge* (2004). He is an internationally published writer who has written on artists such as Beat Streuli, Brian Jungen, and Haim Steinbach.

Mark Wigley is dean of the Graduate School of Architecture, Planning, and Preservation, Columbia University, New York. He has served as guest curator for widely attended exhibitions at The Museum of Modern Art, New York; The Drawing Center, New York; Canadian Centre for Architecture, Montreal; and Witte de With Museum, Rotterdam. Wigley is the author of *The Architecture of Deconstruction: Derrida's Haunt* (1993); *White Walls, Designer Dresses: The Fashioning of Modern Architecture* (1995); and *Constant's New Babylon: The Hyper-Architecture of Desire* (1998). He co-edited *The Activist Drawing: Situationist Architectures from Constant's New Babylon to Beyond* (2001).